All in Sync

The publisher gratefully acknowledges the generous contribution to this book provided by the General Endowment Fund of the University of California Press Associates.

All in Sync

How Music and Art Are Revitalizing American Religion

Robert Wuthnow

UNIVERSITY OF CALIFORNIA PRESS

Berkeley / Los Angeles / London

University of California Press
Berkeley and Los Angeles, California

University of California Press, Ltd.
London, England

First paperback printing 2005
© 2003 by The Regents of the University of California

Library of Congress Cataloging-in-Publication Data
Wuthnow, Robert.
 All in sync : how music and art are revitalizing American religion /
Robert Wuthnow.
 p. cm.
 Includes index.
 ISBN 0-520-24685-3 (pbk : alk. paper)
 1. United States—Religion. 2. Art and religion. I. Title.
BL2525 .W853 2003
291.3'7'0973—dc21 2002067878

Manufactured in the United States of America

14 13 12 11 10 09 08 07 06 05

10 9 8 7 6 5 4 3 2 1

The paper used in this publication is both acid-free and totally
chlorine-free (TCF). It meets the minimum requirements of
ANSI/NISO Z 39.48-1992 (R 1997) (*Permanence of Paper*). ∞

Sometimes when we're singing and the spirit is moving, it's almost like the roof goes away and you can see the heavens. When we're all in sync, you can feel the spirit moving.

<div style="text-align: right">Church member</div>

Contents

Tables

Preface

For more than three decades, my work has focused on Americans' changing interests in spirituality. I try to make sense of these interests and to learn how they are shaped by the culture in which we live. I do this mostly by keeping my ear to the ground. Through interviews and surveys, I listen to people talking about their lives. I pay particular attention to their struggles and their discoveries.

Spirituality is deeply significant to most Americans. Despite the materialism that surrounds us, the quest to know God and to experience the sacred has not diminished. But for many people the search for spirituality is also confusing. Although religious leaders speak confidently about God, the public more often expresses doubts about how to relate to the divine. These are not the doubts entertained by previous generations of agnostics and unbelievers. They are uncertainties about what to believe and whether belief is even the right way to approach spirituality. Many people candidly admit that they have more questions than answers.

Yet it is equally clear that most Americans have made tentative wagers about the sparse answers they have found. Although they seldom define spirituality in terms of theological formulas, they find God in the joys and trials of everyday life. The search for faith is intensely personal. It revolves around struggles to overcome brokenness and the desire to lead a fulfilling life.

I have repeatedly been moved by the quiet insights that people share as they describe their spiritual journeys. One of the most common insights is that spirituality is much more about the heart than about the

head. This frequently prompts people to cry (and occasionally to burst into laughter) as they share their stories.

Another insight that emerges too often and too powerfully to be ignored is that music and poetry, paintings and sculpture, drama and dance play a powerful role in many Americans' spiritual journeys. Music and art are closely wedded with spiritual experience. They draw people closer to God, often by expressing what cannot be put into words. They spark the religious imagination and enrich personal experiences of the sacred.

But surprisingly little attention has been paid to the role of imagination and the arts in Americans' spirituality. Standard treatments of religion and the arts have focused on famous paintings in fine galleries, church architecture, and belles lettres. They fail to tell us how people experience the arts in congregations and communities and in everyday life.

A close look at these experiences shows how importantly the arts figure in the spiritual journeys of most Americans. Faced with loneliness and despair, people turn to art and music for comfort and inspiration. They anchor themselves in congregations through memories of stained-glass windows and favorite hymns. Many people express their experiences of the sacred by writing poetry or painting pictures; some use the creative arts to help others.

These uses of the arts arise from the larger influences that presently shape our spiritual quests as individuals and as a nation. Many of us have been shunted from one community to another. We find it hard to settle down, certainly if settling means adopting a rigid system of religious beliefs. Especially for people who have grown weary of metaphysical arguments, the arts provide an attractive alternative.

Although the mass media make it easy for Americans to explore the arts, the results of such explorations are often disappointing. Media-fed spirituality suffers from superficiality, while momentary inspiration fails to illumine the dark night of the soul. But the mass media are not the only vehicles through which the arts and spirituality have been coming together. Churches and synagogues, museums and galleries, and community art programs are playing an increasing role in bringing Americans' interests in the arts to bear on their quests for the sacred. In the process, new attention is being given to the religious imagination, and many people are experimenting with the arts in their devotional lives, at their houses of worship, and in their efforts to serve others. The consequences are sometimes profound. Making greater use of the arts be-

comes a path to personal growth. For many churches, it has also been a dynamic source of new vitality.

The material I present here comes from a series of investigations conducted over a four-year period into the diverse experiences, understandings, and contexts through which Americans' search for spirituality and their interests in the arts are currently related. The study involved in-depth qualitative interviews with more than 400 people and a representative national survey of the U.S. population.

In lengthy interviews about their spiritual journeys, 200 people from many different walks of life and religious backgrounds were asked to talk about the various experiences that had been most meaningful to them, including experiences of art, music, and literature. An additional 150 interviews were conducted with church members and with people who used the arts avocationally or professionally as part of their ministry or in a religious context. These interviews were supplemented by ten focus groups (involving 100 people) that asked participants to discuss their experiences of the arts and to respond to a series of paintings and musical and literary selections. Besides these interviews and focus groups, 60 randomly selected clergy in one metropolitan community were interviewed about their understandings of religion and the arts, and in five other cities a total of 100 of the most influential clergy and leaders of arts organizations were interviewed to gauge their ideas about relationships between religion and the arts. Finally, to provide quantitative evidence, I designed a national survey (the Arts and Religion Survey) and commissioned the Gallup Organization in Princeton to administer it to a representative national sample of 1,530 adults.

The research was conducted with the support of a grant from the Lilly Endowment in Indianapolis and with supplemental support from the Henry Luce Foundation in New York. I am especially grateful to Craig Dykstra, Dorothy Bass, Jeanne Knoerle, Christopher Coble, John Cook, Ellen Holtzman, and Alberta Arthurs for their interest in and support of the project. Research assistance was provided by Sue Bennetch, Tanya Erzen, Maggie Fishman, Anita Geiger, and Megan McShea. Besides conducting interviews, Natalie Searl supervised the fieldwork and transcriptions. The national survey was supervised by Harry Cotugno and John McNee. Sandra Kunz helped with library research. Valuable feedback and suggestions were provided by audiences who heard public lectures based on earlier drafts of some of the chapters at Eden Seminary in St. Louis; Westminster Presbyterian Church in Springfield, Illinois; the University of Illinois; Duke Divinity School;

the University of Arizona; and the Institute for Advanced Study of Religion at Yale University.

I owe the greatest debt to the hundreds of people who set aside time in their busy schedules to talk about their experiences and understandings. Some gave permission to use their real names, while others preferred to be identified by pseudonyms.

Writing this book has enriched my own sense of spirituality as well as my appreciation of the arts. I have been blessed beyond measure in being able to share these experiences with Sara, my wife, and with Robyn, Brooke, and Joel, my beloved children.

A Puzzle

The Question of Religious Vitality

At a Presbyterian church in southern California, a shadow falls across the pastor's face as he reflects on his denomination. "Our worship styles are archaic and our belief systems are inflexible," he laments. "We are pushing people away." Down the street, a Methodist minister shares this concern. "People are spiritual but not necessarily religious. We've become such an institution that we forget about nurturing the spirit." In Illinois, a Catholic sister worries that "the churches do not offer the deep nourishment people need; they're too superficial." Church members in New Jersey, New Mexico, and Ohio voice similar concerns about their denominations' ability to remain vital. "In the 1950s and '60s it was just accepted that you went to church," explains one. "But that no longer is the case."

By all accounts, American religion *should have* suffered a serious decline during the last third of the twentieth century. Alternatives to organized religion—from cults and encounter groups to therapies and advice columnists—flourished. More people than ever were exposed to the influences of higher education so often presumed to erode traditional religious beliefs. Scientific research was funded at record levels. Longer life expectancies permitted people to focus on the here and now instead of the hereafter. Millions of baby boomers, reared on television rather than the Ten Commandments, came of age. Even the much publicized moral crusades of Jerry Falwell and Pat Robertson drew more negative reactions than public support.

At the start of this period, most observers were already predicting the worst. The firm convictions of the generation that had experienced the

Great Depression and World War II were not being effectively transmitted to younger Americans. Religion, while still pervasive, was becoming a matter of conjecture. Harvey Cox, in his widely read *Secular City,* expressed the prevailing sentiment: "For some, religion provides a hobby, for others a mark of national or ethnic identification, for still others an esthetic delight. For fewer and fewer does it provide an inclusive and commanding system of personal and cosmic values and explanations."[1]

Of course, it was apparent enough to anyone who may have stopped to ponder the matter that Americans could move contentedly into the future, half-heartedly embracing a religion that provided neither cosmic values nor compelling explanations. Will Herberg, writing at the peak of America's postwar religious revival in the 1950s, had observed that religious sentiments were relatively superficial, despite their apparent universality.[2] Americans always had been able to reconcile their churchgoing with schemes and ambitions hardly fitting for truer believers.

The churches' ability to sustain themselves on sheer inertia, however, seemed more doubtful. The tacit assumptions on which churchgoing was predicated were clearly in danger of unraveling. Finding community among fellow congregants was likely to be less attractive to Americans who could effortlessly stay in touch with friends and family by other means. Messages about God could readily be heard on television instead of having to attend one's house of worship. If families that prayed together might, as advertisements suggested, stay together, churchgoing easily could cease to be attractive to the many Americans whose marriages had already failed. The mental jostling that millions of younger Americans experienced when they attended colleges and universities seemed especially likely to unsettle the conventional wisdom offered in pulpits and pews.

Yet the striking feature of American religion during the last decades of the twentieth century was its *remarkable stability.* Large numbers of people continued to affiliate with churches and synagogues and to overwhelmingly express belief in God. Their proclivity to participate in religious services was undiminished. The religious voice in public life continued to be heard, and faith communities played a large role in the nation's philanthropic and service efforts. In a marked turnaround of scholarly and journalistic thought, virtually every observer of American religion became more impressed by its persistence than by signs of its erosion or impending collapse.

Religious statistics provide a ready indication of this persistence.

Each year tens of thousands of respondents in Gallup Polls are asked whether they attended religious services in the past seven days. Although it is suspected that some people say they have attended when in fact they have not, there is no reason to think that prevarication of this kind has become worse in recent years.[3] The fact that the questions are always asked in the same way, and that they are asked of such large numbers of people, gives added meaning to the results. In 1970, approximately four Americans in ten said they had attended religious services in the past seven days; in 1980, the proportions ranged between 40 and 41 percent; in 1990, the figure was 40 percent; and in 2000, it was still virtually the same (41 percent).[4]

The pattern in General Social Surveys, conducted by the National Opinion Research Center at the University of Chicago, is similar to the Gallup findings but shows a small decline in frequent religious service attendance in the closing years of the twentieth century. Making special efforts to achieve high response rates, and using the same sampling procedures since 1973, the General Social Surveys recorded 36 percent of the adult population claiming to attend religious services at least "nearly every week" in 1973, 35 percent doing so in 1983, the same percentage doing so in 1993, 32 percent doing so in 1998, and 30 percent doing so in 2000.[5] After thorough examination of these and other measures, sociologists Michael Hout and Andrew Greeley conclude that there is no evidence to support the notion that church attendance rates in the United States were falling.[6] Reviewing the same evidence, political scientist Robert Putnam in *Bowling Alone* argues that religious participation *did decline* slightly, but emphasizes that this decline was much smaller than for virtually all other kinds of civic involvement, including membership in fraternal organizations and service clubs, voter turnout, and participation in community-wide political events.[7]

Such evidence may be sufficiently rough to raise doubts about its ability to pick up increases or decreases in religious involvement. That concern, however, is diminished by the fact that surveys *did* capture earlier increases and decreases. During the 1950s, for instance, when Cold War fears and family concerns resulted in a widely discussed "revival" of religious membership and new church construction, churchgoing figures in Gallup surveys hit all-time highs. Later, when countercultural unrest and fallout from the Second Vatican Council were thought to have a negative impact on established religion, churchgoing (especially among Roman Catholics) fell according to several surveys taken at the time.

The persistence of religious commitment between 1970 and the end of the century is suggested by other evidence as well. For example, surveys show that the proportion of Americans who thought religion "can answer today's problems" remained virtually constant between the early 1970s and the late 1990s.[8] Qualitative observations, drawn from comparisons between the United States and other technologically advanced societies, also suggested the relative persistence of American religion. Reviewing such evidence, sociologist Peter Berger observed, "A whole body of literature by historians and social scientists loosely labeled 'secularization theory' is essentially mistaken."[9]

My reason for pointing to this stability in American religion is not to take sides in old debates about secularization or to defend the accuracy of social survey results.[10] Rather, I wish to point out that the relative persistence of religious commitment during the last part of the twentieth century poses an interesting puzzle. Why did it persist, especially when so many features of the period would suggest otherwise? Furthermore, what can be learned about the vitality of American religion during this period that might be helpful for those who wish to nurture this vitality in the future?

The last third of the twentieth century was a time of momentous social change. Although no major wars and no serious economic crises occurred, several quiet social developments took place that resulted in profound changes in nearly all sectors of American society. In the economy, one of the most notable changes was the large proportion of women who joined the paid labor force. In the family, social change was especially evident in the rising divorce rate. In community life, neighborhoods became increasingly anonymous as a result of population growth and geographic mobility. In education, the number of young Americans attending colleges and universities hugely increased. The potential for each of these developments to have had negative consequences for religion can be seen from a brief review of the evidence.

The proportion of women participating in the labor force grew from just under 43 percent in 1970 to just under 62 percent in 1999. The largest changes were among women between the ages of twenty-five and forty-four: eight in ten were employed by the latter date, compared with approximately half in 1970.[11] A large number of these women were married mothers of school-age children. Besides participating in the labor force in larger numbers, women also devoted longer hours to their jobs. According to one estimate, annual hours of paid employment for women in the labor force grew by an average of 305 hours between 1969

and 1987.[12] Part of this increase was due to women working more over-time hours and spending more weeks per year at the job. It was also the result of women opting for full-time instead of part-time employment: between 1973 and 1998, the proportion of working women with part-time jobs shrank from one in three to one in five.[13] The reason that this trend had potentially negative implications for religion was that women (especially married women with children) had been the most active participants in churches and synagogues. Compared to men, they had shouldered a large share of church responsibilities requiring volunteer time. Yet, as their free time diminished, their likelihood of participating in religious activities did too. Thus, among women surveyed in 1999, 64 percent who worked fewer than ten hours a week attended religious services every week, but this proportion dropped to 50 percent among those who worked between ten and nineteen hours a week, to 30 percent among those who worked between thirty and forty-nine hours, and to only 9 percent among those who worked more than sixty hours.[14] In short, the more hours a woman worked, the less likely she was to attend religious services.

The rising divorce rate was another factor with potentially negative consequences for religion. The change in this rate was associated with the greater economic independence achieved by women through their participation in the labor force, with unsettled social conditions, and with altered understandings of marriage. Despite the fact that most Americans continued to value marriage, the divorce rate rose from approximately one divorce for every four marriages in 1950 to one for every two marriages in the 1990s. As a result, the proportion of divorced Americans in the 1990s was about four times as high as it was in 1960.[15] The reason that this trend did not bode well for religion is that married men and women attend church at higher rates than divorced or separated people do. For instance, in 1999, 40 percent of married adults claimed to attend religious services every week, compared to only 24 percent among divorced adults and 17 percent among separated adults. Although many people who divorce remarry within a few years, they continue to attend church less frequently than do married people who have never been divorced (31 percent attend compared to 41 percent among the latter).[16] As the proportion of divorced people in the population increased, therefore, the likelihood of people attending religious services should have decreased. Geographic mobility

The nature of community life shifted as well and appears to h the United States has always been rel

remained high between 1970 and 1999.[17] At the latter date, the average number of addresses Americans reported having lived at was ten. Much of this mobility occurred among young people. Whereas previous mobility often had been from small towns to urban areas, a large share of the recent mobility was from one urban area to another urban area. Although the effects of this mobility are in dispute, one implication is that fewer people knew their neighbors or spent time socializing with them. According to one study, the number of people claiming to spend social evenings with neighbors dropped from 44 percent in 1974 to 32 percent in 1998.[18] And neighborhood ties historically have been one of the resources on which religion depends. People with strong neighborhood ties are more likely to hear about and be interested in religious activities. They work together to maintain neighborhood churches, and when they attend church they are more likely to feel at home because they see their neighbors there. Surveys show that neighborhood ties *are* weakened by geographic mobility and that lower involvement in religious activities goes hand in hand with weaker neighborhood ties: in 1999, among people who had lived at one or two addresses during their lifetimes, only 31 percent said they knew few or none of their neighbors, but this proportion rose to 62 percent among those who had lived at ten or more addresses. Among those who knew almost all of their neighbors, 46 percent attended religious services every week, but this proportion declined to 36 percent among those who knew only a quarter of their neighbors, to 31 percent among those who knew a few of their neighbors, and to only 21 percent among those who knew none of their neighbors.[19]

The rise in levels of education during the last third of the twentieth century is well documented. In itself, this rise did not have negative implications for religious participation, because those with more education generally participate in all social activities, including church, at higher than those with less education. But higher education has been widely suspected of eroding traditional religious beliefs—the very beliefs that maintain high levels of religious participation. For instance, the proportion of Americans who believe that the Bible should be taken literally falls percent among those who have not graduated from high school, percent among high school graduates, to 26 percent among those with some college education, and to only 20 percent among college levels were rising. Moreover, at the same time that education levels were rising, a literal interpretation of the Bible was declining, from 65 in 1963 to 33 percent in 1998.[20] Even among

clergy, this belief appears to have declined; for example, at Fuller Seminary in California, one of the nation's largest and most traditionally evangelical institutions, the proportion of students claiming to believe in a literal interpretation of the Bible declined from 48 percent among the classes of 1950–52 to 15 percent among the class of 1982.[21] The reason that decreases in beliefs such as this were not promising for the overall strength of religion is that people who hold such beliefs are much more likely to participate regularly than those who do not. Thus, in 1999, 44 percent of those who took the Bible literally claimed to attend services every week, compared to only 28 percent of those who did not hold this belief.[22]

Even if the nation's churches were particularly clever at staving off the ill effects of these trends, their success is all the more impressive in view of the fact that so many other community organizations suffered. As Robert Putnam has shown, the quarter-century after 1970 witnessed serious losses in the memberships of a wide range of community organizations, including such prominent groups as the PTA, Elks, Moose, veterans' organizations, labor unions, and scouting.[23] Why the churches fared as well as they did is a puzzle.

What could account for this stability? Or, in view of the social trends affecting religion negatively, what else might be contributing enough to the churches' vitality to make up for these losses? A possible answer is that there is simply some inveterate human need for religion, perhaps to cope with our fear of death or to express our faith that someone is in control. This answer has the virtue of explaining a constant with a constant: if religious commitment has not changed, it may be because the need for religion has not changed.

This explanation falters, however, in view of the evidence that religious commitment is *not* constant. It varies from society to society; it rose in the 1950s and declined in the 1960s; and it is different among people with various levels of exposure to the labor force, marital instability, neighborhood ties, and higher education. Indeed, the fact that so many trends have been working against religion suggests that *something else must be working in its favor*. People do not flock to churches only because they feel a need for religion; something about religious organizations has to attract them.

Another possible explanation for the recent persistence of religion is that it is nurtured by religious pluralism. This argument often has been used to explain why religion is stronger in the United States than in Europe. It suggests that the competition between Catholics and Protes-

tants, between Christians and Jews, and among various Protestant denominations sparks interest in religion, whereas the state-funded religious monopolies of England, France, Italy, and Sweden deaden this interest. Focusing as it does on large-scale, historic characteristics of whole societies, this argument is also amenable to explaining a lack of change in religious involvement. Moreover, a version of it has been put forward to suggest that the recent vitality of American religion is due to heightened levels of pluralism resulting from the vibrant and diverse faith communities of new immigrants.[24]

There is a difficulty with this explanation, though. If recent immigration is a source of new vitality in American religion, persons of foreign birth should be more actively involved in their places of worship than are native-born Americans. Anecdotal evidence from case studies of new immigrant congregations suggests that persons of foreign birth *are* more involved.[25] When systematic national evidence is examined, however, these people are on the whole *less* involved: 28 percent attend services every week, compared with 34 percent of native-born Americans.[26] The pluralism argument also founders on the fact that competition among religious groups has *decreased* significantly, as is evident in rising rates of interfaith marriages, greater tolerance toward members of other religions, more ecumenical programs, and denominational mergers.

Explaining Religious Vitality

Were the recent persistence of American religion merely an intellectual puzzle, it might well be less interesting to pursue than any number of other questions about recent social trends. Yet the question of religious vitality and revitalization is one of supreme practical importance, not only for religious leaders themselves but for the wider society. Religious leaders are painfully aware that religious commitment does not simply maintain itself. Each year more than two million people in the United States die, a majority of whom are church members who have to be replaced if memberships are to remain constant. When people move to new communities, programs have to be offered to draw them back to the church. Whole congregations cease to function and need to be replaced by growth in other congregations. And for the wider society, ways to maintain and renew the vitality of religious organizations have come to be of increasing interest to policy makers who recognize the

valuable role these organizations play in generating civic skills, creating social capital, preserving democracy, and providing social services.[27]

There are, in fact, three widely held theories of religious vitality, each of which has been put forward to suggest what religious leaders *should* do, in addition to providing an account of why religious commitment may be holding its own. One has emphasized the special advantages of conservative churches; a second focuses on entrepreneurial church leadership; and the third focuses on the merits of religious groups posing as an embattled subculture.

The argument about conservative churches was first advanced by Dean M. Kelley in *Why Conservative Churches Are Growing.*[28] Writing in the early 1970s, Kelley noticed that conservative denominations such as the Southern Baptist Convention and the Assemblies of God were gaining members, whereas theologically moderate or liberal denominations such as Episcopalians and Methodists were declining. Kelley advanced the provocative thesis that conservatism was attractive because it demanded more from members and thus gave them a clearer sense of their religious identity. The argument was all the more compelling because Kelley himself was affiliated with one of the liberal denominations and because theories of secularization generally had painted a gloomier picture for conservative groups than for denominations more in tune with the times.

Kelley's argument was subsequently extended into a more general theory of religious vitality by sociologists Rodney Stark and William Sims Bainbridge.[29] In their view, people rationally chose to affiliate with conservative religions that offered "compensators" such as promises of heavenly rewards or strong emotional support in the face of illness, bankruptcy, and other forms of travail. In a later work, coauthored with Roger Finke, Stark assembled data on the histories of various "upstart sects" to support this argument.[30]

The argument about entrepreneurial church leadership is harder to trace to a single source. It emerged partly in response to Kelley's thesis and partly from the experiences of church leaders in the 1970s and 1980s who were engaged in building large, nondenominational megachurches. Some of these churches seemed to be growing despite somewhat more moderate theological views than Kelley's argument would have suggested. Observations of their services suggested that otherworldly compensators were downplayed and, for that matter, that participants seemed to be leading fairly comfortable middle-class lives rather than being downtrodden members of their communities. As church analysts

pondered the reasons for these congregations' growth, they were especially impressed by the churches' innovative leadership structures. Rather than being hobbled by denominational hierarchies, most of these congregations were run by pastors who surrounded themselves with talented businesspeople and otherwise had free rein to do as they pleased. Such a structure offered pastors more incentive to initiate programs aimed at church growth. They also made sense when studies were suggesting that denominational loyalties were losing value for many younger Americans.[31]

The idea about embattled subcultures was put forth more recently by sociologist Christian Smith in a national study of American evangelicalism.[32] Extending the work of Kelley, Smith argued that there are special advantages to religious groups that effectively identify themselves as beleaguered minorities, or what historian Laurence Moore has termed "religious outsiders."[33] Evangelicalism grew during the last half of the twentieth century, Smith suggested, because its members regarded themselves as marginal to mainstream culture, even though many of them were not as different in their beliefs and lifestyles as they liked to think. Waging symbolic battles over the role of religion in politics was one way in which evangelicals maintained their distinct identity in the 1980s and early 1990s. Other ways included home-schooling their children or sending them to church-sponsored schools, and criticizing the moral messages presented by the mass media.

Each of these arguments was grounded in empirical research and suggested a practical way not only of explaining religious vitality but also of promoting it. If these arguments are valid, they suggest that the persistence of religious commitment over the past several decades may be largely attributable to religious conservatism, entrepreneurial non-denominational congregations, or evangelicals. For those wishing to nurture religious vitality in the future, the implication of these arguments is that the best way to proceed is to promote religious conservatism, build nondenominational churches, or encourage people to become evangelicals. Unfortunately, none of these three approaches now appears quite as persuasive as it initially seemed.

The Kelley thesis proved better at accounting for church growth during the 1960s and early 1970s than during the 1990s. Whereas the Southern Baptist Convention had grown by 2.26 percent annually in the earlier period, it increased by only 0.6 percent annually during the 1990s. Compared to an impressive annual growth rate of 9.2 percent in the earlier period, Assemblies of God grew by only 1.8 percent annually during

the 1990s. At the same time, mainline Protestant denominations, such as Lutherans and Methodists, which had declined dramatically during the 1960s, mostly held their own during the 1990s. Overall, conservative denominations *were* still growing faster than liberal ones, but the striking growth that had impressed Kelley was mostly a thing of the past. Furthermore, research showed that the main reasons for this growth had been demographic rather than theological: conservatives married earlier and had more children than moderates or liberals did.[34]

The notion that churches could be revitalized by turning more people into religious conservatives also seemed less appealing by the 1990s than it may have seemed in the 1970s. Through the aggressive preaching of Jerry Falwell, Pat Robertson, and thousands of less-visible fundamentalist pastors, major efforts were initiated in the early 1980s to enlarge the number of religious conservatives. Yet, when surveys were taken, little lasting change in the proportion of religious conservatives in the population at large was evident. Between 1984 and 1989, the proportion of self-identified religious conservatives did increase (from 19 percent to 26 percent), but so did the proportion of religious liberals (from 19 percent to 23 percent). *Both* extremes grew because the public became more polarized (fewer opted for a middle position and fewer refused to identify with any of these labels). A decade later, in 1999, no further growth in the number of conservatives was evident (26 percent selected that identity), whereas the proportion of religious liberals had grown (from 23 percent to 28 percent).[35] As a *political* force, religious conservatives did succeed in gaining considerable influence within the Republican party; and yet it was hard to make the case that this influence translated into greater vitality for the churches at large.

The prospect of widespread church renewal taking place through entrepreneurial nondenominational congregations also appears mixed. Some megachurches have experienced dramatic growth, starting with fewer than a hundred members and increasing to several thousand members in only a few years. But it is more difficult to say whether such churches can succeed on a large enough scale to transform American religion. By the end of the twentieth century, only about 1 percent of the nation's congregations were estimated to have more than a thousand members, and, when asked their religious preference, only 6 percent of Protestants identified themselves as nondenominational or independent.[36]

Turning larger numbers of Americans into embattled evangelicals may be as difficult as persuading them to join biblically conservative de-

nominations or switch to nondenominational megachurches. While it is true that evangelicals are more likely to participate regularly in their churches than are Christians who opt for different labels, the number of self-identified evangelicals is actually quite small (as few as one person in seven among Protestants or one in sixteen in the population at large).[37] Moreover, as Smith suggests, their numbers may be self-limiting because part of their appeal is that they perceive themselves as a beleaguered minority. Smith also points out that their interest in evangelism may be weaker than is sometimes supposed.[38]

The main difficulty with these arguments, however, is not that they are weakened by careful consideration of empirical data but that they offer limited options for the revitalization of American religion. To suggest that revitalization can come about mainly through more conservatism, more independent megachurches, or more evangelicalism is limiting because all three suggestions focus on one segment of American Protestantism. They offer little for the revitalization of the Catholic church and are unlikely to appeal to many liberal or mainline Protestants. For the wider society, it is questionable too whether the kind of Protestantism that has been associated historically with fundamentalism and rigid moral crusades may be the most attractive religious option in an increasingly pluralistic world. The puzzle remains, then, of what might be contributing to the recent vitality of religious commitment and what practical insights may be gained for those interested in revitalizing the nation's religious institutions.

Rethinking the Conventional Wisdom

When confronted with a conundrum of this nature, it is wise to reconsider one's assumptions. In the present case, virtually all thinking about religious trends among social scientists has been influenced by a conventional wisdom—theories of secularization—that emerged in the nineteenth century and gradually came to be accepted during the twentieth century. The three arguments just considered were intriguing to social scientists because they challenged these dominant understandings of secularization. These arguments did so, however, by pointing out anomalies, rather than by paying close attention to the assumptions of secularization theory itself.

Although there are conflicting interpretations, one of the core assumptions of secularization theory is that religion gradually loses

influence as its traditional functions come to be performed by other specialized institutions.[39] This process of institutional differentiation, as it is called, is illustrated by the separation of church and state prescribed by the First Amendment of the U.S. Constitution. This amendment, in effect, guarantees that governance of the nation will be performed by political agencies rather than by churches. It contrasts with theocratic forms of government in which religious leaders rule. Other, more recent examples of religion losing influence in this manner include the emergence of specialized social relief agencies at the end of the nineteenth century, which replaced some of the voluntary service activities of churches, and the rise of professional counseling toward the middle of the twentieth century, which created a sharper distinction between therapy and pastoral advice.

The key argument that grew out of this line of reasoning was that by the latter half of the twentieth century religion in America was becoming increasingly *privatized*.[40] Rather than influencing politics or business, as it had done in the past, it was now part of the domestic sphere in which people pursued their private interests. It dealt more with personal than with public morality and was concerned with marital happiness and child rearing, rather than decisions made in corporate boardrooms or legislative halls. The private sphere was the natural place for religion to retreat because this sphere was shielded from government regulations. Individuals could make up their own minds about religion and pursue religion at their leisure.

The idea of privatization provided an explanation for religion's apparent retreat from such realms as politics, medicine, science, higher education, and business. While it suggested that people might remain interested in religion temporarily, it also gave rise to speculation that even within the private realm religion would decline as more of its functions were taken over by other institutions. For example, the growth of professional counseling was regarded as evidence of religion succumbing to a therapeutic motif; similarly, the spread of entertainment technologies was viewed as a serious threat to the leisure time in which religious activities were performed.

In retrospect, the error lay in regarding privatization as a symptom of overwhelming and ever-expanding pressures on religion from larger and more powerful external influences. In this view, religion shrinks into the private realm and then continues to decline. Once this view is taken, the only way to explain religious vitality is to look for groups that successfully resist these external influences—groups such as religious

conservatives, megachurches, and evangelicals. It becomes difficult to explain why religious commitment in the wider population might persist or to find other sources of religious vitality.

There is, however, a different way to think about privatization. This view emphasizes what might be called *selective absorption*. It suggests that religious organizations do not respond passively to social conditions but negotiate with their environment. They do so by identifying new opportunities in their surroundings and developing programs to take advantage of these opportunities. One might think of a pastor strategically determining where best to deploy the resources of his or her congregation. Some niches in the wider community will seem more opportune than others. Multiply these decisions by all the congregations in the country and it becomes possible to imagine how religion strategically adapts to available opportunities.

The process of privatization that scholars wrote about in the 1960s can be understood in this way. At that time, the majority of the nation's families were raising children (the children who were to become known as the baby boom generation). Leisure time was expanding, and the general affluence of the period gave most middle-class families an opportunity to develop their leisure interests as they wished. The private sphere was not so much a last frontier for religion as a new or expanding frontier. Churches deployed resources in this direction because family and leisure concerns provided an attractive opportunity.

To say that religion engages in selective absorption is to suggest that it tries to take or incorporate activities that are being done by other organizations but perhaps being done badly or at levels below public demand. The relationship between religion and therapy can be viewed as an example: the mental-health movement of the 1950s aroused public awareness of so-called psychological problems, opening new opportunities for both secular therapy and pastoral counseling. Another example is the resurgence of interest in faith-based social-service provision during the 1990s as part of the welfare reform legislation of 1996: public frustration with government welfare programs, combined with a coalition of moderate Democrats and conservative Republicans, resulted in opportunities for churches to play a larger and more widely subsidized role in service provision.

These examples suggest that there may be at least three conditions necessary for selective absorption to be pursued effectively. The first is a real or perceived need or interest on the part of some large segment of the population. The second is some precedent that gives religious

leaders a legitimate claim to being able to meet this need. And the third is some weakness on the part of competing contenders for filling the need. In the case of faith-based service provision, for instance, there was a widespread perception that something should be done to help the needy and that volunteering was desirable. Religious organizations had a long history of caring for the needy and were already doing a great deal to encourage volunteering; thus, there was little question about the legitimacy of their involvement. There was also a conviction that government-run programs were not entirely satisfactory.

In this view, the most plausible candidate for explaining the religious vitality of the last years of the twentieth century more generally is what many observers identified as a significant and broad-based upsurge of interest in *spirituality*. It was in these years that growing numbers of people began to talk about spirituality and, indeed, to think about it as a pursuit, as something to be cultivated, sought, and practiced, rather than as a condition of birth or family inheritance. Religious organizations were in business to meet the needs of people interested in spirituality. If this interest was growing, it offered religious organizations opportunities to develop new programs and, in turn, to generate involvement in these programs.

The only problem with this explanation is that interest in spirituality has been widely regarded as happening outside of religious organizations. Baby boomers especially seemed to hold established religion in disrepute, preferring instead to seek spirituality in their own ways.[41] The mass media provided more interesting ideas about the sacred than the churches did. People flocked to gurus and spiritual consultants, read their horoscopes, prayed to crystals, and read fiction thrillers about spiritual warfare.

But suppose that this view of spirituality were wrong. Suppose that the more colorful, esoteric expressions of spirituality captured media attention simply because they were colorful and esoteric, while most of the public's interest in spirituality was being absorbed by organized religion. Or suppose, at least, that most people who developed a *serious* interest in spirituality wound up pursuing that interest through religious organizations. In that case, identifying what might be encouraging interest in spirituality in the wider society becomes crucial to understanding the persistence and vitality of organized religion.

Spirituality, like religion, cannot be understood simply by positing some intrinsic human need for it. To be sure, the quest to know God may arise from existential yearnings, from illness and loneliness, or from

moments of wonder about the ultimate mysteries of life. But these vague yearnings and experiences have to take shape. They have to find *carriers,* vehicles of expression to help people to make sense of their feelings, to become more aware of them, to talk about them, and to realize that other people are having similar feelings. Carriers are the key. They have to be readily available throughout the society. They have to serve as media of expression and communication, linking private experience with public life, and, in the present context, they have to be understood as legitimate ways in which to think about spirituality and to pursue it.

Are the Arts a Factor?

The possibility that *the arts* might have something to do with encouraging this interest in spirituality may seem, at first blush, patently absurd. The arts are commonly viewed as being composed of a relatively small, esoteric group of artists and aficionados who converse mostly with themselves: their interests center around art for art's sake alone, and, with some exceptions, it is only the very rich or the highly educated who can spend time in serious pursuit of the arts. Conceived more broadly, the arts conjure up images of film stars and popular musicians who earn handsome livings and pursue lavish lifestyles, but whose values are fundamentally alien to those of the churches.[42] Public interest in such artistic expressions, in turn, ranges from mindless television viewing to casual consumption of rock music and romance novels. If anything, these popular impressions of the arts suggest that people with artistic interests would be deterred from having serious spiritual interests. Moreover, a long tradition of scholarship in the social sciences regards the arts and religion as *rivals,* rather than as mutually reinforcing.[43]

On closer consideration, however, the arts may be more conducive to spirituality than at first imagined. In fact, *one of the most important reasons that spirituality seems so pervasive in American culture is the publicity it receives because of its presence in the arts.* Consider the spiritual themes running through such popular songs as Bette Midler's "Rose," Amy Grant's "Raining on the Inside," Madonna's "Like a Prayer," Whitney Houston's "When You Believe," or Celine Dion's holiday album *These Are Special Times.* Music lovers' taste for spirituality has helped such albums as Andrea Bocelli's *Sacred Arias,* the Benedictine

monks of Santo Domingo de Silos's *Chant,* and selections from the music of twelfth-century mystic Hildegard von Bingen climb to the top of popular charts, while the works of less widely known composers such as Morten Lauridsen, John Tavener, and Arvo Pärt have also gained substantial audiences.

Music's connection with spirituality is rivaled only by that of television and film. The millions of Americans who watched *Highway to Heaven* in the 1980s turned up in larger numbers in the 1990s for *Touched by an Angel.* Box-office hits with thinly veiled religious themes, such as *The Lion King* and the various *Star Wars* episodes, were accompanied by films with explicit religious content, such as *Mission, Apostle,* and *The Prince of Egypt.*

On stage and in literature, the presence of spirituality is no less evident. The Broadway version of *Lion King* grossed nearly one million dollars a week in the late 1990s, while Tony Kushner's *Angels in America* won major awards, and perennial favorites such as *Godspell* and *Jesus Christ Superstar* played in regional theaters and high school auditoriums. Fiction lists include such best-sellers as Madeleine L'Engle's *Wrinkle in Time,* Barbara Kingsolver's *Poisonwood Bible,* and Tim Lahaye's *Left Behind.* Prominent poets writing on spiritual topics include Robert Bly, Mary Oliver, and Jane Hirshfield. Bill Moyer's popular public television series and subsequent book *The Language of Life: A Festival of Poets* brought otherwise unknown writers to the attention of a wider audience. Selections from the work of a thirteenth-century Sufi poet, Jalal ad-Din ar-Rumi, sold more than half a million copies in the United States during the 1990s alone.[44]

Even painting, sculpture, and other museum exhibits offer the public ample ways of connecting to the sacred. Visitors to the Cleveland Art Museum could view an exhibit of "Vatican Treasures"; in Louisville, they could attend the "Festival of Faiths" at the Cathedral Heritage Foundation; they could view the "Negotiating Rapture" exhibit of postwar artists interested in mysticism at the Museum of Contemporary Art in Chicago; or, in Washington, D.C., they could visit a Smithsonian exhibit about African American spirituality. Besides articles about these and other exhibits in newspapers and magazines, the role of the sacred in visual art is a prominent focus of such newly founded specialty periodicals as *Image, Christianity and the Arts,* and *Religion and the Arts.* "A quiet renaissance is occurring in pockets of the art world," writes one observer. "In place of the modernists' battle cry 'art for art's sake,' other voices are rising that speak of art and music as expressions of . . .

spirituality."[45] Certainly these many examples of spirituality in the arts could be considered carriers: vehicles that helped the American public to become more aware of its interest in spirituality and to find legitimate ways of expressing this interest.

My interviews with rank-and-file Americans suggest that many have been prompted to think about spirituality by participating in the arts or by being exposed to the arts as consumers. One woman who stopped going to church in college started again some years later after listening to Bach's *Passion According to Saint Matthew* on the radio. Another remembers gaining her first understanding of Jesus from a movie on television. A man recalls reading Thomas Merton's poetry as a pivotal moment in his spiritual journey. For others, spiritual interests have emerged from listening to American Indian music, singing in a gospel choir in college, or discovering that painting helped them to pray. Artists themselves frequently refer to the spiritual questions that have arisen as a result of their work. The introspective nature of the artist is in some ways similar to that of the person who meditates or prays. In theory, at least, the arts are concerned with deep questions about human existence—with what Henry Miller called "the edge of the miraculous"—just as spirituality is.[46]

It is also worth noting that institutional arrangements are creating opportunities for religion to capitalize on whatever interests in spirituality the arts may reinforce. Both the democratization of art and the erosion of rigid boundaries between sacred and secular space have played a part. Through the mass media, and through deliberate efforts by arts organizations to expand their audiences, the arts are more readily available to a large majority of the public than ever before. At the same time, many religious organizations are working more cooperatively with arts organizations than in the past. At a church in Brooklyn, local artists have found an inexpensive venue for their performances and exhibits. In Philadelphia, community-arts-council leaders have been working with churches to provide educational opportunities for children from low-income families. Major galleries, such as the Dallas Museum of Art and the San Francisco Museum of Modern Art, have initiated cooperative programs to draw wider audiences from community groups, including churches. For their part, churches increasingly have been experimenting with art festivals and craft fairs, artist-in-residence programs, and concert series, while large congregations sometimes have been able to sponsor entire orchestras and touring musical companies.

The idea of selective absorption suggests that religious organizations may be able to generate commitment when there are new or unmet interests in the wider public, when religion has some precedent for staking claim to these interests, and when competitors may be vulnerable or at a disadvantage. As it happens, there is widespread and, as evidence will suggest, growing public interest in the arts. This interest ranges from attending gallery exhibits and concerts to singing in choirs, listening to compact discs, taking art classes, and writing poetry. Much of it has been encouraged by more abundant music and art programs in the schools, and many Americans have enjoyed incomes and leisure time sufficient to provide opportunities for them and their children to pursue artistic interests. Although religion and the arts have sometimes been at odds with each other, religion has a long history of patronizing certain kinds of artistic activities, and there are reasons to believe the boundaries separating the two may be weakening. Some churches have eagerly incorporated contemporary music into their worship services, while others have experimented with liturgical dance and the visual arts. Moreover, the arts are relatively decentralized organizationally and professionally, meaning that some artistic interests may be easily absorbed by other institutions. In comparison with medicine and law, for example, some expressions of the arts can be absorbed by religion because there is no central certifying agency and the line between avocational and professional interests is less clear. In the wider public, most artistic interests are pursued privately and for personal reasons, and this allows interest in the arts to emerge during quiet times when prayer, meditation, or reflection about one's values occur.

The argument I want to consider is not that the arts are the only influence generating interest in spirituality, but that they are a significant one. This influence is evident in the fact that many religious organizations are already developing innovative ways to make greater use of the arts. This is not to suggest that formal alliances between religious and artistic organizations are primarily how these links are being forged (although such alliances are increasingly common). The connections between spirituality and artistic interests are, for the most part, taking place among ordinary people. In many cases, a childhood interest in spirituality is later encouraged by learning a form of artistic expression; in others, early participation in the arts leads to a later interest in spirituality. The connections are by no means inevitable; yet spirituality has taken on particular meanings in recent years that make it especially amenable to exploration and encouragement through the

arts. As people pursue their artistic interests, their attraction to certain expressions of spirituality increases, and this interest, in turn, promotes involvement in faith communities.

On the surface, it is perhaps far-fetched to propose that the vitality of America's churches may depend significantly on the public's growing interest in artistic activities. If this argument is true, however, it holds wide-ranging implications for religious leaders and for the ways in which they go about promoting spiritual growth. To determine whether this argument has merit, we must turn first to a closer consideration of the public's interest in spirituality.

Contemporary Spirituality

Seeking the Sacred in an Era of Uncertainty

Sitting in church one Sunday, eight-year-old Susan suddenly felt a warm glow spreading from the top of her head down across her face, into her chest, and then throughout her whole body. She flattened the folds in her new pink taffeta skirt. Maybe it was the dress. Or the straw hat she was wearing for the first time. They made her feel good about herself. So grown up. Like her mother, almost.

But this feeling was different. More soothing and, in a way, safe. She couldn't quite place it. It was as if her body were absorbing the warm spring sunshine that shimmered across the Susquehanna Valley and into the church. She let her eyes drift from the pulpit to the left front wall, where the light fell with full force. The red and blue shapes refracting through the stained-glass windows played on her imagination. Momentarily they became brighter and yellowish. She felt sure that God was in the light.

Now in her late fifties, Susan Brock considers herself a serious spiritual seeker. She especially cherishes the memory of that day. She refers to it as an epiphany—an instant in which the world around her fell away and she contacted the sacred. She has clung to this memory over the years because it was one of the few bright spots in her childhood.

Halfway across the continent, Kathleen Peters is also intensely interested in spirituality. She recounts her on-again, off-again relationship with the Catholic church. "I marched home from school one day when I was ten years old and announced to my mother, 'I'm becoming a Catholic!'" More relieved than startled, her mother agreed, and together they walked down the street to inform the priest. It had been

three years since they moved to Chicago, and neither Kathleen nor her mother felt they had quite settled down. Perhaps the church would give them roots.

Up to that point, it seemed that they had been on the road almost constantly. Early in his career, Kathleen's father (a professional musician) had toured with Harry James and Benny Goodman. For the first seven years of her life, Kathleen lived in Las Vegas, cared for mostly by her grandmother, while her mother danced and skated professionally and her father traveled. Moving to Chicago was a way to settle down. Her father got a job at one of the city's prestigious jazz clubs and her mother hoped to teach skating and dance.

Kathleen did join the church, and she remained active until it started to cramp her adolescent yearnings for freedom. Like many Americans, she quit attending church before finishing high school, searched for spirituality elsewhere, and sometimes wondered whether the pursuit mattered at all. Eventually (influenced, as we'll see, by music and film), she decided to become a Catholic again.

In a sprawling middle-class suburb on the north edge of Dallas, David Layton feels acutely that he needs to be doing more to enrich his spiritual life. A physical therapist whose dark-brown mustache and tanned skin complement his muscular build, he talks amiably over a glass of iced tea while the rotary sprinkler follows its obligatory course in the back yard. Having recently celebrated his fortieth birthday, and having realized that the oldest of his three children will soon be entering college, he seems more convinced than ever that even a good Christian can always do better.

David started worrying in high school that most of the church people he knew didn't seem very serious about their faith. His family went to a Methodist church. "A lot of the congregation, they'd show up on Sundays, but then during the week they didn't really practice things." Aside from complaining once in a while about having to get up on Sunday mornings, David usually went happily to church and fit comfortably into its burgeoning youth group. He liked being part of "an organization" (he gives the same reason for being in the high school band) and hoped being active in church would help him overcome having a quick temper. Yet he fretted about the church's superficiality: "The teaching was what we call the 'milk of the Word,' as opposed to the 'meat of the word.' You'd hear the same type of message over and over again."

After high school, David continued living at home while he attended

a nearby junior college. There he met his wife-to-be, Millie, a Baptist who described herself as "born again." Almost immediately, David started attending her church and found it refreshingly serious. The sermons were longer, and the members paid rapt attention to the preacher as he expounded "the Word." A year later, when David and his wife married, he gladly attended an extensive "new members" class, underwent baptism by immersion, and joined the church.

Since then, David has remained faithful to the church. He tries to put its teachings into practice. Worried by the moral torpor he sees when he watches television, he believes it is his job to communicate the solid values of historic Christianity.

The Search for Spirituality

Nearly all serious observers of American religion would agree that people like Susan Brock, Kathleen Peters, and David Layton exemplify a much larger phenomenon in American culture. The public's interest in spirituality apparently has risen dramatically in recent years. A growing number of people seem intent on cultivating a meaningful personal relationship with God. As they are wont to do, social observers disagree about what exactly is driving this interest and what its significance for the religious vitality of our nation may be. In their observations, one nevertheless finds a compelling array of evidence that spirituality is indeed attracting wider public attention. Books about spirituality routinely appear on bestseller lists. Prime-time television, where spirituality was once virtually taboo, now features programs about angels, prayer, meditation, and spiritual healing. Space at retreat centers offering instruction in spirituality fills up months in advance. Seminaries are scrambling to start graduate programs in spiritual direction to train clergy to better serve parishioners with interests in these topics.

But how widespread is this interest? Is it limited to the flaky fringe, the few whose unusual spiritual pursuits pique the fancy of journalists? Or is it truly a national trend? Although surveys have their limitations, they provide a systematic way to gauge whether the present interest in spirituality is as widespread as most observers think it is. The evidence suggests that interest in spirituality is by no means universal, but for a large segment of the population, it does appear to be increasing. Nationally, more than four people in ten (43 percent) said their interest in spirituality had been increasing during the past five years. In contrast,

only 7 percent said their interest in spirituality had been decreasing (the remainder said it has stayed the same).[1]

If, for the moment, this response is taken as evidence that there is in fact an increase in the public's interest in spirituality, this is surely good news for churches and synagogues. People who are searching for ways to relate to God would seem to be prime candidates for new-member classes. Clergy uniformly single out spiritual growth as one of the top priorities of their congregations.[2] And people who talk about why they go to church or why they have joined small-group Bible studies and prayer fellowships overwhelmingly mention the desire to grow spiritually as one of their top reasons.

Yet there has been a persistent and, in my view, justified queasiness about the current interest in spirituality. For one thing, *spirituality* itself is seldom precisely defined. To most Americans, it means something about their relationship to God. But how this relationship is understood and pursued varies immensely. Some emphasize relating to God through traditional means, such as praying to Jesus and asking forgiveness; yet, for many others, relating to God may mean little more than enjoying a spring day or feeling worried about an exam. When spirituality can mean so many different things, it is hard to know how to interpret people's responses to a survey question about whether their interest in spirituality is increasing. For another thing, contemporary spirituality often smacks of gullibility and irrationality—the kind of wishful thinking and self-indulgent fantasizing about miracles and wonders that makes more sober-minded folks blanch.

While acknowledging that interest in spirituality may be on the rise, many writers therefore express misgivings about it. Their appraisals suggest that popular interest in the spiritual life is shallow or superficial, that people are not really committed to developing a relationship with God but are pursuing spirituality because it happens to be in vogue. Sociologist Wade Clark Roof cautions, "There is enough flakiness in contemporary spirituality that we should keep open the possibility that the long-term consequences for the religious landscape may be less than we might imagine or many might hope for. Much of what passes as spirituality is as thin as chicken soup and as transparent as celestine profits."[3]

This unease about the public's attraction to spirituality underscores the need to examine it carefully and critically. If interest in spirituality is as superficial as skeptical observers suggest, it may hold little promise for the larger vitality of American religion. The current fascination with spirituality may even pose a threat to the nation's churches and syna-

gogues, especially if the theological wisdom and service-oriented dedication that have been central to the Christian and Jewish traditions are being abandoned for a do-it-yourself faith oriented toward good feelings. But determining empirically whether spirituality is superficial or profound requires being more precise than simply suggesting that people are shallow.

Careful consideration of the issue suggests that any number of criteria may be put forward as ways in which to evaluate the contemporary interest in spirituality. Roof's remark, for example, might be interpreted (apart from its humorous intent) to suggest that spirituality inspired by bestselling books is almost by definition worthy of criticism. Books such as *Chicken Soup for the Soul* and *The Celestine Prophecy* arouse concern from serious-minded observers of American religion because they provide ready-made answers for the small setbacks and petty anxieties of ordinary life but do not speak of a righteous God who demands anything of believers. These books also raise questions about religious authority: is it possible for relatively isolated popular writers oriented toward making a profit from their books to convey the deep wisdom that has accumulated over the centuries as part of the orderly collective deliberations of scholars and sages associated with religious traditions? Clearly, some value judgments are implied in questions such as this. If one were to pose different criteria, such as innovativeness or the ability to synthesize or to appeal to a wide audience, then such expressions of spirituality would be evaluated quite differently.

The criteria for evaluating contemporary spirituality that I want to consider in this chapter stem largely from the questions I raised in the last chapter about religious vitality—particularly the vitality of Christian churches in the United States—and whether current interest in spirituality might be a source of this vitality. These questions suggest that spirituality can usefully be examined for present purposes in terms of its relationship to organized religion. That is, do people who claim to be most seriously interested in spirituality differ from those who are more casual about spirituality in ways that conform with the norms of organized religion? Thus, one criterion is whether the present interest in spirituality is so newly acquired that it may be ungrounded, as opposed to being rooted in more extensive exposure to a religious tradition. Another criterion is whether spirituality is a private, perhaps personally invented, set of beliefs and practices or whether it is pursued in the context of a religious community that gives it depth and stability. An additional criterion is whether spirituality involves borrowing from

all the ideas to which a person may be exposed or whether there is some deeper commitment to a particular religious tradition. Another criterion is whether spirituality is a topic that people simply talk about or whether it is something that they are actually trying to work at and develop. Yet another criterion is whether spirituality affects the way a person actually lives.

Each of these criteria can be operationalized; that is, we can identify some questions to ask people and then compare the answers of those who claim to be most interested in spirituality and of those who are less interested in spirituality. It will also be helpful to employ the idea of *spiritual growth*. Most people who claim to be interested in spirituality are familiar with this term; indeed, they respond easily to questions about experiences and events that have helped them to grow spiritually. It is also a term that is familiar in religious contexts. In talking with clergy about spirituality, we found that virtually all of them emphasize the need for growth. A few prefer phrases such as *spiritual formation* or *faith development,* but central to their remarks is the idea that spirituality should mature, deepen, and become richer with time. Pastors and priests sometimes paraphrase passages from the Bible to explain that spirituality should grow. "We should grow in the nurture and admonition of the Lord," says one. "Grow in grace and in the knowledge of our Lord and Savior," quotes another. This emphasis on growth is punctuated with words such as *process, dynamic, walk, run, journey,* and *stages.*[4] Clergy are also quick to point out that spiritual growth does not just happen. In their view, it has to be nurtured. Although they usually acknowledge that the Holy Spirit is ultimately responsible for spiritual growth, they emphasize that people who desire growth must take an active role in pursuing it. The pastor of an Assembly of God church draws an analogy with seeking to be physically fit. "You exercise, you run, you lift weights, you eat properly, and this helps you develop. It's the same with spiritual growth. You read God's Word, you study, you develop your prayer life, you meditate on the Lord." A Catholic priest also emphasizes the similarities between spiritual growth and other activities at which one works to improve. "Why do you practice gymnastics? Why do you practice the piano? You want to be the best person you can be. Why do you practice your faith? To be the best person the good Lord has intended you to be." The idea of *spiritual growth,* then, provides a good way of approaching the topic of spirituality: because this term is commonly used, both among people in the wider society who talk about spirituality and among church leaders, we can see whether people

who claim to be most interested in spiritual growth do things that match the expectations that clergy have in mind when they talk about spiritual growth, or whether spirituality has come to mean something rather different.

The survey shows the extent to which rank-and-file Americans agree with clergy about the importance of spiritual growth. When asked, "How important has it been to you as an adult to grow in your spiritual life?" the public divides as follows: 26 percent say this has been extremely important, 28 percent say it has been very important, 23 percent say it has been fairly important, and 21 percent say it has been not very important or not at all important (2 percent are unsure).[5] Judging from these responses, interest in spirituality is widespread, and yet truly serious interest probably is limited to relatively few. Approximately one person in four appears to have relatively little interest in spirituality. Another quarter of the public may have enough interest in it to dabble or take part in religious activities from time to time, but probably has insufficient interest to do very much to cultivate their spiritual growth. This leaves half of the public who, by their own accounts, are quite interested in spirituality. And yet, it may be that only half of these people regard spiritual growth as an essential part of their lives.

In considering the various ways in which spirituality may be assessed, it will be useful, therefore, to compare the quarter of the population who express the most intense interest in spirituality with the remaining three-quarters, for whom spirituality is of only moderate or passing interest. Does intense interest in spirituality differ in predictable ways from casual interest? Is it more likely to be rooted in solid childhood exposure to religion? Does it entail active involvement in a religious community and commitment to one's faith tradition? Do those who profess serious interest in spirituality actually devote effort to spiritual growth, and do they experience results in their lives? If so, serious interest in spirituality may indeed hold the key to understanding vitality of the nation's churches; if not, spirituality may be as superficial as some of its critics have suggested.

Practices with Roots

Throughout most of our nation's history, gave people a sense of continuity with the past. What the children. They may knee was what they tried to transmit to t

have been immigrants, wrenched from the daily sights and sounds and smells of their homelands, but their parishes and meeting halls grounded them in familiar terrain. They did not have to invent their own views of the sacred.

Such "communities of memory," as philosopher Alasdair MacIntyre has called them, are badly needed in today's world because so many people feel rootless.[6] Communities of memory are places where the old stories are retold, and where the retelling is accompanied with the sights, sounds, and smells that embed them in subterranean levels of consciousness. Congregations that pass traditions from grandparents to parents to children serve powerfully as such places. Thus, it behooves us to know whether contemporary spirituality is rooted in such communities of memory or whether it is rootless and shallow.

The perception that contemporary spirituality may not be firmly grounded in communities of memory arises from the fact that some churches seem to throw out tradition in favor of whatever spiritual expression is popular at the moment. They encourage spiritual seekers to think about what is relevant for the moment, rather than instructing them in church history or conveying respect for the insights and struggles of previous generations of believers. More broadly, the current upsurge in spirituality appears, almost by definition, to be without roots. People who recently have become converts, whether to evangelicalism or New Age beliefs, talk as if they have no prior grounding in religion—or as if such grounding is unimportant. Stories from baby boomers, not to mention their children, suggest that many have grown up with little serious religious exposure. They are like babes in the woods of spirituality.

But is this perception accurate? To be sure, the average churchgoer probably has less knowledge of religious history than scholars specializing in religious history would like, just as the American public more generally is known to have trouble answering questions about the nation's founding fathers or the history of its democratic traditions. To say that people lack historical knowledge, though, is quite different from suggesting that their spiritual quests are invented from whole cloth, woven from the few strands they have been able to draw from the latest bestselling book about spirituality or a popular television program about any kind of religious upbringing. To say that contemporary spirituality is entirely without roots is to claim that spiritual seekers have not been influenced by religious upbringing.

Kathleen is an interesting case in point. Her peripatetic par-

ents were the kind who might have found it easy to let her sleep or watch cartoons on Sunday mornings instead of going to church. Had it not been for the friends she met or her grandmother, she may well have had to discover spirituality virtually from scratch some time later in life. Nevertheless, Kathleen's mother sensed the value of settling into a community of memory and somehow passed this conviction to her daughter. At the time she declared her childhood interest in the church, Kathleen was already no stranger to religion. Almost from birth, she was taken by her grandmother to services at various Episcopal churches. English by descent, her grandmother wanted Kathleen to grow up with, and hopefully marry in, the Anglican tradition. Indeed, despite the fact that Kathleen's mother had been raised Catholic, the family had honored the grandmother's wishes that they would have nothing to do with the Catholic church. It was for this reason that at age nine Kathleen found herself attending a Lutheran school, rather than the Catholic school that most of her friends in the neighborhood attended.

In retrospect, Kathleen thinks it was probably having Catholic friends that accounted for her decision to become Catholic. She admits she often took her mother's side in the many arguments that occurred between her mother and grandmother. And the more she thinks about it, the more she wonders if the distinct tradition of the Catholic church wasn't an attraction as well: "The Catholics had something. You couldn't just go to their churches if you weren't a Catholic. You know, Episcopalians could sort of hop around before they found a philosophy that suited them. I think I had some inkling that Episcopalians aren't real. They're just sort of getting comfy. But the Catholics, you can't just be comfy with them. They have these rules you've got to follow Maybe I wanted real rules like that, I don't know."

Kathleen sometimes talks as if her spirituality as an adul' some-
thing that she has recently discovered. Like many others w ave un-
dergone dramatic changes in their spiritual journeys, s metimes
minimizes what she learned in Sunday school and talks t her pre-
sent insights as if they have no precedents in religious on. But her
childhood history sheds a different light on her story ever insights
she may have discovered as an adult, her spiritu s roots. It is
grounded in having been taken to church as a athleen's story,
therefore, casts some doubt on the criticism th mporary spiritu-
ality is largely without roots. ence of having at-

The survey data suggest that Kathleen jority of Americans.
tended church as a child is still that of th

TABLE 1. Having a Religious Background Is More Common among Those Whose Interest in Spiritual Growth Is High
(Percentage responding as indicated among people in each category of spiritual interest)

	Interest in Spiritual Growth			
	Highest	*High*	*Low*	*Lowest*
Attended services almost weekly during childhood	81%	85%	76%	67%
Had special meaning during childhood:				
A favorite hymn	66	55	43	23
Religious picture	47	41	28	16
Religious objects	31	35	29	15
Shrine or altar	9	9	6	3
At least one of these	80	76	66	39
Had mysterious encounter	19	15	11	9
Have read a fair amount of religious history	52	38	26	21
NUMBER	(428)	(424)	(359)	(295)

NOTE: "Highest" refers to those who say it is extremely important as an adult to grow in their spiritual life, "high" refers to those who say this is very important, "low" refers to those who say this is fairly important, and "lowest" refers to those who say this is not very important or not at all important.

The path to spiritual discovery does, for most people, have religious roots—generally in a Sunday-school room, a parish hall, or a meeting house, or around a family prayer circle. Nationally, 78 percent of adults claim they attended religious services every week or almost every week while they were growing up, and this proportion is slightly higher among those who currently have the greatest interest in spirituality.

Still, a person's present interest in spirituality is not associated very strongly with how often he or she attended church as a child (table 1).[7] Among those with the highest interest in spirituality as adults, 81 percent claim to have gone to church almost every week while they were growing up, but at the next highest level of interest in spirituality, the proportion who attended as children is even higher (85 percent). Then, as adult interest in spirituality falls, childhood religious involvement declines, but only modestly (to 76 percent and 67 percent in the two right-hand columns of the table). If most Americans have religious roots, at least to the extent that they can remember having gone to church regularly as children, that they went to church regularly seriously these roots seem not to matter much in terms of how interviews suggest, *spirituality* as adults. Apparently, as anecdotes from many Americans went to church (perhaps because

their parents sent them) but found little there to spark a lasting interest in spirituality, while others who went infrequently as children had experiences later in life that led them to take spirituality more seriously.

But childhood church attendance is not the only way of gauging whether people have religious roots in a community of memory. What matters more is the material culture, as it has been called, of childhood religion.[8] In qualitative interviews people sometimes give vivid descriptions of particular childhood influences that shaped their later interests in spirituality. Like Susan Brock, they remember the light shining through a stained-glass window, or they recall the words of a favorite hymn or the painting they stared at Sunday after Sunday during the sermons. Many have vivid memories of Bibles, wall hangings, crucifixes, and other sacred objects in their homes. A few had mysterious encounters with angels or other supernatural beings.[9] Material culture of this kind often has been ignored in discussions of religious socialization because the truths of religious tradition were assumed to be communicated in doctrines, creeds, and other expressions of biblical knowledge. But communities of memory are not best thought of as abstract formulations of the community's principles; they are better conceived as places where people live, baking meals whose aromas seep through open windows, planting flowers along sidewalks, watching excited children playing games, and gathering to commemorate past lives and new beginnings. Material culture links the public dimensions of community life with the private experiences of its members. It creates memories that can be retained and can influence one's longing for a spiritual home, long after one has moved to a different community.

The survey suggests how strongly related adult interest in spirituality is to these childhood experiences. In the public at large, 47 percent recall that "hymns or other religious music" had special meaning for them when they were growing up, but among those with the highest level of interest in spiritual growth, this proportion rises to 66 percent (table 1). For 34 percent of the public, "a religious picture, plaque, or wall-hanging in your home" had special meaning when they were children, but this proportion is 47 percent among those who indicate that spiritual growth is extremely important. In all, a striking 80 percent of those who value spiritual growth the most recall that some hymn, religious painting, or sacred object had meaning to them as children, whereas this proportion drops to only 39 percent among those who do not value spiritual growth. Having had "a mysterious encounter such as seeing an angel or a spirit" is, in comparison, much less common (re-

called by 15 percent of adults), but an experience of this kind is also somewhat more likely to be remembered by people with strong interests in spiritual growth than by people with weaker interests.[10]

The other troubling impression of contemporary spirituality, though, is that too few Americans have read enough religious history to avoid committing the mistakes of the past, such as getting carried away with fanatical ideas or thinking that their own beliefs are more innovative than they really are. This concern appears to be well founded. Nationally, only one person in ten has done a great deal of reading about the history of religion in the United States, and only one in three has done at least a fair amount of such reading. Among people with the highest interest in spiritual growth, this proportion rises only to about half.

On the question of rootedness, therefore, contemporary spirituality turns out to have more connections with the past than is sometimes imagined. People with modest levels of interest in spirituality generally have been taken to religious services as children, as is true of those with more intense levels of interest in spirituality. Yet the childhood exposure that matters most is not attendance at services but the subliminal contact with the holy that comes through hymns and other religious music, pictures, Bibles, crosses, candles, and other sacred objects. Adults with moderate interest in spirituality do *not* have deep roots in these kinds of experiences, whereas adults with the most intense interest in spirituality are much more likely to have been influenced by these childhood experiences.

Involvement in a Religious Community

Apart from questions about rootedness in childhood religious training, the concern that spirituality is superficial stems from the observation that spirituality may be occurring largely outside of established religious communities and traditions. This is the "Sheila problem," which takes its name from a woman in the widely read book *Habits of the Heart* who is passionately interested in spirituality but who relies entirely on her own strength.[11] Lacking ties with organized religion, she invents her own faith, dubbing it Sheilaism.

The idea that spirituality is being pursued outside of organized religion is both plausible and worrisome. Countless studies show that upward of 95 percent of the population believes in God, even though far fewer regularly participate in the nation's churches and synagogues. Spirituality is easily pursued in the comfort of one's home instead of

trekking to a place of worship. Yet worshipping alone is quite different from participating in a community of believers.

Although churches do many things, they are primarily concerned with spirituality. To a person, clergy emphasize that spiritual growth is most effectively accomplished in a community of believers. The worship experience is intended to help parishioners grow. Small-group fellowships provide instruction in the Bible and are places where people can share their problems and receive advice. Evangelism helps people grow as they share their faith with others. Even social-outreach programs are for many clergy a vehicle for growth because they challenge people to face up to their own priorities. Above all, clergy caution that people are social creatures who flourish best in community. A Methodist pastor puts it simply: "I take a corporate view of these things. The individual is an integral part of the worship life of the congregation, a part of the agencies of the church that reach out in ministry."

Yet, in candid conversations many people draw a sharp distinction between spirituality and religion. *Religion* conjures up words such as *organization, institution, structure,* and *dogma*. In contrast, *spirituality* evokes phrases such as *believing in God, walking the walk, surrendering, being consistent,* and *actively searching*. Susan Brock draws the distinction this way: "Religion represents dogma; spirituality represents spontaneity and freedom of belief." Most people emphasize, in one way or another, that religion is "out there" as a part of history and culture. They may value its traditions and regard it as a carrier of truth, but they also worry about the extent to which it is corrupted by false teachings and struggles for power. In their view, spirituality speaks more to the essence of their relationship to God.

It follows that spirituality is regarded by most people as an intensely personal activity. Nationally, nearly three-quarters (72 percent) of the public agree with the statement "My religious beliefs are very personal and private." An equally high proportion (70 percent) agree with this one: "My spirituality does not depend on being involved in a religious organization." Yet the fact that spirituality is personal, or that it can be distinguished from organized religion, does not mean that people abandon religious communities easily or permanently. The struggle to achieve a working balance between personal spirituality and participation in organized religion is often difficult, involving compromises and searching as well as unanticipated responses from the communities with which one affiliates.

Susan Brock's story illustrates some of the ways in which people become disconnected from religious communities. The oldest of three

children, she bore the special burden of her father's chronic alcoholism, and she has struggled to integrate her own damaged interior life with her understandings of the sacred. Her father, a traveling salesman, often stopped for a few drinks along the highway on his journey home. Susan knew her mother prayed daily for his safety. On those recurrent nights when Susan went to bed before her father's return, she also prayed, begging God to let her father's car appear in the driveway one more time. Neither permitted herself to talk openly of her fears. Susan learned early, therefore, that her attempts to relate to God were highly personal.

By the time she was in high school, Susan was shouldering the difficult task of caring for her father during his increasingly frequent bouts of depression. One night she stayed up with him until dawn, watching, pleading, and cajoling him not to take his life. She grew up quickly as a result. "I was not a little child who went out and skipped and jumped and played," she recalls. "I missed all that. It's given me a heaviness that I have to deal with. I still weep about it sometimes."

Leaving for college provided a temporary escape. Having grown up retreating into painting and drawing when she felt particularly distraught, Susan decided to major in interior design and planned someday to start her own business. She hoped to develop the artistic talents that her teachers said she had and to fulfill the career dream that her mother had set aside to raise a family. But by the time she graduated, Susan had fallen in love, married, and was herself a mother.

She had also quit going to church. The decision had not been immediate. She had tried to find a church that provided the same secure feelings she associated with the neighborhood Presbyterian congregation in which she had been raised. But the energy on campus was in the pubs and on the streets, not in the churches. Many of her classmates were protesting the Vietnam War. Susan decided that helping other people was a better way to serve God than languishing in the pews.

Over the next decade, Susan's attention was riveted almost totally on raising her three children. Determined not to let her artistic career evaporate completely, however, she advertised her services and attracted a few clients. But interior design proved more difficult than she had imagined. Her career was on indefinite hold. Because of the children, she tried to revive her interest in church. Feeling no particular reason to remain Presbyterian (her parents by this time had started attending a Catholic church), she and her husband joined a nearby Lutheran parish.

Susan liked being a Lutheran, not because the church had a special corner on the truth, but because the assistant pastor was a freethinker

who wasn't afraid to listen as she verbalized her own questions about Christianity. Together they initiated a coffeehouse for teenagers in the community. It flourished. High school students came to hang out, and some stayed to talk about life, spirituality, their families, and their fears. A few of the ones who wandered in during the wee hours of the morning were on drugs. Susan was glad they came; the church people weren't. They voted to terminate the coffeehouse.

That pretty much ended Susan's ties to organized religion. Like many others of her generation, she had grown up believing in God and feeling that she could relate to God in the privacy of her bedroom. She considered it normal to express her faith in God by participating in church, yet she also considered it acceptable to participate on her own terms. From her parents and friends, she had learned that there might be appropriate times to switch churches or to spend time on activities more worthwhile than going to church. The coffeehouse incident probably would not have resulted in her dropping out had it not been for this longer history of tenuous relationships with churches. Even when she did drop out, she continued to be interested in spirituality.

Kathleen Peters also illustrates the process by which spirituality and religion may become disconnected. She found herself pursuing spirituality on her own for a significant part of her life. She was a faithful Catholic from age ten to age fifteen. Then she dropped out. The rules at the Catholic high school she was attending had become too restrictive. She isn't sure if she was just going through a phase of adolescent rebellion or if she was attracted to the bohemian lifestyles of her parents' friends in the entertainment business, but for the next eight years she didn't set foot inside a church. "I was a real hippie type, into drugs, very anti-establishment," she recalls. She supported herself as a waitress, took voice lessons in hopes of launching herself as a rock singer, and got married.

For both Susan Brock and Kathleen Peters, then, the habit of going to church was difficult to sustain against a view of religion that made churchgoing optional. Both women had learned as children that they could approach God on their own, rather than having to look for God at church. As they matured, they retained their interest in spirituality but lost interest in religion.

Stories like these have become commonplace, yet there is a surprise in both cases. Susan Brock has started going to church again in recent years. As her personal quest to know God has intensified, she has yearned for fellowship with others. Lately she has been attending religious services at a nondenominational meeting house ("for people on the fringes of religion") that asks nothing other than honesty about

one's doubts. Kathleen Peters resumed going to church when she married and had children. Both women discovered that spirituality, especially when they decided to become seriously interested in spiritual growth, could be pursued better in association with a religious community than on their own.

The survey data show that people with modest levels of interest in spirituality often do not participate in churches, but the data also suggest caution in generalizing too quickly about the gap between contemporary spirituality and organized religion. It is true that interest in spirituality seems to be increasing at the same time that trends in church involvement are flat. Yet, when asked if their interest in *religion* has increased in the past five years, 34 percent of the public say it has, while only 10 percent say their interest has decreased. Moreover, interest in *spirituality* is closely associated with interest in religion: 76 percent of those who say their interest in spirituality has increased also say this about their interest in religion, while 78 percent of those whose interest in spirituality has decreased say their interest in religion has decreased.

Interest may not translate into action, however. Other data in the survey show that people with moderate levels of interest in spirituality often separate themselves from organized religion. Among those who say that spirituality is fairly important, for example, three-quarters do not attend services regularly and half are not church members. But people with the highest commitment to spiritual growth are overwhelmingly involved in religious organizations: 80 percent of those who value spiritual growth the most are church members, and 71 percent say they attend worship services almost every week (table 2).

Responses to other questions about religious involvement show a similar pattern. Nationally, only 42 percent of the public say "attending services at your place of worship" has been very important in their efforts to develop a closer relationship with God. But among those whose interest in spiritual growth is highest, this proportion is 74 percent. Interesting, too, is the fact that attitudes toward clergy are divided in the public at large (half admire them a great deal and half admire them less) but are much more favorable among people with strong interest in spiritual growth.[12]

The overall picture, then, is one of mixed interest in religion despite widespread interest in spirituality. Many Americans find it possible to be at least moderately interested in spirituality without becoming very involved in a congregation. At the high end of interest in spirituality, however, most people are involved. Indeed, their involvement suggests

TABLE 2. Commitment to Organized Religion Is More Common
among Those Whose Interest in Spiritual Growth Is High
(Percentage responding as indicated among people in each category of spiritual interest)

| | Interest in Spiritual Growth | | | |
	Highest	*High*	*Low*	*Lowest*
Interest in religion has increased	60%	43%	21%	10%
Church member	80	74	49	29
Attend church almost weekly	71	53	24	14
Services very important to own spiritual growth	74	56	20	12
Admire clergy a great deal	72	60	42	27
Shopped around for a place of worship	53	42	31	24
NUMBER	(428)	(424)	(359)	(295)

NOTE: "Highest" refers to those who say it is extremely important as an adult to grow in their spiritual life, "high" refers to those who say this is very important, "low" refers to those who say this is fairly important, and "lowest" refers to those who say this is not very important or not at all important.

that if more people had a strong interest in spiritual growth, church participation would undoubtedly increase as well.

What is different about connections with organized religion now from those in the past is that many people have *chosen* their particular congregation or denomination, rather than simply staying in the one in which they were raised. Susan Brock, Kathleen Peters, and David Layton have all switched churches. They did so partly because they had moved to new communities, but also because they had become uncomfortable at their houses of worship.

Approximately four persons in ten (38 percent) nationally have engaged in what has become known as "church shopping," judging from their responses when asked, "As an adult, have you ever shopped around for a church or synagogue—that is, gone to different churches or synagogues or other places of worship in order to compare and decide which one you wanted to attend regularly?"

It has always been possible for people to do this, given the rich array of denominational and confessional traditions in the United States. Yet it appears that such shopping has become more prevalent, at least if the experiences of different birth cohorts are any indication: among those born in the 1910s, only 25 percent say they have ever shopped for a church or synagogue (even though they have had longer to do it),

whereas among those born during the 1950s, this proportion is 47 percent. And, in any event, the likelihood of having shopped around is virtually a direct function of the number of times people have moved. Thus, among those who have lived at only one or two addresses, 23 percent have shopped for a congregation, while among those who have lived at fifteen or more addresses, 55 percent have shopped for one.

While moving from neighborhood to neighborhood has probably not become any more prevalent in the past few years than it was several decades ago, it is a fact of life for the typical American. It is particularly common among young adults who are still in the process of figuring out where they want to attend church and how much they want to participate in a church. Moving to a new community provides an opportunity to break ties with a previous congregation.

It might be supposed that shopping around is a sign of flaccid interest in spirituality; indeed, many of the critics of contemporary spirituality draw on economic metaphors (such as "shopping," "marketplace," and "consumerism") to suggest that spirituality has become so influenced by the wider culture that it cannot be very serious.[13] But the survey data suggest a different picture. Shopping for a congregation and valuing spiritual growth actually go hand in hand. Among those whose interest in spirituality is highest, a majority (53 percent) have shopped for a congregation, while among those for whom spirituality is only fairly important, this proportion drops to a third (31 percent). Why might this be the case? The more one feels the need for spiritual growth, the more one may feel inclined to look around for a congregation that will nurture this growth, rather than to simply stay put. Having switched congregations, a person may also be prompted to ask new questions that in turn lead to spiritual growth. Whichever happens first, spiritual development is apparently regarded as a matter that requires taking action.

If the current fascination with spirituality is defined as including all those who express even a minimal interest in spiritual growth, then there is clearly a large number of Americans who profess such interest but who seldom participate in organized religion. For the minority who profess the greatest interest in spiritual growth, however, churchgoing remains vitally relevant. Indeed, the more a person values spiritual growth, the more likely it is that this person is actively involved in a religious community, rather than pursuing spirituality alone.

Devotion to a Tradition

Apart from how much people participate in religious communities, now or while they were growing up, there is still the lingering sense that spiritual interests are not sufficiently grounded. This is the *dabbling* problem, which is suggested by the facts that so many people shop around for a place of worship and that the ideas featured in popular books on spirituality are so often a casual mixture of teachings from many different religious traditions. Many people have relatively little knowledge of religious teachings but are bombarded with messages on television about some generic form of spirituality, and they probably interact with people who believe quite differently than they do. To say that spirituality is superficial, then, can mean either that people do not care about its intellectual foundations or that they willingly accept the value of all religious teachings rather than exhibiting loyalty to their own.

For the clergy, devotion to a particular confessional tradition nearly always tops the list of criteria for spiritual growth. A Presbyterian pastor expresses this idea as three "tests of faith" or "evidences." He says the first is "proper belief," by which he means, "Do you believe that Jesus Christ is the son of God who died for the sins for the world?" The second test is "a desire to know and keep his commandments." The third is to love one's neighbor. At least two of the three specifically involve understanding and believing what the Bible says. A Catholic priest makes a similar point, suggesting that Christians should strive for "a better understanding of what you believe, why you believe, why you practice, and why you worship." He complains that too many people have a "grade school understanding of the faith."

Clergy vary in how much emphasis they place on particular doctrines or on the Bible itself in comparison with theological aids to understanding the Bible. Although their language often suggests that knowledge of church teachings is primary, they nearly always insist that *depth* of understanding comes from participating in a faith community that challenges one to absorb these understandings into one's very outlook on life. The pastor of an African Methodist Episcopal church illustrates this emphasis when she asserts that God seems to "up the ante" as people grow spiritually. "It's easy for people to know the law, the Word, and be able to quote it, even use it to beat up on people. If you learn the Word without learning the giver of the Word, you miss the heart of God. If you miss the heart of God, you don't understand his objectives." In this view, serious interest in spiritual growth should involve both knowledge of one's religious tradition and a commitment to ori-

ent one's relationship to God through the wisdom and practices of that tradition.

It is hard to determine the extent of Americans' commitment to a particular confessional tradition. In personal interviews, people seldom admit that they dabble; indeed, they generally express misgivings about people they know who seem to be spiritual dilettantes. Yet these same people often acknowledge having been influenced by other religious traditions than the one in which they were raised and sometimes express doubts about the teachings of their own tradition. Survey data are equally difficult to interpret, especially because a few questions can scarcely measure assent to the teachings of the many religious traditions present in the United States. A crude assessment is nevertheless possible, given the fact that a majority of Americans claim to be Christians. Their loyalty to the Christian tradition can thus be examined in relation to how serious they consider their interest in spiritual growth to be.

The data show, on the one hand, that people with strong interest in spiritual growth are mostly committed to basic Christian teachings, whereas this commitment drops considerably among those who have moderate or lesser interest in spiritual growth. Nationally, about two people in three (68 percent) agree with the statement "God has been fully revealed to humans in Jesus Christ." Those who value spiritual growth are more likely to agree (79 percent), while those who do not value spiritual growth are less likely to agree (49 percent). On another statement, "Christianity is the best way to understand God," 61 percent of the public at large agree; 74 percent do among those who value spiritual growth, compared to only 46 percent among those who do not. In short, most people who particularly value spiritual growth express commitment to Christianity, and the more one values spiritual growth, the more likely that person is to value Christianity as well; at the same time, modest levels of interest in spirituality do seem to be associated with weak commitment to the Christian tradition (table 3).[14]

Some other responses also follow this pattern. For instance, when asked to choose between the statements "God's nature is fully revealed to us in Jesus Christ" and "God's nature is ultimately a mystery," slightly more than half (53 percent) of the public opt for the former. This proportion rises to 73 percent among those who say spiritual growth is extremely important, and it drops to 34 percent among those for whom spiritual growth is not very important. Even the statement "Everything in the Bible should be taken literally, word for word," which evokes agreement from only 35 percent of the public at large, re-

TABLE 3. Christian Belief Is More Common among Those Whose Interest in Spiritual Growth Is High, but Pluralism Is Also Evident
(Percentage responding as indicated among people in each category of spiritual interest)

	Interest in Spiritual Growth			
	Highest	*High*	*Low*	*Lowest*
God is fully revealed in Jesus	79%	74%	67%	49%
Christianity is best way to understand God	74	71	58	46
God's nature is:				
Revealed in Jesus	73	63	42	34
Ultimately a mystery	24	33	54	60
Bible is literally true	50	51	30	17
Know a Jew, Muslim, Hindu, or Buddhist	66	66	65	61
Attended services at mosque, temple, or synagogue	27	21	17	16
Interested in learning more about other world religions	58	53	41	21
God's truth is revealed in many ways	72	75	78	78
All religions contain some truth about God	71	71	76	70
NUMBER	(428)	(424)	(359)	(295)

NOTE: "Highest" refers to those who say it is extremely important as an adult to grow in their spiritual life, "high" refers to those who say this is very important, "low" refers to those who say this is fairly important, and "lowest" refers to those who say this is not very important or not at all important.

ceives assent from 50 percent of those who value spiritual growth, compared to only 17 percent of those who do not value it.

On the other hand, the fact that spirituality is shaped by Americans' exposure to religious pluralism is evident as well. Two-thirds of the public claim to know someone of a religion other than Christianity (e.g., Muslims, Hindus, Buddhists, or Jews), and this proportion is roughly the same among people who do or do not value spiritual growth. But approximately a quarter of those who value spiritual growth say they have attended religious services at a mosque, temple, or synagogue (compared with only a sixth of those who do not value spiritual growth). And, among the former, 58 percent say they are interested in learning about other world religions, whereas this proportion is only 21 percent among the latter.

The influence of this exposure to religious pluralism is further evidenced by the fact that few Americans think the Bible is the only means

of divine revelation. For instance, when asked to choose between the statements "God's truth is fully revealed only in the Bible" and "The Bible is one of many ways in which God's truth is revealed," 20 percent opt for the former, while 75 percent choose the latter. These proportions are about the same among people with different levels of interest in spiritual growth. More to the point, nearly three-quarters of every group (those who value spiritual growth to greater or lesser degrees) also agree that "all religions contain some truth about God." [15]

It is not evident from these questions that Americans actually dabble with numerous religious traditions. Yet the data do give reason to think that spirituality is presently shaped by the high religious pluralism that characterizes American society. Among people with moderate levels of interest in spirituality, substantial numbers do not adhere to traditional Christian doctrines and a majority see truth in all religions. Those who are the most committed to spiritual growth are much more likely to express belief in Christian teachings, and yet these people are also open to other religions. It is particularly interesting that *half* of those who attach the greatest value to spiritual growth think "religious doctrines get in the way of truly relating to God." Similarly, half of these people agree that "God is a mystery and can never be understood by humans."

Whether they have remained true to the Christian faith or adopted different beliefs, nearly everyone in our interviews illustrates the influences of religious pluralism. Susan Brock remembers that her mother (a Sunday-school teacher) was enthralled with Hinduism. Susan has carried the quest a step further. Since college, she has puzzled through the sacred texts of the world's major religions, trying to see how they are similar or different. "You begin to see the message is the same, that it is all about oneness."

Like many Americans, Susan ultimately feels most at home in her own tradition. "I'm a Christian," she asserts, noting that she believes in Jesus as the son of God and the Bible as a "strong message from God." But her Christianity is a mixture of practices influenced by Buddhism, psychotherapy, yoga, American Indian rituals, African drumming, and such contemporary teachings as *The Course in Miracles*. She is intensely serious about her spirituality, praying and meditating every day, and describes it as the core of her being. Yet she believes firmly that people need to find God in their own ways. Little by little, she has given up the idea that absolute truth is contained exclusively in any single tradition.

Other Americans are more like Kathleen Peters. Her youthful dabbling with party drugs, astrology, and psychics convinced her that it was dangerous to stray too far from the religious mainstream. As a mother,

she wants clear moral and religious rules for her daughters. The Catholic church provides these rules. Her daily schedule is so full that she has little time to explore beyond its borders, even though she disagrees with many of its teachings and wishes she had more of a sense of community at her church. She mostly wants to be a good person. Her faith gives her an occasional glimpse of the mystery of God, and she doubts that this mystery can ever be understood.

David Layton's evangelical Christianity exemplifies yet another pattern. Americans who belong to conservative Protestant churches, as he does, typically believe strongly that God's identity is fully and exclusively revealed in the Bible. Many evangelicals are nevertheless similar to him in being reluctant to push their beliefs on others; indeed, it is not uncommon in private conversations to hear them entertain the possibility of people finding God in other ways.

As these examples suggest, the key response to the growing diversity of American—and world—culture is a subtle reorientation of what it means to be spiritual. Americans have always stressed the individual believer's relationship to God, but they do so now more than ever. Seeking on one's own terms replaces conforming to any authoritative religious tradition. The search can be shallow, sometimes yielding remorse rather than results, especially when it is squeezed into the cracks of busy family schedules, as it is for Kathleen Peters. For others, it is pursued with utter seriousness. They want to deepen their relationship with God. They do so by exploring widely, as Susan Brock does, or by following a single path, as David Layton does. But in all of these cases it appears, as Peter Berger has suggested, that pluralism profoundly influences *how* Americans believe.[16] Those who are most seriously interested in spirituality generally find that their growth is deepened by coming to terms with the historic truths of one tradition, but their commitment to this tradition has fuzzy edges; this lets them absorb ideas from other traditions and come up with their own interpretations. Those who are less serious about spiritual growth are less committed to the truth of a particular tradition; they have not abandoned faith that God exists, but they believe that they can relate to God in ways of their own choosing.

Effort Devoted to Spiritual Growth

The concern about effort is rooted in the observation that so much of contemporary spirituality seems to be driven by a consumer mentality.

Consumers want everything now, and they want it as inexpensively as possible. This is the *passivity* problem. People who watch television programs about angels can sit back and somehow "feel spiritual" without having to do anything. The same is true of people who "get saved" at a revival meeting: after saying a short prayer, they are home free.

The consumer orientation contrasts with the idea that most things worth doing require work to do well. Consumers watch other people play baseball, rather than learning to play themselves. Baseball, however, is an example of what has been called a social practice.[17] One learns it by practicing, and, as skills develop, one appreciates the game more fully, internalizes its rules, and perhaps even gains such virtues as patience and a sense of fairness. Spirituality, too, can be understood as a practice that requires personal involvement: only as one expends effort does one grow.[18] We recognize the need for psychological growth as we mature through various life stages. In our careers we express a desire to grow and complain of feeling stagnant if growth is absent. A form of spirituality that does not entail growth, therefore, seems shallow.

Among clergy and in the population at large, ideas about spirituality and spiritual growth are closely associated with an emphasis on prayer, meditation, and other forms of devotional activity. These are among the specific activities on which people who are serious about spiritual growth are expected to expend effort. A Mennonite preacher defines spiritual growth as "practicing spiritual disciplines that strengthen the inner life and then affect one's outer life—forming the inner life with readings, prayer, and meditation." The pastor of an independent evangelical church says the defining characteristics of a mature Christian are "a devotional life, a prayer life, being in the Word of God." A United Church of Christ pastor emphasizes the inner life as well, defining spiritual growth as "a personal spiritual connection with God." These pastors do not believe that spiritual growth consists only of a rich devotional life, but they do insist that an inward, personal relationship to God must be present for spirituality to be effective.

David Layton most clearly illustrates the idea that one must exert effort in order to grow spiritually. Like Susan Brock and Kathleen Peters, his interest in spirituality was molded by attending church as a child, but the decisive influences came in early adulthood when he was attempting to get settled. With little money to finish his education or start a family, David enlisted in the Air Force. He considers himself fortunate to have been able to spend four years at a base in the United States where his wife, Millie, could be with him. They affiliated with a conservative Baptist church with an aging membership. David feels he

gained as much maturity from observing these saintly people as he did from learning the rigors of military discipline. By the time he left the Air Force, he had also completed the required training to be certified as a physical therapist. His aggressive approach to spirituality is similar to what he has come to appreciate through his military training and his work.

David and Millie selected their present community by taking account of its proximity to a Baptist church that they wanted to attend, as well as its schools and affordability. They are pleased that the church, as David puts it, "is growing not only in numbers but in spirituality and understanding." It offers programs for their children, Sunday-school classes, and good fellowship with like-minded Christians. David especially values the men's fellowship group. He says he can confide in the men and count on them to pray with him and offer wise counsel. "They take their walk very seriously." Indeed, there's hardly a thing David doesn't like about the church. Although the members try to follow the clear messages God has given them in the Bible, they strike David as being open-minded and willing to accept differences. At first he worried that they wouldn't accept his wife having a job, but he says his fears were unfounded. Most of the members try to be good witnesses in the wider community as well as in the church, but David says they are careful to avoid being obnoxious about proclaiming their faith.

With so many good things to observe among his fellow believers, David's concerns focus mostly on his own shortcomings. Besides his continuing struggle with his temper, his greatest desire is to become less selfish. So, he admits, his prayers often emphasize what he wants from God rather than giving thanks to God. He wishes his prayers could reflect a better attitude toward life in general. That attitude, he says, would be a life of "exalting God and worshipping God," a life devoted to "giving God his due." This is the main reason he prays every day and tries to read his Bible as often as he can.

David's emphasis on spiritual effort reflects the teachings of the evangelical churches in which he has participated most of his life. But this emphasis is evident in Susan Brock's case as well. She has been meditating and praying every day for the past twenty-five years. As she grows older, she desires more and more to be in the presence of God as much of the time as she possibly can. Meditation, she says, is "listening to God," while prayer is "talking to God." Kathleen Peters also believes it takes effort to grow in one's spiritual life. As a child, she said the rosary with her mother every night before going to bed. She has never felt comfortable meditating, but she still prays daily to the Blessed Mother.

TABLE 4. Effort Devoted to Spiritual Life Is More Common
among Those Whose Interest in Spiritual Growth Is High
(Percentage responding as indicated among people in each category of spiritual interest)

	Interest in Spiritual Growth			
	Highest	*High*	*Low*	*Lowest*
Devoted at least a fair amount of effort to spiritual life in past year	93%	79%	34%	12%
Devoted a great deal of effort to spiritual life in past year	61	21	3	4
Pray every day	84	62	38	21
Meditate every day	45	31	14	12
Interest in spirituality has increased	75	52	24	12
NUMBER	(428)	(424)	(359)	(295)

NOTE: "Highest" refers to those who say it is extremely important as an adult to grow in their spiritual life, "high" refers to those who say this is very important, "low" refers to those who say this is fairly important, and "lowest" refers to those who say this is not very important or not at all important.

From the survey, we can see how many Americans perceive themselves to be making some effort to nurture their spiritual growth. One person in four (23 percent) claims to have devoted a great deal of effort to his or her spiritual life during the past year, while more than half (56 percent) say they have devoted at least a fair amount of effort to their spiritual life in the past year.[19] The remainder break down as follows: 23 percent say they have devoted only a little effort to their spiritual life, 13 percent say they have devoted hardly any effort to it, and 7 percent have devoted none to it. Again, it appears that truly serious commitment to spirituality may be limited to a relatively small percentage of Americans, even though most people claim to devote at least a little effort to it.

As we might hope, the extent to which people *value* spiritual growth does seem to translate into how much *effort* they say they devote to their spiritual life. Thus, 93 percent of those for whom spiritual growth is extremely important indicate that they have given a great deal or a fair amount of attention to their spiritual life in the past year, as do 79 percent of those for whom spiritual growth is very important. This proportion drops to 34 percent among those for whom spiritual growth is only fairly important, and to a mere 12 percent among those who say it is not very important (table 4). Among other things, devotional practices appear to be an important aspect of this effort. Whereas 50 percent

of the public at large claim to pray every day, this proportion rises to more than four in five among those who value spiritual growth the most, and it falls to a fifth among those who value it least. Meditation, while not as common as prayer, is also more likely to be practiced by those who value spiritual growth.[20]

These responses, then, suggest that much of the concern about contemporary spirituality may be well founded but also point to the fact that some Americans take their need for spiritual growth quite seriously and devote effort to fulfilling this need. Approximately one person in four values spiritual growth a great deal and engages regularly in prayer and meditation, while the rest of the public devotes far less attention to spirituality, even though they may claim to be casually interested in it.

Practices with Results

Perhaps the most significant of all the concerns about contemporary spirituality is that it just doesn't matter. This is the *self-indulgence* problem. People talk about spiritual growth, pray, give lip service to religious teachings, and even go to church, but they do so for purely self-interested reasons. They never find enough strength to serve others, and they never actually experience the presence of God in their lives. Both the horizontal and vertical dimensions of spirituality are lacking. It is either too weak or too concerned with personal happiness to result in efforts to help others, and it is so preoccupied with daily problems that it does not lead to transcendent experiences of divine grace.

Nationally, 34 percent of the public claim to be involved in "any charity or social-service activities, such as helping the poor, the sick, or the elderly." This is perhaps a weak measure of social involvement, but it does suggest some commitment to helping other people. Among those who value spiritual growth the most, the proportion rises to 49 percent, but it falls to only 19 percent among those who do not value spiritual growth (table 5). A question about volunteering shows a similar pattern. In the public at large, 38 percent claim to do some volunteering each week. Among those who value spiritual growth the most, the figure is 53 percent, compared to 19 percent of those who do not value spiritual growth. The former are also likely to spend *more hours* volunteering each week than the latter (approximately a quarter volunteer at least four hours a week, compared to an eighth of the public at large). Thus, it appears that a strong interest in spiritual growth tempers self-interestedness to some extent.

TABLE 5. Involvement in Service Activities and Having Religious
Experiences Are More Common among Those Whose Interest
in Spiritual Growth Is High
(Percentage responding as indicated among people in each category of spiritual interest)

	Interest in Spiritual Growth			
	Highest	*High*	*Low*	*Lowest*
Service:				
Involved in charity or social service activities	49%	41%	28%	19%
Do volunteer work	53	45	33	19
Felt close to God:				
Listening to a sermon	79	65	54	25
In nature	75	66	63	46
Among friends	55	41	33	23
Reading inspirational book	69	48	26	12
NUMBER	(428)	(424)	(359)	(295)

NOTE: "Highest" refers to those who say it is extremely important as an adult to grow in their spiritual life, "high" refers to those who say this is very important, "low" refers to those who say this is fairly important, and "lowest" refers to those who say this is not very important or not at all important.

While most people recognize that service to others should (at least in principle) be an attribute of those who value spirituality, there is an even livelier interest in the experiential benefits that may derive from spirituality, such as feeling God's presence. In qualitative interviews, people report a strong desire to feel close to God, and they frequently describe in rich detail times when they have been blessed with this feeling. In some cases, a memorable experience of God's presence starts them on a spiritual journey. But in most cases, this presence is felt as a result of seeking to establish a closer relationship with God. Descriptions range from the rare occurrence when God's voice is actually heard to more common experiences of feeling moved by divine beauty, feeling God's love or forgiveness, or feeling that God is providing comfort and assurance.

The survey suggests that personal experience is central to many Americans' understanding of what it means to grow spiritually. Nationally, nearly twice as many Americans believe that "personal experience is the best way to understand God" (61 percent) than say that "church doctrines and teachings are the best way to understand God" (33 percent). Among those who value spiritual growth the most, a majority opt for personal experience. Even more striking is the fact that 56 percent of the public think "God can only be known as people empty their minds

and look inside themselves." Among those who value spiritual growth the most, this proportion is slightly higher (60 percent).

It isn't that people consider themselves to have grown spiritually *only* when they have a feeling or experience that validates their sense of being spiritual. But it is difficult to underestimate the importance of religious experience in contemporary understandings of spiritual growth. Even among clergy, spiritual growth is frequently characterized as a moving experience of some kind—an "inner happening," as one pastor put it. The interior life is paramount, not because people are overly concerned with their emotional problems (although this may be the case), but because this is where God is most readily found. The inner self, portable as it is, lets people experience God anywhere. Thus, when asked if they have felt close to God in the past year, virtually everyone says they have, and one of the most common contexts of this experience (for 56 percent of the public) is listening to a sermon. And yet, being out in nature has made even more people feel close to God (63 percent of the public at large; 75 percent of those who value spiritual growth the most).[21]

When people talk about spirituality and about growing in their spiritual life, then, it is especially common for them to emphasize their personal relationship to God. They appreciate moments when they are able to feel close to God and to sense God's guidance and protection. They feel they are growing when these moments are more frequent or when they exercise a greater influence over the rest of their thoughts, feelings, decisions, and relationships. Although people often attest to the importance of Jesus as a model or the Bible as a guide, they mention Jesus and the Bible less frequently than they do their relationship to God. Paradoxically, this highly personal orientation nevertheless encourages them to take a more active part in their congregations and to seek ways to serve others.

Evangelicals, Mainliners, and Catholics

Thus far I have ignored the differences in understandings of spirituality that distinguish the various traditions within American Christianity. Part of my reason for doing so is that there are common emphases that cut across these various traditions and that reflect exposure to common cultural influences. These similarities are nevertheless more evident if some of the differences are examined.

It is worth emphasizing that interest in spiritual growth is not re-

TABLE 6. Religious Preferences Are Widely Distributed
among Those Whose Interest in Spiritual Growth Is High
(Percentage responding as indicated among people in each category of spiritual interest)

	Interest in Spiritual Growth			
Religious Preference	*Highest*	*High*	*Low*	*Lowest*
Protestant				
Fundamentalist	14%	8%	6%	4%
Evangelical	12	7	6	2
Liberal or mainline	16	22	17	18
Other	16	15	15	17
Catholic	19	29	32	23
Other	13	7	10	9
None	4	7	10	27
NUMBER	(428)	(424)	(359)	(295)

NOTE: "Highest" refers to those who say it is extremely important as an adult to grow
in their spiritual life, "high" refers to those who say this is very important, "low" refers to
those who say this is fairly important, and "lowest" refers to those who say this is not very
important or not at all important.

stricted to any particular confessional tradition. When we look at those
who say spiritual growth is extremely important, for instance, we see
that 14 percent identify themselves as Protestant fundamentalists, 12
percent as Protestant evangelicals, 16 percent as mainline or liberal
Protestants, 16 percent as other kinds of Protestant, 19 percent as
Catholics, and 13 percent as adherents of various other religious bodies
(table 6).[22] When we look at people who attach less value to spiritual
growth, we also see that the various religious traditions are represented
and, as expected, that the percentage who say they have no religious
affiliation increases among those who place little importance on spiri-
tual growth. Spiritual growth is clearly something that all the various
confessional traditions value, both in theory and in practice, and any-
thing that reinforces the importance of spiritual growth is likely to be of
interest to all these traditions.

Of course, spiritual growth is pursued differently and with different
meanings in the various traditions. Even with the relatively general
questions included in the survey, these differences are evident in com-
parisons among Protestant evangelicals (including fundamentalists),
mainline or liberal Protestants, and Catholics (table 7). Although a ma-
jority of those who actively participate in each of these traditions say
that attending services at their place of worship is very important, this
view is held more commonly among evangelicals (approximately four

TABLE 7. Religious Traditions Show Both Differences and Similarities
on Aspects of Spirituality

*(Percentage responding as indicated among people in each religious category;
only for those who attend services at least once a month)*

	Evangelicals and Fundamentalists	Mainline and Liberal Protestants	Roman Catholics
Questions showing differences:			
Religious services very important	83%	64%	56%
God's nature revealed in Jesus	87	67	53
Bible literally true	59	38	28
God's truth only in Bible	34	21	15
Questions showing similarities:			
Effort to spiritual life	80	75	71
Best way to know God:			
Church doctrines	47	48	42
Personal experience	47	49	49
All religions have truth	62	69	79
Interested in other religions	52	53	57
God is ultimately a mystery	46	58	61
Empty oneself to know God	51	59	60
Doctrines get in the way	51	50	47
NUMBER	(209)	(174)	(247)

NOTE: Religious traditions categorized from responses to questions about religious preference
and, among Protestants, whether the term *evangelical, fundamentalist, mainline,* or *liberal* best
describes their religious identity.

out of five) than among mainline Protestants (about two out of three),
who in turn are somewhat more likely to hold it than Catholics (slightly
more than half). The same pattern is evident when the three are com-
pared in terms of whether God's nature is fully revealed in Jesus Christ.
Because of their historic emphasis on the Bible, evangelicals are signifi-
cantly more likely than mainline Protestants or Catholics to say that the
Bible should be taken literally and that God's truth is revealed only in
the Bible. It is perhaps notable, though, that even among evangelicals,
four in ten do not believe the Bible should be taken literally and two-
thirds believe the Bible is only one of many ways in which God's truth
is revealed.

More interesting are the ways in which people in these traditions are
similar. A large majority in each tradition (better than seven in ten) say

they have devoted at least a fair amount of effort in the past year to their spiritual life. In each tradition, there is a division of opinion about the relative importance of church doctrines and teachings compared to personal experience: about half in each category say church doctrines are the best way to understand God, while the other half opt for personal experience. Equally notable, a sizable majority (even among evangelicals) believe that all religions contain some truth about God, and one person in two expresses interest in learning more about other world religions. Thus, while there is commitment to Christianity in each of these traditions (large majorities believe that God is fully revealed in Jesus and that Christianity is the best way to understand God), there is considerable openness to learning about God in other ways as well.

Summing Up

For the nation at large, the picture of spirituality that emerges from this evidence is sobering. Despite the fact that three-quarters of the public claim to be interested in spirituality (and nearly half say their interest is increasing), most people do not expend a lot of effort in pursuing spiritual growth. They may pray fairly regularly, but they participate sporadically in their congregations, if at all, and they are not at all convinced that church teachings are the best way to know God. Most Americans may have been raised with some exposure to religion, but few have read much about religious history, and many think the best way to approach God is by emptying their minds. Especially among the majority of Americans who express some (but limited) interest in spiritual growth, the criticisms that have been voiced about contemporary spirituality seem to be well placed. This casual interest in spirituality is sufficient to propel people to pray once in a while and to attend religious services on special occasions; it creates a substantial market for those who wish to reap profits from marketing inspirational books or setting up web sites about spirituality; but it does not involve significant personal effort or serious commitment to learning the teachings of a religious tradition.

The hopeful part, as far as organized religion is concerned, is that a solid minority of the public is seriously committed to the pursuit of spiritual growth. As many as one person in four attaches utmost importance to spiritual growth, and of these, a large majority pray or meditate daily and in other ways try to improve their spiritual lives. Some of these

people are only marginally involved in organized religion, but at least three-quarters attend worship services regularly and consider these services quite significant to their spiritual growth. Their affiliations range widely, from Protestants to Catholics and from fundamentalists to liberals. Because most are affiliated with Christian churches, they overwhelmingly believe in Jesus and the Bible and they are firmly devoted to the unique truth of Christianity. At the same time, they are exposed to other religions, are interested in learning more about them, and are open to the possibility that divine truth can be revealed in many ways. Nearly all of these people value personal experience as a way of knowing God and often feel the presence of God in their lives. A majority are involved in helping others through social-service activities.

It is worth emphasizing that Americans who express moderate interest in spirituality are like those who value it greatly in some ways. They may not be as actively involved in congregations or as committed to religious principles, but they have not entirely rejected these principles either. The more they value spiritual growth, the more likely they are to devote effort to it and to be active in their congregations. If their interest in spiritual growth were to increase, an even larger number of people undoubtedly would be involved in the nation's churches. This prospect is, in fact, tantalizing. Although clergy generally talk as if active participation promotes spiritual growth, more interest in spiritual growth probably in turn encourages participation. Anything that nudges the public's interest in spiritual growth to higher levels is likely to benefit organized religion. It may benefit the wider society, too, at least if these people become involved in social-service activities.

If spirituality is superficial for the many and serious for a few, the research also shows that it has acquired some interesting *qualitative* emphases. Several historic dimensions of spirituality are notably absent, at least when people talk spontaneously about what has been most meaningful in their spiritual journeys. One is preparation for an afterlife. Spiritual growth appears overwhelmingly to be concerned with the here and now. Another is the idea of God's kingdom. Spiritual growth is concerned with biography, not history, and pertains to individuals rather than the nation or church. Spiritual growth is often lacking in dogma as well, either as formulaic creeds or as cognitive systems that must be mastered.

The words that most readily describe serious interest in spiritual growth at the start of the twenty-first century are *reflective, experiential,* and *practical. Reflective* means that spiritual growth is tantamount to

what in other contexts has been called the examined life. Growth is perceived retrospectively by looking back on one's thoughts and actions. It is furthered by prayer and meditation, as both help to quiet ordinary concerns and stimulate thinking about who one is and how one should live. *Experiential* means that moments of special closeness to God serve as a means of spiritual growth and as its reward. Experiential also means that spirituality is validated, as it were, from the inside—by living oneself into it, rather than by considering it objectively. *Practical* means that spiritual growth is attainable by those who are willing to practice it and that this growth has healthy consequences for developing one's talents or simply coping with the difficulties of daily life.

These attributes underscore the highly personal character of spiritual growth. But for those who take it most seriously, spiritual growth does not encourage a preoccupation with instrumental tasks as much as it reinforces reflection on the deeper meanings of life. This reflection is highly personal, and yet spiritual growth does not require individuals to isolate themselves from religious communities. Quite the contrary. For the most serious, spiritual growth goes hand in hand with participating in communities of worship and service. Yet the contemporary understanding of spiritual growth does encourage people to view these communities as contexts in which to attain a *personal* experience of the sacred and as sources of support and encouragement. Insofar as service to the needy is encouraged, it too is personalized, both in the sense of helping needy individuals and as a way to act out one's convictions or develop one's talents more fully. Doctrine is also personalized in a way that adapts it to a pluralistic environment. Rather than consisting of intellectual arguments that win by persuasion (or that acquire legitimacy through historical knowledge), religious teachings are validated almost aesthetically through repetition and familiarity. They make sense compared to the teachings of other religions not because they are absolutely true, but because it would be inconvenient to believe in something else.[23] Embedded as they are in the rich symbolism of one's own tradition, these teachings nevertheless provide standards that help to guide one's behavior.

Depending on how seriously the problems of our time are associated with religious solutions, one might hope for a form of spirituality that paid greater heed to social justice or to national and global concerns. If we are to understand why religion in America has fared as well as it has, however, these personalized meanings of spiritual growth are surely an important key. Religious involvement is as widespread as it is not be-

cause religious institutions have carried forward a belief system that is alien to the society in which we live, but because contemporary understandings of spiritual growth fit so well with the prevailing assumptions of our culture.

Paradoxically, these meanings of spiritual growth challenge people to lead better lives even as they help people make the compromises required by contemporary conditions. As people take spiritual growth more seriously, they do spend more time in prayer listening for God's voice; and they become more involved in faith communities, finding support there to move past deadening life crises and addictions, as well as opportunities to be of greater service. If for the most part they do not believe dogmatically in the teachings of their own tradition, they do gain a greater appreciation of this tradition.

For those who believe that strong religious institutions, on balance, make a valuable contribution to American life, the question of how to keep these institutions vital is, therefore, intimately connected with how we understand spirituality. Whatever the cultural limitations of our present conceptions of spiritual growth, increases in the numbers of people who seriously value spiritual growth and who devote significant attention to it are likely to contribute positively to levels of religious involvement. In this sense, the present interest in spirituality is probably good for churches, especially when this interest can be deepened and enriched. Although casual interest in spirituality is currently, as it probably always has been, a threat to organized religion because its very casualness can inoculate people against taking the sacred more seriously, there is reason to believe that heightened (and growing) interest in spirituality may be one of the reasons for the present strength of organized religion. Indeed, if the alternative for maintaining the vitality of American religion is a harsh fundamentalism that generates dogmatic allegiance, then many surely would opt for greater emphasis on a spiritual growth that is reflective, experiential, and practical.

A Blending of Cultures

The Arts and Spirituality

For Susan Brock, a career in interior design has provided ample oppor-
tunities to bring a lifelong interest in the arts together with her search
for spirituality. Although she created and enjoyed art and music as a
child, this relationship between spirituality and the arts has emerged
gradually over the years. In her early thirties, she began experimenting
with ways to make home furnishings more conducive to self-expression.
Too often, her customers bought what they thought was fashionable,
rather than what they truly wanted. Indeed, they often did not know
what they wanted. She found it helped to get them talking about what
they loved doing most (such as writing letters to friends, jogging, cook-
ing, or spending time with their children), and then she helped them to
create a space that would be conducive to this activity. Focusing on self-
expression eventually led her to think more about ways to facilitate spir-
itual development. She took classes to learn about the spiritual signifi-
cance ascribed to different colors in religious traditions. More recently,
she learned Feng Shui, the Chinese understanding of spiritual energy in
the home. She now teaches a seminar, called "Designing Your Life,"
that helps participants to reflect on their experiences of the sacred. Re-
sponding to a growing interest in prayer and meditation, she also helps
people to create spaces that nurture their devotional practices.

For Kathleen Peters, the artistic temperament she inherited from her
show-business parents has failed to result in full-time artistic work like
Susan Brock's, but Kathleen's private life is enriched by participating in
the arts. Her grandmother not only took her to the Episcopal church,
where she could hear the traditional hymns, but also taught her to play

the piano and sing. Kathleen still loves the Celtic songs she learned as a child. One thing she continues to admire about the Episcopal church is the pageantry of its music at Christmas and Easter. These experiences have shaped how she relates to God as an adult. Prayer is difficult for her, but listening to Handel or Bach or Mozart puts her in the mood to pray. Singing, too, is a way of feeling closer to God. She often sings when she is troubled, and then she feels God's comforting presence.

Similarly, David Layton's participation in the arts occurs largely in his spare time, but unlike Kathleen Peters, he connects the arts and spirituality through an activity at his church. For the past seven years he has been part of a gospel ensemble. His interest in music emerged in high school, when he learned to sing, play the guitar, and perform in a rock band. After his religious conversion, he channeled his interests toward Christian music, occasionally performing during church services. He decided to join the gospel ensemble as a way to be more public about his faith. He recalls the event that prompted his decision: he and his wife were camping one summer during their vacation, and one evening he started singing gospel songs. "The next morning I found out that people around the campsite were turning off their little televisions or radios and trying to hear. That was a turning point for me. I don't have to be embarrassed to share the Word of God." The gospel ensemble puts on concerts about once a month at various evangelical churches. Church members invite their friends, hoping the experience will draw them to God. David says singing contributes to his own growth as a Christian. It especially challenges him to focus on the Bible and to associate with other Christians. "My goodness," he exclaims, "I'm not alone; there's a whole bunch of us who believe the same way!"

These are only a few of the ways in which people are finding spiritual enrichment through the arts, music, and literature. The range of contemporary possibilities is immense. A Lutheran woman in her sixties says her closest moments with God occur when she is quilting. A Presbyterian man is gaining new appreciation of his religious heritage as he learns the bagpipe. Artists in a Catholic parish in San Francisco paint a mural on their parish hall depicting their Aztec roots. A Jewish woman who practices yoga draws pictures to help her pray. A gay men's chorus cultivates the spiritual support that its members no longer find in their churches. A motorcycle gang in Brooklyn brings homemade crafts to adorn the grave of a loved one. A Muslim leader with fifteen nationalities at his mosque says the cantor's chanting has become the only effective form of communication.

As these examples suggest, the way to begin understanding how the arts may be related to spirituality and religion is not by visiting art museums and concert halls but by talking with ordinary people. Most Americans are exposed to the arts as children, either at school or through family and friends. As adults, the overwhelming majority of Americans participates at least casually in artistic activities, ranging from the occasional outing to an exhibit or play to dabbling in painting, pottery, or poetry. Virtually everyone listens to music on the radio, goes to the movies, or reads novels. Creativity, a trait that some people bemoan having too little of, is so highly valued that most people find ways to express it—many by singing or playing an instrument, writing, or learning crafts. And, despite the fact that people have different opportunities to experience the arts, a large number of Americans say their lives have been significantly influenced by them.

Of course, the links between the arts and spirituality have been evident throughout American history. From the decorative carvings adorning El Santuario in Chimayo, New Mexico, to the meditative serenity of the Rothko Chapel in Houston, and from the simple lines of a Shaker meeting house to the splendor of the St. Louis Cathedral, the visual arts have been prominently associated with places of worship and prayer. Even more so, music has been the medium of choice, whether performed instrumentally by a Moravian brass ensemble or sung a cappella from a split-leaf Psalter. Beyond the walls of holy places, writers from Herman Melville to William Faulkner and painters from Richard Hick to William Johnson have emphasized spiritual and religious themes in their work.

Such connections notwithstanding, there is reason to think that the arts and spirituality may influence each other more profoundly now than they did in the recent past. Through electronic and digital media, the barriers that once separated religion from the arts are breaking down. Gregorian chant can be heard in shopping malls as well as in monasteries. Cable television brings Christian rock music and the anthems sung in large Baptist or Catholic churches to millions of Americans. The sizable numbers of Americans who have been exposed to art, art history, drama, music, and literature in high school and college continue to pursue these interests by visiting galleries and museums, by patronizing theaters and concert halls, and by reading books. Music directors, playwrights, and authors have supplied works in abundance that deal with religious and spiritual themes.

As a starting point, it is useful to know what kinds of artistic activi-

ties people have been exposed to as children, which of these and other activities they participate in as adults, how much of their creativity is expressed through the arts, and whether they regard themselves as artistic and believe that they were influenced by the arts. With this information it becomes possible to determine what proportion of the public is highly involved in artistic activities, how many people are relatively less involved, and what some of the social factors that influence these different levels of involvement may be. Comparisons can then be made among people with varying levels of artistic interest to see how these levels are related to different measures of spirituality and religion.

Childhood Exposure to the Arts

The extent to which adults remember having participated in various kinds of artistic activities while they were growing up is shown in table 8.[1] A majority of adults say they performed at one time or another in a school play. Approximately one in two claim they learned to play a musical instrument. Almost half say they sang in a choir or ensemble at school, and about the same number remember having taken art classes. Four in ten sang in a choir or ensemble at church. Almost as many say they kept a personal diary or wrote poetry. And one in four played in the band or orchestra. In all, nearly everyone (86 percent) remembers doing at least one of these activities during childhood. Seven people in ten claim to have done more than one of these activities, and four in ten say they participated in a majority (four) of them. Through childhood experiences alone, then, exposure to the arts is widespread.

Whether childhood exposure to artistic activities like these has increased over the years, decreased, or remained constant is more difficult to determine. Many educators express concern about declining budgets in public schools for music and art programs. In the 1960s, science instruction became a higher priority in the nation's schools as a result of Cold War competition between the United States and the Soviet Union in nuclear armaments and space exploration. During the 1980s, taxpayer protests resulted in widespread budget cuts in some states, while budget increases failed to keep up with rising enrollments in others. Yet, the twentieth century witnessed a gradual increase in the proportions of young people who completed high school and who went on to college, and during this period the average number of days that young people spent in school increased significantly.[2] Over the course of the

TABLE 8. Childhood Exposure to the Arts Is Fairly Widespread
(Percentage nationally who say they did each activity while they were growing up)

Performed in a school play	54%
Learned to play a musical instrument	49
Sang in a choir or ensemble at school	47
Took art classes	46
Sang in a choir or ensemble at church	41
Kept a personal diary or wrote poetry	38
Played in a band or orchestra	26
NUMBER	(1,530)

century, as more of the population moved from farms and small towns to cities and suburbs, schools became larger and school districts consolidated, resulting in economies of scale that permitted more opportunities for bands, orchestras, choirs, and specialized instruction in the visual arts. Statistics compiled by the U.S. Department of Education show that the proportion of public secondary school teachers specializing in art increased significantly during the last third of the twentieth century, as did the proportion of high school graduates who had taken courses in the arts.[3] Beyond the classroom, rising levels of family income may have permitted more young people to take private music or art lessons and to participate in after-school activities as well.

One indication that childhood exposure to artistic activities increased during the twentieth century can be seen by comparing the experiences of people who are members of different "birth cohorts" (i.e., born in different decades). Higher proportions of more recent cohorts say they participated in the arts as children than among earlier cohorts. Thus, the proportion who participated in at least four of these seven activities rose from only 22 percent among the 1910s cohort to 31 percent among the 1920s cohort, dropped slightly to 28 percent among the 1930s cohort (perhaps because of the Great Depression or World War II), increased to 45 percent among the 1950s cohort, and reached a high of 49 percent among the 1970s cohort.

Adult Participation in the Arts

Estimates of participation in the arts among adults vary widely because of differences in question wording and survey methodology.[4] In addition, studies differ in what they consider appropriate to include: some

focus on attendance at formal activities sponsored by arts organizations, while others include a wider variety of informal and avocational activities. But most studies show that large minorities of the population participate in particular kinds of artistic activities, that most Americans take part in the arts at least in small ways, and that participation in many artistic activities appears to have increased in recent decades.

Some of the most extensive studies of public participation in the arts have been conducted by the National Endowment for the Arts. Two national studies, conducted in 1992 and 1997, suggested strong growth during that five-year period in the proportion of Americans engaged in various artistic activities: the proportion who had purchased an art work within the past year rose from 22 percent to 35 percent of the public; attendance at an art museum or gallery climbed from 27 percent to 35 percent; reading literature increased from 54 percent to 63 percent; pottery making, from 8 percent to 15 percent; and creative writing, from 7 percent to 12 percent.[5] The NEA studies also found that people were attending arts events more frequently. Thus, the total annual audience for classical musical performances grew from 60.3 million to 88.5 million; for opera, from 10.4 million to 16.5 million; and for musical plays, from 74.5 million to 105.4 million.[6]

My Arts and Religion Survey included a wider range of artistic activities than some of the previous studies. It asked about activities in which people could participate passively as consumers, such as listening to music on the radio and going to movies, and those that required more active but still casual involvement, such as purchasing music, taking photographs, and reading novels. Some of the questions were designed to assess involvement with the organized arts, such as attending a live concert or opera, visiting an art museum or gallery, and purchasing a painting, sculpture, or craft item. Several questions probed more active personal involvement, such as making art or craft objects, playing a musical instrument, and writing poetry. Some additional questions were included to fill possible gaps, such as helping children with art or music projects, reading religious or inspirational literature, and going dancing. Depending on what counts as "art," some of these activities are clearly more artistic than others, but all bear some relation to the performing arts, visual arts, or literature.

The proportions of Americans who say they did each of these activities within the twelve months prior to the survey are shown in table 9.[7] Not surprisingly, casual consumer activities head the list in frequency of participation. More than nine people in ten say they have listened to

TABLE 9. Adults' Exposure to the Arts Is Fairly Widespread
(Percentage nationally who say they have done each activity in the past twelve months)

Listened to music on the radio	92%
Purchased music on a tape or compact disc	70
Taken photographs	67
Gone out to see a movie	64
Read religious or inspirational literature	50
Read a novel	49
Helped children with art projects or music	38
Gone to a school play or concert	37
Purchased a painting, sculpture, or craft item	35
Gone dancing	33
Made art or craft objects	33
Attended a live concert or opera	31
Read poetry	30
Visited an art museum or gallery	26
Played a musical instrument	20
Written poetry	9
NUMBER	(1,530)

music on the radio in the past year, seven in ten claim to have purchased music on a tape or compact disc, and approximately two-thirds have taken photographs or gone out to see a movie. One half of the public claims to have read a novel in the past year, and the same proportion claims to have read religious or inspirational literature. A number of activities appear to be ones in which about a third of the public participates each year: helping children with art projects or music, going to a school play or concert, purchasing a painting or sculpture, going dancing, making art or craft objects, attending a live concert or opera, and reading poetry. The activities that involve the smallest proportions of the public are visiting an art museum or gallery, playing a musical instrument, and writing poetry. Only 2 percent of the public have done none of these activities within the past year, while three-quarters of the public have done at least four of them, and a third of the public has done eight of them.

Because these questions were not asked in exactly the same way in previous surveys, they cannot be used to show whether participation rates have been rising. Two indications, nevertheless, suggest that these rates probably are increasing. One is that participation is higher in more recent cohorts than in earlier cohorts, as is true of childhood activities. For instance, the mean number of activities for the 1910s cohort is 4.0,

rising to 5.1 and 5.4 for the 1920s and 1930s cohorts, and rising further to 7.4 for the 1950s, 1960s, and 1970s cohorts. The other indication is an inference from the fact that childhood exposure to the arts has a powerful effect on adult participation in the arts: the mean number of adult activities rises from 3.2 among those who had no exposure to the seven childhood activities considered previously, to 4.7 among those with exposure to only one childhood activity, to 8.4 among those exposed to four childhood activities, and 11.0 among those involved in all seven childhood activities. Because childhood activities appear to have increased in more recent cohorts, it stands to reason that adult participation is likely to have increased as well.

That a growing number of Americans is participating in the arts is also suggested by attendance figures reported by arts organizations themselves. Although some organizations have fared better than others, many of the trends have been decidedly upward. For instance, the total audience for nonprofit professional theaters exceeded twenty million for the first time in 1994, up from approximately five million in 1975; opera audiences topped twenty million in 1989, compared with fewer than five million in 1970; and symphony orchestra audiences grew to more than thirty million in 1996 from only twelve million in 1970.[8] By some indications, mass consumption of music and the arts has also been growing. For instance, total domestic sales of compact discs, albums, cassettes, and music videos reached one billion units in 1994, approximately twice the number in 1980; and these sales exceeded the ten-billion-dollar mark for the first time in 1993, nearly triple their value in 1980.[9]

Of course, an upward trend in the arts should be reflected not only in public demand for artistic works and performances, but also in the *supply* of artists available to create these works and performances. There has, in fact, been an upward trend in the supply of artists as well: in the fifteen years between 1983 and 1998, the number of painters and sculptors increased from 186,000 to 241,000; the number of musicians and composers, from 155,000 to 183,000; actors and directors, from 60,000 to 130,000; and authors, from 62,000 to 130,000. Overall, this was a 48 percent increase in the number of Americans employed professionally as artists. In comparison, the number of clergy grew during this period by only 11 percent.[10] Thus, by the latter date, there were more than twice as many artists in the United States as clergy.

This increase in numbers of artists was accompanied by an even more dramatic rise in the numbers of arts organizations. According to na-

tional figures compiled in the early 1990s, the number of professional orchestras and museums doubled between 1965 and 1992; during the same period, the number of opera companies multiplied four-fold; the number of professional nonprofit theaters, seven-fold; the number of professional dance companies, eight-fold; and the number of local arts agencies, more than twenty-fold.[11] Little wonder, then, that larger and larger shares of the public were reporting that they had participated in events sponsored by these organizations.

Expressing Creativity

In qualitative interviews, people are sometimes unsure what "the arts" refer to but talk more easily about creativity. For this reason, we included questions in the survey asking people how they express creativity. We offered several options pertaining specifically to the arts, such as engaging in arts and crafts or singing or playing a musical instrument. The question, however, included a number of other ways in which people conceivably could express their creativity, such as through their work, cooking, sports, home decoration, gardening, and traveling. These questions, therefore, provide a different perspective on the arts by giving a sense of how commonly the arts are used as a means of creative expression compared with other outlets for creativity.

The results are shown in table 10.[12] Traveling, taking trips, and sightseeing are the most common ways in which people express their creativity, selected by one person in two. Reading is almost as common, followed by spending time in nature, cooking or entertaining, and the person's work, all of which are mentioned by nearly half the public. Home decoration, sports, other hobbies, prayer or meditation, and gardening are all selected by at least a third of the public. At the bottom of the list are religious activities, engaging in arts and crafts, singing or playing a musical instrument, and writing. The two activities that refer specifically to art and music are each selected by a quarter of the public.

Unlike childhood and adult participation in the arts, these ways of expressing creativity seem not to vary much among different birth cohorts. Indeed, they suggest that people of all ages and in all eras find multiple ways in which to be creative; for instance, people in midlife are most likely to say their work sparks their creativity, whereas older people say this about gardening and reading, and younger people say it about sports and physical exercise. Nevertheless, those activities most clearly

TABLE 10. Americans Express Their Creativity in a Variety of Ways
(Percentage nationally who say each activity especially sparks their creativity)

Traveling, taking trips, sightseeing	52%
Reading	49
Spending time in nature	47
Cooking or entertaining	47
Your work	46
Decorating your home	39
Engaging in some other hobby	39
Participating in sports or physical exercise	37
Prayer or meditation	35
Gardening	33
Taking part in religious activities	29
Engaging in arts and crafts	27
Singing or playing a musical instrument	24
Writing	21
NUMBER	(1,530)

pertaining to the arts (engaging in arts and crafts, singing or playing a musical instrument, and writing) are relatively more likely to be mentioned by people born in recent decades than by those born in earlier decades.[13] Although these differences are not strong, they are consistent with the data showing that younger cohorts are more likely to have had childhood exposure to the arts and that such exposure is conducive to adult participation in and appreciation of the arts.

Self-Definition and Valuing the Arts

Two other ways of thinking about the arts round out the possibilities for assessing their role in personal life. One is how people think of themselves. In qualitative interviews we found considerable variation in the degree to which people think of themselves as being creative or artistic. Yet these self-definitions matter. They can, for instance, cause some people to think that they are good at art, even though they may have had little time to spend on it, or lead others to say they especially appreciate music and art because they themselves like to be creative. The other is how much value people attach to the arts, specifically in terms of how important the arts are to them personally.

Given what we have seen about ways of expressing creativity, it is not surprising that more people think of themselves as being "creative" than

"artistic." Nationally, 58 percent of the public agree that the former attribute applies to them, while only 25 percent agree that the latter does.[14] Because many of our questions avoided defining the arts, one statement was included (after the questions about participation) that offered an explicit definition ("painting, sculpture, music of all kinds, dance, theater, and creative literature") and asked people to say how important the arts, so defined, were in their own lives.[15] The responses show the kind of variation that might be expected when people frankly assess their own attitude toward the arts. One person in six says the arts are extremely important. Four in ten say the arts are either very important or extremely important. Nearly eight in ten say the arts are at least fairly important. Only one person in twenty says the arts are not important to them at all.[16]

Perceiving oneself as creative or artistic and saying that the arts have been very important in one's life are more common among persons born in more recent decades than among persons born in earlier decades. Thus, among those born in the 1970s, 66 percent say they are creative, compared with 45 percent of those born in the 1930s and only 30 percent of those born in the 1910s; 28 percent of those born in the 1960s and 1970s say they are artistic, compared to 18 percent of those born in the 1930s and 16 percent of those born in the 1910s. Similarly, among those born in the 1940s, 1950s, 1960s, or 1970s, nearly half say the arts have been very important to their lives, compared to 39 percent of those born in the 1930s and 23 percent of those born in the 1910s. Again, then, the survey results are at least consistent with other data showing rising levels of exposure to and participation in the arts.

A Summary Measure

People who specialize in the arts know that participation varies both in levels and in kind: classical music fans may have little in common with devotees of rock music, just as those who follow the visual arts may have little interest in ballet or opera. Yet research on musical tastes and arts participation in the public at large suggests that artistic interests do tend to go together: people with interests in one form of artistic expression often pursue others as well.[17] As the evidence presented thus far suggests, different ways of asking questions also tap into alternative ways of expressing artistic interests, and each kind of question has limitations and strengths. It is helpful, therefore, to combine some

TABLE 11. Validation of the Artistic Interest Scale
(Percentage responding as indicated among people in each category of artistic interest)

	Score on Artistic Interest Scale					
	Low 0	*1*	*2*	*3*	*4*	*High* 5
Visited an art museum or gallery	4%	8%	17%	26%	34%	54%
Attended a live concert or opera	4	15	22	29	40	54
Purchased an art object	2	13	25	37	45	62
Admire artists a great deal	12	19	26	26	37	55
Close friends interested in arts	5	23	39	46	60	84
Relatives interested in arts	12	26	40	46	56	77
Had art history/appreciation class	10	30	41	54	65	79
NUMBER	(96)	(262)	(317)	(301)	(306)	(248)

of these questions to create an overall measure of people's involvement with the arts.

The measure that will be used in the remainder of the chapter is a scale of artistic interest that gives people a point for each of the following: having done at least one of the previously discussed artistic activities as a child; having played an instrument, made art or craft objects, or written poetry within the past year; claiming to express one's creativity through singing or playing an instrument, writing, or engaging in arts and crafts; saying that the arts have been very important in one's life; and defining oneself either as creative or artistic.[18] At the low end of this scale, 6 percent of the public score 0 and 17 percent score 1. In the middle, 21 percent score 2 and 20 percent score 3. And at the high end, 20 percent score 4 and 16 percent score 5. The scale thus provides a way of comparing people with varying degrees of exposure to and interest in the arts.

Table 11 shows that the scale does a good job of predicting the likelihood of people participating in other kinds of artistic activities besides those included in the scale. From those at the low end of the scale to those at the high end, the likelihood of having visited an art museum or gallery in the past year rises from 4 percent to 54 percent, while the likelihood of having purchased an art object in the past year rises from 2 percent to 62 percent. Attitudes toward the arts vary similarly. At the low end of the scale, only 12 percent admire artists a great deal, while at the high end, 55 percent do. The data also suggest that artistic interest is embedded in social relationships: at the low end of the scale, only 5 percent have close friends with artistic interests, whereas at the high end,

84 percent do. Having relatives interested in the arts and having taken a class in art appreciation or art history vary similarly.

The Arts and Spirituality

Do the arts contribute to or in some way reinforce people's interest in spirituality? In my personal interviews with them, leaders of major arts organizations overwhelmingly see a connection between the arts and spirituality and thus believe that the arts could encourage people to express and deepen their interests in spirituality. At the prestigious Dallas Institute of Humanities and Culture, director Larry Allums explains the connection in an interview this way: "If a person had a healthy artistic life in terms of reflecting on or pondering artistic presences, then that could not help but augment a formally religious presence in his or her life. Art, poetry, painting, music—they really do deal with the sacred, with the spiritual." At the New York Foundation for the Arts, executive director Ted Berger offers a similar observation: "When you start looking at your strengths and vulnerabilities, there's a connection to these wider things. Art and spirituality are ways of approaching the secrets of the heart, the secrets of the soul." Lori Fogarty, executive director of San Francisco's Museum of Modern Art, agrees that the two go hand in hand: "The greatest music that's ever been composed has been in celebration of spirituality. A lot of the best art is intended to open people's minds, to have them see things in new ways, to direct them toward fundamental issues. Experiencing art and participating in art can open people's minds to whole other planes of possibility."

Many prominent members of the clergy also believe there is much to be said for the spiritual implications of the arts. At New York's Riverside Church, Reverend James Forbes emphasizes the fundamental mystery of God and art's capacity to evoke that mystery: "Not knowing what God is like creates the space to say I know there is something there. What might it be? In the moment of creative artistry, one gains the audacity to take a stab at it. How do we talk about God: unmoved mover, the oblong blur, that than which nothing greater exists? Imaginative and theological work is creatively risky, making more real what we know is in the mystery realm. We tend not to be able to leave mystery alone. We want to do something about it, we want to name it, we want to claim it, we want to touch it. I think that's the way art functions."

Roman Catholic bishop Anthony Pilla says there is a basic similarity

between religion and the arts: "They both deal with the spirit of humanity. There should be a great complementarity because the arts are one of the manifestations of the glory of God, one of the infinite manifestations of that glory. I don't know how you express divine sentiment and spiritual values without some artistic involvement."[19]

In the survey, a majority of the public seems to share these leaders' views. Faced with the statement "Art can help people to deepen their spirituality," 56 percent agree, while only 31 percent disagree. A larger proportion (73 percent) agree with the statement "Any art or music can be a way to communicate one's spirituality"; and an even larger proportion (78 percent) with "Art, music, and literature help us to experience the deeper meaning and purpose of life."

At a more personal level, large numbers of Americans indicate that the arts have been important to their own spiritual development. A Catholic woman in Georgia says that listening to the work of a gifted musician has always made her think about God's gifts—especially because she seems to lack this gift. In Pennsylvania, a member of an African Methodist Episcopal church says music almost *visually* deepens her relationship to God: "Even if I was deaf and couldn't hear, the vibration of the music would still create images. You've heard deaf people describe what they experience when they feel music. They can't hear it, but the vibrations are creating images. We don't always pay attention to them, but they're happening. It becomes part of the fabric of our experience with God, and I believe that all of those pieces become material that the Holy Spirit uses to weave together our experience of God." In New York, a recent convert to an evangelical church says he has especially appreciated the congregation's efforts to incorporate drama and the visual arts into the worship service: "It's given me more of an awareness of God using people in different ways to get his message across. It has broadened my horizons as to how God can use people."

When asked in the survey about activities that have been important in their efforts to grow spiritually and to develop a closer relationship with God, 61 percent of the public say "listening to music" has been very important or fairly important. Thirty-five percent say this about "singing or playing a musical instrument." The same proportion give these responses for "reading literature or poetry." On another question, 62 percent of the public report that music has been very important or fairly important to their spiritual life; 26 percent say this about poetry.[20]

This, at least, is how the public *perceives* the relationship between the arts and spirituality. But is there evidence to support this perception?

Do people with different levels of involvement in artistic activities actually vary in how they respond to questions about spirituality?

The data show that there is indeed a positive relationship between the two. On the spiritual interest question discussed in the last chapter, the proportions who say that spiritual growth is very important or extremely important rise from 33 percent among those at the low end of the Artistic Interest Scale to 69 percent among those at the high end. According to these data, it is also those most interested in the arts for whom interest in spirituality has been increasing: 60 percent at the high end of the art scale report an increasing interest in spirituality, compared with only 24 percent at the low end of the scale.[21]

The reasons for this connection between artistic activity and commitment to spirituality appear to lie in the distinctive ways in which spirituality is currently understood. As many of the comments from both clergy and lay people suggest, one of the most important of these understandings is that spirituality should involve *devotional effort*. People who are seriously committed to spiritual growth believe it is essential to pray, meditate, and in other ways work on their spiritual life. This emphasis is similar to the way in which many people approach the arts. They read poetry to reflect on the deeper meanings of life, listen to music to quiet their hearts, or engage in an art project with the same kind of devotion that causes them to meditate regularly. That there is a relationship of this kind is evident in the survey. The more involved a person is in artistic interests, the more likely that person is to have devoted a great deal of effort to his or her spiritual life in the past year, to pray regularly, and to meditate (table 12). These relationships remain when the effects of other factors, such as age, education, sex, and theological orientation, are taken into account. They also remain when different levels of interest in spirituality are considered: those who are involved in artistic interests are more likely to engage in devotional activities than those who are not involved, no matter what their level of interest in spirituality.[22]

A second point of intersection between the arts and spirituality is *childhood exposure*. The childhood activities that so strongly influence adult spirituality are ones that bring the arts and religion together. Hymns and other religious music, memories of religious pictures or plaques in one's childhood home, and religious objects powerfully influence the likelihood that adults will be interested in spiritual growth. These hymns, pictures, and objects are also works of art. People who score high on artistic interests of other kinds are more likely to have

TABLE 12. Indicators of Spirituality Are More Common among People Who Score Higher on the Artistic Interest Scale
(Percentage responding as indicated among people in each category of artistic interest)

	Score on Artistic Interest Scale					
	Low 0	1	2	3	4	*High* 5
Devotionalism:						
Devoted effort to spiritual life during the past year	7%	17%	20%	25%	31%	35%
Pray nearly every day	45	58	65	68	69	71
Meditate nearly every day	12	24	33	35	41	51
Childhood exposure to the arts:						
Hymn or religious music	27	38	43	50	56	64
Religious pictures	21	28	34	35	39	41
Religious objects	20	22	28	28	29	39
Religious pluralism:						
Know someone of another religion	45	53	61	63	69	85
Attended services of another religion	16	10	15	20	25	35
Interested in learning more about other world religions	22	30	41	45	51	66
Experienced closeness to God:						
In nature	42	48	59	64	70	85
Among friends	17	29	32	39	48	56
Reading inspirational book	12	29	33	44	54	56
NUMBER	(96)	(262)	(317)	(301)	(306)	(248)

been influenced by these kinds of religious music and art as children (table 12).[23]

Another way in which the arts and spirituality come together is that artistic interests go hand in hand with *spiritual seeking,* including searching on the perimeter of one's own faith. The more involved a person is in artistic interests, the more likely that person is to have shopped for a church or synagogue, to have attended services of a different religion, to know someone of a different religion, and to express interest in learning about other world religions (table 12). At the same time, artistic interests seem to be compatible with retaining loyalty to one's own tradition, judging from the fact that there are *not* significant differences in responses to questions about Christianity, Jesus, and the Bible among people with lower or higher levels of interest in artistic activities.[24]

Yet another meeting point between contemporary spirituality and

the arts is a shared emphasis on *transcendent experience*. Although people with higher levels of interest in the arts do not reject doctrinal approaches to the sacred, they do show a slightly stronger inclination toward experience as a way of knowing God. More importantly, they are much more likely to report feeling close to God and to have had such experiences in a wider range of contexts (table 12).[25]

On most of the dimensions previously identified as characteristics of *serious* interest in spiritual growth, then, people with more involvement in artistic activities are more likely to exhibit these characteristics. How this influence works undoubtedly various from person to person. For some, an interest in spirituality may result in greater participation in the arts, while for others, involvement in the arts may precede an emerging interest in spirituality. The important thing is that the two reinforce each other.

Social Factors

We can now return to some of the broader social developments, such as changing gender roles, divorce, the breakdown of community, and rising cultural pluralism, that have put organized religion at risk of losing members and support.[26] Each of these developments, it will be recalled, has had negative implications for organized religion: changing gender roles, because women who participate fully in the labor force are less likely to participate in religious organizations than women who do not participate; divorce, because divorced people do not participate in religious organizations as often as married people do; the breakdown of community, because people who move frequently and who do not know their neighbors are less involved in religious organizations than those who are more integrated into their communities; and cultural pluralism, because exposure to pluralism through higher education erodes literalistic religious beliefs that undergird more active involvement in churches. Looking again at these developments, but keeping in mind that interest in the arts appears to have increased and to be favorably related to spirituality, helps to explain why religious vitality has remained relatively strong despite these trends. The arts are also influenced by these developments. But, whereas religion is negatively affected, other things being equal, the arts have either been positively affected or unaffected. We must consider each of these developments carefully.

The contrast between the ways in which religious involvement and

artistic involvement have been affected by women's inclusion in the labor force is instructive. Women are more likely to be involved in artistic activities than men (just as they are in religious activities). At the high end of the Artistic Interest Scale, for example, 62 percent are women, whereas at the low end 75 percent are men. Much of this difference appears to result from the activities in which girls and boys are involved. Thus, 58 percent of women sang in a choir at school, compared to only 33 percent of men. Similarly, 53 percent of women remember keeping a diary or writing poetry, whereas only 22 percent of men do. As women have become more fully integrated into the labor force, their involvement in religious organizations appears to have diminished, other things being equal, but their involvement in the arts has not diminished. In fact, it may have increased, judging from the fact that 44 percent of women keeping house score high on artistic involvement, compared with 48 percent of those working part-time and 55 percent of those working fifty or more hours a week.

The connection between the rising divorce rate and the arts is indirect. Whereas the rising divorce rate appears to have had negative implications for religion, other things being equal, the same does not appear to be the case for artistic involvement. There is no evidence that people who get divorced or separated are more likely to be interested in the arts than people who stay married (and none that childhood arts participation is associated with divorce as an adult). But there is considerable evidence that divorce raises the chances of having to work through painful emotional experiences, and these experiences are in turn associated with greater interest in the arts. For instance, people who are currently divorced or who were divorced and remarried are significantly more likely than married people who have never been divorced to say they have had to move past something painful from their upbringing; they are also more likely to report having faced conflicts at work, addictions, and having to forgive themselves and others.[27] Each of these issues raises the odds of a person scoring at the high end of the Artistic Interest Scale. For example, 49 percent of those who have had to move past something from their upbringing score high, compared with 29 percent of those who have not had to move past something.[28] Thus, the rising divorce rate has been, as it were, a friendlier development for the arts than it has been for religion.

The reason for this relationship between working through personal issues and being interested in artistic activities is probably evident from responses to other questions in the survey. Nationally, 76 percent of the

public agree that "art and music do a good job of expressing the pain that many people experience in their personal lives." Among those who say they have experienced illness, loneliness, or grief, 70 percent report that music was helpful during this time, and 77 percent say this about activities such as sewing, woodworking, or painting.[29]

Artistic interests are also related to an experience many Americans have: feeling cut off from their neighbors. The connection is not that people without friends retreat into the arts. Most people with interests in the arts claim to have friends who share these interests. People who know few or none of their neighbors are no more likely to score high on artistic interests than those who know most of their neighbors. Nor does the likelihood of having artistic interests differ much for people who prefer to be alone compared to those who are energized by being around others.[30] The connection is rather that *perceiving* problems in social life is related to artistic interests. Those who *think* the breakdown of community is an extremely serious problem, for instance, are more likely to score high on artistic interests than those who do not feel this way.[31]

This perception that all is not well appears to be increasing, at least when surveys measuring trust in others and confidence in institutions are considered.[32] It is evident, too, in the large proportion of Americans who believe that selfishness and materialism have become serious social problems.[33] In personal interviews people talk about these problems as evidence of living in a shallow, consumerist culture in which deeper values no longer matter. As one man observed, "Everybody seems to feel they deserve a bigger piece of the pie, and basically, in our society, that seems to be the measure of success. It's how much money you have. That attitude is an extreme detriment to our society." For some people, the arts apparently are perceived as an antidote or at least as an escape from this cultural veneer. Reflecting on a painting or writing poetry can be a way to get in touch with deeper values.

The other development mentioned earlier is the uncertainty about religious beliefs that appears to increase with rising levels of higher education. This uncertainty is related to greater exposure to other world religions among the better educated and is sometimes expressed in an emphasis on religious experience at the expense of doctrine. But when asked to choose between the two, people with higher levels of education are more likely than those with lower levels to opt for *both*. They are also more likely to reject the idea that people should relate to God simply by emptying their minds.[34] Artistic interests fit well with these

developments. Although artistic interests are positively related to having transcendent experiences, they are fairly neutral with respect to various positions on doctrine and theology, such as views of Jesus and the Bible. In other words, artistic interests appear to be compatible with cultural pluralism, partly because artistic interests go along with an emphasis on personal experience (one way of adapting to pluralism), and partly because artistic interests *do not* seem to be incompatible with holding to more traditional religious beliefs. Overall, artistic interests are also more pronounced among those with higher levels of education than among those with less education.

The relationships between these social developments and the arts, then, suggest that artistic interests are likely to be encouraged by some of them and at least not discouraged by others. Working women remain actively interested in the arts, as do people experiencing broken relationships and other personal traumas. Artistic activities provide ways to express pain and reflect on values that deviate from the veneer of a materialistic culture. These activities can be pursued by people who are relatively isolated as well as by those who are fully integrated into their communities. And they offer experiential ways of knowing without necessitating a retreat from the counsel of religious teachings.

Making the Connections

We can now pull together the evidence that has been examined in this and the preceding chapters and summarize what we have learned about the relationships among religious vitality, spirituality, and the arts. The evidence considered thus far suggests that the arts *may be* a source of vitality for the nation's religious institutions. The persistence of Americans' commitment to organized religion over the past few decades has been striking, especially since major social trends have been working against this commitment. The proportion of women in the labor force, the divorce rate, the sense of isolation from neighbors, and uncertainties about religious beliefs have all risen in recent decades, and each of these conditions is negatively associated with religious participation. The fact that religious involvement has remained steady, therefore, suggests that some other cultural developments with positive influences on religious participation are at work.

Although fundamentalism or other forms of religious conservatism may be partly responsible for the persistence of religious involvement,

they have not been pervasive enough to effect revitalization in many segments of American religion. A more likely candidate is the public's growing interest in spirituality. Much of this interest is, as critics point out, superficial; it consists of casual shopping for effortless gratification and too infrequently draws people into a religious community or encourages them to serve others. Yet there is a minority, perhaps including as much as a quarter of the public, who appear quite serious about their efforts to grow spiritually. These people spend time regularly praying, meditating, and in other ways working to improve their spiritual lives; they report feeling the presence of God in their lives; they take part in service activities; and they are deeply involved in their congregations. They are in fact the main source of grassroots vitality in the nation's churches and synagogues. As their interest in spirituality has increased, so has their interest and involvement in organized religion.

This rising interest in spirituality is in turn driven by developments in the wider culture. Paradoxically, one of these developments has been the public's growing exposure to the arts. Because of elementary and secondary school programs, the large number of young people who go to college, the mass media and entertainment industries, the entrepreneurial efforts of arts organizations themselves, and a relatively affluent middle class, artistic interests and participation have become considerably more widespread over the past half century. Although these developments were often feared by religious leaders as a potential threat to religious participation, they appear to be having quite different consequences. People with greater exposure to artistic activities are *more* likely than those with less exposure to be seriously committed to spiritual growth.

The reasons that artistic interests are conducive to an interest in spiritual growth have to do with the distinctive ways in which spirituality is currently understood and experienced. Were it viewed primarily as a theological enterprise requiring instruction from clergy or as a means of escaping eternal punishment through good works and affirming doctrinal statements, spirituality might well be unreceptive to influences from the arts. At present, however, serious pursuit of spiritual growth has come largely to mean engaging in devotional activities that encourage a reflective orientation to life, drawing on resources in one's religious upbringing that give a kind of ambiance to one's spiritual reflections, adhering to a religious tradition that is held with a certain degree of openness toward other traditions, engaging in some deeds of kindness toward others, and especially cherishing experiences in which one feels

close to God. The ways in which large numbers of Americans participate in the arts are compatible with these understandings of spirituality. Artistic activities provide quiet times in which to meditate and they are conducive to prayer and self-reflection. They have often been mixed with the religious experiences of one's upbringing through music programs at church or school and through the religious artifacts in one's home. The arts are relatively open to religious and cultural diversity and yet in the public's mind are not incompatible with other approaches to knowledge. The arts also serve as a common means of encouraging and expressing experiences of transcendence.

These connections between the arts and spirituality are particularly important in view of the social developments that hold potentially negative consequences for the strength of American religion. Women have been and remain more actively involved in artistic activities than men, and as women have moved into the labor force these interests have remained strong and gained more widespread legitimacy. Divorce and other painful experiences in interpersonal relationships have encouraged large numbers of Americans to seek artistic activities as ways of expressing pain and engaging in recovery. The anonymity of community life has heightened interest in artistic activities that point beyond the materialism and selfishness of ordinary experience. And rising levels of education have encouraged greater awareness of the possibilities of multiple ways of knowing, including the arts.

The implication for religious organizations is that the arts hold potential as a source of religious revitalization, at least insofar as artistic activities help to nurture interest in spiritual growth. This potential is evident in the fact that people with greater involvement in artistic activities are also more likely than those with less involvement to say that their interest in religion has been increasing, to attend religious services regularly, and to say that these services are important to their spiritual growth. These differences are not a function of other factors (such as age, sex, or education), but they are a function of whether artistic activities lead people to be interested in spiritual growth and whether this interest encourages them to take part in congregations.[35]

For artistic interests to benefit the nation's churches and synagogues, then, religious organizations must channel these interests in ways that encourage serious commitment to spiritual growth and, in turn, involvement in congregations. Some of this channeling occurs privately or through the work of arts organizations. But the lion's share has to be done through congregations, small groups, retreat centers, publishing

efforts, and other vehicles by which the public comes into contact with organized religion. Many such efforts are in fact under way. They range from contemporary worship services and liturgical renewal efforts in congregations, to small-group ministries and spiritual direction programs, to artistic initiatives aimed at encouraging the religious imagination, to cooperative ventures between community arts organizations and churches. Considering these efforts will provide insight into the many ways in which music and art are helping to revitalize American religion.

Personal Spirituality

Art and the Practice of Spiritual Discipline

Sandra Lommasson is a tall, brown-eyed brunette with delicate features and a warm smile. She lives in Davis, California. When Sandra got married, the minister officiating at the wedding urged her and her husband to join the church. Sandra had attended another church as a child but hadn't participated since fifth grade. At nineteen, she had other things on her mind. Falling in love and planning her wedding had been a huge preoccupation. Getting her feet on the ground as a college freshman was another. She was also passionate about the Vietnam War. It challenged Sandra to think about what she truly valued in life and how she could make a positive difference in the world. She decided to major in elementary education and become a teacher.

During college, Sandra studied hard and found opportunities to tutor children from low-income families. Her interests in social justice were sparked by the discussions that swirled around campus after the assassination of Dr. Martin Luther King, Jr. Sandra followed her husband to California when she graduated, and soon found a job teaching at a preschool for Hispanic children. She loved the job, but she eventually became a political liability to the program because she was not Hispanic herself. Budget cutbacks in California made it impossible to find a job in the public schools. In desperation, she applied for a job at a cooperative nursery school run by a church. Although the pay was meager, she was able to continue working with children. She was also able to take a leave of absence when her daughter was born and then another leave three years later when her son was born.

Shortly after her son was born, Sandra's life took an unexpected and

terrifying turn. She remembers lying in bed one night, the baby in his crib nearby and her daughter down the hall. Her husband was away on business. Suddenly Sandra sensed that someone was in the room. When she opened her eyes, she saw a man standing over her with a knife. He muffled her scream and then brutally raped her. After he fled, Sandra staggered out the back door and managed to make it to the neighbor's before she passed out.

In the ensuing months, Sandra realized that her assumptions about life had been shaken to the core. She not only had to rethink them; she needed to rediscover who she was—bodily, spiritually, emotionally, and mentally. Memories started to return. She remembered an abusive childhood that had caused her to be fearful and to retreat within herself. As she recounted some of these feelings in her daily journal, she recalled other times when some power outside her seemed to draw her into itself. Memories of sitting in the porch swing on summer evenings came back. She remembered how she would sit watching the sun go down, elated by its beauty and feeling that the universe must be inscribed with goodness.

These memories drew her thoughts increasingly toward God. She somehow associated that goodness in the universe with God. Yet it was a different God than the one she had learned about at church and in Sunday school. The nuns had taught her about sins—mortal ones and venal ones—and the priest had explained one time that it would be a terrible sin ever to venture into a Protestant church. Theirs was a God of structure and rules and fear, not one of goodness. Hers, in contrast, was "harder to describe." Looking into the twilight sky as a child, she knew only "the hugeness of some power that was a loving, creative power. I'd be pulled out of myself into it and become a part of it."

Sandra had gone to church through fifth grade mostly because her parents had vowed to raise their children in the church. When the Methodist minister who performed her wedding suggested she come to church, she said it didn't interest her. And when the Presbyterian church that ran the nursery school hired her, she made it clear that she was not a church person and wanted nothing to do with the church. The only time that childhood yearning for God had reawakened was when her daughter was born. Sandra was filled with awe at the preciousness of life. She wanted to rejoice and give thanks. But the moment passed.

Now, in her despair, she started to seek God in a new way. She started to pray, not by reciting the formulaic prayers she had learned as a child,

but simply asking, "God, are you there? If you're there, help." She began reading the Bible—not the epistles or prophecies, not even the sayings of Jesus, but the Psalms. Reading them at night was the only way she could get to sleep. She found comfort in the psalmist's laments.

"The door to God had been cracked," she remembers, "and I had been cracked. I found myself in God's mercy. Not that God sent the trouble or made it happen. But God was there in power when it did. I found myself wanting life, wanting to bring some life out of me, wanting to bring some healing out. That really was my entry into a spiritual journey." As she explored, she gradually realized that she "had to know about Jesus, had to know about Christ. Earlier in my life I had professed belief, but it didn't touch me. It was a head belief. Now it began to become alive."

At an Al-Anon meeting, Sandra found people like herself. She went because her husband was drinking and because a friend had said it was a place where people who needed healing could recover. She found others whose lives had been shattered. "It's life or death for these folks. They grab the hand of God and go with it. They are utter rock bottom. They know their own powerlessness. That's what I had encountered. I came to know it in a way that was just absolutely unmistakable." Hearing people talk at these meetings about their fears and their personal problems gave Sandra a valuable insight about herself. "I was used to comparing my *insides* with other people's *outsides*." She says she always tried to hide inside herself because other people seemed so much more "together" than she was. Once she saw people at Al-Anon "cracking open the doors of their lives," she realized she could too.

It took Sandra ten full years to regain some sense of who she was and of what she could be. During this period her relationship with her husband steadily worsened, and eventually they decided to divorce. She started reading to learn more about spirituality, and she continued to pray. "I was under no illusion about being able to find security," she explains. "There really is no safe place in the world. That illusion was gone." But she gradually realized that she could find "a safe connection with God and with God in other people."

Today, Sandra runs a program called Bread of Life, sponsored by the Presbyterian church where her nursery school was located. It is for people like herself whose lives have been broken. Some come to her for counseling, others for spiritual guidance. She offers group sessions and classes as well. Her master's degree in education was good preparation, as was the pain of having to work through her own personal crises. She

also trained for five years, first receiving a master's degree in spiritual formation at a nearby seminary and then spending three years working with a Catholic sister who did spiritual direction and taught her students to do the same.

In the process, Sandra has rediscovered the value of art. When she was growing up, she did what many middle-class youngsters do: she took lessons. These lessons included ballet. She never excelled, but she stayed with it until she was in eighth grade. After that, her body seemed to balk at the very suggestion of balancing on her toes. She also dabbled in writing, sometimes keeping a journal and sometimes writing poetry that expressed what she was feeling inside. Throughout college and her years as a teacher, these interests largely had lain dormant. But as her sense of spirituality awakened, they too came alive.

Of her newfound interest in writing, Sandra says, "I had to write. When I cracked open, the voice that had been submerged, that had been hidden, had to come out. It *had to* come out. It's like I write myself into existence." She pauses, then corrects herself, explaining that the writing is more from God than from her. "I am written into existence." This insight is why she encourages the men and women who come to Bread of Life to keep a journal. She offers a writers' workshop for those who want to go further. Drawing and dance are important parts of the program as well: "I have crayons and paper over there on my shelf. When I work with somebody, we're as likely to pick up those as we are to work with words. We also have what we call biospirituality or embodied spirituality. It has to do with movement, dance, physical expression. We are so limited in this culture. So much of our activity is from the chin up. For people to really experience the incarnate Christ, it's got to be embodied."

Through it all, *prayer* has become a vital part of Sandra Lommasson's life. Her half-formulated pleas for God's help are still important because she continually needs God's assistance. Sometimes she prays longer prayers, using words from the Bible or words that have come to her when she writes poetry. But she increasingly is convinced that prayer involves her whole being and thus must include more than words. "My prayer often is dancing. Just when I'm by myself. It may be with music or it may be without, but some things can't be expressed in words. Or my prayer is silence, deep silence, and something emerges out of that silence that is a kernel of whatever it is that God's moving in me. It takes flesh sometimes in words, sometimes in art."

Rediscovering Prayer

Sandra Lommasson is one of the millions of Americans who have been rediscovering the power of prayer in recent years—and in doing so, finding that music and the arts are playing an important role in their devotional lives. I say "rediscovering" because most adults have been exposed to prayer at some point during childhood. In Sandra's case, this exposure took the form of seeing people pray during mass at the Catholic church she attended: "It was the visual word. It was the ambiance of people praying. I would look at the little old ladies on either side of me and I'd see their lips moving. I'd see the rosary beads going, and there was something that they connected to. It wasn't something that I felt at that point, but I knew that there was something to feel, and I knew that they did and they connected. The lights, the candles. It was very, very powerful. It was very visceral. It was very much in my body, and it wouldn't ever let me go. So even when I left [church] at the ripe old age of ten or eleven, there was that hunger that just wouldn't die."

This emphasis on the "ambiance" of prayer comes up again and again in people's memories of how they first learned about prayer. A Baptist in her forties says she prayed as a child looking at a picture of Jesus that hung on her bedroom wall. A Catholic in her fifties remembers the "stitchery" pieces her mother made and hung on the walls as visible reminders for her children to pray. "They were blessings," she says. An Episcopalian in his fifties also associates his childhood prayers with a painting: "There was a picture in our hallway of an old man in a suit and tie. He was sort of like an icon. I had the feeling that he was sort of the holder of the higher values."

Other people associate hymns, stories, and special places with their childhood prayers. A woman in her thirties who grew up in an independent evangelical church says her family always sang a hymn together before they prayed. An elderly Methodist recalls his parents praying and reading stories about Bible characters and missionaries for what seemed like "two hours" every night. "I always wanted more," he says. "Those were my heroes." A Nazarene in his sixties remembers a "primitive prayer altar" at a summer camp he attended as a boy; it was where he "found Jesus." A lifelong Presbyterian in her mid-forties still associates prayer with the savory aroma of her mother's cooking. When she was a child, the whole family sat down together and repeated, "For all these gifts, O Lord, make us truly thankful," before digging into the evening meal.[1]

Most of the research on prayer has overlooked the importance of am-

biance. Focusing instead on the idea that prayer is simply talking to God, researchers have examined the verbal content of prayer. For instance, in their book *Varieties of Prayer* Margaret Poloma and George Gallup report that 96 percent of Americans thank God for blessings when they pray, 91 percent ask God for forgiveness, 90 percent ask God for guidance in making decisions, and 42 percent ask God for material things.[2]

Of course, the verbal content of prayer *is* important. In personal interviews, people often describe their prayer lives in terms of what they *say* to God. A devout Roman Catholic says she just talks to God as she would to herself: "Oh, God, I don't know what I'm going to do or say when I meet Margaret this afternoon for this meeting. I really want to tell her off. I think she's a total jerk. She's really destroying [things], and yet I know that you want me to be kind. I know that you want me to be fair, and I know that you want me to do the right thing in this instance. How do I balance all of that?" A man in his early thirties (also a Catholic) says, "I just thank God for my life, the good things that are going on, even some of the bad things that have been going on that have come to resolution. I thank God for the opportunity, I guess, for faith, for the strength to keep going, stuff like that. Basically I just thank him for what's going on in my life." A Lutheran in her eighties recites a prayer of thanksgiving every morning: "I have lived through the night. The Lord be with me and my family. Bring us home again safely this evening. May this day be a blessed, rewarding, fulfilling day for all of us, not just me but for all my family."

But many Americans are like Sandra Lommasson: even for adults, prayer has a visceral dimension that requires them to do more than simply verbalize their petitions to God. A Methodist in his early sixties who has been praying more fervently in the last ten years than ever before says he often puts classical music on his CD player before he starts to pray: "When I listen to that music, it takes me to a space that's very open, very open and spacious. I feel very free in those places. I think, for me, when I move to those places and I am open, that it really is a place where God can enter into me and enter into that experience. I think also, when we're at those places, something evil can enter into there as well, and so we need to say, 'Is this of God or is this not of God? How do we check this out?'"

An Episcopalian in her fifties whose children have grown up and left home has used the extra space in her house to create an altar with several icons and a candle. She says she prays more creatively there than in

other places. She often writes her prayer for the day, sometimes as a poem, rather than reading one from the prayer book. A young woman who combines her Protestant upbringing with spirituality from other world religions says she sometimes prays by singing a chant that includes ancient names for God. This woman also prays by trying to sense God's spirit in nature: "I've started trying to make time in my day where I try to sense God. Maybe it's focusing on a tree. Recently I've just felt it in colors. I feel sort of the greatness or the oneness or the isness. I feel it in different colors, depending on what's happening. I'm cultivating a deeper curiosity in God as the great mystery, and being comfortable with the mystery and even loving it."

Nationally, 50 percent of Americans say they pray every day. Another 11 percent say they pray nearly every day, and 9 percent claim to pray about once a week. Thirteen percent pray at least several times a year but less than once a week. Only 15 percent say they never pray or hardly ever pray. Prayer is thus one of the more common forms of religious expression in our society: 70 percent of the public pray at least once a week, compared to fewer than half that number who attend religious services this often.

Survey responses like these merit a certain degree of caution. Like reports of going to church, the percentages are probably inflated, especially if people think they ought to pray more often than they actually do. In fact, personal interviews turn up a fair number of people who acknowledge that their prayer lives are pretty casual: they mutter a perfunctory prayer at meals, sigh a note of gratitude when they wake up, or repeat a prayer with their children while putting them to bed. A Methodist in her twenties equates praying with simply thinking about someone: "I just hold them in my heart and I just send them some good energy and just hope that they're well." Another woman chuckles, "Prayer is like dieting. I usually start faithfully each year in January, and by February I've started slacking off."

But prayer, when it does happen, is a vital aspect of a person's efforts to reach out to God and to grow in his or her faith. Indeed, prayer is one of the best predictors of other ways in which Americans participate in religious activities or pursue spiritual interests (table 13). Among those who pray every day, more than half (52 percent) attend church every week, whereas this proportion falls considerably (to 30 percent) among those who pray almost every day, and declines to only 2 percent among those who pray several times a month. How often a person prays is also a good indication of whether that person's interest in spirituality

TABLE 13. Other Aspects of Spirituality Are More Common
among People Who Pray Frequently

*(Percentage of people in each category of prayer frequency who have each of the other
characteristics listed)*

	Frequency of Prayer				
	Daily	*Almost Daily*	*Weekly*	*Monthly*	*Hardly Ever*
Attend church every week	52%	30%	14%	2%	5%
Increasing interest in spirituality	60	35	30	20	16
Spiritual growth is extremely important	43	15	12	10	6
Devote a great deal of effort to spiritual life	40	10	5	2	4
Read Bible nearly every day	40	12	3	1	1
Meditate nearly every day	54	40	13	6	12
Learning to forgive self	52	50	44	40	30
Learning to forgive others	62	58	50	54	46
NUMBER	(825)	(167)	(131)	(102)	(274)

is increasing: 60 percent of those who pray every day say their interest is increasing, compared to only 16 percent of those who hardly ever pray. If fact, the more often a person prays, the more likely that person is to express interest or involvement in virtually every other kind of spiritual activity: saying that spiritual growth is important, saying that they have devoted a great deal of effort to spiritual growth in the past year, reading the Bible, meditating, and saying that they have tried to learn how to forgive themselves and others. In short, prayer *actually* seems to be a mark of how seriously people take their spiritual life, just as religious leaders have always argued it should be.

If prayer is widespread and closely related to other forms of spiritual activity, it is by no means as common in some segments of the population as it is in others (table 14). In particular, younger people are much less likely to pray than older people: slightly more than a third of Americans between the ages of eighteen and twenty-nine pray every day, whereas two-thirds of those age fifty and older pray this often. Of course younger people may eventually start praying in larger numbers as they mature, especially if prayer is sparked by aging, illness, and the fear of impending death. But there is also reason to think that younger people may not be learning as much about prayer from their parents or by attending church as they did in the past, and, if so, that other forces

TABLE 14. Frequent Prayer Is More Common among Certain Groups Than Others and among Those Who Score Higher on the Artistic Interest Scale

(Percentage in each category listed who say they pray every day)

Age 18–29	38%
Age 30–49	49
Age 50 and over	67
Grade school	60
High school	52
Some college	54
College graduate	54
Male	44
Female	63
Black	59
White	54
Church member	80
Nonmember	42
Evangelical or fundamentalist	79
Mainline or liberal Protestant	52
Roman Catholic	49
Artistic Interest Scale:	
0 (Low)	30
1	45
2	55
3	55
4	59
5 (High)	62

may need to be discovered in order to find ways to encourage younger people to pray. Education, it appears, is unlikely to be one of these forces. In fact, people with high school diplomas and people with even some college training are less likely to pray regularly than those who have attended only grade school. Gender differences remain (in virtually all studies, women are more likely to pray regularly than men), despite the fact that gender roles have been changing. So these changes may not be dampening interest in prayer, but perhaps are not promoting it either. Not surprisingly, church members are much more likely to pray than nonmembers, and among church members, evangelical Protestants are more likely to pray than either mainline Protestants or Roman Catholics.[3] What is perhaps most intriguing is that those with

TABLE 15. Many People Include Artistic Activities When They Pray
(Among those who pray at least several times a year, the percentages who ever do each activity while praying)

Listen to music or sing	43%
Read the Bible	40
Read a devotional guide	32
Look at a sacred object, such as a cross or a painting	23
Read poetry or literature	20
Light candles	19
Any music, poetry, or objects	56
NUMBER	(1,225)

artistic interests are significantly more likely to pray than those without artistic interests. In fact, more than six in ten of those at the high end of the Artistic Interest Scale pray every day, whereas this proportion drops to only three in ten of those at the low end of the scale.[4]

Why might there be a positive relationship between artistic interest and prayer? One possible reason is that many people, like Sandra Lommasson, include some form of artistic expression as *part of* their prayer time (table 15). In fact, among those who pray at least several times a year, *more than half* (56 percent) say they include listening to music or singing, looking at an object (such as a cross or a painting), or reading poetry or literature when they pray. The most common of these (mentioned by 43 percent) is listening to music or singing. This is even more common than reading the Bible (mentioned by 40 percent). About a third (32 percent) read a devotional guide. At least one person in five looks at a sacred object while praying. The same proportion reads poetry or literature. And almost one in five mentions lighting candles while praying. In short, *ambiance* is important, and for many people, something artistic helps to create this ambiance.

One person for whom the arts play an important role is Laurie Sagona, an actor in New York City who faithfully attends a Roman Catholic church. Having grown up saying the rosary and feeling especially prayerful when she looks at the Virgin Mary in the stained-glass window at church, she has recently been discovering the value of music as she prays privately in her apartment each evening. "I listen to some music. It's very peaceful. I like that to calm me down. The [music] lets me sit and stop the madness, the insanity, the constant thinking."

A woman in Pennsylvania describes the effect of music in similar terms. "I feel that the Holy Spirit can work within me. It releases my

daily worries about the rent, the dinner, the laundry. I just am able to let that go and really be in the present and just be totally here." She describes how she prays each morning: "I put on music. I select a reading for the day. I sit down and I do some deep breathing. Sometimes, if my mind is very agitated, I'll journal a little bit. I usually do a reading, and I might or might not write a little bit after that. Then I do more deep breathing, and then I just meditate. Of course, the music is on at that time." She says this process releases her energy and helps her to offer her concerns to God.

Like these two women, most of the people we talked to who included music or art in their devotional times had started doing so on their own. A few, however, had learned to do so by taking classes. For instance, one woman has been taking classes in "spiritual focusing" that involve deep breathing, looking at icons, and creating images inside herself that symbolize her concerns. She then cleanses herself by mentally erasing these images. At that point, she is better able to listen to God's leading.

An older man in California has also studied icons and their relationship to prayer. He says icons, like music, help to get him "out of my head." This is especially important to him because he thinks the essence of prayer is transcending oneself. Usually he looks at an icon that depicts Christ. But he also has a small fountain in the room where he prays, and behind the fountain is a picture of a Japanese house in a forest. Sometimes he imagines himself entering this house as he prays: "It's an interesting house. It's got a place to sit under the eaves all the way around the house. On a rainy day you can go out there and watch the raindrops coming down. So one time I imagined myself going into the house and I knelt back on my haunches. There was in front of me a book, and the book was closed. 'Don't open the book.' Interesting message, yeah? 'Be there. Be in the presence. Don't open the book.' It meant don't use your head so much."[5]

It is interesting to consider which kinds of people are most likely to include music, poetry, or artistic objects when they pray (table 16). Judging from the survey, younger people (who pray at all) are just as likely to do this as older people (who pray at all). In other words, the age differences that are evident in sheer frequency of prayer disappear, suggesting perhaps that artistic activities may be a way of encouraging younger people to pray. The educational differences observed in frequency of prayer are now reversed: better-educated people are somewhat *more* likely to include artistic activities in prayer than are those

TABLE 16. People Who Are More Interested in Spirituality and Those Who Score High on the Artistic Interest Scale Are More Likely to Include Music and Art When They Pray

(Among those who pray, the percentage in each category who include music, poetry, or objects when they pray)

Age 18–29	55%
Age 30–49	55
Age 50 and over	57
Grade school	52
High school	52
Some college	60
College graduate	58
Male	53
Female	58
Evangelical or fundamentalist	57
Mainline or liberal Protestant	53
Roman Catholic	60
Pray every day	60
Pray less often	48
Meditate nearly every day	72
Meditate less often	45
Spiritual growth is:	
Extremely important	67
Very important	60
Fairly important	48
Not very important	35
Had favorite hymns as child	64
Did not have favorite hymns	47
Had religious object/painting	69
Did not have religious object	48
Artistic Interest Scale:	
0 (Low)	40
1	48
2	52
3	55
4	58
5 (High)	71

with lower levels of education. Women are somewhat more likely to include them than men, but these differences are statistically insignificant. Differences among evangelical Protestants, mainline Protestants, and Catholics are also statistically insignificant. Not surprisingly, those who pray more often are more likely to include artistic activities when they pray. But the differences are even stronger between those who meditate often and those who do not; in other words, artistic activities seem to go hand in hand with what has been termed "meditative prayer." The Artistic Interest Scale is a strong predictor of how likely people are to include artistic activities when they pray, too. Moreover, there is some evidence that how one was reared affects one's disposition to include the arts in prayer: those who had favorite hymns, plaques, or sacred paintings while growing up are significantly more likely to include the arts while praying than those who did not.

On balance, these results suggest that the arts play a role in the prayer life of a wide cross-section of the American public: younger and older people, men and women, people with various levels of education, and those from different confessional traditions. Including the arts among one's devotional activities appears to be rooted in the childhood religious training that has encouraged many Americans to see a connection between spirituality, art, and music. It is reinforced by the more general interest in artistic activities that has been growing in American culture as well.

We might also ask, what difference does it make if people include music and art in their devotional lives? Does their presence mean that people are just listening to music or reading poems, rather than truly praying? Or do music and art help to create an atmosphere conducive to prayer? The survey sheds some light on these questions (table 17). Those who include music, poetry, or paintings while they pray are *more likely* than those who do not include these artistic expressions to say they like to spend time reflecting on their life, to say they have lost track of time while praying, to say they have felt close to God while listening to music or viewing a painting, and to say they have felt close to God while reading poetry. In other words, the inclusion of artistic activities in one's prayer life seems to go along with enjoying it more and being more likely to experience the presence of God in at least some situations.[6]

The man who listens to classical music while he prays in order to put himself in an "open space" illustrates these broader connections. He was not trained in music or the arts, but his devotional life has made

TABLE 17. Including Music and Art in Prayer Is Associated with Other Aspects of Religious Experience

(Among those who do or do not include music and art in prayer, the percentages who respond to each item as indicated)

	Include	Do Not Include
Like to spend time reflecting on life	48%	34%
Have lost track of time while praying	43	24
Have felt close to God listening to music	58	37
Have felt close to God viewing a painting	31	17
Have felt close to God reading poetry	20	7
Have felt close to God when viewing work of art	42	24
NUMBER	(686)	(539)

TABLE 18. Including Music and Art in Prayer Is Associated with Attitudes about Art and Spirituality

(Among those who do or do not include music and art in prayer, the percentages who respond to each item as indicated)

	Include	Do Not Include
Art can help deepen spirituality	62%	50%
Art helps experience deeper purpose in life	40	24
A beautiful painting is pleasing to God	51	30
Music has been very important in spiritual life	40	18
Want congregation to sponsor class on prayer	44	26
Interested in spiritual direction	46	24
NUMBER	(686)	(539)

him more aware of God's presence in works of art. He says: "I think the arts are a really valuable tool. I wish I knew more about how to access that for myself. For example, *The Lion King* is absolutely full of spiritual movement, of characters that move towards God or away from God. The story line is really about a religious experience, about looking up at the stars and having this sense of God. The arts help us do that. They help us get in touch with what you believe cognitively, but also with that movement inside yourself."

There are other differences between those who include artistic activities in their prayer time and those who do not (table 18). People who include artistic activities in their devotional lives are more confident than those who don't that art has a significant connection with spiritu-

ality: they agree that art can help deepen one's spiritual life, that art helps one to experience deeper meaning and purpose in life, that a beautiful painting is pleasing to God, and that music has been very important in their own spiritual lives. While it is difficult to know which comes first, this relationship suggests that devotional life may be one of the ways in which people come to a greater appreciation of how the arts can contribute to their spiritual growth. The data also suggest that including music and art in one's devotional life may encourage one to attach greater importance to devotional activities in general: at least those who have included music and art are more likely than those who haven't to say they would like their congregations to sponsor a class on prayer and to say they are interested in learning more about spiritual direction.

Spiritual Direction

Sandra Lommasson's Bread of Life program in Davis, California, is one of hundreds of such programs that have been initiated in the past few decades to provide spiritual guidance for people seeking to deepen their relationship with God. Many of these programs have been modeled on the Shalem Institute, an ecumenical organization in suburban Washington, D.C., that was founded in 1974 as a place for lay leaders and clergy to receive training in prayer and meditation. Programs such as Shalem and Bread of Life, while including insights from Buddhism and other world religions, generally draw most heavily from the contemplative traditions of early and medieval Christianity, traditions that have been actively reinvigorated in monastic communities and retreat centers. In recent years, spiritual direction has increasingly proven attractive in Protestant circles as well, through the auspices of local programs sponsored by churches, such as Bread of Life, and through seminaries, such as Fuller Seminary in Pasadena, California.

Although it is practiced differently in these various settings, *spiritual direction* refers to a mentoring process in which the directee meets regularly over a period of months or years with a spiritual director who has received extensive training in prayer and meditation and has sought to deepen his or her own experience of the personal presence of God. Spiritual direction includes self-examination, often through keeping a journal of one's thoughts and aspirations as well as discussing one's life with the spiritual director; reading or attending classes about the Christian tradition and its teachings concerning the virtues of Christian life and

service; learning disciplines designed to encourage regular participation in prayer and meditation, including cleansing and focusing one's thoughts; and, often, participating in group events that provide support and encouragement. Most forms of Christian spiritual direction involve an approach called contemplative prayer, developed by Ignatius of Loyola in the sixteenth century. Acknowledging that God is always present, the person engaged in contemplative prayer seeks to be intentional about his or her own awareness of God's presence.

Spiritual direction's popularity has grown in recent years through word of mouth, as satisfied participants invite friends to take part in programs and retreats, and through announcements in church newsletters, mailings put out by institutes and centers, advertisements in holistic health magazines, notices in religious periodicals, and feature stories on television. Nationally, 30 percent of the public claim to be very interested in "learning more about spiritual direction," and another 32 percent say they are fairly interested.

It is doubtful that everyone giving these responses in the survey is sufficiently knowledgeable about spiritual direction to avoid sometimes confusing it with other forms of spiritual guidance or spiritual growth. However, the profile of persons expressing serious interest in spiritual direction conforms largely to the impressions one receives from attending programs and talking with spiritual directors (table 19). People of all ages appear to be interested in spiritual direction in about equal proportions, a fact that is notable since churchgoing, prayer, and many other forms of religious participation draw more heavily from older, rather than younger, segments of the population. Women are more likely than men to express interest in spiritual direction, but interest cuts across all levels of education. Church members are considerably more likely to be interested than nonmembers; indeed, the fact that more than four church members in ten express serious interest in learning about spiritual direction suggests that there is a huge opportunity for churches to do more in attempting to fulfill this interest.

The survey shows that people who pray and meditate regularly, who consider it important to growth in their spiritual lives, and who devote effort to spiritual growth are the most likely to express interest in spiritual direction. The data also suggest that interest in *the arts* is one of the factors currently reinforcing interest in spiritual direction. Thus, among those at the high end of the Artistic Interest Scale, nearly half say they are very interested in learning about spiritual direction, whereas at the low end of the Artistic Interest Scale, only one in eight says they are interested in spiritual direction.

TABLE 19. People Who Are More Interested in Spirituality and Those Who Score High on the Artistic Interest Scale Are More Likely to Be Interested in Learning about Spiritual Direction

(Percentage in each category shown who say they are very interested in learning more about spiritual direction)

Age 18–29	31%
Age 30–49	32
Age 50 and over	33
Grade school	33
High school	31
Some college	35
College graduate	30
Male	27
Female	37
Church member	41
Nonmember	18
Pray every day	46
Pray less often	16
Meditate nearly every day	50
Meditate less often	22
Spiritual growth is:	
Extremely important	65
Very important	35
Fairly important	11
Not very important	8
Spiritual effort:	
Great deal	66
Fair amount	33
A little	16
None	5
Artistic Interest Scale:	
0 (Low)	13
1	21
2	31
3	32
4	40
5 (High)	44

The relationship between artistic interests and spiritual direction is not coincidental. Spiritual direction is usually understood as a matter of the heart, rather than one strictly of the mind. Directees are encouraged to clear their minds of intrusive thoughts that prevent them from experiencing the presence of God in their lives. Breathing techniques are often part of the cleansing process. The body's connection with mind, heart, and soul is usually emphasized. Art, music, poetry, and participation in the arts through pottery, weaving, chanting, or creative writing are often included in the programs of centers concerned with spiritual direction.

Pendle Hill is a Quaker center for study and contemplation in Wallingford, Pennsylvania. Founded in 1930, it was conceived as a kind of seminary for lay people interested in understanding more about the Quaker tradition and oriented toward ministering through their own lives and work. Some of its participants lived together as part of the community, while others participated on a short-term basis through classes and special programs. Today, Pendle Hill offers weekend conferences and retreats, five-day courses, and a resident study program consisting of three ten-week terms each year. Its twenty-two-acre campus hosts some seventy staff and resident participants, while others from the wider community come for Monday-evening lectures, silent retreats, and classes. Many of the participants are undergoing major life transitions, ranging from deciding on initial careers or new careers, to experiencing divorce, to recovering from bereavement. The curriculum gives them opportunities to explore Quaker teachings, study the Bible, learn about nonviolent social change, and experiment with the relationships between art and spirituality.

Sally Palmer directs many of the activities at Pendle Hill that connect the arts with spirituality. Through an acquaintance, she joined a weekly meditation group at Shalem Institute in the 1970s and has been meditating regularly ever since. "The whole practice of meditation and of silence was very foreign to me, having grown up in mainline Protestant churches. Silence in those days often meant twenty seconds of the choir singing 'Sweet Hour of Prayer,' and the minister and everybody else fidgeting. So sitting in stillness, in silence, was totally new to me." At first, meditation seemed bizarre because it was so unfamiliar. "But I was in a covenant relationship with this meditation group and found that although the sitting was very difficult for me and the practice itself took real discipline, it seemed to be impacting the rest of my life in significant ways. In that sense it was reminiscent of my experience as a jogger. I

used to jog and hated the jogging itself, but it made a big difference in my life. The group that I met with was primarily clergy and some Roman Catholic sisters. I was one of two lay people. The sharing of life experiences, our faith journeys, and what was happening in our meditation times was very important and moving to me."

Since 1975, Sally Palmer has lived at Pendle Hill, taught classes, counseled spiritual seekers, and headed its art program (except for the years between 1985 and 1990, when she lived and taught at a Benedictine monastery and ecumenical retreat center in Wisconsin). One of her favorite courses teaches students to explore creativity, playfulness, and prayerfulness by working with clay; another is titled "Weaving as a Spiritual Pathway." She encourages her students to use "pottery, weaving, or whatever we're working with as metaphor[s] for their own spiritual journeys." As preparation for the course, she looks for quotes that connect weaving to the spiritual journey or creative work to the spiritual pathway. She also prays, including the class and its students in her daily cycle of prayer, which often begins at three in the morning if she is unable to sleep, and ends when she retires at night. Typically, the class begins with a period of silence, followed by one of the quotes and several minutes of silent worship. "I try to let go and ask that the Spirit move through me and work with us in the class. I see all of my students as potential teachers as well as learners and try to create a space where they can teach and offer the wisdom that they bring from their own life experience."

Weaving and working with clay give students who are otherwise preoccupied with thoughts about their work, their families, and often their own personal issues an opportunity to focus their attention elsewhere. The rhythm of the loom or of the potter's wheel and the tactile sensation of the yarn or clay break through the cycle of ordinary concerns. Sally hopes the students will experience some of the transformation that she experienced when she first started working with clay: "I would sit down at the potter's wheel and be lost for hours. I felt a deep connection to an unnamable within me. It was very much a centering process, and I still, when I need to get centered, go to the studio and throw pots. There's a connection there for me that's very powerful. It puts me in touch with the Creative Source, and I love it. It's a wonderful experience. The clay and the earth remind me of my connection with God's creation, with materials, with the fluidity of clay. It's very beautiful."

For some students, weaving or working with clay become times of prayer and may even substitute for more traditional forms. Sally Palmer

thinks it is still important to pray intentionally, rather than letting artistic practices take its place. She attends daily meetings for worship with the community and cofacilitates a weekly service of vocal, intercessory prayer involving staff and resident participants at Pendle Hill. She also prays in private, spending at least fifteen minutes daily in concerted prayer and then praying intermittently throughout the day as thoughts and needs arise. For years, she read books about prayer, until she finally realized that it might be more important to devote that time to actually praying. "I think initially prayer felt like it had to be sort of a formula and there were certain ways to pray and certain vocabularies to use and good ways of praying and not-so-effective ways of praying. I don't believe that any more for myself. I feel the more real I can be in my prayer life, the more real my relationship is with God: if I feel like hollering at God, I will. For me it's a kind of conversation and a deep listening. The listening piece is really important." Over the years, she feels, her understanding of prayer has grown. And yet, she believes firmly that prayer ultimately defies understanding. "It's a mystery to me! That's part of my fascination, I think. I know that connection is extremely important to me and yet sometimes it seems very elusive."

The trouble with prayer, when traditionally understood as talking with God, is that it too often becomes a purely mental or verbal activity, leaving the body, as it were, in poor second place compared to the spirit. This is why Sally Palmer believes the physical aspects of artistic work are so important. Weaving and working with clay involve bodily movement. To bring movement even closer to the foreground, she often includes dance and motion in her workshops: "My work with movement has been an effort to connect with my body and to connect body and spirituality. I sometimes become disembodied in terms of my work with spirituality, but we are given bodies. They're God-given, and we've got to live with them. Furthermore, my faith is incarnational. So the more connection I can make, the better I am in terms of my own spiritual growth. We do shed our bodies eventually, but we've got to live with them, and most of the time I do try to honor my body and its needs."

If a major benefit of these activities is feeling more aware of God's presence, a key by-product is releasing the creative powers that are present in all of human life: "I see that released in students again and again. People who feel they aren't creative create something, and the joy and the sense of deep connection with some inner part of themselves come alive. They often articulate this experience in spiritual terms. This is crucial in my own life. I do see us cocreating with God. I see us as God's

hands and feet and mouth, and so feel a responsibility as creator, as cocreator. It's all of those things. They connect very deeply with my own sense of spirituality and spiritual life."

The role of art, therefore, is to deepen a person's prayer life by evoking some of the yearnings that lie buried within that person's inner being. Sally Palmer's idea of creativity implies this sense of inner discovery. Sandra Lommasson finds that going "deeper" into one's relationship with God involves self-discovery as well. At first, she did a lot of talking to God, mostly about the needs and desires that were already at the surface of her consciousness. Yet these petitions seemed not to express fully what was in her heart. The words of the Psalms helped to bring some of these desires to the surface. She recalls: "Praying the Psalms just spoke to me, because of their fullness. They were real. Above all, prayer must be real." As she got in touch with more of what was inside her, she remembers, "my prayer became my writing and would just pour out. It's like there's something that happens. I don't know what I know until it's birthed there, and that is prayer. It's a communion place, it's the meeting place for me and for the spirit, so it's two-way. But it's not just dialogue. It's two-way communion. That was when I started dancing my prayers, because I was becoming embodied again. I was reentering my body, which was at first very painful, but it was also where I needed to be. Prayer became walking. Going out into nature has been a place of prayer for me. I like sitting here looking out the window at the red and yellow trees. As Gerald Manley Hopkins says, 'The world is charged with the grandeur of God.'"

Hopkins is just one of the poets Sandra Lommasson has come to appreciate. In learning more about prayer, she has become more self-conscious about the limitations of words. This is why she distinguishes *dialogue* from *communion*. Dialogue is like conversation, exchanging ideas. Communion occurs nonverbally as well as verbally. Poetry, she says, helps her to pray because it points to that which cannot be put into words: "I love to read Rumi. I have a book of Mary Oliver's poems by my bed. Some of Toni Morrison's work is almost like poetry for me. These [writers] have a way of getting to the core. Poetry cracks something open for me. It's hard to describe. It's deeper than words. Words are so often used to hide behind or control or manage. There's something that's wild and unruly about poetry that I just love. It throws things askew, the unexpected image. There's always more. It's like Jesus' parables. I will never mine them completely. There is always more there. That's so like God. There's always more. Poetry does that."

But how, exactly, does spiritual direction bring this growing appre-

ciation of mystery and beauty, of art and poetry, of creativity together with one's relationship to God? One of Sandra Lommasson's directees, Katie Hager, helps us to understand this process. Trained in Chinese language and literature, she works as a librarian and sometimes does tutoring on the side. As a child, she and her sister were sent by their parents to a Methodist church (their parents did not attend). During her adolescence, her family lived in Afghanistan, Jordan, and Korea, where Katie attended various nondenominational churches for Americans and periodically met Christians. As a young adult, she spent about as much time in China and Taiwan as in the United States. She studied, taught, got married, and, after her marriage ended in divorce, raised her two daughters alone. Moving around as much as she did made it hard to feel that she was truly part of any church, even though she generally tried to stay connected with some church or religious group. Meeting missionaries and talking with women in China who were trying against cultural odds to live as Christians inspired her to take her own spiritual life more seriously. She remembers realizing that doing so meant she had to pray and to read her Bible on her own, no matter where she was or how busy her life had become. For the past three years, she has been meeting regularly with Sandra Lommasson for spiritual direction.

"My work schedule made it impossible for me to go to the Tuesday-evening prayer group. But I needed something. I wasn't in a warm church situation. I needed God. I needed a Christian in my life. I needed something that fell into the general category of Bible study or spiritual life study." The meetings with Sandra have taught her to approach God differently than she did in the past. "I used to rant and rave at God, but I never listened back. I'm not even sure I knew that I could. What Sandra does is say, 'Stop and take a minute. How do you think God feels about that?' And in her office I can do this. I just shut my eyes and I think. I'm a very concrete person. I can feel a reaction from God, and [it] frequently surprises me. She will say, 'This is your prayer point with God.' She sorts through all the words that I say and says, 'This is what I'm hearing. I'm hearing right now that this is what you need. Let this be your prayer point with God.' It's come as a revelation to me that I don't have to find the answer just like that. I've put myself under incredible pressure because I have the expectation that within a short period of time I should be able to solve the problem. And God doesn't work that fast. Sandra says, 'Give God your need and just pray about the need and let the solution filter in.'"

For Katie Hager, spiritual direction thus far mostly has involved

calming herself so she can be more attentive to God's leading. What she describes as ranting and raving at God has been a harried feeling of being pressured to the point that she can hardly think straight. Sandra helps her by listening to her and by picking out what seems to be bothering her the most. Sandra is also trying to get Katie to look at life more from God's perspective and less from the perspective of her own needs and worries. This will probably take a long time, Katie recognizes, but in the meantime she is learning to trust in God and to have faith that God will work things out.

Part of what Katie has been overcoming is a lifelong habit of telling herself that God relates to people mostly by giving them rules to follow, which they inevitably break and then feel guilty about breaking. These "shoulds," as she calls them, became so powerful in her mind that she was unable to trust her impulses to do what was right or to give herself freedom to do what she really enjoyed. In learning how to trust in God, she has had to learn to trust more in herself. Rather than assuming that she was always making the wrong choices, she has started recognizing that following her impulses may not matter one way or the other to God, and that some of these impulses may even result in personal growth.

This is where creativity and the arts connect with her spiritual journey. As a young mother living in China, she had found that she enjoyed making dolls for her daughters. Once her daughters were past the point of playing with dolls, she told herself that making dolls was no longer acceptable. But lately, she has allowed herself to make dolls again. Her meetings with Sandra have encouraged her to trust the impulse that making dolls is something she would enjoy. Sandra has also helped Katie to see in her dolls an object lesson about God's love: "They are my creation, as I am God's creation. I have a hard time really taking into my core [the idea] that God cares. But I know how I care about my dolls. These are just pieces of cloth, but still I care about them because I've put time into them. Surely God does have a greater involvement with me than I have with my pieces of cloth."

Doll making has also contributed to Katie's spiritual development by giving her an opportunity to reflect on who she is: "The other thing is they give me peace making them, and sometimes I get ideas. I feel sometimes that God is inspiring me, that he's approving of and encouraging my creativity, and that's a new thing for me. My creativity, nobody's ever really cared that much about it. I think insofar as I have anything, any talent that is not totally ordinary, I'm just a little bit more

creative than the average person. I'm getting better, too. It was a new concept for me that practice makes perfect. I thought you had to start out perfect, and if you didn't, then there was no point in doing it."

By becoming more aware of her creative talents, Katie has been able to draw on them in other ways that connect with her spiritual life. One way has been to express grief and to console others. Not long ago, a friend's daughter died. Katie recalls: "Sandra had been telling me to try to express feelings in whatever medium felt natural. I don't know how the idea of calligraphy came, but I looked up the words for *grief* and *sadness* and *sorrow* in Chinese, and I practiced a bit, and then I made a card for him [her friend] that was black characters sort of raining down on a bright-red character that was the character for *woman*. My feeling at the time was that red is a color of celebration in China, and I felt that there had to be something to celebrate in the death of this child because otherwise it was too horrible to contemplate. I felt that heaven had to be celebrating because she was there, because there was so much goodness in her. There had to be another form of celebration here, not because she was dead, but because of how much she had brought when she was here. That was why I did that character in red, because it's the Chinese color for celebration. But I had the sorrow raining down on it."

Katie drew on visual symbols in this case because her grief was too deep to express fully in words. She has found her own relationship with God to be the same. Although she talks about this relationship, it fills her with such emotion that she sometimes expresses it through artistic forms. One was a picture. "It started out gray. You know how sidewalks crack and a seed gets in them. As you went around this circle, a little grass grew and then a few flowers until in the end it was just flowers. This was a picture of God breaking down my walls, planting seeds that would grow and bring something beautiful out of what had been a brick wall, a cement wall. When I bring another medium to my thoughts, it's like 3-D or something. They're just clearer." She also finds that writing poetry helps to clarify her thoughts. "One [poem] is about pain, and I just reread it the other day and it's very expressive. I don't always think of doing that because I read very little poetry, but for some reason I did that. If I weren't so controlled by shoulds, I would allow myself to do that more, and it's much more expressive and it's a much more satisfying expression of what I've felt."

Katie realizes that self-expression and relating to God are not the same. But neither can they be separated. Art helps her to understand more clearly the relationship between herself and God: "I see things.

I'm a concrete person, so when I'm trying to think of where I am in relation to God I will see things. Beauty and ugliness have been part of that. To me a garden is a form of art. It's beauty. I have two music tapes made by a Christian woman singing about sorrow and pain and suffering, and when I get really low, I listen to them. The music calms me down. I don't make a big separation between life and spiritual life. To me they're sort of all the same thing, and so when I say music calms me down, it really is another way of saying that it brings me closer to God."

Art, then, can play an important role in spiritual direction. As this example suggests, art can provide images that evoke God's presence, it can quiet one's anxieties so that prayer can more effectively include trusting in God, and it can be a way of expressing grief and deep personal anguish. Katie Hager summarizes its contribution to her spiritual growth this way: "I'm not quite so lost and desolate. I have a great deal of growing left to do, but I have found ways to connect with God. I like doing creative things, whether it's the calligraphy or my dolls, and I have allowed myself to do them even though they have no practical purpose. This is another way of saying that I have acknowledged that God has given me this ability or this interest. I have decided that perhaps God knows what he was doing and that it's okay to develop this interest, as opposed to just throwing it away as not being practical. As that feeling grows, I think it gives me a greater feeling of acceptance of myself, and that's something that I need. It's letting out a part of me that has to have come from God, and when I do that I'm acknowledging God and his contribution, his connection with me. His connection with me and my life. His involvement in who I am. I think that must be the epitome of spiritual growth, to know that God is involved in every aspect of your life and being. I can't imagine a greater feeling than that. I don't see spiritual growth as memorizing the Bible. It has got to be a feeling of connectiveness with God."

Art and Discipline

Discipline is a recurring word among spiritual directors and directees. To get anywhere in one's spiritual life, they insist, requires focusing one's efforts, perhaps over a period of many years and through times when results seem all too infrequent. Sally Palmer says she took up weaving because it was a way to learn this kind of discipline: "I remember defining it as my spiritual discipline because I found it very difficult.

I'm not a natural weaver. It's very calculated. There's a discipline to it that I rail against. There's a tedium to setting up a loom, and I saw it as a kind of spiritual discipline to engage in this process, and I still do. It's become more pleasant for me in the practice of it, but there is a rhythm. There is a kind of mantra in the rhythm of throwing the shuttle in the loom, in the setting up of the loom. It's one step at a time. There's no way you can push it."

The rhythm becomes its own discipline, providing a method for getting from one step to the next, just like the discipline involved in daily prayers, chants, meditation, or devotional reading. For Sally, doing something that does not come naturally puts her in touch with her own limitations and thus with her need for God. Weaving itself becomes a kind of metaphor for her relationship to God: "All of this is very relevant to my own spiritual journey, and I've learned a lot about myself and watching myself in the studio because there are a lot of times when I want to push it. I'm impatient, and yet there is a step-at-a-time discipline in weaving, so that's some of the dot-to-dot connection that I sense in the weaving: the weaving of the fabric of life and the interconnection of the thread. Somebody once spoke of how the warp is really the given of one's life, the pieces we're given to work with. But what we can do with it is the waft, the design that we weave. All of those are important metaphors and images to recognizing our connectedness: to recognize that we are given a set of givens, but that we can work with those givens in a kind of cocreation."

Katie Hager has come to appreciate discipline more, too. Referring to her dolls, she observes, "I started out very badly and I learned not to give up. I tried and I got better, and for me that has been a discipline. To make something that would not meet my expectations and to try again and improve it, step by step, that's discipline. That has been what I have been doing in terms of my spiritual growth, just going step by step." She says there is a fine line between being disciplined and getting bound up with "shoulds." But something about making dolls seems to serve as an appropriate metaphor. It takes discipline to get started, especially if she is feeling uncertain about her abilities, but once she starts, she feels more confident, and she enjoys what she is doing because the discipline increases her sense of creativity.

Discipline is one of those perplexing ideas that is perhaps best captured in metaphors and images. It is expressed better through the act of writing than as something that one writes about. Knowledge of discipline comes from the struggle, from engaging in the daily grind, more

than from theorizing about the nature of discipline. This is why artists themselves provide some of the most valuable insights about spiritual discipline. Whether they have tried to teach others spiritual discipline through the arts, as Sally Palmer has, or have simply found their own artistic endeavors to be a lesson in spiritual discipline, they show that devotional life is not so much about prayer or meditation as isolated attempts to reach God, but is about *devotion* itself as a mode of life, an orientation to the sacred.[7]

Monica Armstrong is a painter who lives in Germantown, Pennsylvania. A devout Roman Catholic, she has been studying spiritual direction for the past few years at Chestnut Hill College. She sees a strong connection between the discipline it takes to be an artist and growth in her spiritual life. "First of all, I've got to show up. That's the big one. Show up every day. Set aside a special time that's regular. Don't allow interferences. Have whatever it is you need in terms of supplies, whether it's reading or music or space to move or whatever it is that you need to open yourself up. You need to have that."

She says the key to showing up is remembering that the responsibility to do so ultimately falls on *you:* "Nobody can do your art work. You can only do your own. Nobody's going to do it for you. If you don't balance your checkbook, the bank will do it or your husband will do it or you just go out of business. But if you don't do your art work, that's your life un-done. The level of commitment that's necessary to survive as a professional artist is so profound." She sees a direct parallel with her spiritual life: "There's nobody who's going to tell you what to do. There is a way that you can do art and there's a way you can do spirituality where you can get people to tell you what to do, but it's *their* way. If you're going to do your *own* life, your own work, your own spirituality, you're on your own path. You have to do it, you just have to do it. There is no substitute for showing up and doing the work. Putting the time in. Committing yourself to being open and doing whatever work you have to do in order to be open."

This notion of doing things her own way is not just an abstract idea. Over the years, she has learned that some things help her to pray, just as they help her to do her painting, and others interfere: "I have to have music, I have to do movement. I have to exercise at least four times a week for an hour. I have to, or physically my body gets so tight that I can't be open spiritually. I know that about myself. I hate exercise, but it's a discipline I have to do. I have to do it because my neck gets screwed up and I can't do large paintings if I don't do those exercises.

That's just another example of a discipline in my life. I know that I can't drink a lot of caffeine and do good paintings. I get too jumpy. I love caffeine, but I can't drink it. That's a discipline. I have to take care of myself physically. I cannot abuse my body if I'm going to live long enough to do the kind of work I want to do. I cannot. I would love to smoke cigarettes. I would love to drink caffeine. I would love to eat sweets. I can't do that. I pay too high a price, and the price that I pay is I can't do my art work, and if I can't do my art work, I can't pray. So it's all interconnected."

Michael Eade, a painter in New York, explains the connections among art, spirituality, and discipline this way: "I see the daily discipline of making art as a practice, and like the practice of a belief system, I feel bad if I don't do it. I'm always working on some project. It could be in my thought processes that I'm painting and getting ready for the next day. It is very disciplined. In all artists [who] achieve some level of completeness in their work, there's a lot of discipline there."

Another man (who has been a musician since the age of three) speaks forcefully of the value of discipline, both as an artist and for achieving spiritual maturity: "When you know that you've got to spend six hours alone at a piano every day to accomplish your goal, that's a discipline, and that discipline does carry over to the rest of your life. The discipline I've learned to become a musician, to become a better musician, carries over into everything I do. You can't be a gardener and only spend thirty minutes once every couple weeks or so at it. It's a discipline, and you do learn the discipline and it really is difficult." He relates this emphasis on discipline to spiritual growth: "By and large, growth comes best when there is a deliberate plan or a deliberate setting aside of time and energy. Now, it's true that if somebody has no discipline about spiritual life and is struck with cancer, it's amazing how quickly their spiritual life will grow. That isn't a discipline; that's just out of sheer necessity. But I've seen it over and over where [if] people will devote the time, you see the growth."

An actress who lives in New York cautions that one should not get carried away with the idea of spiritual discipline. "God loves you all the time, and he doesn't love you more when you pray than he did before." Still, she argues, it takes discipline to grow. "You change if you show up a lot. You can't expect to meet the cute guy who works at the library if you never go there. You have to keep going there. Prayer is like that: you have to do it a lot. You learn to listen and understand and hear the cues. Acting is like that, too. It isn't all just standing up on the stage and

emoting. It's listening, learning to listen to each other, watching body stuff, showing up, having the discipline, trying again and again and again and again."

Most of the people we talked to echoed this idea that discipline implies a commitment to hard work, and that hard work is necessary to grow spiritually, just as it is to develop one's artistic talents. But some of the artists we talked to recognized that this view of discipline is limiting. It focuses too much on the struggle to master techniques and not enough on the *desire* that propels a person toward painting or sculpture—or prayer—and the fulfillment that comes from pursuing this desire.

One of the best illustrations of this larger view of discipline comes from Jack Stagliano, professor of studio art at Villanova University. As an Augustinian friar, he has had ample opportunity to reflect on the relationships between spirituality and the arts. "Almost all of the art that really engages me comes from the Roman Catholic tradition," he explains, "especially the medieval Latin hymns. Doing and making are acts of faith. I see the process of doing and making as a spiritual exercise. It can be gardening. It can be cooking. It just happens that for me it's putting paint on canvas."

When asked about discipline, Jack's first impulse is to quote an elderly friar who used to insist that "there's no growth without struggle." To his ear, this idea reflected the Catholic tradition of mortifying the flesh in order to grow spiritually. But something about it has never seemed quite right. He uses his experience as an artist as an example: "I'm not sure whether discipline means punishing yourself by being in the studio a certain number of hours and slaving over a hot painting, or whether it means something else. For me, I would think it's almost more about finding the time to do the thing, the painting. But the act of the painting may not be a discipline at all. In other words, it may be choreographing the rest of your life to allow yourself the three hours of time that you need. That might be the more disciplined part of it." Prayer may be the same way, he thinks. The discipline required to have a rich devotional life does not consist of doing something for fifteen minutes a day that proves to be painful. The actual time spent communing with God may be quite enjoyable. But to achieve this rewarding time, it is probably necessary to structure the rest of one's schedule, and that may take discipline.

He believes, too, that discipline, ironically, may consist of getting to the place where one no longer tries to control everything. Artistry re-

quires a certain amount of spontaneity, and there may be a spiritual lesson to be learned from reflecting on this need for spontaneity. Jack puts it this way: "I think initially in the spiritual life and initially as an artist one is concerned with what we call 'formal issues,' with understanding color theory, understanding how to use line forms, color, design, and shapes. In the early spiritual life, discipline means not having your mind wander if you are trying to meditate, or learning to recite prayers from a book. But I think one of the major wisdoms, if you will, of spiritual growth is essentially learning to let go. As they say, 'Let go and let God.' I think that's probably one of *the* wisdoms of the spiritual life. In my painting, there's also that need to let a more spontaneous thing occur. I'm sure you've heard the story of a Japanese calligrapher who spent his whole life doing calligraphy and finally said, 'I don't do the lettering any more. I just hold the brush and the brush does the lettering.' I would like to think that that's the direction at least that one moves toward as you grow older in spiritual life, just as in the arts."

Being able to let go, to be spontaneous, may be the goal that one achieves eventually, but getting there does not happen quickly. Spontaneity sometimes results in chaos, a painting that is truly confused, or a spiritual life that amounts to little more than self-indulgence. In this respect, spirituality is less like a watercolor that can be finished quickly and more like a sculpture that requires a long, slow process of chipping away without seeing many immediate results. It takes patience.

Jack remembers the first sculpture he made from a piece of marble: "It was a tombstone that I got from the dump of a cemetery. I had worked on it for a few weeks and was cutting to allow for heads and shoulders to appear, and one shot of the chisel and the hammer and off came the head! Then I really had to learn, 'Well, now how do you address stone? How do you put even a hole or an indentation into stone without chopping off somebody's arm or leg?' You learn to go with the flow of the stone. The stone forces you. I very much can resonate with Michelangelo saying, 'The statue is in there. You just have to take away what isn't the statue.' That's certainly true in woodcutting or stonecutting. There's an example of where I had to learn patience. I had to learn the discipline of the stone. You go that way with it and you're going to have another dustpan full of stuff, so you better learn how does the stone go and how is it willing to be cut so that it works for you."

The other word that frequently comes up when artists talk about discipline is *attentiveness*. Learning to sculpt requires being attentive to the configuration of the stone. Becoming skilled as a painter involves being attentive to the colors on one's palette and paying close attention to the

details of the model or object or the effect of one's own brush strokes. Similarly, a meaningful devotional life depends on concentrating one's attention for a period of time on the act of praying. Attention to one's desires is important, as Katie Hager has been learning from Sandra Lommasson, and perhaps even more important is the attention one pays to focusing on God.

For Jack Stagliano, attentiveness was something he learned as a student, but it is also an idea that has become more meaningful to his spiritual journey as he has matured: "Attentiveness is perhaps an Eastern idea, although it certainly can be found in the West both in Protestant and Catholic writers. One of the things that I was taught even as a novice by one of our very elderly friars, who taught us from Virgil, was 'Do what you're doing.' That was a primary thing for us as students. When you were in the chapel, you were to be praying. When you were playing basketball, you were to be playing basketball. When you were doing laundry or scrubbing toilets, you were supposed to be doing laundry or scrubbing toilets. Attentiveness to what you are doing at the moment is most certainly a key to spiritual growth."

Times of Trial

A disciplined devotional life is one that people practice day in and day out, whether they feel particularly in need of God or not. But in nearly all cases, men and women who take their spiritual lives seriously have been jolted into doing so by some personal crisis. For Sandra Lommasson, it was being raped. For Katie Hager, it was experiencing a divorce and on more than one occasion finding herself alone in a foreign country. Jack Stagliano remembers the assassination of President Kennedy shaking him out of his rose-colored view of the world and leading him to think more seriously about God as a way of overcoming his cynicism and despair.

Do music and art play a positive role during such times of trial, and if so, does this role have anything to do with the connection between the arts and spirituality? Normally, one thinks of music and art as forms of entertainment, or perhaps as sources of inspiration. But examples like the ones we have been considering suggest that music and art have a more complex relationship to people's personal lives than simply providing them with amusement. One of their roles is surely to provide comfort when a person is in need.

Nationally, 85 percent of Americans say there has been a time in their

TABLE 20. Crafts and Music Are among the Activities That Help
People in Times of Trouble
*(Among those who have been ill, lonely, or troubled, percentages who say each activity
was very helpful, fairly helpful, or not helpful)*

	Very Helpful	Fairly Helpful	Not Helpful
Talking with friends	74%	19%	6%
The Bible	41	24	32
Doing something with your hands, such as sewing, woodworking, or painting	39	28	31
Music	37	33	26
Literature, such as a novel or poetry	18	25	53
Art	7	14	46

lives when they were ill, lonely, troubled, or grieving the loss of a loved one. Not surprisingly, personal relationships are the most common source of comfort in these times. Among everyone who had experienced a time of illness, loneliness, trouble, or grief, 74 percent reported that talking with friends had been very helpful, and another 19 percent said this had been fairly helpful (table 20). These figures provide a point of comparison for some of the more specific activities asked about in the survey. The Bible, again not surprisingly, was one of the most commonly cited sources of comfort: 41 percent of those who had been troubled said the Bible had been very helpful; another 24 percent said it had been fairly helpful. But two kinds of artistic activities were helpful to nearly as many people as the Bible: 39 percent said that doing something with their hands, such as sewing, woodworking, or painting, had been very helpful; and 37 percent said this about music. In fact, the proportions who said that handcrafts and music were at least *fairly helpful* were actually larger than those who said this about the Bible. Two other artistic activities—reading literature, such as a novel or poetry, and viewing art—were less commonly reported as having been helpful, but a substantial minority of the public found them at least fairly helpful. In all, a majority of the public (59 percent) replied that at least one of the art forms listed had been very helpful.

The ways in which art helps during personal crises are numerous. Susan Brock, it will be recalled, turned to painting and drawing as a child when she was worried about her father's drinking. These activities helped her to escape temporarily from her fears that he would die in an automobile accident. As an adult, she turned to the arts again, this time to music, to block the pain during a bout in the hospital. Kathleen Peters found that singing was the one constant element in her life after her

first husband abandoned her. Another woman remembers a time, more than a decade long, when she felt spiritually lost, worried about her marriage, and uncertain of her career. What sustained her was the church in which she had been reared—not the people, for she no longer attended; and not the music she had learned there, which she admits was awful; and not even the Bible stories, which she remembered but not with any depth of understanding. It was the beauty of the church building that comforted her: "There was that sense of beauty and awe and magic and wonder, that sense of faith and belief, that was very much connected to the beauty of those early years. When I came back to the church and when I became connected to spiritual growth again, that was really the thread that I held onto all those years. I was drawn because of the art. But the content really was there, too, and was inescapable. Whether it was specifically religious art or not, there was still the spiritual impulse of art making that was always there."

These examples all involve women, and in fact statistics show that women are more inclined to say they were helped by the arts during times of crisis than men are. Nationally, the percentages of women who say they have been helped by music, by literature, and by crafts are all higher than the comparable percentages for men; only "art" does not show these differences (table 21). People who have been to college are more likely than those who have not been to college to say they have been helped by music, art, and literature—probably because they have had greater opportunities to gain an appreciation of these artistic forms. But those with lower levels of education are more likely than those with higher levels of education to say they have been comforted by doing handicrafts. There are also some differences among people with different religious affiliations: evangelical Protestants are more likely than mainline Protestants or Catholics to say they have been helped by music. Being helped by art, in contrast, is most common among mainline Protestants. Being helped by handicrafts appears to be more common among Protestants in general than among Catholics. What matters most, though, is the exposure to the arts one has received as a child. Those with the highest levels of childhood exposure are much more likely to say they have been helped by music, art, literature, and even to some extent by handicrafts than those with lower levels of childhood exposure. While this finding is not surprising, it does suggest that training children in the arts is a way of giving them a resource that they can rely on throughout life as a form of support and comfort during times of trial.

But does such reliance on the arts play a role in Americans' spiritual

TABLE 21. Kinds of People Who Have Been Helped by Music, Art, Literature, or Crafts

(Among those who have been ill, lonely, or troubled, percentages in each category shown who say each activity was very helpful)

	Music	Art	Literature	Crafts
Male	34%	7%	14%	36%
Female	40	7	22	42
Age 18–29	40	6	22	32
Age 30–49	38	10	19	40
Age 50 and over	36	6	17	42
Grade school	32	5	12	40
High school	33	5	15	40
Some college	42	9	21	42
College graduate	42	11	24	35
Evangelical or fundamentalist	43	6	18	42
Mainline or liberal Protestant	36	9	18	44
Roman Catholic	31	6	16	36
Childhood exposure to the arts:				
0 (Low)	26	3	9	37
1	29	5	12	38
2	29	7	15	36
3	36	7	18	37
4	47	8	23	43
5	52	9	25	43
6 (High)	58	21	39	50

lives? Conceivably, the arts might prevent people from facing their sorrows or from turning to God in response to personal crises. Undoubtedly, these are the consequences in some cases. Yet the survey data suggest that, on balance, turning to the arts during times of trouble is probably conducive to a greater interest in both spirituality and the spiritual implications of the arts. More of those who say they were helped at some point in their life by the arts currently pray than those who say they were not helped (table 22). More of the former also say they meditate regularly, devote a great deal of effort to their spiritual life, and have a growing interest in spirituality. Having been helped by the arts also seems to reinforce the idea that music and art are relevant to one's spiritual life. Those who have been helped are more likely than those who have not been helped to include music and art when they pray; to say that music, singing, and literature have been important to their spir-

TABLE 22. Having Been Helped by the Arts Is Associated with Other
Aspects of Spirituality and Attitudes toward the Arts

(Among those who have been ill, lonely, or troubled, percentages of those who say the arts have or have not been helpful who respond as indicated to questions about spirituality)

	Helpful	Not Helpful
Pray every day	29%	20%
Meditate every day	35	20
Devote a great deal of effort to spiritual life	29	20
Interest in spirituality is increasing	52	39
Prayer time includes art or music	61	42
Music is important to spiritual life	39	15
Singing is important to spiritual life	21	9
Literature is important to spiritual life	16	7
Arts help with deeper purpose in life	44	18

itual lives; and to agree that art helps us to understand the deeper meaning and purpose of life.[8]

Periods of illness, loneliness, grief, and other troubles are moments when people feel most vulnerable. If they receive no comfort, no emotional or spiritual support, they can easily become embittered. But if there are sources of comfort and support, the journey through these times of trial is often a pathway to greater hope, greater trust, and even greater faith in God. The arts are one such source of comfort and support. When the arts are part of a religious tradition or embedded in a regimen of personal devotion, they may well be the key to a stronger interest in spiritual growth. But even when the arts are not explicitly linked to a religious tradition, they often convey messages of hope. They point to a better reality, to a sphere of transcendence that, once experienced, may be sought again and again.

The Role of Groups

Although the devotional life is popularly understood as a lonely one, engaged in by isolates who prefer to spend their time meditating rather than joining the hustle and bustle of a religious community, this image is not entirely accurate. People who pray and meditate every day generally *do* engage in these practices by themselves; spiritual direction often works best in one-on-one settings; and the proverbial dark night of the soul is likely to be a lonely experience, no matter how many friends

one has. But a flourishing devotional life usually does involve other people.

In Sandra Lommasson's case, Al-Anon meetings moved her ahead in her spiritual pilgrimage by giving her an inside look at the vulnerabilities other people experienced. For the first time, she realized she was not alone. At Bread of Life, she now provides similar group opportunities for people wishing to grow in their spiritual lives. Sally Palmer's experience with meditation has been communal from the start: the group at Shalem got her started, and the community at Pendle Hill has sustained her. Other people have found support through Bible study groups and prayer fellowships at their churches.

Small groups have, in fact, been flourishing in recent years. Research has shown that 35 to 40 percent of Americans participate regularly in some kind of small group and that approximately two-thirds of these groups are sponsored by churches. The most common of these groups are Bible studies and prayer fellowships, although churches have also frequently sponsored self-help groups such as Alcoholics Anonymous.[9]

Despite the popularity of these groups, there is considerable misunderstanding about them. Media coverage suggests that people flock to small groups because of an obsession with personal problems, and social commentators depict them as expressions of self-interest. Popular stereotypes lead people to believe that these groups are mainly places where lonely souls come to talk about themselves.[10]

The truth is quite different. The most common reason people give for joining these groups is the desire to grow spiritually. Most members do, in fact, report that their relationship with God has deepened and that they have a better understanding of the Bible. In addition, members become more active in their churches, give more generously, serve on more committees, and do more volunteer work in their communities. For all these reasons, church leaders have recognized that small groups are a key source of religious revitalization.

What has not been as commonly recognized is the role played by music, art, and literature in many of these groups. Although the most common group activities are Bible study and prayer, a majority of groups sing together. Although the singing often lasts for only a few minutes and consists of familiar hymns and choruses, it nevertheless contributes to the sense of belonging and camaraderie that most members experience. More important is the fact that a significant number of small groups in churches have been founded particularly to discuss works of fiction and poetry or to draw people together who have interests in the visual arts or music.

TABLE 23. Saying That Small Groups Have Been Important in One's Spiritual Life Is Associated with Other Aspects of Spirituality

(Among those in each column, the percentages who respond as indicated to questions about spirituality)

	Participating in Small Groups Was:		
	Very Important	*Fairly Important*	*Not Very Important*
Pray every day	82%	61%	36%
Meditate every day	47	26	17
Devote a great deal of effort to spiritual life	52	20	11
Spiritual growth is extremely important	56	28	12
Interest in spirituality is increasing	71	46	28
Prayer time includes art or music	66	56	41
Music is important to spiritual life	52	22	17
Singing is important to spiritual life	33	10	7
Literature is important to spiritual life	22	7	8
NUMBER	(424)	(317)	(789)

In the Arts and Religion Survey, 26 percent of the American public indicated that participating in small Bible-study or prayer groups had been very important in their efforts to grow spiritually and to develop a closer relationship with God. Another 20 percent said such groups had been fairly important to their spiritual development. In short, nearly half of the public attributed a significant role to small groups in thinking about their spiritual growth (among weekly churchgoers, this proportion rose to 77 percent).

In all traditions, Eastern and Western alike, practitioners have been encouraged to pray and meditate by getting involved in groups, and in the survey, the connection between small groups and devotional life is indeed striking. Among those for whom small groups have been very important, 82 percent say they pray every day, and among those for whom small groups are fairly important, this proportion is 61 percent; in comparison, only 36 percent pray daily among those for whom small groups are not important (table 23). Similar patterns are evident in the proportions who meditate regularly, who say they have devoted a great deal of effort to their spiritual lives, who say spiritual growth is extremely important to them, and who say their interest in spirituality has been increasing. In each case, the more important small groups have been, the more likely people are to indicate serious involvement or interest in spirituality.

The data also suggest that there may be a close relationship between meaningful involvement in small groups and recognizing that music and art are relevant to one's spiritual life. At least, those for whom small groups have been the most important are also more likely to say that they include music, pictures, and sacred objects when they pray; and that music, singing, and literature have been important to their spiritual development.

Another look at the role of art and music in small groups comes from a different study. In 1999 I conducted a national survey that focused specifically on participation in small groups. Telephone calls were made to 4,292 randomly selected individuals. Of these, 1,495 (35 percent) said they were currently a member of a small group, such as a Bible study, prayer fellowship, Sunday-school class, self-help group, or support group. Ninety-five percent of these people agreed to answer questions about their group.[11] One of the questions revealed that 70 percent of these people were in groups sponsored by churches. For present purposes, these people are of greatest relevance: their groups are part of the formal activities of a church and are, according to their members' responses, overwhelmingly concerned with Bible study, prayer, and spiritual growth. Most of these groups meet once a week and most have been in existence for at least five years. Of particular interest is the fact that *30 percent of these people said their group discusses art or music.*

These data, then, make it possible to see what kinds of people join religious groups that discuss art and music, how they differ from people in groups that do not discuss art and music, and what these people get from their groups compared to people in other groups. Once we have considered these general characteristics, we can then consider some of the topics that such groups might discuss and how these discussions might be used in churches to nurture spiritual reflection and growth.

A comparison of social characteristics shows that members of groups in which art and music are discussed tend to be younger than members of groups in which art and music are not discussed. This is important not only because young people represent the future of the church, but also because relatively few young adults participate in religious groups. In fact, among the members of groups that do not discuss art and music, only one in seven is between the ages of eighteen and twenty-nine, whereas this proportion rises to one in four among members of groups that discuss art and music. It might also be expected that these groups would attract better-educated people. This, however, is not the case. Although it is true that small groups in general attract better-educated

people at a higher rate than in the population at large, the members of religious groups that discuss art and music are actually a little less likely to have graduated from college than the members of groups that do not discuss art and music (possibly because the former have more younger members who may not have completed their education). There *are* some gender differences: women are more likely than men to join small groups in general, and women are even more highly represented in groups that discuss art and music. Race, too, is a factor: although most small-group members are white, the members of groups that discuss art and music are somewhat more likely to be African American, Hispanic, or Asian American than the members of groups that do not discuss art and music. Overall, these comparisons suggest that groups in which art and music are discussed may be slightly more diverse than other groups, especially in their capacity to attract younger people and members of racial and ethnic minorities.

These data also provide some comparisons of the activities that characterize the two kinds of groups. It might be supposed that groups in which art and music are discussed consist mainly of book clubs, choir steering committees, or other special-interest groups in which such specifically religious activities as Bible study and prayer receive little attention. But this appears not to be the case. The data show that nearly all members of both kinds of groups (that is, ones that discuss music and art and ones that do not) say their group prays together. More than nine members in ten of both kinds of groups say their group studies the Bible, and nearly this many say their group has devoted a lot of attention in the past year to "growing in one's faith." In short, discussions of art and music seem to be integrated into these other, more explicitly spiritual activities, rather than substituting for them. The data do, however, show that singing and book discussions are also more common in groups that discuss art and music than in other groups—suggesting that these discussions are not limited to occasional remarks or private conversations.

The small-group study also shows some interesting differences between the two kinds of groups in the personal results that their members claim to experience as a result of participating. Members of groups that discuss art and music are more likely than members of other groups to say that they have experienced a healing of relationships as a result of being in their group, to say they have felt God's presence many times in their group, to say their understanding of different religious perspectives has improved, and to say their faith has grown a lot. These mem-

bers are also more likely to indicate that being in the group has helped them through an emotional crisis and helped them to forgive someone. Not surprisingly, therefore, these members are also more likely to say their group has been extremely important to them. All of these differences are statistically significant, even when other characteristics of group members are taken into account.[12]

On the whole, then, it appears that discussions of art and music *enhance small groups' effectiveness in nurturing spiritual growth*. This may be surprising, especially to those who regard art and music as a kind of sideshow or distraction from the real purpose of small groups. Certainly the extensive literature on small groups in churches has paid far more attention to such matters as how to lead a Bible study or how to get people to share their feelings than it has to the role of art and music.[13] It could be, of course, that these other issues are more important, especially in view of evidence that learning the Bible and experiencing loving support are what truly makes a difference in small groups. But it also seems likely that art and music do make a significant positive contribution, and that they do so, perhaps, by making small groups more appealing for younger people. Judging from the results that members report, art and music may also help to broaden what people experience in their group. They may be prompted to reflect on a wider range of their personal experiences and think more deeply about their relationship to God. To the extent that these discussions are linked with singing or listening to music, they may also help to create an atmosphere in which people feel closer to God.

Survey results such as these help to establish that the arts *do* play a positive role in small groups, but these data give little sense of *how* discussing the arts may contribute to spiritual insights and vitality. In-depth interviews offer some help, at least in giving anecdotal evidence from people who say they have appreciated being part of church groups that talk about art or music. One category of such people is composed of those who are drawn to a group because they are artists or musicians and because the group specializes in art, music, and related activities. In churches, such groups may include worship teams whose members gather for prayer and Bible study and then work together on planning some aspect of the service, or, for that matter, choir members who meet for prayer and study as well as practice. Other examples include a large church's artist-in-residence who has formed a Bible study group with some of his apprentices (they invariably mingle references to the visual arts with their discussions of the Bible), or a group of church musicians that meets weekly for prayer, sharing of ideas, and support.

A more common kind of group is composed of churchgoers who are not artists but who decide to devote an explicit part of their group's schedule to discussing some aspect of the arts. At one church the members of a Bible study group decided to devote several months of their meetings to discussing one of John Updike's novels. At another church, a mothers'-morning-out group takes a break from its usual Bible study sessions once every three months to go together to a museum or spend an evening together with their spouses at a dinner theater. The ways in which spirituality and the arts come together in such groups can be illustrated best by "listening in" on one such discussion.

The setting is an Episcopal church near the heart of a small city in the Northeast. Ten men and women have gathered this Sunday afternoon to discuss the relationship of the arts to their spiritual journeys. Ordinarily they might spend their time together discussing a book they had read, a piece of music, or an art exhibit. Today, because they have agreed to have their meeting tape recorded, they will discuss how the arts have influenced their spiritual journeys and respond to some particular selections of music, visual art, and poetry.

The group is in no way a cross-section of the congregation's members. They are, like many special-interest groups in churches, a gathering of people for whom the arts have special meaning. One woman fills much of her time by giving piano lessons in her home. Her husband is a professor in the English department at a nearby college. Another man has read extensively about art history. One of the women paints as a hobby. Another woman listens to music when she prays.

All can remember times in their childhood when religious music, a sacred object, or some other work of art made an impression on them. Their memories show how common it is for children to be exposed to the arts in these ways. For one, it was a family Bible filled with reprints of famous paintings—of Adam and Eve, Moses, Jesus, and the Last Supper. She remembers her mother pointing to the pictures as she told her the stories. For another, it was the hymn "Oh, Sweet Mystery of Life." On holidays, the family sang hymns together. She especially remembers how beautiful her aunt's voice was. One of the men says his favorite childhood hymn was "Jesus Loves Me." He sang it every week in Sunday school. For another man, the hymns made a lasting impression because he frequently got scolded for stacking the hymnals during the service. Another man remembers how impressed he was with the architecture of his childhood church. A woman whose parents did not attend church says she was impressed with a German Hummel figurine in the window of a jewelry store showing a child at prayer. Two of the

group were raised Catholic. One recalls the stations of the cross; the other, a painting of Mary and the baby Jesus that hung in her childhood home.

As adults, these people have continued to find their spiritual lives enriched by music and art. One woman says she especially loves Bach's "Jesu, Joy of Man's Desiring." She says the organist played it just last Sunday as the prelude to worship. She always finds it uplifting. Her comment prompts another member of the group to remark that she finds the pastor's sermons equally inspiring. "He often paints word pictures, like of a bird flying or something, that I can relate to." One of the men shares a thought that came to him during a visit to a church in Austria: "We went into a church which I thought really said it all about the Christian concepts of time, space, and light. There were no windows at eye level at all. It was very stark, with some beautiful but low-key stained glass around the top. You couldn't see outside; outside space meant nothing. It was only inside space. While you were in there, the only things that you were supposed to think about were religious thoughts. I thought the architecture said it very well." This observation prompts several of the group to comment about how their own church inspires them. One mentions the serenity of sitting in the sanctuary; another, her love of how the Psalms are incorporated into the service. The piano teacher remembers an evening service in particular: "I looked out toward the front of the church and somehow the lighting in the church was reflecting a cross against the brick wall behind the altar. It was like three crosses, and it was just breathtaking. It really stopped me."

A man in the group shifts the discussion toward ways in which the arts have an influence in personal life. He especially loves the poetry of Gerard Manley Hopkins. "There's real struggle there and real working through spiritual questions, and there's also real music in the poetry." One of the women likes Maya Angelou's work for the same reason: "She has overcome so much in life and has been able to express herself from her background as someone who has found a better road to travel." One of the men mentions Galway Kinnell, who he had heard recently. "He did a great reading. He just stood there and recited. He takes interesting situations and shows you them in a new light. He has a great poem called 'Saint Francis and the Sow,' about this mother pig, and he raises her to a kind of a religious icon in the poem. It's a tremendous poem." Others talk about listening to CDs by John Rutter, liking gospel music, and finding spiritual insights in novels.

The group then responds to several selections of visual art. One is a

slide of New York artist Nancy Azara's *Tree Altar,* a six-foot-high trip-tych that consists of a wood sculpture of a tree against a background of plain wood, flanked on either side by panels embellished with gold leaf.[14] The sculpture encourages the group to reflect on the Crucifixion in new ways. Several of the members focus on the fact that the tree looks dead. For one, the tree is a palpable reminder of Christ's death; for an-other, it suggests the folly of facing one's own death if one's life has been misspent. Another says the very proportions of the sculpture make her uncomfortable, just as thinking about the Crucifixion does. Several are drawn to the gold leaf. One woman says this reminds her of Christ's royalty; another says gold is a symbol of the future; yet another, that it evokes thought of wings, life, spirit.

The next slide is of a small ceramic-looking bowl by master wood-turner David Ellsworth. Seeing it in a museum or gallery, one would scarcely imagine that it could have spiritual connotations. But in the present setting, it becomes an icon that prompts thoughts about the deeper meanings of life. Several in the group note its satiny finish, invit-ing them to touch it, evoking warm thoughts, and conveying peace or serenity. One thinks of it as a vessel in which water, as the essence of life, can be found. Another connects it with the earth, causing him to think about humanity's dependence on the natural environment. Yet another notes a small fissure in the wood, a reminder that all of life is ultimately frail and broken.

After discussing several more pieces of visual art, the group turns its attention to several musical selections. One is a contemporary piece called "Dawn," written by composer Meredith Monk after an early-morning visit to Mount Sinai. Even though the song is intentionally "formless," the group picks up its Middle Eastern inflection. The bass ostinato reminds one man of John Tavener's "Alleluia," which was played at Princess Diana's funeral. Some like the song better than oth-ers do, but all agree that it is prayerful. One man writes "contemplative prayer" on his notepad as he listens. "To me that's the most difficult prayer and it's the prayer that you need to get in a mood for. I saw the beginning of this as really being able to get into a mood, into a con-templative-prayer mood." One of the women says she "doesn't hear music" well but that as the music played she was visualizing dancers de-picting the rising sun. Another woman imagines seeing the dawn as a sign of God's hope after she has climbed the mountain in the dark to watch the sun rise.

Finally, the group spends some time discussing short selections from

poets and other contemporary writers. A selection from writer Jon Davis generates the most reaction: "If we manage to convince ourselves that life holds no mystery, will the universe have any need for us? Aren't we the creatures whose purpose it is to stand before mystery?"[15] For one woman, the statement takes her back to something one of her Sunday-school teachers told her many years ago. "There just are some things about your religion that you have to take on faith. You aren't always going to have the answers, but you just have this faith in what you believe." Another woman observes, "I think mystery is a part of life, but then when I read the next line I considered the mystery to be God, and he is a mystery that you're always trying to find." Others agree. "I do think we are creatures whose purpose it is to stand before mystery," says one, "because we don't know what is going to happen next, and we just have faith and that gets us through life."

This is just one example. In churches around the country, groups like this are drawing on the arts to prompt deeper reflection about God, the world, creation, mystery, struggle, brokenness, and prayer. The discussions encourage participants to think in new ways about their faith and to articulate insights that prove beneficial to others. Art and music do not require right answers, and particular selections may be liked better than others, but they invite people to respond, visualize and listen, and be more attentive to the world around them and to the divinity of that world. Toward the end of their discussion this afternoon at the Episcopal church, one woman provides a fitting summary when she remarks, "The ability to create is God-given. The ability to see someone else's creation and respond to it is incarnational."

From Self to Service

If more and more Americans are praying, meditating, taking spiritual growth seriously, and participating in small groups that nurture their faith, and if music and art are part of this process, then church leaders should surely be pleased. Yet the concern is frequently expressed that all this emphasis on the devotional life may be happening at the expense of Christianity's broader vision of service to others. As one theologian remarked, "Christ's call is to love God and our neighbor, not to dwell on our inner selves."

Church leaders have always insisted that spiritual maturity should, among other things, result in greater concern for the needs of others

and more active involvement in helping to address these needs. In recent years, public officials have joined clergy in challenging church members to become more engaged with meeting community needs. As government programs have been cut, churches have been asked to provide shelter for the homeless, food for the hungry, day care for children, and assistance for the elderly.

Research shows that churches have indeed played a positive role in encouraging people to be of greater service to others. Church members, and especially those who attend regularly, are more likely than other Americans to do volunteer work, both at their churches and through other community agencies. Their involvement seems to be heightened by the fact that they hear of opportunities to serve and by the fact that they are exposed to sermons and other teachings about loving one's neighbors.[16]

But Christians' growing emphasis on personal spirituality and their apparent engagement with the arts inserts a question mark into this relationship between religion and community service. One usually does not think of the arts as being particularly conducive to serving the needy. Artists themselves are stereotypically narcissistic, focused on cultivating their own talents and expressing themselves rather than on doing anything of practical value to help the needy. In the popular imagination, art is largely produced for the expensive tastes of those who can afford it, rather than having much to do with helping the poor. In the typical church, volunteers and budget allocations for the choir or art program may be in direct competition with those for a soup kitchen, homeless shelter, or social-action ministry. If music and the arts are helping to revitalize America's churches, they may be doing so, therefore, at the expense of churches' traditional emphasis on community service.

The Arts and Religion Survey offers a way to determine empirically whether interests in spirituality and involvement in the arts inhibit serving others or whether there may be a more positive connection. In the survey, respondents were asked if they were involved in some charity or social-service activity, such as helping the poor, the sick, or the elderly. Because some people may perform such activities entirely among their own family members or friends, respondents were also asked how many hours a week they spend volunteering. Nationally, only about one person in six (17 percent) is currently involved in charitable or service activities *and* volunteers more than an hour a week. This is perhaps a more conservative estimate of the numbers who are doing something

intentionally to help the needy than some other studies suggest, but it is good to be cautious about such estimates, and this one makes it possible to determine which segments of our society are most—and least—likely to be involved in helping others.

As in other studies, older people are more likely than younger people to be involved in serving others, judging from the survey (table 24). These differences are probably because younger people are busier establishing themselves in their careers and parenting young families, whereas older people may have empty nests and be retired. People with higher levels of education are more likely to be involved in serving others than those with lower levels of education. These differences are partly due to the fact that the former have higher incomes that may give them more opportunities to serve others, rather than focusing on meeting the needs of their own families, but are probably also due to educational experiences and working in the professions. Women are somewhat more likely to be involved in serving others than men are—although the difference is small, probably reflecting the fact that more and more women are working in full-time jobs. Consistent with other research, church members are more likely to serve others in this way than nonmembers are, and those who attend church services every week are almost three times as likely to be involved in helping others than those who attend less frequently. Evangelicals are somewhat more likely to serve others (perhaps because they attend more often), but otherwise there are no differences between Protestants and Catholics.

More to the point, devotional activity, far from discouraging service to others, is positively associated with it: the more people pray and meditate, and the more emphasis they place on spiritual growth, the more likely they are to be involved in serving others. The differences are large, and they cannot be explained away by other factors, such as age, gender, level of education, or frequency of church attendance.

Interest in the arts also appears to be *positively associated* with being involved in serving others. Among those at the high end of the Artistic Interest Scale, more than a quarter are involved in helping others, whereas this proportion drops to fewer than one in ten among those at the low end of the scale. Again, these differences cannot be explained away by factors such as age, gender, level of education, or frequency of church attendance.[17]

But why should the arts encourage people to help others? Surveys are of limited value in answering questions like this, but further analysis of specific kinds of exposure to the arts, both during childhood and as

TABLE 24. Participation in Service Activities Is More Common among the Religiously Involved, Those Who Value Spiritual Growth, and Those Who Score High on the Artistic Interest Scale

(Percentage in each category who say they are involved in some charity or social service activity and who volunteer more than one hour a week)

National	17%
Age 18–29	12
Age 30–49	17
Age 50 and over	20
Grade school	6
High school	13
Some college	23
College graduate	24
Male	16
Female	18
Church member	22
Nonmember	9
Attend church every week	29
Attend less often	10
Evangelical or fundamentalist	26
Mainline or liberal Protestant	21
Roman Catholic	20
Pray every day	22
Pray less often	10
Meditate nearly every day	27
Meditate less often	12
Spiritual growth is:	
Extremely important	26
Very important	20
Fairly important	12
Not very important	6
Spiritual effort:	
Great deal	31
Fair amount	17
A little	11
None	6
Artistic Interest Scale:	
0 (Low)	1
1	8
2	13
3	19
4	22
5 (High)	27

adults, suggests the following: Some artistic activities help to create so-
cial capital—that is, relationships with other people, as in the bonds
formed by playing in an orchestra or singing in a choir—and these ties
are known to encourage helping others by instilling self-confidence,
building interpersonal trust, and putting one at risk of being asked to
participate in helping others. Some artistic activities, such as reading
poetry, viewing plays, or visiting museums, encourage reflection about
basic values and the larger human condition, and such reflection may
result in efforts to help the needy. And in some instances, the arts in-
volve acquiring skills that can be used directly in serving others, such as
helping children from low-income families to paint or draw or putting
on musical performances for the elderly. In contrast, artistic activities
that are engaged in purely for entertainment, or to pass time, appear not
to encourage helping others.

How the arts, spirituality, and service come together can be under-
stood best by considering the lives of some specific individuals whose
stories show that a passionate commitment to the arts can be a power-
ful way in which to serve others. Usually, though, it takes something
else to propel people into action—a personal encounter with someone
in need, a shattering experience in one's own life, the prodding of a
friend or mentor, the encouragement received from other members of
one's religious community, or even a divine call.

The year is 1986. National attention focuses on acquired immune dis-
order syndrome as tens of thousands of young Americans fall victim to
a seemingly incurable disease of epidemic proportions. In San Fran-
cisco, an African American mother in her early thirties turns down the
lights one evening and pours herself a glass of Hennessy cognac. The
melancholy strains of Donny Hathaway in the background reflect her
mood. She is on the verge of despair because one after another of her
neighbors and friends are dying of AIDS. Although she has been reli-
gious all her life, she has seldom felt that God was speaking directly to
her. Tonight is different. A voice clamors in her mind telling her to do
what she can to mitigate the suffering. She turns off the music ("I did
finish my drink," she laughs) and thinks seriously about what she might
be able to do.

Yvette Flunder is an artist, not an activist or a social worker. The
daughter of a jazz musician and a choir director, she began her musical
career at age three when her mother stood her on the communion table
at the front of the church and told her to sing. A few years later, she
joined an ensemble that toured from church to church. During high

school and college, while majoring in business, she devoted her spare time to vocal practice and training.

The "call" she felt that evening to help people with AIDS was not the first time her conscience had been pricked. On a visit to Mississippi in the late 1960s, she had been refused service at a lunch counter because of her race. She came home determined to work for racial equality. Following in the steps of her maternal grandfather, who had died when she was eighteen, she decided to enter the ministry. She attended seminary and began preaching part-time at a small Pentecostal church while caring for her daughter and working at odd jobs to support herself. And she continued to sing.

Knowing it would take funds to help people with AIDS, she decided her best bet was to raise money by singing. With several of her friends, she started doing benefits and eventually made an album. By 1991, she had collected enough money to start a fifteen-member church and to rent a house in which several homeless men with AIDS could be sheltered. By the end of the decade, her congregation had grown to more than six hundred people and the shelter had become one of the most active in the city.

One might suppose that Yvette Flunder's ministry to the needy had little to do with her prayer life or her interest in the arts. Had she not been involved in either, she still might have been moved by seeing people in her neighborhood dying of AIDS, and she might have been inspired to help them because of her experiences with racial discrimination. But the odds would have been lower. Prayer put her in the mood to hear God's call. It turned her despair into hope. And her music became the vehicle with which to raise money and was a centerpiece of her ministry.

Across the continent, Sister Anne Shaw works with indigent men, women, and children in one of the poorest neighborhoods in Philadelphia. In her late sixties now, she is having to slow down a little, but her present work is proving more challenging—and rewarding—than anything she has ever done. She provides art therapy at a hospitality center for people who are chronically mentally ill. Most are unemployed, disabled, and homeless. Giving them an opportunity to paint is a way of giving them new life: "The people who paint, who come regularly, sort of stabilize. My belief is that if all your outer resources should slip away or aren't functioning or working for you, you have your inner resources. The inner resource that I try to help them reach for is their own creativity, believing, without preaching to them, that we are most like God

in the creative act, and beyond that, that color, which is light, is also the light of the world or the divine light that will spark something and begin a healing process in them." She says the process itself is therapeutic: "I just let them plunge in. The projects are usually something that will evoke their own creativity. I may have a starter project, but it's not about landscape drawing and it's not about still life, although it could be, but it's more about self-expressiveness, finding the within and looking at it. I do not act in the role as counselor in that setting. My belief is that if I see it, they see it, and we don't have to talk about it, because it's there." Sometimes she asks the people to paint something that represents themselves; sometimes she just lays out colored paper, scissors, and paste and lets people take it from there.

Having dabbled in art as a child, she began pursuing it more seriously in her late twenties. It was still a hobby, but she took classes and became technically proficient. Then, working as a counselor, she decided to integrate her artistic interests into her work. She learned to be an art therapist but found the formal requirements of this role too restraining. Most of her training has come from reading widely on her own, taking classes, and attending retreats. These classes put her in contact with other artists who were working with the needy. One asked her to come help with her program. Sister Anne learned most of what she now practices by working in this program. "I think I was hearing the radical call of Jesus and the gospel to the poor," she observes. "I was there for three years and I just loved it. I loved the people, I loved the work that they were doing."

But what motivates her the most is knowing that what seems to help others has helped in her own life. "I know the process has worked for me, painting expressively, finding images, and believing that images come from the creative spirit within, the God within each person. I've done that personal work. I just know that it works. If I get into this process, I trust it, the images come. I feel like they are a gift, just like the dream image is a gift. There's a creator in there that we all have. This isn't *the* way, but it is the way I have discovered to access that truth within, the individual truth spoken to the individual soul. I love sharing that. I trust the process, so I take that trust to people who are visibly the most broken people I know and I see. What I see is their beauty, the way they project their images which are very truthful and honest. It's not sophisticated art at all. It's very humble, but it's very truthful and very beautiful. There's something very pristine about it, so I know that it's true and honest."

This is not all that motivates Sister Anne. She says the idea of service is implicit in her understanding of spirituality. It comes from knowing about Jesus and from reading about role models (such as Dorothy Day). She feels that she has had many advantages in life and thus has an obligation to give back. From other sisters she has learned that it is more blessed to give than to receive. Her art is a path to receiving grace in her own life, so she enjoys passing this gift to others.

Few people may be able to devote themselves so fully to serving others. But most of the people we talked to who are engaged in spiritual direction or other devotional activities have found themselves drawn into some form of service. Sally Palmer does volunteer work four hours a week at a hospice for mothers and children who are dying of AIDS. "I live a life of great privilege, and that's a gift. So I feel I have an obligation and a desire to share that." A Lutheran man who plays the saxophone performs regularly at the state prison. He believes in using his musical talent as a way of ministering to the inmates. A woman who is deaf considered entering the ministry but decided to become a visual artist instead; she also works now with prisoners. She thinks the constraint of being unable to hear has given her an understanding of their confinement.

What sets these people apart from the many Americans who seldom do anything to help the needy, and what must be present for the arts to play a factor in their desire to serve? In most cases, a parent or another role model has had a decisive influence, usually by setting an early example of involvement in helping others. Coincidence is important, often putting someone in contact with a needy person almost by accident. But coincidences like this happen to nearly everyone, so what matters is a predisposition to take them seriously. A spiritual orientation often suggests that they are not coincidences at all, but the leading of God. Artists may have a stronger predisposition to identify with the needy, too, because many of them have been marginalized by their careers. Making little money, or being shunned by family members who thought they should be making more of their lives, they may have suffered poverty themselves, lived in low-income neighborhoods, or known how it felt to be unsure of one's future or plagued by self-doubt. Yet another factor is the conviction that helping a few people—or even one person—matters. Both spirituality and the arts seem to reinforce this conviction, spirituality by emphasizing the unique value of each person in relation to God, and the arts by focusing attention on individual gifts and the need for self-expression.

The influence of a person's social context is also evident in these examples. Participating in a church, being a member of a religious order, living in or working with a religious community, or being employed by a faith-based or service-oriented organization all provide encouragement and, indeed, establish social norms that make it harder for people not to get involved in helping others. But these social contacts are also reinforced by beliefs. Religious convictions tell people that they have a responsibility to help the needy. Artistic orientations may or may not carry such humanitarian concerns, and yet many artists firmly believe in the interconnectedness of life, not only of human life with the living environment, but also among humans themselves. This conviction makes it harder to avoid reaching out to people in need. For some artists there is another conviction that propels them in this direction: unlike some of their counterparts who require serenity in order to work, they believe that some creative tension, unsettledness, or even risk is necessary to produce good work. In all these ways, then, the arts and spirituality may come together to generate acts of service.

The Arts and Devotional Life

The examples considered in this chapter make it abundantly clear that not all varieties of music, art, and literature are likely to be included as part of people's devotional activity. In conversations with hundreds of people of all ages, ethnic backgrounds, and regions, not a single person mentioned that their devotional life had been enriched by Snoop Doggy Dogg or Motley Crüe. We may have missed someone upon whom these musicians have had a positive spiritual impact, of course. But it is much more common for people to mention classical music or lyrics with explicit Christian content, icons and pictures of biblical characters, or poetry that focuses specifically on spiritual themes.

The variety of music, art, and literature that currently contributes to Americans' devotional lives is nevertheless considerable. If some prefer to pray with Bach or Beethoven playing in the background, others opt for Amy Grant, Enya, or an old recording of Elvis singing gospel hymns. Poetry from the Bible takes its places alongside selections from Annie Dillard and Maya Angelou. Nor are the arts that people choose to enrich their spiritual lives restricted to those with religious content. Sally Palmer's weaving and pottery classes focus more on the *activity* of working with one's hands than on representing particular themes.

Meredith Monk's "Dawn" and David Ellsworth's wooden vessels inspire devotional thoughts for some people by their very lack of religious definition.

These materials—these songs and pottery classes and poetry—are sufficiently available in the wider culture that virtually everyone is in some way exposed to them. Entertainment conglomerates know that there is a market for gospel and New Age music, and for English choir performances and meditative classical recordings. The same is true of publishing giants that know it is possible to sell twenty to fifty thousand copies of an inspirational book by Mary Oliver or Kathleen Norris. Local congregations are often the places where people hear about these resources, either by hearing a poet mentioned from the pulpit, by singing something that stays with them during the week, or by participating in a small group whose members share tips about favorite authors, new CDs, or retreat centers. Yet it is not the congregations that produce or market most of the art and music to which Americans turn in their devotional lives. The artists and publishers, the musicians and recording companies, are industries that extend well beyond congregations or denominations. Moreover, most people who talk about the role of music and art in their devotional lives also mention that their musical and artistic interests have been encouraged by the wider exposure to the arts that they received in school and continue to maintain by attending concerts, visiting galleries, and purchasing CDs and paintings.

Because music and art are organized on a scale that far exceeds the control of religious organizations, it can legitimately be asked whether this influence is subverting that of the churches. The evidence presented here suggests that the concern implied in this question is largely unfounded. Americans are, as they have always been, a religious people—generally not noted for the depth of their spirituality, but broadly oriented toward spirituality nevertheless. When they turn in their devotional lives, as a growing number of Americans appear to be doing, to music and poetry and art, they are guided by instincts that were nurtured by their religious upbringing and that are still oriented toward deepening their relationship with God.

Music and art play an important role in the devotional lives of a vast majority of Americans. They do not replace prayer, Bible study, and inspirational reading. But anyone who thinks Americans pray only by talking to God or reciting prayers from the Bible is badly mistaken. It has become commonplace for people to listen to music while they pray, to seek the help of a favorite musician or writer to get them in the mood

for prayer, to look at icons or hold mental pictures of Jesus in their minds when they pray, and to turn to music and art for comfort when they feel especially in need.

The consequences of including music and art in devotional life appear, on the whole, to be positive. People who include them are more likely to pray often, to value their times of prayer and meditation, to feel that they have experienced the presence of God, to find spiritual comfort in their times of need, and to recognize the spiritual implications of music and art. A few people mention that they absolutely do not find music and art beneficial, and some say it is downright distracting. But for most people who seriously want to grow in their spiritual lives, the arts have become a form of encouragement.

This conclusion must be placed in perspective. The fact that music and art play positive roles in Americans' devotional lives is in no small measure due to the mental overload that has become so widely familiar in our society. People complain of simply having too many things on their minds: serious professional or workplace decisions that occupy their minds throughout the day; shouldering responsibility for the well-being of their families; staying in contact with dozens of friends and coworkers by telephone or email; and being besieged with information from television, newspapers, and the Internet. What they need more than anything else in order to pray is the mental space in which to do it. This is why they repeatedly talk about music and art helping to quiet their minds, helping them to "focus" or "center," and directing their thoughts away from the immediate and toward the transcendent.

The role of music and art in devotional life is also shaped by the pervasive conviction that it is possible to somehow *feel* the presence of God. Most Americans intuitively sense that prayer should be different from reading the newspaper or studying for a science test. Mood and ambiance matter. One's mind should be quiet. The space and time in which one prays should be set apart, sacralized in a way that differentiate them from the hustle and bustle of daily life. Not all prayer need be this way (certainly not the brief utterances that people squeeze into their workaday routine), but some of it must be: the fifteen minutes in the morning or evening that people with the most serious interest in spirituality point to as the core of their devotional lives. In these times, one expects to hear from God as one prays, perhaps not audibly, but at least by feeling more comforted, secure, or serene. Music and art help. They set the mood, bringing one's feelings and even one's body into a state that seems more in tune with the divine.

Were these devotional times purely contained in the privacy of people's innermost lives, they might well result in all sorts of self-absorbing pathologies. But personal devotion is seldom this isolated. People who pray also take part in small groups where they learn from other people, and many of them engage in service activities aimed at helping those less fortunate than themselves. The arts play an important role in these social aspects of devotional life as well. People listen to music together and thus share it as a common experience, or, short of that, they talk about the books they have read, share tips about favorite authors, and meet like-minded people at their weaving and pottery classes. And for some, especially those who are encouraged to do so by taking part in congregations or other religious communities, the arts create opportunities for serving others.

The Joy of Worship

Expression and Tradition in Congregational Life

Whatever else it may be, American religion is a vast network of congregations and meeting houses, fellowship halls and temples, cathedrals and chapels. And in these places of worship, just as in the private devotional lives of individuals, the influence of music and art on spirituality is becoming increasingly apparent. Church members, recognizing the spiritual implications of the arts, are overwhelmingly interested in them. In most churches, music and art play important roles in worship and in the social life of the congregation. In some congregations, innovative uses of music and art are also a source of new vitality.

The art sections of most newspapers don't reflect it, but churches are one of the main places in nearly every community where people are exposed to the arts. Other than school, churches are where children learn to sing. For most adults, church services are the *only* place where they regularly sing with others, and many adults rarely hear live performances of music except at church. Increasingly, churches are advancing other forms of artistic expression as well: performing skits and dramas, staging liturgical dance in worship services, sponsoring concerts and poetry readings, hosting theater companies, and organizing book discussion groups.[1]

While it is clear to most churchgoers that hearing music during a worship service or listening to the pastor quote a poem during a sermon is different from going to a concert that just *happens* to be held in the church auditorium, the boundaries between spirituality and the arts in congregations are increasingly blurred. Strict teachings in some traditions that for many years excluded all kinds of visual art from church

buildings have gradually been relaxed. Musical instruments that were once considered secular are now used to accompany congregational singing. The verbal communication of the gospel, long performed exclusively through the spoken word, is augmented by dramatic performances and concerts. At the same time, sacred art that was once supervised by church authorities is increasingly available for viewing at museums and galleries and on college campuses and in public buildings.

Consider the following example. On a typical Friday evening, a symphony orchestra in Dallas does *not* perform at a concert hall, but in the auditorium of its sponsor—Prestonwood Baptist Church. Until recently, this church was located at the corner of Hillcrest and Arapaho in a quiet, upscale residential area of the city. It was founded in 1979 by 150 Southern Baptists who hoped the city's rapidly growing population would generate unparalleled opportunities for church expansion. That hope was soon realized. The congregation grew steadily until, in the early 1990s, its expanded physical plant (a modern brick structure that was sometimes mistaken for a movie theater) encompassed nearly five square blocks. Inadequate parking, not to mention the need for additional meeting space, encouraged the church's leaders to purchase a 138-acre tract in the suburban community of Plano, on which a luxurious thirty-six-million-dollar worship facility was opened in 1999. A new family center adjacent to the sanctuary houses classrooms, the Prestonwood Christian Academy, and other activities for all ages. Membership currently exceeds fifteen thousand.

With an annual budget in excess of ten million dollars, Prestonwood Church supports more than a hundred full-time employees, including two dozen pastors. Four of the pastors head the church's extensive musical programs. Besides the 80-member orchestra, there is a 450-member adult choir, a contemporary "praise band" that performs at Sunday-evening services, several vocal ensembles, and five children's choirs for preschoolers through high school. Each year the orchestra and adult choir are featured in the church's "Dallas Christmas Festival," which is attended by more than thirty thousand people and viewed nationally on network television.

Prestonwood's music program illustrates one way in which religion and the arts are currently converging: larger and more powerful religious organizations, often responding to wider cultural influences, are playing a more significant role as producers of religious art. The scale of Prestonwood's membership, staff, and budget is the key to its ability to sponsor such a sizable music program. Smaller churches would have nei-

ther the funds to hire four music ministers nor the space in which to hold such activities. Equally important are the church's state-of-the-art satellite broadcasting equipment and its experienced sound, lighting, and recording technicians.

Besides its music program, Prestonwood Church sponsors a wide variety of other artistic activities. Its monthly "Saturday Nights in Dallas" concert series draws more than forty thousand people annually to hear performances by nationally known Christian vocalists and instrumentalists. It publishes a full-color monthly magazine that complements routine church announcements with photography, essays, and testimonials. Its Sunday services frequently include short dramatic performances, as do special weekday events. Its bookstore is well stocked with Christian fiction and self-help and inspirational books, and several of its many small-group fellowships devote meetings to discussing these books. Its new worship facility, with award-winning architectural design featuring an Italianate bell tower, glass-encased sanctuary, and landscaped fountains, differs dramatically from its more functionally oriented setting of the 1980s.

The Prestonwood example is not atypical. A similar smorgasbord of artistic activities has emerged at such "megachurches" as the seven-thousand-member Trinity Church in Lubbock; the eight-thousand-member Brentwood Baptist Church in Houston; the six-thousand-member Jubilee Christian Center in San Jose; and the seven-thousand-member Calvary Chapel in Philadelphia. Calvary Chapel, for example, offers a bookstore for adults and a video library for children; art classes at its day-care center; a contemporary instrumental ensemble that performs at most worship services; and regular concerts. Jubilee Christian Center boasts a contemporary worship service with "cutting-edge" music directed by the nationally prominent Ron Kenoly, a multimedia center, and frequent performances by guest musicians.

Families gravitate to these churches because they enjoy the opportunity to worship with music sung by a large choir, or appreciate the fact that their children can receive music lessons at the church or go there for Christian rock concerts when they are a little older. In such settings, it is possible to hear good preaching *and* find a full menu of suitable entertainment, ranging from CDs and Christian fiction in the church bookstore to art classes and craft fairs for the whole family.

But what about the average church and the average church member? Are church members at large interested in the arts? Or are these interests only being furthered at a few exceptional churches with budgets

sufficient for producing fine music and art? If there *is* widespread interest in the arts among church members, then appealing to this interest may indeed be one of the ways in which churches are enriching their programs and attracting more active involvement by their members.

The Artistic Involvement of Church Members

In table 25, a wide variety of items from the Arts and Religion Survey is shown. The responses to these items are given for members of evangelical or fundamentalist Protestant churches, members of mainline Protestant churches, and members of Catholic churches.[2] Only those people in the survey who said they were currently members of churches are included here. There are many local variations among parishes and from denomination to denomination or community to community. Nevertheless, these results give a broad overview of how much or how little the members of these three Christian traditions currently are interested in the arts.

The data reveal that the vast majority of church members in all three traditions consider the arts (here, referring to painting, sculpture, music of all kinds, dance, theater, and creative literature) to be important in their personal lives. Among evangelicals, three-quarters do, and among mainline Protestants and Catholics, more than four in five do. This means that the typical pastor, looking out at his or her flock on a given Sunday morning, can be pretty sure that most of the congregation has some appreciation of the arts. They enjoy listening to music, like to read fiction or poetry, consider it important to go to the theater or to a museum once in a while, or have dabbled in the arts themselves.

Of course, there are varying degrees of interest in the arts. When asked if the arts have been *very* important in their lives, the proportion responding affirmatively sinks to about half among mainline Protestants and Catholics and to only a third among evangelicals. Still, these are substantial proportions, probably higher than some pastors might have guessed. And this self-perception of the arts as important is borne out in questions asking about behavior: about two-thirds of church members in all three traditions have purchased music on a CD or tape in the past year, and between a quarter and a third (more among mainline Protestants and Catholics than among evangelicals) have attended a concert, visited an art gallery or museum, done arts and crafts, read poetry, or purchased art in the past year.

TABLE 25. How Evangelicals, Mainline Protestants, and Catholics Compare on Measures of Artistic Involvement

(Among those in each column, the percentages who respond as indicated to each question about the arts; for church members only)

	Evangelical or Fundamentalist	Mainline Protestant	Roman Catholic
Arts are at least fairly important	74%	81%	85%
Arts are very important	36	49	47
Purchased music in past year	64	69	72
Attended concert in past year	22	34	31
Visited art gallery or museum in past year	18	33	30
Did arts and crafts in past year	30	40	32
Read poetry in past year	31	34	25
Purchased art in past year	32	36	38
Played instrument as a child	42	53	48
Was in band or orchestra as a child	23	24	22
Sang in a choir at school as a child	50	56	43
Sang in a choir at church as a child	58	57	39
Was in a school play as a child	56	58	52
Took art classes as a child	39	48	42
Kept a diary or wrote poetry as a child	39	40	32
Relatives are interested in the arts	42	54	50
Friends are interested in the arts	42	50	50
Go with church friends to art performances	40	37	37
Church friends are in the arts	25	23	21
NUMBER	(295)	(227)	(273)

If there is considerable interest in the arts among church members as adults, it is also the case that a majority of church members have had some exposure to the arts as children. On average, about half of church members in all three traditions learned to play an instrument while they were growing up. More than half performed in a school play, sang in a choir at school, or sang in a choir at church. About four in ten took art classes as children, and about a quarter played in the band or orchestra. The fact that so many were involved in church choirs as children is particularly important. In a few prominent cases, such experiences were the basis for careers in music (one thinks of recording artists Whitney Hous-

ton and Jessica Simpson), while in many others they contributed to members' lasting interest in the church as well as in the arts. Given the fact that evangelicals appear somewhat less likely than mainline Protestants or Catholics to participate in the arts as adults, it is also interesting that they do *not* differ much in their childhood artistic activities, suggesting that evangelicals certainly are exposed to the arts through such venues in the wider culture as school plays, bands and orchestras, and school choirs.

Churches pride themselves on being "communities" by promoting social relationships among members, and for this reason it is important to understand, too, that artistic interests are *shared,* rather than being only personal and private. About half of church members say they have relatives who are interested in the arts, and about half say they have friends who are interested in the arts (slightly fewer among evangelicals than among mainline Protestants or Catholics). These are people with whom church members are likely to interact, either in their congregation or elsewhere, and the arts appear to be one common ground for such interaction. That such interaction actually does happen in churches is further suggested by the data: close to four members in ten say they go with friends from their congregation to plays, art galleries, concerts, or other artistic performances. And about a quarter of church members say that some of their church friends actually work as artists, musicians, or writers or in arts-related fields. Perhaps because they are more likely to choose friends from their own congregations, evangelicals are actually somewhat *more* likely than mainline Protestants or Catholics to say they go with church friends to arts events or have church friends who work in the arts.

Many things go on in congregations: bridge clubs, business deals, food drives, and service projects, not to mention preaching, Sunday-school classes, Bible study groups, and programs for children. But these results show that congregations are also full of people with interests in the arts—they are involved in singing or listening to music, go to concerts and art galleries, trained in art or music or drama while growing up, and are connected to friends and fellow church members who go together to arts events or who work in the arts. To say that all church members have some interest in the arts would be an overstatement—but not much of one. Nearly all church members, whether evangelicals, mainline Protestants, or Catholics, have been exposed to the arts in some way or another as children, and most have continued to be interested in some form of artistic expression as adults.

But do they see a connection between the arts and spirituality? It could be that art and music are activities that church members pursue simply for entertainment. The idea of blurred boundaries between religion and the arts, however, suggests that church members would probably recognize that the arts are somehow part of their religious tradition and therefore capable of enriching their own spiritual lives and the lives of others.

It is, therefore, interesting to observe that the vast majority of church members agree that there is a lot of music and poetry in the Bible (table 26). Among evangelical and mainline Protestants, nearly eight in ten agree that this is the case, while among Catholics, about two-thirds do (more Catholics than Protestants say they don't know). About as many—at least seven in ten—church members in all three traditions agree that any art or music can be a way to communicate one's spirituality. In other words, a person might sing as a way of sharing the gospel with others, or paint or write poetry inspired by the beauty of God's creation, or do something similar. An even larger proportion (about nine in ten) believe, as church leaders from Gregory the Great to Martin Luther and Charles Wesley did, that music is an excellent way to teach children about the Bible. And more than half of church members agree that art can help people to deepen their spirituality and that pictures and images enrich our spiritual lives.

We have already considered the extent to which the arts are part of the devotional lives of Americans in general. In thinking now about church members in particular, it is important to recognize that a majority (perhaps as many as six church members in ten) include music or other art forms in their personal times of prayer. It is interesting, too, to see what stimuli are most likely to make church members feel close to God. For pastors' sake, it is probably encouraging to know that listening to sermons is still one of the most common ways in which church members gain a feeling of closeness to God: this is especially true among evangelical Protestants (among whom 82 percent say they have felt close to God in the past year while listening to a sermon) and also is the case for most mainline Protestants (72 percent), but it is true of a slightly smaller share of Catholics (62 percent). The responses concerning sermons are most interesting, though, as a standard against which to compare those for various artistic forms. For instance, just about as many church members say they feel close to God during the musical part of a worship service as during the sermon (slightly more, actually, among mainline Protestants). And, apart from the worship service, nearly three-

TABLE 26. How Evangelicals, Mainline Protestants, and Catholics Compare on Views of Spirituality and the Arts

(Among those in each column, the percentages who respond as indicated to each question about the arts; for church members only)

	Evangelical or Fundamentalist	Mainline Protestant	Roman Catholic
There is a lot of music/poetry in the Bible	79%	78%	65%
Any art or music can be a way to communicate one's spirituality	71	77	73
Music is an excellent way to teach children about the Bible	93	93	81
Art can help people to deepen their spirituality	46	60	62
Pictures and images enrich our spiritual lives	54	66	54
Pray using art or music	60	53	59
Felt close to God listening to a sermon	82	72	62
Felt close to God from music during worship	80	76	56
Felt close to God from other church music	67	56	38
Felt close to God attending a concert	24	22	12
Felt close to God viewing a painting	21	25	30
Felt close to God reading poetry	14	17	12
Felt close to God doing arts and crafts	10	12	10
Felt close to God from any music or art	73	65	54
Music important in spiritual life	81	72	61
Singing/instrument important in spiritual life	54	41	30
Poetry important in spiritual life	43	39	39
NUMBER	(295)	(227)	(273)

quarters of evangelical Protestants say they have felt close to God during the past year as a result of some other musical or artistic exposure, as have two-thirds of mainline Protestants and half of Catholics. Church music performed at times other than the worship service is the most common source of such experiences, but as many as a quarter of church members say they have felt close to God in the past year while attending a concert or viewing a painting.

When asked to assess the overall importance of various art forms to their spiritual development, a large majority of church members say that music has been important: 81 percent of evangelicals, 72 percent of mainline Protestants, and 61 percent of Catholics. Fewer say that actually singing or playing a musical instrument has been important, but the proportions are not small: a majority of evangelicals say this, for example. And, in all three traditions, about four in ten say that reading literature or poetry has been important to their spiritual development.

Most church members, therefore, do see specific connections between music, art, or other forms of artistic expression and their spiritual lives. Despite somewhat lower levels of involvement in artistic activities in general, evangelicals are more likely than mainline Protestants or Catholics to see these connections. Compared with evangelical or mainline Protestants, Catholics are somewhat less likely to draw connections between the arts and spirituality—a finding that is perhaps surprising, given the history of Catholic sponsorship of the visual arts, but less surprising when the lack of emphasis on congregational singing prior to the Second Vatican Council is considered. In any case, the vast majority of church members in all three traditions recognize the spiritual potential of music and the arts. From the evidence considered previously, we know that the relationships between art and devotional life appear to be mostly beneficial. In the context of churches, it is important to know that most members have been positively influenced by the music at their churches or by other musical and artistic experiences, and that most recognize the potential of the arts for conveying biblical truths and spiritual experiences.

What Churches Are Doing

To the naive observer, churches are probably recognized as places where people routinely mouth hymns on Sunday mornings or occasionally put on Christmas pageants. A megachurch such as Prestonwood Baptist that can host a large number of formal artistic events is the stuff from which newspaper stories are made, but is by no means typical. So, the question remains: What does the typical church member actually experience at his or her church? Are most members exposed to formal artistic activities, or not?

The most common artistic activity to which the typical church member is exposed is an adult choir. About four in five members of evangel-

TABLE 27. Artistic Activities Sponsored by Different Kinds of Churches
(Percentages of evangelical Protestants, mainline Protestants, and Roman Catholics who say their congregation has sponsored each activity within the past year; for church members only)

	Evangelical or Fundamentalist	Mainline Protestant	Roman Catholic
An adult choir	78%	80%	67%
A children's choir	64	63	55
A drama or skit	55	46	32
Any musical performance other than during worship services	53	48	32
An art festival or craft fair	22	37	55
Any group discussion of art, literature, or poetry	12	20	26
A liturgical dance performance	8	8	16
Private music lessons	8	11	10
NUMBER	(295)	(227)	(273)

ical and mainline Protestant churches say their congregations have sponsored an adult choir in the past year, as do about two-thirds of Catholics (table 27). Children's choirs are not as common but are apparently present in a majority of the congregations to which church members belong: two-thirds of evangelical and mainline Protestants and more than half of Catholics say their congregations sponsor one. The use of drama or short skits during the worship service has been seen by church leaders as an innovative strategy in recent years for communicating some of the ideas that will be further developed in the sermon, but drama and skits are apparently not as novel as sometimes suggested (or they have caught on quickly): 55 percent of evangelicals say their congregations have sponsored a drama or skit in the past year, 46 percent of mainline Protestants say this, and 32 percent of Catholics do. Other musical performances (i.e., outside of the normal worship service) also appear to be fairly common, mentioned by approximately half of evangelical and mainline Protestants and a third of Catholics. Such performances range from Saturday-night pop/rock concerts by Christian groups, to Sunday-evening or holiday performances by the choir, to opening the church building for performances given by musical groups from the wider community.

While these musical and dramatic activities apparently are more commonly experienced by Protestants than by Catholics, several other artistic activities are mentioned more often by Catholics than by Protestants. One is the art festival or craft fair, an annual tradition in many

Catholic parishes but increasingly common in all traditions as a way to raise funds for special projects or simply to showcase the talents of interested parishioners. Fewer than a quarter of evangelical Protestants say their congregations sponsor one of these, but this figure rises to 37 percent among mainline Protestants and to 55 percent among Catholics. Group discussions of art, literature, and poetry are also more commonly mentioned by Catholics (26 percent) than by mainline Protestants (20 percent) or evangelicals (12 percent). On the whole, this figure corresponds well to the fact that in other research about two-thirds of church members say their churches have small groups of some kind and that about a third of these groups focus on art, literature, music, or poetry. Catholics are also more likely to say their congregations sponsor liturgical dance (16 percent) than are mainline or evangelical Protestants (8 percent), a fact that is probably explained by liturgical dance usually being incorporated into the processional in liturgical settings such as those common in Catholic or Episcopal churches.[3] Finally, about one member in ten says his or her church offers private music lessons. In short, these figures show that churches are indeed one of the important places in which many Americans are exposed to the arts.

The single characteristic of congregations, other than their confessional tradition, that most influences the likelihood of members saying their churches sponsor various artistic activities is *size of the congregation*. For all of the activities considered, size has a statistically significant effect.[4] The nature of this effect can be illustrated by the following comparisons: among evangelical Protestants, 46 percent of members in congregations of fewer than one hundred say their churches sponsor a children's choir, but this proportion rises to 85 percent in evangelical congregations of more than a thousand members; in mainline Protestant churches, 35 percent of members in congregations of fewer than a hundred report that their churches sponsor concerts, compared to 77 percent in churches of more than a thousand members; and among Catholics, 12 percent of members in parishes of fewer than two hundred remember liturgical dance performances, compared with 21 percent in parishes of more than a thousand members.[5]

Does greater size make it possible to have more artistic programs? Or do artistic programs lead to greater size? These are not questions that can be readily answered with survey data. We would need to know the histories of congregations (and from what is known about church growth, it appears that many factors, including location and leadership, play a role, not just the presence or absence of specific programs). Still,

TABLE 28. Church Members' Religious Experiences and Attitudes
Are Associated with Congregational Artistic Activities
(Percentages of church members in congregations with low, medium, or high levels of arts activity who give each of the responses indicated; for church members only)

	Congregational Arts Activities		
	Low	*Medium*	*High*
Have felt uplifted during the past year	68%	86%	92%
Felt close to God during a worship service	53	70	83
Felt close to God listening to music	40	50	69
Music very important in spiritual life	29	37	43
Spiritual growth is extremely important	29	33	46
Great deal of effort to spiritual growth	22	31	43
Increasing interest in spirituality	42	52	62
Increasing interest in religion	36	45	55
NUMBER	(247)	(307)	(373)

NOTE: "Low" refers to congregations that sponsored none or only one of the artistic activities listed in table 27; "medium" refers to congregations that sponsored two or three of these activities; and "high" refers to congregations that sponsored four or more of these activities.

the fact that so many church members value the arts and have been positively influenced by the arts suggests that churches *may attract members* if good musical and artistic programs are part of these churches' activities.

Apart from church growth, we can make use of the survey data to address certain questions about the relationships between congregational musical and artistic activities and the spiritual lives of church members. In table 28, church members are classified into three groups: those who said their congregations sponsored none or only one of the musical and artistic activities previously discussed, those who said their congregations sponsored two or three of these activities, and those who said their congregations sponsored four or more of these activities. The purpose of the table is to see if congregations with more musical and artistic activities seem to be ones with members who are experiencing certain kinds of spiritual experiences and spiritual growth. For instance, insofar as music and art serve for many people as an uplifting experience, we might expect that congregations with more musical and artistic activities would be more likely to have members who said they had felt uplifted at some point in the past year (even though this uplifting could have happened in other settings). The data show that this is the case: where congregational arts activity is low, 68 percent of members report having had an uplifting experience, compared with 86 percent

where congregational arts activity is medium, and 92 percent where it is high. In other words, it would at least be consistent with these results to assume that a greater emphasis on the arts in congregational life may be conducive to members having uplifting experiences.

Other attributes of the spiritual lives of church members also appear to be positively related to the presence of congregational arts activities. In congregations with high levels of musical and artistic activity, members are more likely to say they have felt close to God during a worship service or while listening to other music than those in congregations with lower levels of such activity. Similarly, congregations with high levels of arts activity are more likely to have members who say music has been important to their spiritual life—a finding that, of course, could be the result of some congregations *attracting* the musically oriented. But it is also telling that congregations with more arts activities are more likely to have members with all of the following characteristics: ones who say spiritual growth is extremely important, ones who devote a great deal of effort to their spiritual development, ones who say their interest in spirituality is increasing, and ones who say their interest in religion is increasing. These relationships, moreover, cannot be explained away by the sheer size of the congregation or by the frequency with which members attend services at their churches.[6]

Although one should avoid drawing strong inferences from these results, they nevertheless suggest that the presence of musical and artistic programs in congregations is probably beneficial for the spiritual development of church members. This benefit has been widely assumed by some church leaders, perhaps especially by choir directors and church musicians. But this is the first time that evidence supporting this assumption has been available. It suggests that congregational arts programs are conducive to such direct consequences as might be anticipated, such as feeling close to God while listening to music or saying that music is important to one's spiritual life. The evidence also suggests wider implications: valuing spiritual growth, working at it, and having an increased level of interest in spirituality and religion.

Church leaders might infer from these results that devoting effort to starting and maintaining church choirs, concert programs, literary discussion groups, and the like is a good way to spark the spiritual interests and development of their members, and this would probably be a valid inference. What about members themselves, though? Which kinds of activities and programs would they most like their congregations to sponsor? And how do music and arts programs fare in relation to other options for expending congregational resources?

TABLE 29. Many Church Members Would Like Their Congregations to Sponsor More Activities Concerned with Spirituality and the Arts

(Percentages of evangelical Protestants, mainline Protestants, and Roman Catholics who say they would like to see each of the following; for church members only)

	Evangelical or Fundamentalist	Mainline Protestant	Roman Catholic
Would like their own congregation to sponsor:			
A class to help people deepen their prayer life	63%	56%	41%
More information about spiritual retreats, seminars, and conferences	42	37	35
Opportunities for people to examine the teachings of other world religions	24	40	34
A worship service that features contemporary music	26	32	24
Art festivals, concerts, or poetry readings	22	34	35
A discussion group for people to share their interests in literature, music, or art	16	28	29
Sermons that incorporate ideas from the arts and literature	12	21	19
Would like to see happen in the next few years:			
Churches doing more to encourage the work of artists, musicians, and writers	34	37	34
Art museums and galleries sponsoring more exhibits dealing with spirituality	30	31	27
Churches should experiment more with new forms of music and art (agree)	38	50	56
Churches should encourage the artistic talents of their members (agree)	78	76	71
NUMBER	(295)	(227)	(273)

The data in table 29 show how members of evangelical Protestant, mainline Protestant, and Catholic churches view a variety of hypothetical programs that their congregations could possibly sponsor in the future. At the top of the list in terms of preference is the idea of a class to help people deepen their prayer lives. A class like this is favored by nearly

two-thirds of evangelicals, by more than half of mainline Protestants, and by four in ten Catholics. That so many would like to see a class of this kind is further testimony to the potential role that churches could play in shaping the devotional interests that seem so widespread among Americans today. Also favored by a significant number of church members is the idea of their congregations providing more information about spiritual retreats, seminars, and conferences. This, too, seems to be an expression of the public's wider interest in spirituality, and an indication that church members do not expect their local congregations to be the only sources of such information. The data also suggest a sizable audience for classes or other opportunities to learn more about the teachings of world religions other than Christianity: among evangelicals, only a fourth express interest, but four in ten mainline Protestants do, as do a third of Catholics. These activities have nothing directly to do with the arts but provide a baseline for comparing the popularity of other suggestions that do.

More to the point, about a quarter of church members in all three traditions say they would like their congregations to sponsor a worship service that features contemporary music. In qualitative interviews, contemporary music is usually interpreted as being part of a special worship service that makes use of such instruments as keyboards, guitars, and drums, or that includes recently written praise choruses instead of traditional hymns. A similar proportion (about a quarter) would like their congregations to sponsor art festivals, concerts, or poetry readings (mainline Protestants and Catholics are somewhat more favorable to this idea than evangelicals). And smaller proportions (ranging from an eighth to a quarter) would like their congregations to sponsor discussion groups for people to share their interests in literature, music, or art; sermons that incorporated ideas from the arts and literature; or opportunities to explore spirituality through painting, sculpture, or dance.

Not surprisingly, specific activities such as these do not gain support from a large majority of church members. But they do suggest that in any church of any size there are likely to be enough members with interests in these activities that efforts to initiate such activities could be successful. It is also the case that on more general questions about church sponsorship of the arts, there is support for greater effort in the future. At least a third of church members in all three traditions would like to see churches do more to encourage the work of artists, musicians, and writers. About the same proportion favor art museums and galleries doing more to sponsor exhibits concerned with spirituality. A majority (except among evangelicals) would like to see churches exper-

imenting more with new forms of music and art. And three-quarters think churches should encourage the artistic talents of their members.

A more expanded or innovative program of musical and artistic activities may be beyond the reach of many congregations. Yet it is important for church leaders to know that a majority (52 percent) of all church members favor the idea of their congregations sponsoring at least one of the activities just discussed (contemporary worship, art festivals, concerts, poetry readings, discussion groups about literature or art, sermons incorporating ideas from the arts, or opportunities to explore spirituality through the arts). Among evangelicals, 43 percent are favorable; among mainline Protestants, 58 percent are favorable; and among Catholics, 54 percent are favorable (table 30).[7]

Moreover, it is interesting to know *which members* support sponsoring these activities and which members do not support such sponsorship. Younger people (especially those in their twenties) are more likely to favor the idea of their congregations sponsoring artistic activities than older people are, and among those who are older, persons in their thirties and forties are more likely to favor sponsorship than people in their fifties and beyond are. Those who have been to college are more likely to favor sponsorship than those who have not been to college. There are no differences between men and women and virtually none between blacks and whites. Region makes a small difference: support is lower in the South than elsewhere. Evangelicals are less likely to support sponsorship than mainline Protestants or Catholics. Frequency of church attendance, either presently or while growing up, is unrelated to favoring sponsorship (except that those who attend once or twice a month are most likely to be supportive). Interest in spiritual growth, however, appears to be a factor: the more important spiritual growth is, the more that person favors his or her congregation's sponsorship of an arts activity. And, not surprisingly, the more interested one is in the arts in general, the more favorable one is likely to be toward arts programs in congregations.

These results suggest some interesting implications for church leaders. The future of churches clearly depends on attracting and maintaining the interest of young people; yet, on most measures, young people are less involved in churches than older people, a fact that is worrisome for the future of the church. Thus, the fact that young people are *more* supportive of congregational arts programs than older people suggests that these programs may be a way of generating greater commitment among young people. The finding concerning levels of education is similar: more and more Americans are going to college, so the future

TABLE 30. How Support for More Congregational
Arts Programs Varies among Subgroups of Church Members
(*Percentage in each category listed who want their congregation to
sponsor more artistic activities; for church members only*)

National	52%
Age 18–29	63
Age 30–49	57
Age 50 and over	45
Grade school	32
High school	46
Some college	62
College graduate	65
Male	52
Female	52
Black	49
White	52
East	55
Midwest	53
South	47
West	58
Evangelical or fundamentalist	43
Mainline Protestant	58
Roman Catholic	54
Church attendance:	
Attend every week	51
Almost every week	52
Once or twice a month	61
A few times a year	51
Childhood church attendance:	
Attended every week	51
Almost every week	56
Once or twice a month	49
A few times a year	50
Never attended	53
Spiritual growth is:	
Extremely important	56
Very important	52
Fairly important	49
Not very important	40

TABLE 30. *(continued)*
(Percentage in each category listed who want their congregation to sponsor more artistic activities; for church members only)

Artistic Interest Scale:	
0 (Low)	32
2–3	50
4–5 (High)	66

NOTE: Percentages refer to the proportion of church members in each category who would like their congregation to sponsor at least one of the following: contemporary worship, art festivals, concerts, poetry readings, discussion groups about literature or art, sermons incorporating ideas from the arts, or opportunities to explore spirituality through the arts.

rests more with these people than with those who have not been to college. This does not mean that churches should ignore the interests of persons without a college education. It does suggest, however, that churches that sponsor art programs in the future will be more attractive to churchgoers than churches that do not. It is also suggestive to see that people with infrequent churchgoing habits are supportive of arts programs, indicating that their interest *might* also be sparked by such programs. And certainly it is important for church leaders to recognize that members who are most interested in spiritual growth are also the most supportive of greater efforts to sponsor congregational arts programs. Overall, there is little reason to think that churches devoting more attention to arts programs would be detrimental, whereas there are a number of reasons to think that such programs would contribute positively to the vitality of churches, especially by attracting the young, those with higher levels of education, and those who currently do not attend regularly.

The *facts* that churches are already doing a lot to encourage connections between the arts and spirituality and that there is significant support among members for them to be doing even more are incontestable from these data. But *how* churches are initiating innovative programs of contemporary worship, how they are promoting liturgical renewal through music and art, and what the marks of successful programs are, are matters that can best be addressed by turning to specific examples.

Contemporary Worship

Some of the nation's fastest-growing churches attribute their success to what leaders enthusiastically refer to as contemporary worship. This is a

distinctive innovation that has emerged largely since the mid-1970s. Pioneered by young pastors and lay volunteers at fledgling nondenominational churches, it has grown to the point that many traditional churches have started borrowing from it as well. Contemporary worship lives up to its name. It incorporates musical instruments (such as electric guitars and keyboards) and lyrics unheard of in churches a generation ago and makes use of new communication technologies such as home-produced videos and the Internet. It is meant to attract people with little interest in historic approaches to worship. Some of its advocates further distinguish it by arguing that it offers immediacy, relevancy, and intelligibility, rather than permanence, and that it is an expression of a new generation trying to find its voice in the church.[8]

Contemporary worship is, however, puzzling to many observers. What exactly accounts for its popularity and who is most attracted to it? Are music and art significant factors in contemporary worship, or are they incidental compared to other reasons that people attend these services? Is spirituality—and perhaps even theology—being altered by the music and art of contemporary worship? What promise does contemporary worship hold for the wider revitalization of American churches?

On the outskirts of Chicago, Willow Creek Community Church is one of the best-known examples of contemporary worship in the nation. Founded in the mid-1970s, it has conscientiously striven to be "the church for the unchurched." Music and the arts have played a central role in its ministry from the start. Today, church leaders from around the world flock to its seminars to learn how they can benefit from its success.

Driving onto the church's ninety-acre property, one has no more sense of being at a religious site than one does at the community college across the road or the corporate headquarters down the street. The church structure is glass and steel, a functional building for busy suburbanites. The same feeling is present inside. The auditorium, with its fold-down seats, feels like a movie theater (not by accident, since the congregation used to meet in one). There are no crosses, no stained-glass windows. If a sense of worship is to be created, it has to happen some other way.

Nancy Beach, a mother of two who holds undergraduate and graduate degrees in communications, is program director at Willow Creek. Her job involves planning and oversight for all aspects of the Sunday-morning and midweek services except for the preaching. Raised in a Christian home, she remembers parking her bicycle by a tree one Sun-

day after church when she was seven years old and praying to invite Jesus into her heart. Nancy continued going to church and Sunday school, but by the time she started high school she was searching for something more. Her youth group, she recalls, was "pretty dull and boring." Then the church hired two young men, a musician and an artist, in hopes of pumping new life into the high school program. By the time Nancy was a senior, the youth group had grown from thirty to more than twelve hundred. New music, skits, multi-image visual presentations, and other creative innovations were the key. One of the young men was Bill Hybels, who became the founder of Willow Creek.

During her undergraduate years at Wheaton, Nancy participated in the thriving church, watching its membership climb to more than a thousand. Within a few years, though, the church had grown too rapidly for its own good. Financial problems and personal difficulties among its leaders starting taking their toll. Nancy was glad to be away from it while she worked on her master's degree. She and her husband gained valuable experience by attending several other churches that were experimenting with different styles of worship.

Eventually the Willow Creek Church got back on track. Nancy again became active and several years later assumed her present position. Her training in theater, radio, and television, as well as her background in the church, made her the perfect person to coordinate the worship services that by now were drawing more than ten thousand people every week.

Currently her job centers on programming the four weekend services, two on Saturday evening and two on Sunday morning, which draw some seventeen thousand people, and the two midweek services, on Wednesday and Thursday evenings, to which six to eight thousand of the core members come. Her week begins each Tuesday morning with a staff meeting to evaluate what was good and what was bad about the previous week's services. Then the team turns to final preparations for the following week—usually these have begun a month earlier. Nancy gathers the worship team and looks at the schedule to see who will preach and what the topic will be. Then she pulls out a blank sheet of paper and says, "Okay, what do we want for the first thirty minutes of the services that week?" Instrumentalists and vocalists have to be lined up. Someone needs to begin working on the arrangements. The team tosses around ideas for dramatic scripts and videos. Nothing is ever the same. Every minute is supposed to be worshipful and is meant to draw people closer to God.

With some four hundred volunteers to draw from, she has plenty of talent. The trick is to make the best use of it without burdening people to the point of burnout. Each service involves some contribution from instrumentalists. At least one week a month there is a full orchestra. Another week has a studio band, while other weeks may include only a rhythm section with brass or woodwinds. Vocal music is an important part of the service too. The church rarely has a choir but features soloists and small ensembles. Nancy also coordinates the lighting team and the visual team. Each week the auditorium looks a little different than the week before. Banners, posters, and projected images add to the ambiance.

Drama has continued to be an important part of the services. Virtually all the scripts are original, and the church now makes them available for use by other churches. The dramas aim to capture a small slice of contemporary life, usually something that rings true to the experiences of people in the audience. For instance, one skit portrays two tired businessmen on an airplane who are joined by a mentally challenged young woman and her mother. One of the men is annoyed and asks to be moved. The other patiently accepts the young woman and winds up reading her a story. The skits avoid being preachy. They merely present situations that encourage people to think about their own behavior.

To vary the format, services sometimes include taped video clips. Some are staged skits or interviews; others may include spontaneous conversations with people on the street, while others focus on images of nature. Sometimes a musical number is accompanied by a dance team. And sometimes quiet times for prayer and reflection are accompanied by piano or keyboard. During the midweek services, which long-term members attend, congregational singing and other forms of participation are emphasized, but at the weekend services, the congregation participates in only one or two of the choruses.

As the church has grown larger, its pool of musical and artistic talent has expanded. To be included on the vocal team, the instrumental team, or the drama team, participants have to audition and undergo a personal interview in which they are asked about their faith and their approach to worship. Prima donnas are weeded out. Preference is given to people with talent who want to be part of the team—or, as Nancy puts it, someone who can say, "This is a gift that God gave me, and I didn't ask for it. He made me a great singer, but that's a gift from him, and I want to use it for his purposes and hold it loosely and not be demand-

ing about how it gets used." But those who make it also have to pledge that they will pursue excellence in their performances. Mistakes are tolerated, but laziness and poor preparation are not.

For the newcomers and visitors who attend on weekends, contemporary worship at Willow Creek consists mainly of an attractive alternative to the services people might find at other churches. People who enjoy listening to popular music on the radio do not have to adjust to organ preludes, and people who spend much of their leisure time watching television can sit back and enjoy a video clip or a live skit. The planners know that few people nowadays can find passages in the Bible, so they flash the verses from overhead projectors. Instead of expecting people to wade through unfamiliar hymns, they let soloists and ensembles perform. "It's easy-listening music," one member remarks, "with just a hint of blues and rock."

Sometimes people get hooked. One man says he came because his wife begged him to. He had always taken an intellectual approach to religion, found himself unable to believe, and went knowing he wasn't going to learn anything from the preaching. But the multimedia presentation and the drama made an impact. "The arts did an end run around the back and kind of nipped me, and I didn't realize it." This man gradually got more involved in the church and became one of its leaders.

For long-term members, the music and art that make up their weekly worship experience continue to be vitally important. For them, music and art are not so much a come-on as a way of getting into a worshipful mood. Meeting in the middle of the week and during the evening, most are coming from work. Tired, their thoughts are on other things. The music quiets them. The visual presentations capture their attention. The service draws them in, providing them with an experience that encourages personal reflection on how to lead a Christian life. As Nancy explains, "We really believe with spiritual formation that it's not so much about accumulating knowledge. Knowledge is helpful and important, and we all need to study as best we can, but it has to go further than that or it's empty."

People flock to Willow Creek for many reasons. Some seek it out because they have read about it in national magazines or heard about its pastor. Some like to be part of a large crowd. Like going to a Chicago Bulls game, it makes them feel stronger to just be with so many other people. Others become involved in the church's small-groups ministry or attend because there are activities for their children. But many admit

the music is a big part of why they attend. Its message is often more memorable than the sermon. Many prefer the dramatic skits for this reason too.

One woman who says she often cries during the service remembers especially how moved she was several years ago by the service on Mother's Day. One of the women on the worship team, herself a mother, put together a skit showing a mother and daughter interacting, struggling with each other, loving each other, and growing older. Each segment was punctuated by a song. "I was very moved. As a mom I really desire to get it right and to have God's help in my role as a mother. That was what some of the songs were expressing, that desire. I was just touched that I'm not the only one who's struggling. I'm not alone in my struggle to be a good mom."

Although the services at Willow Creek focus clearly on Christian worship, they reflect the worship team's conviction that music and art can more generally be a way of finding God's truth. Nancy puts it this way: "I very much believe that all truth is God's truth. There are Christian artists and they have a worldview that can be communicated. But I can learn and receive from a variety of artists. I don't think a painting, for example, has to be about something biblical to be sacred. I think people can capture something about life or about the beauty of our world and you go, 'That's sacred.' You don't even know necessarily what they were thinking when they created it." As an example, she mentions how she felt seeing Ibsen's *A Doll's House* on a trip to New York: "I was moved deeply by the character of Nora and how trapped she felt. It wasn't only about her being a woman in her culture and her time, although that was clearly the main point; for me it was the feeling of any human being who feels that the boundaries that have been put around them are so limiting that they can't be free to express who they are."

Music and art are by no means the only emphasis at Willow Creek. Preaching is considered a vital element of the worship services and usually takes thirty to forty minutes. Five "teachers" share this responsibility. In addition, there are approximately ninety "subministries," ranging from food pantries and community outreach to Sunday-school classes and youth groups. As many as ten thousand of the members participate regularly in small Bible-study groups or prayer fellowships. But music and art have clearly become the church's signature.

Willow Creek's influence extends well beyond its own congregants. Hundreds of pastors and lay leaders take its seminars and workshops each year, including ones focused especially on music and the arts. By

1999, more than six hundred congregations around the country had joined the Willow Creek Association, a loose-knit organization that communicates ideas about innovative programs for religious seekers. When sociologist Kimon Sargeant surveyed the pastors of these churches in 1995, he found that 82 percent used contemporary music on a weekly basis and most of the remainder used it at least once a month. Virtually all used dramatic skits during services and about half used video presentations regularly.[9]

There are many reasons for Willow Creek's success. Its sheer size allows it to provide activities for every conceivable need or interest. It has enjoyed stable and talented leadership for most of its history. Nancy Beach believes the team spirit its leaders have cultivated makes a huge difference. As other churches look to it for lessons in vitality, though, its imaginative uses of music and art are among the first to be borrowed.

On the East Coast, a different picture of contemporary worship can be found in Philadelphia. The ethnic neighborhoods in this city are known for their fierce traditionalism. Italian Catholics, Polish Catholics, German Lutherans, Quakers, and Swedenborgians have all laid claim to sections of the city at one time or another. Yet, as these identities are breaking down, Philadelphia has become home to one of the ten fastest-growing congregations in the nation. Calvary Chapel's massive grounds, complete with two auditoriums, a gymnasium, and its own school, draws people from as far away as southern Delaware and northern New Jersey. Founded in 1982, it had grown by 1999 to more than seven thousand weekly worshipers, not counting the four thousand children in its Sunday-school program.

Calvary Chapel of Philadelphia is one of more than seven hundred nondenominational churches nationwide that associate themselves with Calvary Chapel Fellowship. The parent organization of this fellowship is Calvary Chapel of Costa Mesa, California, a church of some thirty thousand members that easily lays claim to being the largest single congregation in the United States. Founded in the late 1960s as a ministry to surfers and hippies, it has matured into a smoothly functioning operation that combines sharp business savvy with free-flowing contemporary worship.

Reverend Joe Focht has shepherded the Philadelphia congregation since its inception and is understandably proud of its accomplishments. Its 2 million-dollar annual budget supports a staff of nearly 150, including 6 full-time clergy. The school provides kindergarten through high school instruction for eight hundred pupils. Besides its worship ser-

vices, the church sponsors Bible studies and prayer groups for all ages, concerts, and city-wide revival meetings.

The 9:45 and 11:45 services each Sunday morning are identical. Both start with about twenty-five minutes of contemporary praise music performed by an ensemble of drums, bass, guitars, keyboards, and vocalists. Unlike Willow Creek, where the music, skits, and multimedia presentations beg worshipers to sit up and pay attention, the service at Calvary Chapel aims to put the audience in a mood of prayerful meditation. There are no images, other than a dove painted above the altar, and no skits or liturgical dance. Lyrics are printed in the church bulletin rather than being projected overhead. Solos and other special music are avoided during this part of the service. The repertoire is kept to about twenty songs, on the assumption that people will be more prayerful if they are not concentrating on learning new tunes and words. Even the words are repetitive and relatively sparse. For example:

> I will keep you in perfect peace, perfect peace, perfect peace
> I will keep you in perfect peace if you'll keep your mind on Me
> Cause you trust, cause you trust, cause you trust in Me
> Perfect peace, perfect peace
> As you trust in Me.[10]

As they sing, repeating choruses like this again and again, many of the participants close their eyes, sometimes swaying slightly or raising their hands in praise.

Important as it is, the music at Calvary Chapel remains secondary to the preaching. Reverend Focht explains, "We put our main emphasis on teaching the Word. What the Scripture says is powerful, it's alive, it affects our lives. The music is a way for people to prepare their hearts. If they're familiar with the lyrics as they sing, it's meditative. They think about their struggles, their sorrows, their joys. So when we open the Word, they're spiritually ready. Emotionally they've been opened, prepared."

The sermons here follow a pattern, common in many evangelical churches, known as expository preaching. They closely follow the biblical text, taking it verse by verse and providing an explanation of what the words mean, how they relate to larger biblical themes, and how believers can apply them to their daily lives. Reverend Focht preaches straight through the Bible, starting in Genesis and ending in Revelation. It takes about ten years from start to finish. Each sermon lasts fifty minutes—at least twice the length of sermons in most churches.

As at any church, members at Calvary Chapel sometimes daydream during the sermons and wish they were not so long. But generally the audience listens attentively. One member puts it this way: "Most of the time I'm just on the edge of my seat, because it's not the kind of message that's boring or dull or lifeless. We're actually getting into God's Word. That's all we have, really. That's the foundation of why we're Christians. It's all written down there. Everything we need is in that book."

This emphasis on the Word reflects a broader pattern in American evangelicalism in recent years. Calvary Chapel, along with a number of independent churches like it, has grown by self-consciously identifying itself as a successor to the two main wings of evangelical Protestantism that emerged early in the twentieth century. One was fundamentalism, which emphasized literal interpretations of the Bible. The other was pentecostalism, in which greater emphasis was given to the gifts of the Spirit, including speaking in tongues, feeling emotionally moved by the Holy Spirit, and receiving direct revelations from God. The former had a limited appeal because of its adherence to many traditional forms of worship and because members sometimes found its doctrines too austere and judgmental, whereas the latter sometimes became divisive because so many different interpretations of God's will could be received. Calvary Chapel put biblical preaching in a more contemporary context, emphasizing God's love more than sin and judgment, and brought in some of the emotionalism of pentecostal churches. But it did so in a way that discouraged individual manifestations of the Spirit, instead using strong biblical preaching as a source of authority.

The relative importance of the Word is evident in Reverend Focht's broader views of the arts. Although he believes God encourages people to be creative, he takes a cautious attitude toward most artistic expressions. In his sermons, contemporary music outside the church comes in for frequent criticism. Reverend Focht regards it as an expression of human fallenness. Within the church, the absence of visual arts reflects his view that "relics and images" are dangerous because people worship them instead of the true God. He thinks the visual arts may have been needed in earlier centuries, when people were illiterate, but the Bible in his view is the best way to know God's truth, and he is happy that people nowadays have so many Bibles to read.

Among the members at Calvary Chapel, there are diverse views of the arts, but a common thread in many of their comments is that the arts hold great potential to do good or to do evil. The reason is that the

main purpose of art, as they see it, is to move one's emotions. Music especially can transform a person to the point of frenzy, or it can quiet one's spirit. In the context of biblical teaching and a carefully controlled church service, it mostly serves a positive function by moving participants' emotions to a place where they can focus more attentively on God.

Music, then, is not so much of value as a form of worship but as a means of getting ready to listen to God's words from the Bible. This is why the lyrics are kept simple and the musicians are asked to lead congregational singing rather than performing solos. Because music is a means rather than an end in itself, it can also be more easily adapted. If young people feel more comfortable with guitars and drums than with an organ, then it makes sense to adjust the service in this way.

Participants at Calvary Chapel view the music much the same as Reverend Focht does. Some of the older members say the main reason for including contemporary music is that younger people like it. Although they themselves would be content with more traditional music, they are happy to follow the new approach if it means drawing in more youthful participants. Most, however, say they do feel emotionally moved by the music. They like the fact that they do not have to concentrate on the words, but as they sing the same words over and over the feelings conveyed become stronger. A young woman says the best part is "the way it touches your innermost, your deepest feelings as far as being blessed, being touched, where you feel filled with the Holy Spirit. There are certain songs that kind of elevate you and you're just blessed and touched." A man who joined the church three years ago says he visualizes Jesus as he sings. By the time the sermon starts, he feels "laid back," submissive, and open to whatever God wants to teach him. "I just feel a connection with the Lord. The music reinforces that feeling of bonding with him. We're just sort of gathered at his feet waiting for him to teach us something."

A spirit of submissiveness like this can be instilled by means other than contemporary music. Indeed, it is somewhat surprising to see music that is often associated with free thinking by the wider culture functioning this way. But at Calvary Chapel it is part of a system of practice that gives unrivaled authority to the Bible, as interpreted by Reverend Focht. There is no hierarchy of authority to which the pastor is accountable. As long as the church grows, the lay leaders are likely to support his continuing presence. The music does not point to a tradition of church history. It is not interrupted by reciting a creed or by hearing

testimonies from members of the congregation. It focuses the audience's attention, showing them how much they depend on the Lord and rendering them eager to hear what the Lord tells them to do.

In *Reinventing American Protestantism,* University of Southern California professor Donald Miller describes the services at the various Calvary Chapel fellowships that he observed as a kind of "sacred lovemaking."[11] The phrase is apt. There is an almost orgiastic quality to the services, an emphasis on having a tactile relationship with Jesus. People are moved by the singing to the point of ecstasy, even if that feeling is carefully monitored. Nothing interrupts the mood. They are not asked to recite a creed, read from scripture, or listen to the morning announcements. The music itself plays a large role in creating this mood. While the rhythm, style, and choice of instruments are definitely contemporary, the tempo and sound levels vary little. The lyrics do not consist, as in some evangelical churches, of theological statements or personal testimonies set to music; rather, they are overwhelmingly *relational,* focusing on an intimate, loving relationship between the believer and God. Significantly, explicit references to *God, Christ,* or *Jesus* are virtually absent. The most common word is *you,* followed in frequency by *I* and *my.*[12] In other words, worshipers focus a great deal of attention on their own selves, feelings, desires, and needs, but do so in relation to an unnamed Other with whom they are on intimate terms.

Yet another glimpse of how contemporary worship works comes from a more traditional setting. Located on Boston's historic Freedom Trail, Park Street Church seems an unlikely place to find contemporary worship. The building, completed in 1809 with towering white steeple and plain brick exterior, exudes staid New England confidence. William Lloyd Garrison is said to have delivered his first antislavery sermon here. A century later, the congregation was led by evangelical preacher Harold Ockenga, who went on to serve as founding president of Fuller Seminary. The church's architecture still adds gravity to the traditional hymns and biblical preaching that make up the morning worship service each Sunday. But on Sunday evenings the church hosts the largest contemporary worship service in New England.

In 1992, Park Street's staff decided it was time to make a more active effort to reach Boston's large student population and its burgeoning cadre of young, well-educated professionals. Influenced by what they had heard about Willow Creek Community Church, the staff commissioned a survey to find out if some of the same ideas would work in Boston. The survey showed exactly what Willow Creek had found in

Chicago: large numbers of people who had no church affiliation at all and who did not attend because church seemed out of date and uninteresting.

Danny Harrell was chosen to initiate a contemporary service. Trained at the University of North Carolina, at Gordon-Conwell Seminary in Massachusetts, and at Boston College, where he earned a Ph.D. in psychology, he was one of seven full-time pastors at the church and had the most experience working with students and young adults. His warm smile and southern accent put people instantly at ease. He says he likes the informality of the Sunday-evening service because he can crack jokes and be sarcastic if he chooses.

The same factors that characterize the leaders at Willow Creek and Calvary Chapel are present in Danny Harrell's spiritual journey. Although he was not particularly interested in music as a child, one of his most vivid memories of church was its occasional rendering of Handel's *Messiah*. In high school he became active in Young Life and in college attended meetings of the Inter-Varsity Christian Fellowship. Both gave him a lasting appreciation for youth ministry. During seminary he specialized in youth ministry, finding it refreshingly open to "thinking outside the box" and "not playing by the rules." He learned to appreciate the orthodox doctrines of Christianity, but even more so, he was drawn to the "radical foundations" that had caused people to die for those doctrines. By the time he finished his doctorate, he had made friends with a number of Jews and Roman Catholics, become ordained in the United Church of Christ, interned as youth pastor at several churches, and become interested in high-church Anglo-Catholic liturgy. He was also starting to read the early church fathers, paying particular attention to their view that Christian life was more like a dance than a race, and was spending more time in prayer and meditation. When the Park Street staff asked him to start something that would appeal to young people in the congregation, he was ready.

Harrell pulled together a group of about ten people to help him plan. They met regularly for a year, reading, gleaning comments from people they knew, and thoroughly evaluating their own understandings of ministry. What they came up with was so radically different that it now appears to him as a kind of postmodern breakthrough: "We found that people weren't so concerned for issues of truth empirically tested as much as they were interested in experience and in trying to be a part of something that appeared meaningful and challenging. It wasn't so much trying to *say* the right thing as *feel* the right thing. We were fine

with that as long as the feelings were directed towards these truths of our faith that we felt derived from scripture."

The plan that emerged involved taking over the Sunday-evening service. Its attendance had fallen so low that the church's leaders were thinking of canceling it anyway. Nothing would be done to disrupt the traditional Sunday-morning service, which most of the older members dearly loved. There would, however, be a cost of some twenty-five thousand dollars to install a sound system and lights and to make some other modifications to the sanctuary. But resistance to this cost melted when a donor willing to foot the bill came forward.

The first service was held in September 1993 with approximately two hundred people. Within five years, attendance rose to more than eight hundred. Given the transience of the participants' residence in Boston, Harrell estimates that as many as forty thousand people have been to the service at least once. They come from all over Boston and include students from Harvard, MIT, and Boston University, as well as young adults who rent apartments downtown or drive in from the suburbs. The average age is twenty-six.

Music is the service's defining feature. The initial band was organized by a drummer who had played with Aerosmith; subsequently, musicians have come and gone, but there is always a band. Pop/rock prevails, but selections range from blues and gospel to hip-hop and grunge. "What folks enjoy about it, whatever mode they find it in," Harrell explains, "is that it's the music of their life. It's what they experience. It bypasses their mind and hits their heart. We just attach new lyrics to the melodies of their soul."

The service, however, is more than a concert staged in a church. Harrell and his team keep clearly in mind that its purpose is worship. The sanctuary itself makes it hard for people to miss this fact—harder than if they met in an unadorned space like Willow Creek or Calvary Chapel. There is a traditional call to worship at the start, often involving a reading from scripture, and themes are selected according to the traditional liturgical calendar. The next twenty minutes to half hour is devoted to music. Some selections are instrumental or vocal performances, but most involve congregational singing. The lyrics are usually written by a member of the worship team and, because they are new, are projected for the audience to see. The projector also flashes images of nature or of people, but these images also include classical paintings, icons, and interiors of cathedrals, all meant to remind people of their links with the past. Mostly they are images that Pastor Harrell has downloaded from the Internet.

This part of the service is followed by a call for people to greet one another (sometimes taking as long as ten minutes). The offering, during which a soloist or ensemble performs (so many musicians have been drawn to the church that there is a long waiting list to perform), comes next. Then a member of the congregation reads the scripture, several more lead in prayer, and the balance of time is devoted to a twenty-five-minute sermon followed by several more songs and the benediction. Afterward, people linger for casual conversations, stay for dinner, or move on to small groups or informal gatherings. Many stay for two hours or more.

Although the fellowship and the expository preaching are part of the attraction, not to mention the fact that people come expecting to find others their own age, the power of music has become all the more evident as the service has grown. Harrell says: "What the contemporary worship movement has done is not unlike what Luther did back in the sixteenth century. It simply borrows the music of the culture and redeems it for the church. 'Plunder the Egyptians,' as Augustine said. We've simply gone to the culture and taken those melodies and those beats and put Christian lyrics to it. It's all just a matter of using everything to the glory of God. That's what happens to people. If they've never experienced that before in a church, it's very disarming. All of a sudden you step in and this is music *I love* in church. That can be very surprising."

Besides numeric success, Park Street's evening service has also witnessed qualitative growth. At first the lyrics were simpler and shallower; now they are more varied and substantial. Congregational singing, rather than performances, has become more important. Participants say they enjoy the opportunity to sing; they also report that the singing gradually transforms their lives, giving them more of an understanding of what it means to be a follower of Christ. The biblical preaching has been paying more attention to ambiguity and unresolved mystery, rather than trying to give people simple answers. And, unlike Willow Creek, where people still come who don't like church, Park Street has dropped its monthly "seeker service" because it found people more likely to come when the service actually seemed like church.

In each of these three churches, then, contemporary music (and to a lesser degree, drama and visual imagery) plays a prominent role in leaders' thinking about how to spark interest among the next generation of churchgoers. The music is in many ways similar in the three churches: keyboards, guitars, and drums have replaced organs and pianos. The

lyrics are recognizably Christian; yet few of the tunes would have been familiar a generation ago, and the words have been altered to create a quieter, more meditative, reflective mood. Feelings receive more emphasis than ideas in this music. Indeed, the worship experience is geared to be just that—an *experience*. Participants return home feeling as if they have been in the presence of God. Enough of them, at least, feel this way that they return week after week.

Contemporary worship is unquestionably an important part of the revitalization that is sweeping through America's churches. Many people simply feel more comfortable at these services. Old-style services conjure up bad memories of being dragged to church as a child. Or they seem too pious and churchy. The newer format is livelier. The lyrics do not sound old-fashioned, and the technology is more engaging. Worship leaders like Nancy Beach and pastors like Reverend Focht and Pastor Harrell insist that these are important benefits. When correctly used, music and art forge bonds among people. They aren't as deadening as simply listening to someone lecture. And they draw people who have artistic gifts.

Proponents of contemporary worship insist that drums and guitars are just as conducive to praising God as pianos and organs. As one young man remarks, "It feels more genuine to me to worship God in the same style of music that I enjoy." And, contrary to popular impressions, it remains possible to combine such music with an attitude of worship, rather than only being entertained by it. Participants note that worship involves thanking God, exalting God, and lifting one's heart to God. For a generation of people who produce and consume music, it makes sense that music should be one of their offerings to God.

Listening to pastors and worship leaders, it is sometimes easy to form the impression that contemporary music is being brought into the churches for purely calculated reasons. In a cynical vein, one is even tempted to conclude that church leaders sometimes are willing to borrow from popular music just to draw in larger crowds. Such interpretations, however, miss the fact that many of the participants at these churches really do have a powerful connection to the music. It isn't only that they feel more comfortable at a church that seems less like a church than like a rock concert. The shift to contemporary music somehow signifies to them that the church cares—that it is for *them*, rather than just for church leaders or for an older generation. For some, the music also resonates with some deep part of their experience. It reminds them of the love song that was especially meaningful when they were dating.

It depicts their relationship with Jesus in the same romantic way. Or it comforts them during their divorce. For others, it was the music that gradually broke down their intellectual reservations and helped them feel genuinely connected to Jesus, perhaps like they had when they were in Sunday school or at church camp.

One man, who had lost his job and was in the midst of divorce proceedings, gives an especially moving account of how a new contemporary music service at his church made him feel closer to God: "I can just remember feeling for the first time that special connection with God that we hadn't really had from the other songs that we were singing as much. I just remember tears starting to come out of my eyes when I just thought of all the mess that my life had been up to that point, the mistakes I made, and how God just still loved me anyway. He was willing to put all that aside and just come into my heart. Just make something worthwhile out of me, even though I had screwed up everything in my whole life up till then. God's love was flowing into my heart. It almost felt like he was opening up his arms and just welcoming me and pulling me close to him. I could almost feel a heartbeat."

The experiences at Willow Creek, Calvary Chapel, and Park Street show that contemporary worship can be adapted to a variety of situations. Indeed, it must be adapted, rather than simply being imported. With its huge numbers, Willow Creek can maintain its seeker services on weekends and offer more participatory worship midweek. Park Street is restricted by its space and by having to share the building with a more traditional service. Calvary Chapel draws a clientele that differs in social composition from either of the other churches. Simpler praise choruses and more authoritative preaching appeal to its audiences. All three churches make extensive use of volunteers and encourage a sense of community among these volunteers. But Willow Creek is more of a staged production that requires long hours of planning and practice, whereas the other two value spontaneity and participation to the point that less advance preparation is needed. At Park Street, virtually all the planning is done by email. Talent, too, makes a difference. From the beginning, Willow Creek has drawn in people interested in drama; Park Street has done little with drama compared to its emphasis on music. By adapting to their local environments, each church has attracted people who otherwise would not be involved.

But contemporary worship has its limitations. One problem is that it can bring God too much into the moment and thus lose sight of God's holiness and otherness. A man at Calvary Chapel who was raised in a

Catholic church describes the music he grew up with: "It taught me that God was *separate* and *holy*. And then when I opened up my eyes after the music, I was kind of by myself and God was over here because he was too big and too pure." In contrast, the present music gives him a more intimate feeling of God's presence: "And now, it's like I hear the music and it's cool and all, but God's my friend and he's right here with me, so it's not like I have to get into this transcendent feeling in order to experience God any more." Nancy Beach says she constantly has to remind herself that God isn't "my buddy," but is fully righteous compared to the sin-filled world in which we live. She thinks it is harder to remember this at Willow Creek than at other churches because the architecture does not remind her of the reverence that God commands and much of the music is meant to make people feel at home with God, rather than putting them in awe of God.

Critics of contemporary worship go further, sometimes referring to it as "funk and junk." In their view, church should take its traditions seriously, even to the point of preserving the Psalms, chants, and hymns of an earlier era. Contemporary worship seems to these critics like selling the sacred birthright just to attract a few more people. They worry that older members will be offended or that trying to pour new wine in old wineskins is asking for trouble.

Another potential problem is the authority structure that has grown up with churches in which contemporary music is emphasized. Calvary Chapel illustrates this problem most clearly. Like Reverend Focht, many of the pastors who have started local Calvary fellowships have never left. There is no denominational system of rotation to encourage them to leave. After a while, they can develop an almost unchallenged grip on their congregations. The submissive attitude produced by the music reinforces their authority. People sit back, eagerly waiting to hear whatever the pastor says. It's a little like soothing background music at the supermarket.

The contemporary worship style clearly is not for everyone. Despite its popularity, people of all ages continue to attend churches in which more traditional music and preaching are emphasized. Many of these churches do not have the resources required to make a successful transition to a contemporary format: nobody in the congregation plays electric guitar or drums, and the order of worship prescribed by the denomination offers no opportunity for dramatic skits or videos. But people also attend churches with more traditional formats because they prefer familiar hymns and "church-looking" architecture. In many of

these churches, music and art are also playing a more prominent role as a result of liturgical renewal.

Liturgical Renewal

The liturgical renewal movement began in the 1960s, following the Second Vatican Council's call for greater lay participation in the mass. Catholic services in the United States shifted quickly from Latin to English. Seating was rearranged to put parishioners closer to the altar. More congregational singing was encouraged, and many parishes quietly shut down the organ in favor of guitar accompaniment. The "hootenanny mass," as critics sometimes labeled it, gained limited popularity. But the door had been opened for widespread rethinking of how the liturgy should be performed.[13]

By the mid-1970s, at the time that Willow Creek and Calvary Chapel were developing their seeker services, Protestant and Catholic congregations across the country were experimenting with new hymnbooks and new ways of integrating worship and preaching. Handmade felt banners added color to previously drab sanctuaries, altar cloths and vestments took on new designs, and sermons often became more informal, self-disclosing, and even conversational. But music nearly always remained the focal point of efforts to renew the liturgy. Congregations sometimes erupted in near violent conflict over such decisions as where to place the new organ or which version of the doxology to sing.

As large churches with seeker-style services have attracted the media's attention, the liturgical revival that has continued to take place in other churches has been virtually overlooked. Yet this revival is having a profound impact on American religion. It is encouraging churchgoers to rediscover the vitality of their traditions and to gain a new appreciation for the beauty of timeless sacred music. It has forced pastors and worship leaders to be more intentional about how they structure the morning service. In some congregations, it has given musicians and artists new ways in which to serve, while in others, it has helped parishioners understand more clearly what they like or dislike about familiar patterns of worship.

Like virtually all renewal movements, the present one is defined by its more extreme or visible manifestations: while limited to a few settings, these innovations provide models that other churches emulate in smaller ways. Churches that innovate, or that become very good at ex-

emplifying a certain style of worship, set the standard for others. The atypical, paradoxically, defines the typical. Attending church conferences, pastors and music directors hear their colleagues talking about what a certain church is doing and come home feeling mildly unsettled. They know this would never work at their church. Or would it? Perhaps a piece of it would.

The models from which pastors and music directors gain inspiration are too numerous and too diverse to capture in any neat summary or typology. Some involve incorporating contemporary music selectively (even more so than at Park Street) into an overall program that remains steadfastly traditional. Many of these models are known only in local communities or in a particular denomination. But conversations with scores of pastors and music directors *are* revealing. In such conversations, at least three widely different kinds of churches seem to serve as inspiration for grassroots liturgical renewal. Virtually everyone knows of a church in which the *beaux arts* excel, not just for the sake of exhibiting the fine arts, but as a special rendering of beauty and harmony in divine worship: the organist and choir are exceptionally talented, great care goes into the selection of hymns and anthems, the church probably makes good use of its architectural space, and it may be innovative in other uses of the visual and performing arts. Besides such churches, virtually everyone, whatever their denomination or race, also knows about an African American church that sets the standard for enthusiasm and vitality in worship or is drawn more generally toward African American gospel and spiritual traditions. Then too, perhaps only on a slightly more restricted scale, people are fascinated with the centuries-old beauty of Eastern Orthodox churches in their communities and are either drawn to these churches or are interested in learning from the Orthodox tradition. These models not only inspire innovative thinking but also help to define the outer limits, as it were, of what the ordinary Presbyterian, Baptist, Methodist, or Catholic congregation may be able to accomplish and what the ordinary member of these churches may appreciate.

Nestled among San Francisco's rolling hills, Saint Gregory of Nyssa Episcopal Church is the epitome of a *beaux arts* congregation. It occupies an architecturally creative building (that looks like something from a movie set) constructed in the mid-1990s after nearly two decades of intensive planning and fundraising. Currently, its membership is only slightly more than 100, but as many as 250 attend its Sunday services. Many are attracted by its emphasis on music, dance, and the visual arts;

many of its participants work in the arts or spend ample amounts of time in San Francisco's nearby arts district. Indeed, the arts have become the church's distinctive signature for many in the wider community. As one community leader observes, "Art is more of a common factor in that church than the fact that it's Episcopalian."

From the beginning, its organizers associated the church's mission with the broader liturgical reform movement they saw revitalizing contemporary Christianity in the wake of the Second Vatican Council. "Every historic liturgical reform has affected the whole of Christian community life," wrote Rick Fabian, one of the church's cofounders. "This is a revolutionary program, and calls for new approaches to help carry it out." [14] These approaches would eventually include an innovative form of church government and a demanding standard of involvement for the church's members, as well as an affirmation of their commitment to the principles of early Christianity. But music was also given a central role, as Fabian observed: "The most powerful tool for Church reform is music. Each previous reform has brought a new infusion of music into the Church's life, conveying the reforming ideals into the hearts of church folk, and drawing unchurched people in great numbers into the new movement. The present reform has got well underway without a satisfactory musical vehicle, and the need for it is increasingly clear. This reform particularly deserves a musical approach, not only because music makes theology popular, but because music is the readiest means of sharing among the churches. No means could be more effective for uniting the churches in a common mission to tell the world about our common life in Christ." [15]

The philosophy behind the worship services at Saint Gregory is to draw from the deepest Christian traditions in a way that encourages maximum lay participation. Musical selections run the gamut from Gregorian chant, to selections from the Geneva Psalter, to Anglican plainsong, to early American and African American shape-note singing, to South American freedom songs. Sometimes the singing is accompanied by hand clapping or by simple dance steps, which are practiced before the service begins. All the singing is a capella, and, although there is a choir, the choir members are interspersed with the rest of the congregation during most of the service.

As the liturgy begins, the congregation gathers in a big open space at one end of the building that's close to the front door. The celebrant tells the congregation that the liturgy is something they will make together and is intended to express their nature as a worshipping com-

munity; long-term members will not only have heard this injunction many times but will have read detailed discussions of the philosophy behind every aspect of the service in church pamphlets and newsletters. The processional consists of the whole congregation moving to their pews while singing the opening hymn. The seats are arranged choir-style, with people facing one another across an aisle that runs down the middle of the large, open-beamed meeting room. There is a chair at one end where the presider sits, with a musician on one side and a deacon on the other. The first part of the service includes readings from the Old and New Testaments by members of the congregation, each followed by the ringing of a bell, a time for meditation, and singing. The sermon, which generally lasts ten to fifteen minutes, follows the liturgical calendar but includes reflections drawn from the priest's personal experience. The sermon is followed by a Quaker-style time of silent meditation, after which people who are led to do so may offer brief statements or observations. Following announcements and prayers, including the Lord's Prayer (which is sung), the service shifts to the Great Thanksgiving. The entire congregation dances forward, accompanied by an African drum, and circles the communion table. There they exchange "the peace" and join with the celebrant in receiving the bread and wine. Incense usually burns during this part of the service. The concluding hymn is also danced, as the congregation joins hands and spirals the table a final time.

In the background, the visual arts make an important contribution to the liturgical experience. As congregants listen to the sermon, their attention can hardly help drifting over the priest's shoulder to the mural-size icon (eighteen feet high and twelve feet wide) of Gregory of Nyssa preaching, and above him a female figure (who some say represents God) presiding over the marriage described in Song of Songs and interpreted as the union of Christ and the church. As the congregation dances toward the communion table, they are accompanied by what will eventually be more than seventy icons (each nine feet high) of saints dancing in a procession led by Christ.

Reverend Donald Schell, the other cofounder of Saint Gregory, says the arts have become central to the life of the congregation itself: "We're not interested in just decorating the church or hanging something around because it's pretty. We're interested in something that is completely integrated into the life of the church as a community of people gathered around love and desire for the creator. The expressive arts engage our being, our imaginations, our hearts in ways that are

on their own terms completely comprehensible as spiritual practice. One of the ways that we pray together is by singing together and dancing together, and the 'together' that emerges from doing that builds community."

One of the members, a venture capitalist who joined the congregation in the late 1990s after years of deep spiritual searching, explains that the music, the dancing, the icons, and the preaching all come together to create an exceptionally powerful worship experience. "The multisensory aspect of Saint Gregory's, for me, is the key to our liturgy. It acts on all different parts of you." He says shape-note music is especially powerful. "It connects me up at a different level. It makes the hair on the back of your neck rise up. It makes your guts palpate. It's about trying to somehow really connect up with salvation and what that might mean, and what it might mean to see the Lord."

Saint Gregory has been called "one weird little church" by some of its fond admirers—a phrase that gains meaning when one realizes that its architect was known mostly for designing Chinese restaurants, that the bell that calls people to worship is of Tibetan origin, or that there are Maori and Russian influences in its murals. But its leaders and members are utterly serious about their Christian commitment; for them, innovation means honoring the fullness of the Christian tradition. Like Gregory of Nyssa, they strive to be original in their thinking, yet true to their faith.

In another section of San Francisco, a very different kind of church illustrates another way in which new forms of liturgy are making greater use of music and the arts. Located two blocks from the Tenderloin district, City of Refuge United Church of Christ looks like a commercial building from the outside. Founded in 1991, its membership grew from fifteen to six hundred in less than a decade. Its five-hundred-seat auditorium (a former union hall) is usually full for the weekly worship services that begin at one o'clock each Sunday afternoon. This particular Sunday the audience sits meditatively waiting for the service to begin. Then, barely above a whisper, a throaty voice echoes through the dimly lit auditorium:

> Have thine own way, Lord, have thine own way
> Thou art the potter, I am the clay
> Mold me and make me after thy will
> While I am waiting, yielded and still.

As the vocalist concludes the third stanza of Adelaide Addison Pollard's familiar hymn, lights flash across the auditorium and drum beats pound

through the amplifying system. Spotlights focus on the singer, who announces, "Welcome to the City of Refuge!" The tempo of the music quickens and the audience joins in, clapping and repeating, "There's power, praise Him, there's power."

The vocalist is Yvette Flunder, the African American woman introduced in chapter 4, who heard God's call to start a ministry to people with AIDS in 1986. City of Refuge is the result of this call. The congregation—"an experiment in radical inclusivity"—is predominantly African American with a mixture of Hispanics, Asian Americans, and Caucasians, gay and straight, old and young. It maintains support and advocacy ministries for members and people in the community who have AIDS. Next door is a shelter for battered women, and down the street is a neighborhood center where members, the homeless, and others meet throughout the week for services (both spiritual and physical). Ending institutional racism, homophobia, domestic violence, and oppression are the themes that run through all these programs.

After twenty minutes of singing, the music ends, a few announcements are made, and an offering is taken. Then there is an informal time that gives the audience an opportunity to participate: people rise to give brief testimonials, pray, request prayer, or suggest a song. The rest of the service follows a more traditional pattern, including a sermon, several selections by the choir, and more congregational singing. Besides leading the singing, Reverend Flunder (who, in 2002, is nearly finished with doctoral training at a Bay Area seminary) delivers the sermon, which often lasts more than an hour.

The philosophy of the church is by no means to entertain or even to use music simply to grow. The ministry is firmly rooted in Christian theology and oriented toward interpreting that theology in a way that is true especially to the African American experience. Reverend Flunder explains: "African American folk coming up from grassroots churches have a marvelous spirituality. But sometimes our theology is inherited from the churches that our churches were born out of. We came here colonized by the churches that existed, the European Protestant churches. And what we lack is the skills to forge our own way through spiritual texts and languages and writings, so we have to take other people's word for it. I'm of the opinion that we need to know more about how to find our own way and to eke out our own theology and to understand how we can be Christian." Music is one way to do this.

Reverend Flunder believes strongly that music and art have an important place in the church. She says they should be "message oriented." She means that the words and the atmosphere created by the

music, or by visual art (behind the pulpit is a large red-yellow-and-blue banner that reads, "Prepare to Be Amazed"), must be worshipful and must communicate the gospel. "I don't want to just entertain you, but then I don't mind using entertainment to get the Word over. I'm very purpose-oriented in what I do. The reason I sing like I sing is because of my relationship with God. Otherwise it would just be an art form. And it's not an art form."

The services at City of Refuge inspire a high level of emotional involvement, especially when the electric keyboard, organ, tambourines, and drums are playing. "They exude energy," says one participant. Some of this energy is simply built into the African American pentecostal tradition in which Reverend Flunder and many of the members were raised. But Reverend Flunder intentionally cultivates it as well: "I think of the music as a way to take the truth and to raise it to a higher emotional level than what you could raise it to speaking it. When you sing it or you play it or you dance it, you give it the passion that you really feel in your heart. When anything is sung, there are things you can do with your voice that really let folk know where your heart is on a subject."

Members at City of Refuge generally deny they come just for the music. As one says, "We could listen to music at home." And others point out that the preaching is what attracts them most, especially when it gives them new ways of looking at familiar biblical stories. Yet it is clear that the music is an important part of the worship experience for nearly everyone. Some like the old gospel hymns best, while others prefer the newer choruses. One woman recalls how moved she was at a recent service when Pastor Yvette spontaneously broke into a chorus called "Even Me": "I just started singing along. I was going through some difficult times. And it was like a confirmation of the Holy Spirit. Like, 'You know what, I'm with you and it's going to be all right.' Some of the lyrics go, 'I hear a shower of blessings falling upon me.' The writer's saying, 'Lord, just let some drops fall on me, I'm in need of a blessing.' She just started singing it. I'm like, 'Oh, my God!'"

City of Refuge, like Saint Gregory of Nyssa, is a relatively new congregation that has been able to experiment with new ideas about worship because there were no long traditions to overcome. Virtually the opposite is the case at most Orthodox churches, which have jealously guarded a tradition that is more than a thousand years old. Yet many of these churches are growing because new members from other churches are being drawn to the novelty of this tradition. Orthodoxy is also in-

spiring other church leaders to reexamine their understanding of liturgy, music, and the role of icons in worship.[16]

John Kahle grew up in the Lutheran church but started attending Orthodox services because it was his wife's tradition. Over the years he became increasingly attracted to the Orthodox style of worship. In his fifties, he decided to seek ordination. He now pastors a small Orthodox church in northeastern Pennsylvania. The church is a spinoff from a Syrian Orthodox congregation nearby. During the 1980s, the Syrian population grew rapidly as a result of new immigration to the region. Eventually, most of the services were being performed in Arabic. The English-speakers decided it was time to start their own church. From an initial 45, Kahle's congregation has grown to approximately 150.

Experiences like Kahle's are not uncommon. In 1978, the Orthodox Church in America numbered 440 congregations and had 531 clergy; by 1995, the number of congregations had grown to 600 and the number of clergy to 792. During the same period, membership grew from 1 million nationally to approximately 2 million. In addition, as many as 3 million members belonged to other Orthodox denominations, including Greek, Syrian, Serbian, Coptic, Romanian, and Ukrainian churches. While much of this growth was a result of immigration to the United States following the breakup of the Soviet Union, native-born Americans like Kahle were also joining in record numbers.

The reasons for this growth are many: intermarriage, as in Kahle's case; people looking for religious traditions that seemed more stable than in Protestant or Catholic churches; and people who liked the combination of high liturgy and strict biblical teachings. A number of articles in leading Christian magazines during the 1980s and 1990s helped, as did such widely read books as Frank Schaeffer's *Dancing Alone* and Peter Gillchrest's *Becoming Orthodox*.[17] But for many converts, the centrality of icons, the richly decorated churches, the use of incense, and the richness of Orthodox music were especially attractive features.

Although Orthodox churches vary in size and interior furnishings, the typical format consists of a sanctuary presided over by a square altar behind an icon screen that usually has a center opening with an icon of Jesus on the right, an icon of Mary on the left, and icons of various biblical figures and saints on either side. More icons are likely to be painted on the walls and ceiling, and stained-glass windows usually include depictions of biblical stories. The liturgy begins with the cantor leading the congregation in morning prayers while the priest prepares the Eu-

charist. The service proceeds with numerous litanies, a processional in which the priest carries the Great Book through the congregation, a homily, the Eucharist, and more litanies. The a capella singing, the litanies, and the preaching all follow time-worn patterns that create palpable connections with church history. The worship space itself is sharply demarcated from the exterior world, calling worshipers to enter physically and spiritually into the kingdom of heaven. The icons serve as windows into heaven. Each color is symbolic: blue represents humanity; red, divinity; gold, the light of Christ. Even the smallest gestures are symbolic: the act of blessing oneself, for example, is performed with three fingers raised to represent the trinity and the thumb and small finger crossed over the palm of the hand to represent Christ's divinity and humanity.

John Kahle explains the attraction of the Orthodox liturgy: "It's not just the mind that's involved: it's your ears in music, your eyes in the icons, and the art within the church. All that is important. If I know someone is coming to an Orthodox service for the first time, I like to take them aside and say, 'Look, you're going to come into a different world. You're going to see all kinds of things happening. People venerating crosses, venerating icons, exchanging the kiss of peace, the salutation. You'll see incense being used. You have your hearing, your sight, your feeling. All of your senses are touched in an Orthodox service.'"

One of the members says she feels the presence of God and the angels the minute she enters the sanctuary: "Your whole body, everything is immersed in prayer from the moment that you walk in. You start to venerate the icons and let your heavenly father know that you're happy you're there. We're all praying together to God. I feel a unity with everyone and the power of that prayer, whatever we're praying, the litanies, whatever, I feel that God really hears us and he's touching each one of us."

In their distinctive ways, Saint Gregory, City of Refuge, and Kahle's Orthodox congregation represent a much broader interest in forms of worship that offer a multisensory experience. The spoken word, through the reading of scripture and the sermon, remains central. Yet, just as in churches featuring praise choruses and electric guitars, the wider variety of churches in which liturgical renewal is being sought are paying increasing attention to the ways in which the service creates a particular mood. From visually pleasing architecture, to music that inspires praise, to vestments that connote the liturgical year, to banners that encapsulate congregational priorities, the arts create a visual, auditory, kinesthetic, and sometimes even a tactile worship experience.

The move toward liturgical enrichment is facilitated by the affluence that Americans have enjoyed in recent decades. Although the benefits of an expanding economy have not always redounded to the churches, affluence made it possible for many churches to maintain music programs on an unprecedented scale and for others to construct new buildings. The population's transience, from rural areas to suburbs, and from older suburbs to newer ones, meant that churches were always being established or expanding, even as other ones were shutting their doors. In the process, congregations selectively adapted to the changing interests of clergy and laity.

The demand for multisensory experience was by no means new, for churches throughout American history have been places where fine music could be heard or where stained-glass windows provided visual inspiration. Yet there appears to be a growing appreciation among church leaders that people worship with their bodies as well as their minds. Carla DeSola, a pioneer in liturgical dance following the Second Vatican Council's call for greater integration of gesture and worship, says, "When you're moving, things come to you. Moving frees the mind. You find things with your body. If you cannot honor your body and learn from the body's wisdom, something is missing deeply in your spirituality. We are incarnate. It is the central part of Christianity, incarnation, resurrection."

Although they take different forms, the innovations involving music and the arts reflect an awareness that churches must work harder than they did in the past to make the liturgy a meaningful worship experience. While sometimes reluctant to admit that they are competing with television, motion pictures, and MTV for worshipers' attention, church leaders are acutely aware that this is the case. Few members— other than college students—are used to sitting for long periods listening to the spoken word. Most information is now transmitted through a combination of words and pictures, and advertising, cinema, and the music industry have conditioned Americans to expect some emotional charge if the information is to be meaningful.

Paradoxically, the willingness of church leaders to experiment with styles of worship is rooted in respect for tradition—indeed, in a desire to regain authentic connections with Christian traditions of worship. At Saint Gregory, the eclectic musical selections and murals aim to help worshippers participate more actively in the liturgy, just as they were assumed to do in early Christianity. Yvette Flunder's goal is to find African and African American roots that are more authentic for her audience than customs derived from Europe. Even for Reverend Kahle, new

ways of appropriating tradition are important. He distinguishes small-*t* traditions from capital-*T* traditions: the former develop within congregations, letting them express their own styles of worship, while the latter give a sense of permanence.

What is most obviously new is not so much the lyrics or the instruments but a willingness to borrow from other forms of Christian expression. It is not uncommon for African melodies to be included in Episcopal services, or for Catholic choirs to lead congregations in a cappella singing from a Scottish Presbyterian Psalter. Music has often distinguished the various confessional traditions in the past, but now, with fewer people placing emphasis on these traditions, and with church leaders promoting ecumenical agreements, music becomes an attractive means of registering unity amid diversity. More and more sermons draw examples from a wide cross-section of poetry and literature, television programs and films, rather than looking to the writings of particular denominational leaders. Increasingly, architecture itself may signal a congregation's awareness of its eclectic roots.

The borrowing that takes place nevertheless happens within clear boundaries. Not just anything goes. Church leaders insist that artistic elements in liturgy must be conducive to the worship experience, rather than distracting participants' attention or being included only because of their artistic merit. This is especially true of iconography in the Orthodox tradition, where the artist must not only be talented but also deeply prayerful. "An icon should be of the highest order," explains one Orthodox member. "When you look upon the icon, you should be transported by that vision." The same is true of liturgical dance. "It has to fit in with the liturgy," Carla DeSola observes. "Are people being gathered together? Are people being challenged in a prophetic way? Inspired? Every gesture says something, it has a theology."

At the same time, church leaders emphasize the importance of striving for dignity and beauty in liturgical uses of the arts. Jeffery Brillhart, music director at a large Presbyterian church in suburban Philadelphia and founder of a national network of church musicians, says it is essential to avoid "worship lite" in today's churches. Whatever the church, he thinks its liturgy should engage hearts *and* minds, doing so by employing musical and artistic talents to their fullest extent as an act of glorifying God. Reverend Schell agrees. Even if a church is small and has few resources, he suggests, worship should be performed with the greatest level of perfection possible.

The Difference It Makes

Participating in Sunday worship services, it is easy to wonder what people are really thinking about and whether any of the effort to provide an engaging liturgical experience makes much of a difference. It is especially easy to wonder if people get much from singing—or from listening to the choir sing—and to wonder what occupies their minds when their attention drifts from the morning sermon. If leaders' theories about the arts are correct, then good, worshipful music and innovative uses of the visual arts should make a difference to the worship experience and, in turn, to the spiritual growth of church members. But does it?

At a six-hundred-member Catholic church in Oregon, a woman in her early thirties observes that "just about every week there is at least one song that really draws me to a deeper sense of prayer and worship." Meditative, reflective music that the congregation sings together is particularly powerful. She recalls a recent example: "After the entire assembly had gone forward, received Holy Communion, and returned to their pew, a second communion song was sung a cappella. Having that happen at the time of Holy Communion when we had just received our Lord's sacramental presence really just tied together what we had done, what we had moved to, what we were all experiencing, and what we were then singing. All those different facets of the mass came together at that point."

In the same parish, a teacher in his forties says the visual arts are particularly meaningful to his worship experience. He remembers how effective it was during Lent when the worship committee constructed a replica of a dry riverbed in front of the altar to depict the barrenness of the spirit during this part of the liturgical cycle. "The mass is a kind of reenactment or remembering of the action of Jesus at the Last Supper," he says. "The arts help to bring that alive in a way that goes beyond just hearing the words in an intellectual way."

At a predominantly African American United Methodist church in Atlanta, a woman in her forties especially likes the gospel music that precedes the sermon. The audience of more than a thousand "really gets into it," she says, and they sing along with the gospel choir, organ, guitar, and drums. "Sometimes when we're singing and the spirit is moving, it's almost like the roof goes away and you can see the heavens. When we're all in sync, you can feel the spirit moving. That's the good part. That's what's exciting."

In New York City, a medical writer in his sixties talks about the changes that have been taking place at the five-hundred-member Lutheran church he attends. The Sunday services generally follow a traditional Lutheran pattern that includes hymns, the reading of collects and scriptures, sermon, and Eucharist. But the congregation is experimenting with a new hymnbook that includes selections from Africa and South America. Periodically, all the music is replaced by instrumentation from a jazz band. On one occasion an actor read a story about Moses as if he were reporting the evening news. On another occasion the entire congregation participated in acting out the trial of Jesus. Still, some of the most moving times have been during the Eucharist when the choir leads in singing a familiar hymn.

Churches like this are large enough to provide inspiring music, drama, and effective uses of the visual arts. But members of small churches testify that music and art are important in their congregations as well. A man in his eighties who attends a Christian Missionary Alliance church in Pennsylvania says the music is not as lively at this church as it is at the huge nondenominational church his daughter attends in Atlanta. But lately the pastor has been encouraging the congregation to sing wholeheartedly ("Make it sound like there's fifty of you instead of twenty"). The man says scarcely a week goes by without the music moving him deeply. "It just makes you want to serve Him more and to do more for the church and for the people," he says.

This man is not quite sure what it means to talk about the arts in church, but music is not the only thing he likes about the service. He says the pastor does a good job of putting "drama" into the sermons. Drama makes the stories come alive better than when the preacher just gets up and lectures. The man's wife likes the drama, too, although she admits her mind wanders sometimes. When it does, she looks at the cross hanging behind the pulpit and thinks about Christ's death and resurrection.

These responses appear to be typical. Most members appreciate their congregation's music, perhaps not all the time, but enough of the time that it is a significant part of their worship experience. Tastes differ from one church to another, but most members can think of at least one occasion during the past year on which they felt especially close to God because of the music. They point to times when someone singing off key distracted them, or lament the fact that they themselves cannot sing better. The quality of the music is clearly important to them, and many prefer familiar tunes or hymns that are simple enough to remember. Yet

TABLE 31. Religious Activities Are Associated with Levels of Satisfaction
with Church Music

(Among church members, the percentages of those whose level of satisfaction with the music at their congregation is low, medium, or high who give each of the other responses listed)

Percentage Who:	Level of Satisfaction with Church Music		
	Low	*Medium*	*High*
Attend services every week	36%	45%	61%
Have felt especially close to God while singing or listening to music during a worship service	56	67	78
Say attending religious services has been very important to their spiritual growth	39	59	73
Say their interest in religion has been increasing in the past five years	33	39	55
Say their interest in spirituality has been increasing in the past five years	40	52	59
NUMBER	(204)	(202)	(521)

NOTE: "Low" refers to members who give responses of 1, 2, or 3 on a scale from 1 to 5, where 1 means not satisfied and 5 means very satisfied; "medium" refers to responses of 4; and "high" refers to responses of 5; the question was asked about music at the member's own church.

it is often how well integrated the music (or visual art) is with the rest of the service that matters most. The music enriches their experience of the Eucharist, puts them in a reflective mood, and underscores their unity with other members of the congregation.

Nationally, the Arts and Religion Survey shows that congregants' satisfaction with the music program at their church is a key predictor of other aspects of personal and corporate spirituality (table 31). Specifically, when church members' satisfaction with the music at their churches is higher, they are more likely to attend services regularly, feel close to God while they worship, say that attending services has been important to their spiritual growth, register an increasing interest in religion, and claim that their interest in spirituality is increasing.[18] Of course, cause and effect cannot be determined from responses like these, but the data do suggest that churches may be able to increase their members' satisfaction and involvement by devoting resources to their music programs.

In the final analysis, it is impossible to gauge exactly how much of the continuing vitality of America's churches can be attributed to their musical and artistic programs. Certainly, most churches think that music is

important enough that they devote a large share of the worship service to it, and all but the smallest churches have some kind of choir, music leader, and an organ or piano. Take all this away and churches would hardly be churches.

Liturgical renewal in recent years has meant many different things, ranging from efforts in some churches to say the creeds and celebrate communion more often, to innovations in other churches involving congregational singing, hand clapping, and personal testimonies. The research presented here suggests a broader, almost generic meaning of liturgical renewal: church members, pastors, and other church leaders are simply coming to a clearer realization that worship itself is central to the life of any congregation. And when they do, music and other forms of artistic expression are generally taken more seriously, whether the particular styles are old or new.

Redeeming the Imagination

The Arts and Spiritual Virtue

"The church has been known throughout history for sucking creativity out of people," says a Presbyterian pastor in Pennsylvania. "We need to repent of that attitude and do everything we can to encourage people to be imaginative and creative." In Boston, a Baptist minister explains that using one's religious imagination means being able to "sensually connect with God" and thereby gain the "freedom for spirituality to grow and morph and transcend." A Lutheran pastor says the imagination is vital to Christianity; without it, people would be unable to envision what it might mean to worship God, to love their neighbors, and to live in harmony.

All across the country, clergy and lay leaders are rethinking the relationship between faith and the imagination.[1] Music and art do not just prompt people to feel close to God when they pray or enrich their experience of the liturgy. As people participate in musical and artistic experiences, they gain a greater appreciation of what it means to be creative—to let the imagination roam freely, thinking new thoughts and seeing in new ways. In the life of faith, imagination points toward thoughts that go beyond what can be known and demonstrated rationally. The religious imagination questions received interpretations that seek to define the nature of God too precisely or that limit the ways in which a person's relationship to God is experienced.

Historically, church leaders have often been skeptical of the imagination. Early Christian writers discouraged fictional and allegorical approaches that threatened to undermine the teaching that Christianity was firmly rooted in the historical fact of Jesus' death and resurrection.

After Constantine, the church increasingly sought to guide believers' interpretations of Christian doctrines. To the extent that music and the visual arts were utilized in the churches for instructional purposes, their meanings were carefully circumscribed. The Protestant reformers further restricted the use of images, arguing that rational interpretations of the Bible were the firmest foundation on which to maintain church doctrine.

The legacy of these historic teachings is very much evident in contemporary approaches to the religious imagination. "My tradition doesn't encourage the imagination," says an evangelical pastor. "I mean, the Protestant Reformation is built on iconoclasm. It's built on squelching the imagination and on taking out anything that might entice the imagination away from the spoken Word." Although he has mixed feelings about this tradition, other ministers state baldly that it is dangerous to be too imaginative in realms of the spirit. Says one, "We would do better not to imagine too much about religion and just stick with what the Word says." Many of the people we talked to, clergy and laity alike, said they had never heard the term *religious imagination,* or had not thought about it if they had. To some, it seems like an outright contradiction of terms.

In the survey, it was also clear that creativity and religious activities generally do not occupy the same category of Americans' mental landscape. Despite the fact that most people pray regularly and take part in religious activities at least fairly often, only about a third of Americans say these are among the ways in which they express their creativity. In fact, fewer people express their creativity through religious activities than do so by working, exercising, taking trips, or cooking.[2]

But the historic disjuncture between religion and the imagination—what historian Karen Armstrong has termed an "excessively theoretical and limiting cast of mind in Western theology"—appears to be breaking down.[3] Church members and other spiritual seekers who emphasize a personal relationship with God often insist that this relationship cannot be fully expressed through formal church doctrines; instead, it is a feeling—a presence—that is ultimately mysterious but can be imagined through metaphors, pictures, and images. Although there is widespread interest in the Bible, much of this interest stops short of viewing the Bible like a textbook of philosophical truths. Pastors and laity assert that faith is different from mathematical equations and chemical formulas. Faith, they argue, is putting one's trust in those things that cannot be empirically demonstrated. To have faith, one must be able to imagine realities that cannot be proven to exist.

What Americans Try to Imagine

That there *is* a grassroots connection between faith and the imagination is evident in responses to some of the questions in the Arts and Religion Survey. Respondents were posed with a series of phrases describing some of the things that people might try to imagine. For each phrase, they were asked to say whether they themselves had spent a lot of time trying to imagine it, spent a little time trying to imagine it, or had not tried to imagine it.

The two topics that Americans are most likely to say they have tried to imagine are "what God is like" and "what heaven is like." Eighty-four percent of the public have spent at least a little time trying to imagine what God is like, and 83 percent have spent this much time trying to imagine what heaven is like (table 32). It is interesting that both phrases are concerned with questions that generally arise in religious contexts. Thus, the connection between the imagination and faith is implied by the fact that so many people say they have thought about these matters. It is also interesting to note that these are apparently more than passing questions for many people: according to the survey, 44 percent of Americans have spent *a lot* of time trying to imagine what God is like, and 51 percent have spent this much time trying to imagine what heaven is like.

Three other questions apparently capture the imagination of a great number of Americans as well. Seventy-eight percent of the respondents in the survey say they have spent at least a little time trying to imagine how the universe came into existence. Seventy-five percent have tried to imagine what angels are like. And nearly this many (72 percent) have spent time trying to imagine if there is life on other planets. In each of these cases, at least a third of the public claim to have spent a lot of time thinking about these matters. That such a large proportion tries to imagine what angels are like seems consistent with the recent popularity of books and television programs about angels. Questions about the origins of the universe and life on other planets have also been popularized, both by the mass media and by scientific investigations.

Another question evoked fairly widespread interest in the survey. When asked if they have tried to imagine if there is some other reality beyond the one we know, 67 percent of the public say they have spent at least a little time trying to imagine this, and a third say they have spent a lot of time on it. In comparison, one of the questions included in the survey elicited interest from a smaller share of the public than might have been expected. Only 27 percent of the public say they have

TABLE 32. Most Americans Have Exercised What Might Be Called
the Religious Imagination
(Percentage nationally who respond to each item as indicated)

Have Imagined:	A Lot	A Little	Total
What God is like	44%	40%	84%
What heaven is like	51	32	83
How the universe came into existence	43	35	78
What angels are like	33	42	75
If there is life on other planets	32	40	72
If there is some other reality beyond the one we know	34	33	67
The feminine characteristics of God	9	18	27

NOTE: The question read: "Here are some things that people try to imagine. For each one, is this something that you have spent a lot of time trying to imagine, spent a little time trying to imagine, or have not tried to imagine?"

spent time trying to imagine the feminine characteristics of God, and only 9 percent have spent a lot of time doing so. In view of the widespread discussion of goddesses, androgynous images of God, and related ideas in feminist theology, it appears that relatively few of the public have been inspired to devote much of their time to rethinking the more traditional patriarchal images of God.

The fact that nearly all Americans have tried to imagine what God is like, while fewer than three in ten has tried to imagine the feminine characteristics of God, suggests that people's imaginations may run in different tracks or be sparked in different ways. For instance, one man says he imagines that God is like a loving father; another man says he has tried to imagine what God is like but has only come to the realization that no word or image is adequate. From the survey responses, it is also safe to infer that some people may be more inclined to think about heaven or angels, while other people's imaginations have been inspired more by discussions about life on other planets. The data nevertheless challenge the view that imagination is generally restricted to a particular metaphysical question that has just happened to spark someone's interest. Quite the contrary. People who say they have spent a lot of time trying to imagine one kind of question are also more likely to say they have devoted time to imagining other issues as well. Judging from these data, at least, using the imagination in one area seems to go hand in hand with using it in other areas.[4] The data also suggest that some people are simply more likely to exercise their imaginations than others.

Who, then, is most likely to exercise the imagination in these ways? Nationally, about a third of the population (31 percent) say they have

spent a lot of time trying to imagine a majority of the topics shown in table 32. In table 33, people in various sectors of the population are compared to see if certain kinds of people are more likely to exercise the imagination than others. The data show that younger people are slightly more likely than middle-aged or older people to say they have exercised their imaginations thinking about these kinds of questions. The differences are not large; they do nevertheless correspond with the biblical wisdom that young people will "dream dreams," and with statements from some of the older people we interviewed who said they had thought about such matters as the existence of other realities or how the universe came into being more when they were young than they do now. The responses from people with different levels of education are interesting: contrary to the view that higher education sparks the imagination, they show that people who have attained only some college education are more likely to have spent time trying to imagine answers to these particular questions than those who have graduated from college (and those who did not graduate from high school are more likely to score high than those who did graduate from high school). The data also show that women are somewhat more likely than men to score high, and that African Americans are a little more inclined to score high than are white Americans. In both cases, however, the differences are small.

Both religion and spirituality are related to people's likelihood of exercising the imagination in these ways. But the two are related somewhat differently. Religion's role is relatively weak. For instance, church members are slightly more likely than nonmembers to think about these questions (perhaps because several of the questions pertain specifically to God, heaven, and angels). Furthermore, evangelical Protestants are somewhat more likely to think about these questions than mainline Protestants; yet there is virtually no difference on the whole between Protestants and Catholics. In contrast, spirituality is strongly related to thinking about these questions: more than twice as many of those whose interest in spirituality is increasing score high than among those whose interest in spirituality is decreasing (and the percentage of those whose interest is staying the same is about equal to that of those whose interest is decreasing). In short, using one's imagination to think about cosmic questions seems to be about as common among people outside the churches as those inside them, but it does go hand in hand with being interested in spirituality.

But, apart from religion or spirituality, it appears to be creativity in general and the arts in particular that are most strongly associated with

TABLE 33. How the Religious Imagination Varies
among Subgroups of the American Population
*(Percentage in each category listed who scored high on the Index
of Religious Imagination)*

National	31%
Age 18–29	35
Age 30–49	31
Age 50 and over	29
Grade school	32
High school	27
Some college	40
College graduate	28
Male	29
Female	33
Black	34
White	30
Church member	33
Nonmember	28
Evangelical or fundamentalist	36
Mainline Protestant	29
Roman Catholic	34
Spiritual interest:	
Increasing	41
Staying the same	24
Decreasing	20
Creativity:	
Low	21
Medium	34
High	38
Artistic Interest Scale:	
0 (Low)	19
2–3	30
4–5 (High)	40
Felt closer to God through art	42
Have not felt this way	26
Felt uplifted by beauty	34
Have not felt this way	20
Felt closer to God in nature	24
Have not felt this way	25

NOTE: Persons who scored "high" on the Index of Religious Imagi-
nation say they had spent a lot of time trying to imagine at least four of
the seven items shown in table 32.

using the imagination to think about these kinds of cosmic questions. The role of creativity is seen in a comparison of three categories of people: those who score low, medium, or high on creativity as judged by combining their responses to a variety of questions in the survey.[5] Among those who score low, only 21 percent think a lot about cosmic questions, whereas 34 percent do among those who score medium, and 38 percent do among those who score high. The relationship between the Artistic Interest Scale and thinking about cosmic questions is even stronger: 19 percent think about these questions among those who score low on the scale, but this proportion climbs to 40 percent among those who score high on the Artistic Interest Scale. These relationships suggest, as some proponents of the arts have argued, that the arts may encourage people to reflect more imaginatively about such matters as the character of God or the existence of other realities. If nothing else, the two ways of exercising the imagination—asking cosmic questions and engaging in the arts—seem to go together.

The data also help to pin down a more specific aspect of this relationship between the arts and the religious imagination. In our personal interviews, we found a number of people who said their thoughts about God (and other cosmic questions) had been inspired by viewing a particular work of art, such as a painting of Jesus that made them wonder if Jesus really looked like that, or a beautiful landscape that helped them to imagine that God's own beauty must truly be radiant. The survey shows that this impression from anecdotal evidence has some statistical validity: among those who say they feel close to God when viewing a work of art, 42 percent have thought a lot about cosmic questions, compared to only 26 percent of those who do not feel this way. The data also show similar differences between those who have and those who have not felt uplifted recently by seeing something beautiful, and between those who have and those who have not felt close to God as a result of being out in nature. These relationships all suggest that the religious imagination tends to be sparked by moments of special beauty or inspiration.

Changing Meanings of the Imagination

When people say they try to imagine what God is like, or when a teacher challenges students to "use your imagination," we have an intuitive sense of what it means to be imaginative. Words such as *creative* or *artistic* come to mind, just as phrases do such as *think freely, let your mind*

roam, or *try to visualize it.* But it is important to understand that the imagination has not always meant what it does today, and that its connections with religion are currently undergoing significant modifications as clergy and lay leaders seek to bring the arts more engagingly into a relationship with the churches.

To most Americans, the meanings of the imagination have been deeply influenced by the scientific worldview that has dominated much of Western civilization since the seventeenth century. In this view, imagination is defined largely in relation to what can be established either through reason or an examination of the facts. The realms in which the imagination most obviously prevails are thus the creative arts, including fiction and poetry, drama, music, and the visual arts. In these realms, fantasy takes precedence over factual reality. Rational argument and scientific investigation may proceed from flights of fantasy (such as the proverbial "aha" experience that leads to a scientific discovery), but rational and scientific modes of understanding aim fundamentally to curb what is regarded only as conjecture by bringing its reality into a form of existence that can be verified by all who may be interested.

When the imagination comes to be defined as that which is left over as a result of reason and science, there is an inevitable affinity between religion and the arts. Both are realms of the imagination. Yet these are not the only occupants of this realm. The imagination also includes daydreaming, prevarication, lies, telling half truths, play, pretending, fantasizing, hallucinations, paranoia, and delusions. Most of these have negative connotations. Thus, both religion and the arts have sought to protect themselves from these negative connotations. Religion has done so partly through the authority of the church, but also by focusing heavily on the more rational aspects of Christian theology. In contrast, the arts have necessarily encouraged the imagination, but have carefully specified the training, skills, and professional modes of certification that needed to be satisfied in order for a person to be considered a legitimate practitioner of the arts.

Religious skepticism toward the imagination has thus been influenced by its relationship to the sciences. Wanting not to leave themselves open to accusations of promoting hallucinations and lies, religious leaders have sought firmer grounds than the imagination on which to argue the bases of faith. To be sure, imagination might be considered relevant to faith, insofar as faith could not fully be defended through rational argument or scientific investigation. But it was imperative for the imagination to be kept within appropriate bounds. Believers might try to imagine what God was like, but should be careful about

how they did so. Because God's nature could never be fully imagined, the act of imagination was itself of minimal value. Better simply to acknowledge that God was beyond comprehension than to "make up" images and descriptions of God. To the extent that the imagination was deemed useful, it was to be guided chiefly by images and metaphors readily available in the Bible or sanctioned by the church. A story of God protecting believers like a shepherd protecting sheep was thus appropriate, but a picture depicting God as a large flower would not be.

In recent decades, the relationship between religion and the imagination has started to change as a result of shifts in public perceptions of science and rational thought as well as shifts in the character of both religious and artistic communities. The change in attitudes toward science is sometimes described as an erosion of confidence in science itself. That interpretation is probably inaccurate, especially in view of the fact that most people continue to hold scientists in high regard and willingly support scientific studies, from explorations of outer space to studies of the genetic makeup of humans. A more accurate rendering of the change is that science, far from reducing the complexities of life to a few mathematical laws requiring little imagination, has increased the realm of wonder and imagination by demonstrating that the universe is infinitely complex and changeable. Testimonials from scientists who claim to understand small pieces of the natural world, and who yet express wonder at all that they do not understand, help to underscore the continuing importance of the imagination.[6]

Religion and the arts, in turn, have been assisted in giving a more inclusive role to the imagination by this rethinking that has taken place in the sciences. Although many religious people consider their beliefs fully rational and beyond the critical scrutiny of scientists, they do so increasingly, it appears, by arguing (just as scientists do) that the universe is too vast—and too much of it still unknown—for alleged contradictions between faith and reason to be matters of serious concern. When scientists readily acknowledge the limits of their knowledge, moreover, it is easier for the public to conclude that religious leaders probably have limited knowledge as well. Personal experience takes precedence alongside the teachings of church leaders. At the same time, standards of artistic evaluation have also blurred, leaving greater room for variety and weaker distinctions between the forms of creativity used by professional artists and those expressed by amateurs and consumers.

These changes in the wider culture have made it easier for the average church member (or pastor) to think about ways in which the imagination might play a positive role. In personal interviews, people of all

ages, education levels, and faiths certainly argue that it is legitimate to use their imagination in thinking about cosmic questions, and they assert, almost to a person, that spirituality and creativity reinforce each other. Comments range from suggesting that one *has* to be imaginative about God because nobody has ever seen God, to saying that people need to think creatively about spirituality because every person is unique or because God expects people to use their creative talents.

But a more significant rethinking of the relationship between religion and the imagination is taking place. Religious leaders are themselves focusing increasing attention on what many call the religious imagination, and in so doing, they are casting it into a more positive—and in some cases, a more theologically informed—light by showing how it connects with the oldest and most fundamental of Christian virtues. These virtues are, in turn, being rethought in ways that make them more compatible with an era in which creativity and freedom of expression have gained ascendancy over dogma and obedience. The nature of faith itself is changing, as are the meanings of prophetic hope and the loving community.

The Imagination and Faith

Of the three traditionally defined theological virtues (faith, hope, and love), faith has been accorded such importance in the modern era that its primacy has often seemed to outshine the other two. Faith is the essence of Christianity, the pathway to salvation, the truest mark of God's chosen. As an act of will, faith is fundamentally an attribute of the individual believer, a fact fully affirmed by the Protestant reformers who insisted that the faithful person ultimately stands alone before God to be judged, not on the merits of his or her works, but on the basis of his or her faith. Faith (the ability to have faith) is, in turn, granted by God and thus stands in a complex relationship with divine grace. Moreover, the community of believers plays a role in bringing the believing individual to faith, especially through the baptism of children and its support of families. In the long view of historic Christianity, faith is an act of the imagination to the degree that one must believe in an unseen God. But to a greater extent, it is an act of will—both in overcoming the natural willfulness of the unregenerate person to succumb to a life of temptation and in conforming one's personal inclinations to the teachings of the church. Faith is guided less by imagination and more

by careful biblical instruction, especially in the virtues exhibited by Jesus and toward an understanding of Jesus' redemptive role in the individual's salvation. Indeed, the imagination may well lead the individual astray (by engaging in "vain imaginings") or result in heterodox beliefs. For the imagination to be associated more positively with faith at the present time, therefore, is a matter of reconceiving the nature of faith itself.

An illustration of how the imagination is coming to be understood by some religious leaders as a more positive aspect of faith than in the past can be seen in the remarks of Reverend William Tully, rector of Saint Bartholomew's Episcopal Church in New York City. Reverend Tully tries to encourage parishioners to make full use of the arts to spark their religious imaginations. The church sponsors one of the most expansive choir programs in its denomination and is regarded by leaders of arts organizations in New York as one of the best examples of cooperation between religion and the arts. Tully's understanding of the importance of the religious imagination began to blossom in seminary. Studying Hebrew for the first time, he realized that the language is sufficiently flexible to invite different ways of thinking about the attributes of God. Over the past two decades, his preaching has persuaded him that Jesus himself illustrates this use of the imagination. "Jesus was one of the most imaginative people who ever lived. He told stories to give people pictures. He used the stuff of their ordinary lives, but took them out of it. The authentic Jesus that comes through in the pages of the New Testament is very imaginative. Religious people who reduce Jesus to a giver of orders miss the imagination."

In this view, faith can thus be centered in the authentic life of Jesus, while one's own imagination is sparked by the very qualities evident in Jesus. The connection is grounded in a strong emphasis on the incarnation, the teaching that Jesus was God in human form, and more generally the belief that all the created order is an incarnation of God because God created it. Believers are encouraged to emulate Jesus in his use of the imagination and, because Jesus is no longer physically present, they *must* imagine how best to follow him and to fulfill his mission.

If this sounds straightforward and incontestable, Tully nevertheless fears that the church has too often tried to reduce Jesus' life to a set of moral principles, rather than encouraging people to see the creativity in his teachings: "One of the things that stifles religious faith and community life and imagination is the strain of moralism in the Christian

life. The anxiety that people have about doing right comes across as a stern moralism and it kills everything. It kills the spirit. It kills religious life. As a pastor, and particularly where we're seeing lots of newcomers and returnees to church, we hear over and over again the anxiety that they're going to walk back into a moralistic community. It's just not freeing. It doesn't mean that there isn't a moral quality to the Christian life, but to be moral is one thing, to be moralistic is something else again. An imaginative Christian life and the freedom that comes with it can deepen one's life and get around that block which is moralism."

Tully's argument illustrates one of the ways in which faith can be reconnected to the imagination without risking the possibility of entering into an arena in which any belief or activity that an individual can imagine is acceptable. Jesus now becomes the standard by which imagination is guided. If Jesus was a creative person, then followers of Jesus can legitimately be creative. For some (not necessarily Tully), this view is reinforced by emphasizing the humanity of Jesus. Thus, faith consists less in thinking of Jesus as someone who defies rational or scientific description (an amalgam of divinity and humanity) and more in recognizing Jesus as a role model or guide. Indeed, in some contemporary views, Jesus' special place in history is almost regarded as a function of his ability to exercise his creativity—thinking outside the box, as it were, and challenging the received rules of his day.

Setting the creativity of Jesus in opposition to the "moralism" of the church, as Tully does, also helps to establish at least an implicit link to a long-standing tradition of thinking about religious reform and revitalization. Here, moralism represents a lack of creativity, a restriction on the imagination that hampers church growth by causing potential newcomers to worry about the rules to which they will have to conform. In contrast, the creativity associated with Jesus connotes possibilities of change, of church growth, and indeed of returning to the dynamic faith of the first Christians.

A second example of someone who shows how people are rethinking the relationship between the imagination and faith is Marie Bricher, director of adult education and coordinator of RCIA (Rite of Christian Initiation of Adults) at Saint Paul Roman Catholic Church in Eugene, Oregon. A lifelong Catholic, she began working part-time with RCIA in 1988 at a parish in Seattle and has worked full-time in her present position since 1995. With some nine hundred families, Saint Paul's has grown steadily in recent years as a result of expansion in the nearby Weyerhaeuser lumber industry and new corporate arrivals, such as Sony and Hyundai. The building itself was constructed in the 1960s and reflects

the liturgical reforms of the Second Vatican Council. Seating surrounds the altar and brightly colored banners add to the visual impact of a large crucifix. Although the mass follows the prescribed liturgy and emphasizes the Bible, parishioners are also encouraged to learn in new ways, especially by singing contemporary praise hymns and experiencing an occasional liturgical drama. Marie Bricher says she has come to a new appreciation of the imagination both through the liturgy and in her personal life.

She defines faith as those things to which she has given "assent," including her belief in the existence of God, God's revelation in Christ and the church, her own sinfulness and that of all humanity, God's redemptive love, and her desire to know God's will. Giving assent to these teachings has been relatively easy in her case because she went to church regularly as a child with her parents, grew up admiring two of her uncles who were priests, and through high school and college had ample opportunities to worship and study with other Catholics. To be sure, there have been times when she questioned the church's teachings. But "assent" has meant largely that she made a tacit agreement with herself along the way to consider the basic elements of her faith "true," even if she did not fully understand them.

What is harder—and what occupies much of her personal and professional life as an adult—is moving from assent to what she calls "enlightenment." She does not mean this in an Eastern religious sense or in the way that eighteenth-century European philosophers did, but as a process by which she discerns the will of God. Enlightenment is shorthand for spiritual growth. As she explains it: "My growth in spirituality has meant that I am more free to give my will to God, to do God's will in my life, and that I derive more joy and peace from doing so. In other words, there is less of a struggle inside of me to assent to God's will. I find that I can more easily interpret and explain to people elements of the faith, which means that they are more integrated in my life, that they are not just something I have learned, but are something I act upon and understand, with the guidance of the Holy Spirit. I guess you could summarize that in the word *enlightenment*. My spiritual growth has led to more enlightenment."

The religious imagination is essential to her understanding of enlightenment (or spiritual growth). She defines it as "the meeting place between God's will and our ability to understand its meaning and its purpose." It is "communicated not so much in proposition and doctrine as in metaphor and story, which is often the only way to express fundamental truths." She says the religious imagination plays two im-

portant roles in a person's spiritual life: "When one reads sacred Scripture, particularly places where truth is communicated through myth or story, one must make use of religious imagination in order to get anything out of it, in order to not be completely befuddled by what one reads. Secondly, religious imagination as a form of intellectual play is the way one can make connections in one's own life between great spiritual truths and what's happening to me today."

What exactly is she saying? Her understanding of God's will is the key to the importance she attaches to the religious imagination. God is, in her view, ultimately a mystery, where mystery, as she explains it, does not mean something that one can eventually understand, but something that can never be understood. Sometimes she uses a spatial metaphor: God is over "there," wholly other, holy, loving, but inscrutable. The person who desires to know and follow God must move closer to God. She describes this closeness (which she experiences most often during the mass) as achieving a palpable, transformative relationship with God. "It is profoundly humbling, and at the same time, just completely uplifting. There is a sense, on the one hand, of losing one's self into something far greater, namely, God, and, on the other hand, finding out who you truly are, namely, God's beloved. It's that dynamic of letting go and being found that I think is most profound." When this merging of herself and God occurs, she is able more fully to give assent to what she knows about God and more easily to follow God's will for her life.

But achieving closeness to God requires effort. Over the years, she has tried to gain a closer relationship with God (or what people in the past would have termed a stronger faith) by supplementing her participation at church with devotional activities in her day-to-day life. She learned the technique of reading the Bible, known as *lexio divina,* which involves meditating on the meaning of a passage of scripture, including imagining oneself as a character in the biblical stories. She also learned a version of contemplative prayer, advanced by the Catholic writer Thomas Keating, in which one meditates on the events of the day, examines them in light of one's understanding of God's will, and asks for God's guidance both in interpreting and responding to them. For the past several years, she and her husband have been praying together every day, and she spends several minutes in prayer at least four times a day, not to mention uttering dozens of one-sentence prayers throughout the day.

The Bible is central to her efforts to pray and to know God's will. Yet she acknowledges that there are times in her life (and certainly in her in-

volvement in the lives of people in her RCIA classes) when it is difficult to know how to interpret the Bible: "One of my senses is that we have profaned the written word. There is so much written out there that is so bad, and the Internet has only increased it. There is so much junk that it is hard to be certain of something that one must be certain about, such as one's faith and does God really exist? Is this really what I should be believing? One has to look for something besides the printed word to confirm that, because most people have seen that the printed word in our culture is filled with lies, misinterpretations."

The religious imagination comes into play in helping a person to know what to make of the Bible and church teachings. Marie gives two examples. When she prays, she often listens to music. She prefers music that is relatively quiet, slow, and that includes lyrics taken directly from the Bible or paraphrased from the Bible, especially lyrics that she can readily understand as she listens. This kind of music helps her to imagine what the words mean better than if she simply read them. She says the slowness of the music and the fact that the music establishes a rhythm or pace (unlike reading at her own pace) forces her to pay more attention to the words and to let her mind wander over some of their implications for her life. The other example emerges as she tries to explain what happens when she imagines what God is like. "God is spirit, God is creator, God is redeemer, God is love, God is purposeful, God acts," she begins. But, noting that these are abstract words that may have little meaning to someone's daily life, she adds: "These are all descriptive words. None of them are visual words. It takes the religious imagination to help put them in a way that you can see or touch or hear something that truly is unknowable. That is why we like the poem 'My Love Is Like a Red, Red Rose.' It helps us put an image on something that is really unimaginable."

In these examples, the religious imagination facilitates spiritual growth by moving one's mind beyond familiar or abstract words to images or examples that have greater meaning for one's personal life. The religious imagination plays another role, too, which emerges most clearly as Marie talks about creativity. It involves coming up with creative ways of seeking God's will amid the routine problems one faces in daily life. The difficulty in dealing with such problems is that a person can read scripture, attend mass, and feel close to God, and yet not know exactly how to follow God's will when confronted with a particular problem. For instance, she recalls an evening recently when her son was afraid to go to sleep because he had dreamed the night before that a giraffe was looking in his second-story bedroom window. Besides com-

things will work out in the end, that there will be heavenly rewards after death, or that one's confidence in the existence of God is not misplaced ("I hope God really is there"). But in recent thinking about the religious imagination, hope takes on a more prophetic connotation. It suggests activities or ideas that give people hope—reason to think that present problems can be alleviated, a vision of bringing biblical ideals, such as peace and justice, to fruition. Being hopeful means overcoming despair, lifting one's sights to higher ground, working to achieve equality. The religious imagination becomes a means of keeping hope alive. By exercising the imagination, people are able to break free of cultural constraints that inhibit them from realizing their own potential or devoting themselves fully to helping others.

Image: A Journal of the Arts and Religion, founded in 1989, has become an important vehicle through which the relationships between the religious imagination and hope are being explored. The journal's quarterly format includes movie reviews, original poetry, interviews with artists, articles about visual art and music, symposia, essays, and book reviews. It is by no means concerned especially with social change or with ministries to the disadvantaged. Yet its pages consistently focus on the ways in which art and artists are reshaping and enriching the world of religion, including its prophetic voice.

The journal's philosophy reflects that of its founding editor, Gregory Wolfe, a writer in his early forties who holds a master's degree in English literature from Oxford University. Raised first as a Christian Scientist and then as a New England Congregationalist, he grew increasingly restless during high school with what he describes as the church's "tepid" approach to spirituality, read avidly about other traditions, mostly attended Episcopal churches while in college, and eventually converted to Catholicism at Oxford. Feeling drawn to "that which can be embodied very concretely in story or symbol," as opposed to abstract thought, he shaped his course work in history and literature to undertake a broad exploration of the relationship between the creative arts and religion. Under the "self-given mission statement of trying to understand how modern artists and writers could embody the traditional faith in modern forums," he became devoted to Gerald Manley Hopkins, Flannery O'Connor, Evelyn Waugh, Walker Percy, and Shusaku Endo, among others, all of whom represented, in his view, the leading edge of a twentieth-century Catholic renaissance. His decision to join the Catholic church was thus as much a reflection of his attraction to Catholic writing as to the Catholic liturgy.

His decision to start a journal grew from the same conviction that led

him to become Catholic: a deep concern over the breach between contemporary culture and contemporary religion. His goal was to demonstrate that there *were* interesting writers and artists whose work was profoundly important for healing this breach. At first, he and his wife, with another couple, entertained the idea of initiating a utopian colony for such writers and artists. The cost of doing so soon ended that vision. But a new journal seemed within reach. "We always wanted *Image* to be a two-edged sword," he explains. On the one hand, it challenged people within the religious community to engage more actively with the culture; on the other hand, it sought to show the secular culture that good writing and art were still being done by people with religious convictions.

Conceding that his penchant for concrete symbols and metaphors may be a personal weakness, he says his own spiritual journey has been facilitated most by praying with the aid of Psalms, icons, poetry, and prayer books. He prays daily by himself and with his wife and children. He says he can only describe his understanding of prayer metaphorically: "uncovering one's self, taking off the masks and the layers that we wrap around ourselves on a daily basis in order to become vulnerable and open and receptive to God's presence." This feeling of God's presence is one he experiences regularly during the mass as well. "It is the moment of heaven and earth coming together and Christ and me coming together in a way that's palpable."

Just as Marie Bricher does, he resorts to a spatial image in describing what happens when he experiences God's presence. Prayer, the liturgy, reading novels, viewing a work of art all help him to engage in what he describes as an "imaginative placing of one's self in the experience of the Other." In relating to God, the self moves, as it were, into a new space, a sanctified place. "The essence of Christianity is to be able to revere the other, whether that's the radical otherness of God, the ultimate other, or the otherness of neighbor." Being able to relocate oneself this way is a feat of the imagination; it requires conceiving of oneself *as if* in a different place than one really is.

This capacity to imagine is also the key to Wolfe's understanding of hope. "One of the essential facets of the imagination is placing you inside the consciousness of the other. By doing that, we deepen our compassion and we deepen our understanding. We deepen the nature of our forgiveness and we at the same time are challenged ourselves." Only by placing oneself in the shoes of one's neighbor is it fully possible, in this view, to have compassion, which, in turn, motivates a person to work

forting him and trying to dispel his fears, she invented a story involving one of his toys, a stuffed puffin. Together, she and her son decided that the puffin could "eat" his dreams. Thus, if he dreamed again of giraffes, he could call on the puffin to clear the air of these bad dreams. Afterward, she thanked God for letting her use her imagination in this way to resolve the problem.

The arts can help a person's faith by sparking the religious imagination. Marie Bricher does not consider herself artistically gifted, even though she learned to play the piano as a child and has periodically done quite a lot of drawing ever since she was in high school. It has been more as a consumer of music and art that she has come to appreciate its ability to spark her imagination. Sometimes seeing a work of art, like listening to music, has helped her to understand a biblical passage more clearly. For instance, she walks the stations of the cross at a nearby abbey at least once a year because the carved stations help her to imagine what Jesus was doing. On other occasions, a painting or a dramatic production that has no obvious connection to religion helps her to think about her need to be obedient to God or to love other people. In fact, she sees a strong parallel between art and prayer: both draw her outside of herself so that she can focus more clearly on God.

In this example, then, most of the traditional understandings of faith are preserved, especially the idea that a person of faith must not only give tacit assent to church teachings but must also seek to know and follow God's will. Prayer and Bible reading remain central in this understanding of spiritual growth. But the imagination also becomes more important. It supplements propositional truths that are either too abstract or subject to too many different interpretations to provide reliable guides for faithful living. The imagination can run wild and lead a person astray, but that possibility seems not to be a particular concern. Instead, the imagination is a human gift that can be trusted. Because God is a mystery that can never be fully understood, any and all images that point the believer toward this mystery—toward what Auguste Rodin called the "something more that cannot be known"—are helpful.[7] And because situations and individuals are all different, the imagination is needed in order to discern God's will.

The Imagination and Hope

In popular understandings of the theological virtues, hope is often difficult to distinguish from faith. Hope refers to the expectation that

for social change. Art fails, he thinks, if it focuses directly on achieving some moral purpose, such as eradicating evil or helping the needy. But it succeeds indirectly by transporting a person to a new reality. And in doing so, it fulfills the most vital functions of religion, which, in his words, is "ultimately about the encounter between man's woundedness and God's healing glory."

The realization of hope through a transposition of oneself into a more glorious, whole, divine location shifts from image to practice in the work of Francisco Herrera. A California native, Herrera works for the Interfaith Coalition for Immigrant Rights in San Francisco, an organization that seeks to assist immigrants by lobbying for legislative reforms and sponsoring conferences to change community perceptions of immigrants. Except for being Catholic, Herrera's life has been almost the mirror opposite of Wolfe's. Instead of being raised by upper-middle-class parents in New England, Herrera grew up in a working-class family and lived in a neighborhood that was virtually all Mexican American. His childhood experiences with religion were far from tepid: they included the sensuousness of the liturgy, candles, adoration of the saints, guitars, and folk music. He eventually earned a master's degree (in theology), but his spiritual journey was shaped less by reading and more by doing: working with refugees and migrant laborers and spending time in El Salvador, where he was very nearly killed by marauding soldiers.

Herrera's understanding of the religious imagination is in many ways different from Wolfe's. His religious experiences never suffered from abstraction. He did not have to discover the arts as a way to make theology concrete. Although the Jesuits taught him about the mystery of God by requiring him to read theology, he concluded that the real mysteries of God are "of our sexuality, the mysteries of our love with our wife and husband, as opposed to the Trinity or all these other ideas that people who were not hungry sat down and thought about." Nor did he have to imagine what it might be like to experience life as a member of a minority group or to put himself in someone else's place by reading fiction. He physically put himself in others' place, living with them, helping them, and sometimes dodging bullets for his efforts.

Still, there are similarities between Herrera and Wolfe. Like Wolfe, Herrera understands that relating to God requires moving outside oneself into a sacred place. He says his experience of church during childhood was an example of this kind of transposition. He went to church so often, lived so close to it, and participated with his family to such an extent that there was little difference between church and home. Some-

times the sights and smells of the church were so familiar that they lost their ability to evoke a feeling of sacredness. But he learned gradually that the objects at church were sacred because of how they were *interpreted*. In other words, it required imagination to see that bread and wine were really the body and blood of Jesus or that smoke from a candle represented the people's prayers to God.

Imagination and the arts connect with hope for Herrera, just as they do for Wolfe. As a teenager, his playing the guitar was instinctively associated with his hopes for a better future: like many young people, he dreamed of joining a rock band and striking it rich. He gave up that dream when he found it was more rewarding to work with the poor. Yet he quickly discovered that he did not have to give up music entirely. Playing the guitar and composing simple folk songs was a way of lifting the spirits of the people he was helping. They could imagine a better day, a time of justice.

He, too, says it keeps him from losing hope when he is able to imagine a better world. Sometimes he thinks of Gandhi and figures Gandhi must have had a keen imagination to see what India could become. He playfully entertains the idea that imagination may be a "sixth sense," as real as the other five. But in the final analysis, his view of the religious imagination focuses on hope itself: "to be able to visualize the utopia, the lion sleeping with the lamb, the resurrection, going beyond the possibilities that are thought about, and really following the dream of humanity, the dream of God." People can imagine war, he observes, but people cannot imagine peace. "What is God's dream? That's what we need to ask."

In these two examples, the imagination is positively valued largely because it helps people to envision a world that is more in keeping with God's will than the one that presently exists. The imagination breaks through the taken-for-granted reality of ordinary life and helps, as Walter Brueggemann has written, "to liberate people from this contrived, false, idolatrous construct of reality."[8] This use of the imagination is not unlike that of prophets and visionaries who offer glimpses of future worlds or kingdoms of God on earth. Dreamers like this have often started new religious movements, earning themselves the wrath of more sober-minded church leaders. The same is considered possible with present uses of the imagination, especially if visions and dreams challenge established social customs. But the images that the arts inspire are generally more private or more practical than this. Few would argue with a vision of hope inspired by a Flannery O'Connor novel or put into prac-

tice by helping immigrant laborers. Thus, the imagination can be brought safely into the realm of religion; through its association with hope, it gives people a legitimate way in which to be creative in their thinking.

The Imagination and Community

The third—and, according to biblical tradition, highest—theological virtue is love. For people like Francisco Herrera, love is linked to the imagination chiefly through acts of service that give hope to the needy. Throughout its history, the Christian church has also recognized, however, that love should be embodied in the community of believers. Here, among those drawn to the love of Christ, mutual acts of service combine with a broader and more corporate sense of identity. The self, with its selfish desires, is tempered by the kindnesses, monitoring, and positive examples set by other members of the community. Talking with contemporary religious leaders shows (as we shall see) that understandings of love are closely wedded to an emphasis on community.

But the imagination has not often been regarded as a characteristic that could easily be reconciled with this emphasis on community. Whereas the self is restrained by the community, the imagination connotes freedom of self-expression. In community, believers conform to the norms established by their peers, while the imagination encourages diversity and deviance from these norms. Thus, it is interesting that another important way in which the imagination is currently being brought again into the center of religious discussions is by associating it positively with community.

Perspective on the relationship between the imagination and community is given by Father Daniel Mackle, director of the Office for Worship in the Roman Catholic Archdiocese of Philadelphia. Established in 1989, his office supervises the diocese's efforts in liturgy, the celebration of sacraments or devotional life in the church, church music, the diocesan choirs, the coordination of choirs and music direction in the diocese's 287 parishes, the artistic design and construction of all churches and chapels in the diocese, and any other activities involving sacred art and the environment. These efforts have expanded significantly in recent years as the church has attempted to respond to concerns about the preservation of traditional art and the commissioning of innovative art and music. An influx of Hispanics, Asian Americans, and African Amer-

icans to the city has added to the office's work of integrating the arts and religion. Father Mackle views the religious imagination particularly in relation to its capacity to promote community.

When asked to explain his understanding of the religious imagination, he notes that contemporary thinking is rediscovering the church's historic teaching about the role of images. "Many authors today, and there are a variety of them, will say that since we have not experienced God in his essence, that various pieces of art or liturgy will give us insights into God, and when the human person is touched by those pieces, then in some way we can imagine or bring ourselves to an understanding of who or what God is." He emphasizes that this use of the imagination creates a potential for tension between the church and individual interpretations of the essence of God. "We believe in the Catholic church that God not only speaks through the hierarchy or the bishop of the church, but also speaks to individuals." This belief is rooted in the assumption that individuals are formed in the "image and likeness of God" and for this reason have some of the creativity evident in God's nature as the creator of the universe. But Father Mackle moves immediately to minimize the potential for conflict between individual creativity and the community through the following observation: "If we believe that we are in the image and likeness of our God, then the religious imagination, either on a communal level or an individual level, transmits our experience of faith. There is some validity to it; it helps people to grow, not only in a relationship with that God, but in a relationship with the whole community, with their brothers and sisters." In other words, there is a two-fold connection between the imagination and community. In its *origin*, the imagination flows from God, and since all people are made in the image of God, there is a certain commonality or common bond in what they are likely to imagine. And in its *function*, the imagination helps people to express their faith and thus contributes to the strengthening of their relationships with fellow believers.

Father Mackle recognizes that the imagination is still viewed skeptically in some quarters, perhaps especially those who associate it with telling "fairy tales." In contrast with this view, he suggests that the religious imagination is better understood as the way in which "kernels or pieces of divine truth are appropriated in a particular person's life or in a community's life." As an example, he points to the role of "popular devotions" among the Hispanic population in the Philadelphia archdiocese. These devotions (such as the ceremony performed when a girl

reaches the age of fifteen) are, in his view, an expression of the community's religious imagination. They celebrate a particular understanding of God, not necessarily one that is in every way sanctioned by the church, but collective nonetheless: a ceremony that weaves individual creativity together with family and neighborhood traditions. "The values of God that this community has come to understand from their experience are transmitted and carried in these popular devotions."

With ethnic and cultural diversity growing in the United States, Father Mackle believes the Catholic tradition of enculturation—adapting church practices to the distinctive traditions of particular ethnic groups—is being rediscovered as an important use of the religious imagination: "In theology or liturgical studies today, one of the main forefronts is enculturation. How does a community express its relationship with God through these popular devotions, through its culture, through its music, and how has it carried those essential truths? When official church practices have changed, some of these communal or cultural things have maintained the burden of carrying the mystery much better than the official interpretation. It is something that demands humility, because for most of us who are professionals in church work, we come with degrees, with a very intellectual understanding of things, and if these popular experiences don't match categories or intellectual understandings, we think they are not valid. So there needs to be a humility that says there is truth, there is faith in a lot of these creative expressions through culture, through music, and through art."

Although the religious imagination can be thought of abstractly (as creating new connections among religious symbols and their meanings), its significance for the church is thus legitimated by associating it with the grassroots needs of local communities. Father Mackle distinguishes these grassroots needs from official church teachings: "We sometimes get so tied into dogma or doctrine, especially in the Catholic church, that we see dogma or doctrine isolated from religious imagination, rather than seeing it as part of an integrated whole. Dogma or doctrine is the way you officially summarize or encapsulate something that has been in the religious imagination of the people or of a denomination that's carried over into worship, that's found in popular devotions. In those popular devotions would be all sorts of dramas and art, family customs, traditions as simple as baking certain goods, the way you clean the house, or the way you decorate at certain seasons, all of that would carry, in a sense, a religious environment."

In this view, then, paying greater attention to the religious imagina-

tion—which Father Mackle says is consistent with the teachings of the Second Vatican Council—is a way to revitalize the church. Doctrine can become stultifying, especially when it is promoted by intellectuals whose roots in the community have been severed. At the same time, the cultural environment of local neighborhoods and families is continually threatened by the secularizing forces of advertising and materialism. Using the imagination to re-create popular expressions of religious devotion helps to solidify the relationship between communities and God.

An equally strong, though somewhat different, connection between the religious imagination and community is drawn by leaders in the Orthodox tradition. In fact, some of the best thinking about the religious imagination in recent years has been done by leaders in the Russian and Greek Orthodox churches, whose traditions have historically emphasized the role of visual imagery to a greater extent than most of the Western churches. At Saint Tikhon's Orthodox Seminary and Monastery near Scranton, Pennsylvania, Father Alexander Golubov is an articulate spokesman for rediscovering the power of sacred imagery. He divides his time between teaching and serving as academic dean at the seminary and conducting services for the nine hundred families who attend Saint Nicholas Russian Orthodox Church in New York City.

For Father Golubov, the mandate for exercising the religious imagination comes, as it does for Father Mackle, from the biblical understanding of creation: "It comes essentially from the book of Genesis, the first book of the Bible, which tells us that God created the human being in his own image and likeness, which essentially sets out for the human being a whole program of growth and perfection, to come as near as possible to God as the human being can. If God is a creator, the human being is not only a creator, but creative. If God loves, then the human being also has the capability to love and is a lover, and so on boundlessly, because God is boundless. The essential aspects of the human being are in the image and likeness of God. The Orthodox essentially makes the distinction between image and likeness in the manner of saying image is what is given to us. The potentiality and likeness is what we make of it, the actualization of the potential. If all human beings are endowed with divine creativity, which essentially pours out into all aspects of human life, it is impossible not to be creative in human life. Depending on what a person's individual gifts are, he is called and challenged to be creative in those areas of life where he is gifted."

This understanding of the imagination, or creativity, resolves one of the perennial questions that have plagued church discussions of the arts

in particular and of the imagination in general: should the imagination be encouraged, especially if some people have more of it than others and thus endanger the solidarity of the community by showcasing their particular talents? As Golubov explains, "Creativity is a spiritual concept. It cannot be felt. It cannot be defined. It cannot be rationalized. It takes just as much creativity to be a good surgeon as it takes to be a good musician, as it takes to be a good teacher, as it takes to be a good lawyer, as it takes to be a good politician, because the essential spiritual qualities are there, are ingrained in the human being. Depending on the gifts you are given, you are called to actualize them through creativity in life. There is no possibility of any single individual not being creative. If that happens, or if a person says it is happening, there is something wrong on the spiritual level." In other words, creativity is not only hard to define but also universal. This means that every person who is part of the spiritual community has something to contribute.

Golubov underscores this point by associating the imagination with the soul: "The soul, which every human being has, is the creative aspect of the human being par excellence. The soul is the mind. The soul is the memory. The soul is the imagination. The soul is the reasoning. The soul is the whole inner universe which exists in the dimension of the arts, and the arts are the tools that bring out the capabilities of the human soul. Imagination is a part of the soul. The arts essentially both define and express the human imaginative potential. Without the arts, it is impossible to live. It is like being blind, it is like being deaf. It is impossible."

If the imagination is inherent in the soul, the connection between creativity and community nevertheless depends on some means of sparking the imagination and causing its work to become visible. This is the role played by the arts in particular and by symbols more generally. Father Golubov asserts: "The expression of the imaginative world cannot happen rationally. It has to happen through the arts, because the arts are what provide the language of symbols. Symbolism is only understood in the arts. Symbolism cannot be understood technically and rationally, because it is beyond rationality. It is metalogical. It is metarational. The language of symbols is understood on different dimensions. A symbol is a sign that brings meanings together. *Sym boli*, two Greek roots, which mean together and bring. A symbol brings together meanings from different dimensions, different levels of human existence and makes a sign. A person relates to that sign on many different levels of his being."

Symbolism is, in this view, the opposite of "diabolic"—the separation or fragmentation of meanings. Virtually by definition, then, symbolism, as the expression of the imagination, brings people together by producing relationships among meanings. This is why symbolism plays such an important role in the church: "The task of the church is to reintegrate the human being with God, with nature, and with each other. Again, we get that basically from the book of Genesis. What happened in paradise between Adam and Eve was that essentially the process of disintegration set in. The church is called to overcome that disintegration by reintegration. Reintegration can only be accomplished by understanding and defining a language of symbolism, because essentially what you need to do first is to reintegrate the meaning of things. That can only be accomplished by the arts. We are back again to very foundational processes that the arts impose on the human being, because if one lives in the world of the arts that are imposed, one begins to think in artistic forms. One begins to think in the language of symbols, whether one rationally realizes this or not."

To make this argument more concrete, Father Golubov suggests how an icon, say, of the Madonna and Child, overcomes rational thought and draws people together in a common relationship to God: "I don't have to worry about your theological beliefs. I don't have to worry about your rational theological structures. All I show you is a picture, and a picture shows you what? What you see is a mother and child. You talk about the language of motherhood, you talk about the relationship between mother and child, you talk about the relationship of child and mother, you talk about the relationship of child and God. A whole conversation starts just by looking." Theology and doctrine remain important to the church for other reasons, but the picture opens up discussion, which is essential to the functioning of any community.

More important, however, are symbols that spark thoughts and feelings about the community itself. For Golubov, this is the essential role that the imagination plays during the Eucharist: "Beyond the intellectual constructs, there is a deeper meaning attached to the bread and the wine. What does it mean when you say you commune? It means that we are involved together in something very deep and very meaningful for human life. So you say, 'Well, what is bread?' Then you think of that insignificant little seed that has to fall into the ground and die. It has nothing to do with intellectual concepts. That little seed has to die in order to blossom forth as a green shoot, a stalk, a plant. But then that plant in itself is not the end. That plant will produce seeds and also die

in producing these seeds. These seeds will be collected and they will be ground up in order to make flour. Then the flour will be taken and scalding hot water poured into it. Then as it cools down, yeast will be added so it can ferment and grow. Finally this whole mess will be stuck in the oven. It will become bread. It will be aromatic. It will be wonderful. But then it will be sliced. Its existence will be ended as such and human beings will take it for food. We say, 'Thank God for bread.' What are you doing when you are communing? You are basically accepting life itself, because bread is life. That is the process of life. If you don't understand the symbolic language, you have missed the whole thing. The same thing happens with wine, but on a different level." This is how symbols spark the imagination to reflect on life—the common life of the gathered community.

To suggest that the imagination contributes to the communal functioning of the church, then, is to emphasize the centrality of sacraments that stimulate the imagination at many levels. Not every symbol works this way, meaning that vigilance is always needed to protect against uses of the imagination that are divisive. At the same time, churches have a responsibility, in this view, to provide opportunities, perhaps especially through the use of music and the visual arts, for members' imaginations to be stimulated, as well as educational programs that forge connections between the imagination and Christian understandings of faith, hope, and love.

Encouraging the Imagination

What are churches doing to spark the religious imagination? In churches like Father Golubov's or the one Marie Bricher attends, the music and icons, sculpture, banners, and other forms of visual and performative art all aim to encourage parishioners to respond more creatively to the gospel. But most clergy are trying at least in small ways to stimulate their members' imaginations. At one nondenominational evangelical church, the pastor handed out crayons and paper to his new members class and asked each person to draw a picture that expressed some of their feelings about God. The pastor of a Moravian church dressed up like a shepherd one morning and presented the Christmas message as an eyewitness account. A Lutheran pastor says she has encouraged Sunday-school teachers at her church to let children act out stories from the Bible. A Methodist minister has introduced liturgical

dance on special occasions. A Presbyterian taught a class recently that John Calvin was a more imaginative person than people may have thought.

Activities like these are being encouraged more aggressively in some congregations than in others. But church leaders might be interested to know that there is a widespread feeling among the American public that the churches *should* pay attention to such activities. Nationally, 65 percent of the public agree that churches should do more to encourage their members' creativity and imagination (table 34). Young people are more likely to agree than are middle-aged and older people, and those with college education are more likely to agree than those with lower levels of education. There is virtually no difference in the response of church members and nonmembers, and the differences among evangelical Protestants, mainline Protestants, and Catholics are small. These responses suggest not only that Americans think the churches should be doing more to spark the imagination, but also that some groups (such as young people) who are currently underrepresented in the churches might become more interested if more was done.

Further evidence that encouraging the imagination might be good for church vitality is suggested by the fact that people whose interest in spirituality is increasing are more likely to say the churches should do more of this than are people whose interest in spirituality is stagnant or declining. Interestingly enough, those who attend church services only a few times a year are more likely to register this view than are those who attend church every week. What people like this sometimes acknowledge in qualitative interviews is that they do not attend more often because the church seems to stifle creativity; they would like its leaders to be more imaginative.

The survey also shows that people who exercise their religious imagination more often, and those who are more creative and artistic, are especially likely to say the churches should do more to encourage the imagination. If the number of Americans who are exposed to and interested in the arts is in fact growing, this growth, then, also suggests that there is an increasing audience who would like the imagination to be more of what churches emphasize than has been so in the past.

Clearly, the imagination is a part of the human spirit that most religious leaders take seriously. It continues to worry some, especially because Americans seem more inclined than ever to piece together their own ideas about God, rather than be guided by church traditions. Yet there are also new efforts within the churches to strike back, as it were,

TABLE 34. How the Public Feels about Churches
Encouraging Members' Creativity and Imagination
*(Percentage in each category listed who agree that "churches should do
more to encourage their members' creativity and imagination")*

National	65%
Age 18–29	70
Age 30–49	66
Age 50 and over	63
Grade school	59
High school	62
Some college	68
College graduate	73
Male	67
Female	64
Black	65
White	66
Church member	66
Nonmember	65
Evangelical or fundamentalist	64
Mainline Protestant	66
Roman Catholic	70
Spiritual interest:	
Increasing	72
Staying the same	62
Decreasing	62
Church attendance:	
Attend every week	63
Almost every week	67
Once or twice a month	67
A few times a year	71
Index of Religious Imagination:	
High	75
Low	61
Creativity:	
Low	56
Medium	65
High	75
Artistic Interest Scale:	
0 (Low)	56
2–3	65
4–5 (High)	73

recapturing the creativity of their own traditions and persuading parish-ioners that they do not have to park their imaginations at the door when they come to worship. Church leaders are reflecting theologically on the connections between divine and human creativity and on the many ways in which the religious imagination may be compatible with such central theological virtues as faith, hope, and love. As these connections are becoming more explicit, the arts and religion are also coming into a closer relationship with each other.

recapturing the creativity of their own traditions and persuading parish-
ioners that they do not have to park their imaginations at the door when
they come to worship. Church leaders are reflecting theologically on
the connections between divine and human creativity and on the many
ways in which the religious imagination may be compatible with such
central theological virtues as faith, hope, and love. As these connections
are becoming more explicit, the arts and religion are also coming into a
closer relationship with each other.

CHAPTER 7

The Morality Problem
Why Churches and Artists Disagree

If there has been, as much of the evidence suggests, a convergence be-
tween the arts and religion in recent decades, then one aspect of the re-
lationship between the two remains puzzling: Why does it appear that
the arts and religion are often in tension? Indeed, why have the media
sometimes portrayed the two as being at war with each other? Is this
yet another example of the media getting it wrong—creating scandal
and division where there is in fact harmony? Or are there inconsisten-
cies or differences of purpose that fundamentally separate the arts and
religion, no matter how much they may interact and benefit from this
interaction?

It is the case that several highly publicized events have showcased the
tensions between the arts and religion. An exhibit of Andres Serrano's
photograph of a crucifix immersed in urine was one such event. The
Brooklyn Museum's "Sensation" exhibit, which included a painting
of the Virgin Mary splattered with elephant dung, was another. Less
widely discussed incidents have occurred in many communities: a stage
play depicting Christ as a homosexual, an exhibit including a sculpture
of two female characters from the Bible kissing, a nude performance
artist eliciting protests from religious groups.[1]

Most people understand that these incidents are the exception,
rather than the rule. Yet there is a widespread perception, among both
clergy and leading figures in the arts community, that the arts and reli-
gion suffer from mutual misunderstanding. Reverend Schell at Saint
Gregory's in San Francisco, for instance, characterizes the problem this
way: "The two things that contribute to [misunderstanding] are a reli-

gious voice which is outspoken in its claim to defend what 'God ex-
pects,' on the one hand, and, on the other hand, what I would describe
as the confrontive, egoistic, lone artist who says, 'I will know I'm an
artist if people hate my work. It is my job to confront and offend, and
that's how I become an artist.' These are two significant polarizing
forces."[2]

Public Perceptions of the Arts

But is Reverend Schell right? Just how widespread is the feeling that re-
ligion and the arts are somehow at odds with each other? And, more
generally, have some of the scandals involving artists or, for that matter,
some of the historically negative images that have been associated with
writers and artists colored the public's perception of the arts, perhaps in
ways that may discourage the churches from drawing more actively on
music and art as a source of spiritual revitalization?

One of the commonly expressed criticisms of the arts, even among
artists themselves, is that the art world has become too commercialized.
This concern may have little to do with the relationship between reli-
gion and the arts. Yet, to the extent that artists are perceived as having
"sold out," they are probably less likely to be regarded as fonts of spir-
itual wisdom or as uncompromising seekers of beauty and truth.

In the Arts and Religion Survey, the concern about art being com-
mercialized is one that a majority of the public shares. When faced with
the statement "Most artists nowadays will do anything just to make
money," 51 percent of the public agree (table 35). This is, in fact, the
most widely held of any negative impressions of artists asked about in
the survey.

In comparison with their concern about art becoming commer-
cialized, relatively few Americans are troubled by the possibility, sug-
gested by the Brooklyn Museum and Serrano exhibits, that artists are
irreligious, sacrilegious, morally corrupt, or bent on dishonoring the
churches. Only a minority of Americans hold these perceptions. Still,
the proportion of people nationally who register some of these con-
cerns is by no means insignificant. In the survey, about one person in
five agrees that "most of the art one sees in galleries and museums is dis-
honoring to God." About one person in six thinks "contemporary
artists are destroying the moral fabric of our society." And one person
in four agrees that "most contemporary artists and musicians have no

TABLE 35. At Least a Minority of the Public Holds Negative Views of the Arts
(Percentage nationally who agree with each of the statements shown)

Most artists nowadays will do anything just to make money	51%
Most of the art one sees in galleries and museums is dishonoring to God	19
Contemporary artists are destroying the moral fabric of our society	15
Most contemporary artists and musicians have no respect for the teachings of the churches	26
During the past twelve months [you] have seen a work of art that disgusted you	23
NUMBER	(1,530)

respect for the teachings of the churches." It is also notable that one person in four claims to have seen a work of art during the twelve months preceding the survey that he or she considered disgusting.

Negative perceptions like these generally have some basis in fact. Undoubtedly there are *some* artists who would do anything to make money, *some* of the art exhibited in galleries and museums may be dishonoring to God, and *some* artists and musicians may have no respect for the churches. If some people have seen works of art that disgusted them, this too may not be surprising: Americans (even those who seldom go to exhibits or who do so selectively) are bombarded with pictures of art, on television and in newspapers, that may well be distasteful or disgusting.

But it also appears that one negative view leads to other negative views. Indeed, there is a small, hardcore segment of the American population that is overtly negative toward the arts by almost any definition of negativity. In the survey, people who express a negative view of the arts on any one of the items shown in table 35 are more likely than those who do not express such a view to respond in the same negative way on other questions. This being the case, it is possible to say that some Americans are *in general* more negative toward the arts than other Americans are.

How negativity toward the arts in some areas influences perceptions of the arts in other areas is evident in table 36. An Index of Negative Imagery is constructed by giving people in the survey one point for each of the following responses: agreeing that most artists will do anything just to make money, agreeing that most of the art one sees in galleries and museums is dishonoring to God, agreeing that most contemporary artists and musicians have no respect for the teachings of the churches,

TABLE 36. Negative Views of the Arts Are Associated with Moral and Religious Concerns about the Arts

(Percentage among those in each category of the index who agree with each of the statements shown)

	Index of Negative Imagery				
	Lowest	*Low*	*Medium*	*High*	*Highest*
Most of the music one hears on the radio these days is harmful to our young people	35%	50%	63%	86%	90%
Seen a preview for a movie that disgusted you	38	50	55	72	92
Heard a song that disgusted you	44	54	63	78	95
Religious leaders should speak out strongly against contemporary art	6	10	21	28	62
Churches should only promote Christian art or music	26	30	43	49	63
NUMBER	(278)	(306)	(193)	(107)	(43)

NOTE: The Index of Negative Imagery gives persons one point for agreeing with each of the first two and last two items shown in table 35.

and having seen a work of art in the past year that was disgusting.[3] In the table, those who score high on this index are considerably more likely to express other kinds of concerns about the arts than those who score low and to agree with statements suggesting that the churches should be cautious in their dealings with artists and musicians. Thus, 90 percent of those who score high on the index agree that "most of the music one hears on the radio these days is harmful to our young people," whereas only 35 percent of those who score low on the index agree with this statement (for the nation at large, 52 percent agree). Similarly, more than nine in ten of those at the high end of the index say they have seen a movie preview or heard a song that disgusted them, compared with about four in ten of those at the low end of the index. How these negative views relate to attitudes concerning the churches is evident in the fact that more than six in ten of those at the high end of the scale think "religious leaders should speak out strongly against contemporary art," whereas fewer than one in ten among those at the low end of the scale think this. At the high end, more than six in ten also agree that "churches should only promote Christian art or music," compared with about a quarter of those at the low end of the scale.

The question, then, is why some people hold negative views of the arts while others do not. Nationally, the minority who consistently express negative views makes up about a seventh (14 percent) of the population. These are the people who score either a 3 or 4 on the Index of Negative Imagery. By looking at particular segments of the population, we can see if this proportion is higher among people with certain characteristics or lower among people with other characteristics.

Because younger people are more exposed to many kinds of art, especially contemporary art and music, than older people, we might expect that they would be less negative toward the arts than middle-aged or old people. This, in fact, is what the survey shows. Among people age eighteen to twenty-nine, only 9 percent are consistently negative toward the arts, whereas this proportion is 15 percent among people in older age groups (table 37).

It might also be expected that people with higher levels of education would be less negative toward the arts than people with lower levels of education: either because the better educated have more opportunities for exposure to the arts or because they are more tolerant in general. The data, however, do not support this expectation. Although those with only a high school diploma are slightly more likely than other groups to hold a negative opinion of the arts, the difference is small, and those with grade school educations, only some college, and college degrees are virtually the same.

African Americans are slightly more likely to express a negative view of the arts than white Americans, but again the difference is small. And, in one of the few instances where the region of the country appears to affect responses in the survey, Midwesterners and Southerners are somewhat more likely to hold negative sentiments toward the arts than people in other regions (especially those on the West Coast). But it is likely that regional differences also reflect other cultural differences, such as those rooted in religious traditions.

Religion is, in fact, the crucial characteristic that seems to affect these attitudes toward the arts. Members of mainline Protestant and Catholic churches are less likely than people in the nation at large to hold negative views of the arts, but members of evangelical Protestant churches are more likely than people in the nation at large to hold such views. And the differences are substantial: whereas only one mainline Protestant or Catholic in nine is negative toward the arts, about one evangelical Protestant in four is negative.[4]

The role of religion looms even more prominently when other factors that might affect these attitudes are considered. It might be supposed,

TABLE 37. How Negative Imagery of the Arts Varies among
Subgroups of the American Population
(*Percentage in each category listed who score high on the
Index of Negative Imagery*)

National	14%
Age 18–29	9
Age 30–49	15
Age 50 and over	15
Grade school	12
High school	15
Some college	13
College graduate	12
Male	13
Female	14
Black	16
White	14
East	12
Midwest	17
South	15
West	9
Evangelical or fundamentalist	23
Mainline Protestant	11
Roman Catholic	11
Taken art class	13
Not taken art class	14
Relatives in arts	14
No relatives in arts	14
Close friends in arts	12
No close friends in arts	15
Childhood exposure to the arts:	
Low	14
Medium	14
High	14
Artistic Interest Scale:	
0 (Low)	13
2–3	13
4–5 (High)	15

NOTE: "High" scores in this table refer to persons who score 3 or 4
on the Index of Negative Imagery.

for instance, that evangelical Protestants are more negative than average because they are less knowledgeable about the arts or have had fewer opportunities to be exposed to the arts (perhaps because of having lower levels of education or living in certain parts of the country). For this to be true, there would have to be significant differences in attitudes toward the arts among people with different degrees of exposure to the arts. But this is not the case. The likelihood of holding negative views of the arts is virtually the same among people who have taken a class in art or art appreciation as it is among those who have never taken such a class; similarly, there are virtually no differences in attitudes between those who have relatives or friends in the arts and those who do not have relatives or friends in the arts; and the same is true of those with high, medium, or low levels of exposure to the arts as children. Perhaps even more important, there are virtually no differences in the likelihood of holding these negative views among those whose overall interest in the arts (as measured by the Artistic Interest Scale) is high, medium, or low. In short, the only factor that makes much of a difference to the likelihood of having negative attitudes toward the arts is being a member of an evangelical Protestant church.[5]

Why evangelicals might be inclined to hold negative views of the arts is a question that can partly be addressed by looking more closely at how they differ in the survey from mainline Protestants and Catholics on a variety of other attitudes and beliefs. Religiously, the way in which they differ most from mainline Protestants and Catholics is in their distinctive view of the Bible: nearly two-thirds of evangelicals say the Bible should be interpreted literally, compared with about a third of mainline Protestants and about a quarter of Catholics (table 38). Believing in a literal interpretation of the Bible may be conducive to negative attitudes toward the arts for several reasons: for instance, thinking that truth is to be found only in the Bible instead of in the arts, taking admonitions against the use of graven images literally, or being concerned about wider issues (such as homosexuality or promiscuity) that may be associated with the arts.

But religious views are only one of the relevant ways in which evangelicals differ from mainline Protestants and Catholics. They also differ politically. Four in ten evangelicals identify themselves as political conservatives, compared with three in ten mainline Protestants and about a quarter of Catholics. Artistic tastes also differ. Evangelicals are much more likely to say they especially like gospel music (70 percent say this) than are mainline Protestants (of whom about half do), or Catholics (of

TABLE 38. How Evangelicals Compare with Mainline Protestants
and Catholics on Selected Beliefs and Attitudes

(Among those in each column, percentages who respond as indicated to each question; for church members only)

	Evangelical or Fundamentalist	Mainline Protestant	Roman Catholic
Believe the Bible should be taken literally	64%	37%	26%
Say political views are very conservative	41	32	24
Especially like gospel music	70	47	21
Especially like Christian music	59	48	24
Do not like pop/rock music	57	54	38
Do not highly value the arts	64	51	53
Think artists are materialistic	63	44	46
Believe artists dishonor God	30	19	19
Say artists have no respect for churches	34	26	23
Have seen art works that disgusted them	29	22	21
Church friends include people outside of neighborhood	58	50	34
Feel pessimistic about nation's future	32	25	16
Concerned about breakdown of community	51	35	33
Concerned about moral corruption	71	58	48
Concerned about people turning away from God	59	37	36
NUMBER	(295)	(227)	(273)

whom only one in five does). Similarly, evangelicals are significantly more likely than the other two groups to say they prefer Christian music. In other words, their musical tastes appear to be governed more by their identity as Christians and perhaps by what they hear in churches than are the tastes of mainline Protestants or Catholics. This preference for Christian music does *not* necessarily mean that evangelical Protestants dislike other kinds of music. Yet, it is the case that a majority of them refrain from saying they like pop/rock music (a slightly higher percentage than among mainline Protestants and a significantly higher percentage than among Catholics). Evangelical Protestants are also the most likely of the three groups to say that they have *not* been significantly influenced by the arts in general.

Thus, on specific attitudes toward the arts, evangelicals are more likely than mainline Protestants or Catholics to give answers that emphasize the tension between art and religion: agreeing that artists dishonor God and that artists have no respect for the churches. They are also most likely of the three groups to say they have seen a work of art that disgusted them.

Two other factors associated with evangelicalism are also suggested by the data. One is that more evangelicals draw their church friends from outside their own neighborhoods than is the case for mainline Protestants and Catholics. While it is important not to infer too much from this difference, it may mean that evangelicals *selectively* choose their church friends on the basis of similar beliefs to a greater extent than mainline Protestants or Catholics do; it may also mean that they selectively choose where they go to church to a greater extent (commuting outside their neighborhoods and thus making church friends from other neighborhoods). In either case, this pattern is consistent with what is often suggested in studies of evangelicals: that they interact more with people with views similar to their own and thus are reinforced in their views by this interaction. If so, their favorable views toward Christian music and their unfavorable views toward artists in general may also be reinforced by this interaction. The other factor is that evangelicals are considerably more likely than mainline Protestants or Catholics to hold negative views of the culture in general: they are more likely to be pessimistic about the nation's future, more likely to be concerned about the breakdown of community and moral corruption, and more likely to worry that people are turning away from God. In other words, evangelicals' negative views of the arts appear to be part of a larger pattern; artists may symbolize moral decay, but they are just one expression of it.

The survey data, then, suggest that there are a variety of factors in the subculture of evangelical churches that may discourage some members of these churches from drawing very widely on music and art from the outside world for spiritual inspiration. But how do these scattered sentiments become mobilized? Do people simply absorb negative views of the arts by interacting with like-minded people at evangelical churches? Do they perhaps already hold these views even before they join? Or is there something more explicit about what they see and hear that shapes their opinions?

One clue is that twice as many evangelicals say they have actually heard a sermon warning them of the dangers of contemporary art and

TABLE 39. Negative Sermons about Contemporary Art and Music Are Associated with Negative Attitudes among Evangelicals and Catholics
(Percentage among those in each cell of the table who score high on the Index of Negative Imagery toward the arts; for church members only)

	Evangelical or Fundamentalist	Mainline Protestant	Roman Catholic
Among those who have heard a sermon on the dangers of contemporary art and music	49%	13%	23%
Among those who have not heard a sermon on these topics	16	11	10

music in the past year (21 percent) than do mainline Protestants (10 percent) or Catholics (11 percent). While this may not be a large percentage, it does suggest that pastors may be a significant source of the negative sentiments that evangelicals express toward the arts (especially if pastors' opinions are expressed, as they certainly must be, informally and in classes as well as in sermons). It is also possible to estimate the effect of these sermons by comparing church members in each of the three traditions who have heard such a sermon with those who have not heard a sermon on this topic (table 39). Among evangelicals who have heard a sermon on the dangers of contemporary art and music, nearly *half* (49 percent) express negative views toward the arts, compared with only a sixth of evangelicals who have not heard a sermon of this kind.[6] Among mainline Protestants, there is virtually no difference between those who have and those who have not heard a sermon on this topic. And among Catholics, about a quarter of those who have heard a sermon against contemporary art and music hold negative views, compared to a tenth of those who have not heard such a sermon. Sermons, then, do seem to make a difference, especially among evangelicals. In fact, in the absence of such a sermon, evangelicals are only slightly more likely than members of other churches to hold negative views of the arts, but where a sermon of this kind is present, the odds of evangelicals holding negative views increase markedly.

It may be, of course, that evangelicals who dislike contemporary art and music are simply more likely than other evangelicals to *hear* or *remember hearing* sermons on this topic, rather than actually being influenced by their pastors. But this possibility can at least partly be discounted by considering what pastors say. Although we do not have na-

TABLE 40. Theologically Conservative Clergy Are More Negative toward the Arts and Less Exposed to the Arts

(Percentage of Lehigh Valley clergy who gave each response listed among those whose churches are theologically conservative, moderate, or liberal)

	Conservative	Moderate	Liberal
Contemporary artists are destroying the moral fabric of society	38%	24%	0%
Contemporary art and music are leading us away from the Bible	41	5	0
Churches should promote only Christian art or music	45	14	20
Religious leaders should speak out strongly against contemporary art	24	14	0
Visited art gallery or museum	45	81	80
Not very interested in the arts	35	5	10
Positive reaction to *Born Again*	76	57	50
Positive reaction to clip-art Bible and cross	66	43	40
Positive reaction to *Tree Altar*	31	52	50
NUMBER	(29)	(21)	(10)

tional data from pastors, our in-depth study of sixty randomly selected pastors in northeastern Pennsylvania provides some evidence. Among those who identified the theological orientation of their congregation as conservative, significantly more held views similar to the ones expressed by evangelical members nationally than among those who said their congregation's theology was moderate or liberal (table 40). Specifically, about four in ten of those in conservative settings agreed that "contemporary artists are destroying the moral fabric of society." About the same proportion agreed that "contemporary art and music are leading us away from the Bible." And slightly more agreed that "churches should only promote Christian art or music." On each of these statements, the percentages agreeing were significantly higher in conservative settings than in moderate or liberal churches. Fewer of the pastors agreed that "religious leaders should speak out strongly against contemporary art" (about a quarter) than agreed with the other statements, but evangelicals were again more likely to agree than pastors in the other settings. The data also suggested that pastors in evangelical settings may be responding to the arts on the basis of less exposure than pastors in other settings. For instance, fewer than half of the evangeli-

cal pastors had visited an art gallery or museum in the past year, compared with 80 percent of pastors in moderate or liberal churches. More than a third of evangelical pastors said they were not very interested in the arts, compared to a tenth or less in the other two settings. Tastes also differed. When presented with a reproduction of a painting entitled *Born Again,* three-quarters of the evangelical pastors responded favorably, compared to about half the pastors in the other settings. Two-thirds also responded favorably to a clip-art drawing of a Bible and cross (compared with about four in ten of the other pastors). In contrast, a picture of Nancy Azara's contemporary *Tree Altar* evoked positive reactions from only a third of the pastors in conservative churches, compared with positive reactions from half the pastors in moderate or liberal churches.

Data such as these are of course limited. They suggest that the current borrowing from the wider arts community that is evident in many churches probably does not occur as extensively in some evangelical churches as in more moderate or liberal mainline Protestant and Catholic churches. These findings also help to make sense of some of the tensions that seem present in the wider culture between the arts and religion. Despite the many ways in which churches of all kinds are making use of music and the arts, tensions do exist between organized religion and what is sometimes referred to as the organized arts—that is, galleries, theaters, and concert halls in the wider community and the artists and musicians whose work is presented at these places. These tensions, it appears, are not of much concern to members of mainline Protestant or Catholic churches, but *are* felt—and indeed are reinforced—by beliefs and attitudes in evangelical churches. A better understanding of these beliefs and attitudes, however, requires moving from the survey data to evidence obtained from listening to the ways in which the various parties involved talk about the arts. It is helpful to consider the views of leaders in the arts, the views of church leaders, and the views of rank-and-file evangelicals.

What Arts Leaders Think

The leaders of major arts organizations around the country are aware that much of what they do is of relevance to the churches. Although opinions and experiences vary, most arts leaders recognize the *potential* for mutually beneficial interaction between artists and churches. Yet

they also express misgivings—that church leaders and arts organizations may not be working together as closely as they could, and that some religious leaders seem not to understand what arts organizations are trying to do. Sometimes the opinions of arts leaders appear to play directly into the concerns that some religious leaders express about the arts.

Examples of the misgivings that leaders of arts organizations express concerning their interaction with churches are not hard to find. One comes from Lori Fogarty of the San Francisco Museum of Modern Art. In her years at the museum, she has become intimately acquainted with the Bay Area arts community and the many foundations, corporations, and civic organizations supporting it. She says contact with religious organizations is "fairly limited." The only sustained interaction she can identify is between some of the arts organizations and downtown churches that sponsor service projects and educational activities for inner-city children. Across the bay, Oakland's Edsel Matthews, general manager of the Koncepts Cultural Gallery, agrees. "You know, it's a funny thing," he muses. "Religious organizations as a rule live in their own world. They don't venture out of their world in order to participate in things. At least not in the arts that I'm part of." Edith Baker, a longtime Dallas resident and owner of the prestigious Edith Baker Gallery, shares his view. "I don't know of any religious organization that has sent people over or asked to have us talk to them; nor have we asked any ministers or priests or rabbis to come and talk to us. There is not a close-knit relationship between the two." Cliff Redd, another longtime resident, who heads the Five Hundred, Inc., a coalition of the wealthiest patrons of the arts in Dallas, points to biases that keep religious organizations from interacting with the arts. "They're silent about the arts unless we're involved in programming that is contrary to the beliefs of the church." Some of Cleveland's leaders express similar views. For instance, William Busta, who heads the William Busta Gallery and serves as president of the Poets League (and is described by contemporaries as "Mr. Art" in the city), is deeply interested in the overlap between religion and the arts, but he laments, "I just don't see the linkages. I think the churches may perceive themselves to be more linked to the arts than the arts perceive themselves to be linked to religion. I think that they're different communities."

What these and other leaders are suggesting is *not* that church people are uninterested in the arts, or even that churches are failing to utilize art and music in their own programs. For instance, the director of the

Dallas Museum of Art, Jay Gates, remarks, "I think you will find there are musical performances that happen in churches all over town. Drive into work in the morning and if you listen to certain stations, you will invariably find out about some chamber orchestra or choral group or string quartet that is appearing at one church after another." Similarly, Kola Thomas of San Francisco's Center for African and African American Culture observes, "When you look at some churches that raise money for artistic purposes in their churches, you could say that they do understand the role that arts and culture can play in furthering the cause of their religious activity."

The concern is rather that organization-to-organization interaction seems rare. In the view of these leaders, clergy and the heads of other prominent religious organizations in their communities seem to live in worlds separate from those inhabited by artists and patrons of the arts. They understand this separation at one level: leaders of all organizations, including their own, have busy schedules and are furthering their own agendas. Still, the separation puzzles them, given the fact that many churches do seem interested in promoting music and art, as well as the fact that many arts organizations sponsor exhibits and performances about religion and spirituality.

They also consider the lack of formal interaction between religious and arts organizations troubling. They think it contributes to misunderstanding and makes it harder for leaders of both kinds of organizations to appreciate the other's perspectives, especially when controversies arise. One leader who emphasizes this potential for misunderstanding is Ted Berger of the New York Foundation for the Arts, who interacts with dozens of arts organizations and hundreds of individual artists. An active member of Congregation B'nai Jeshuran, he is also interested in promoting greater cooperation between the arts and religious organizations. Yet he sees very little constructive interaction taking place. "We have different ways of approaching the secrets of the heart, of the soul, of the mind. The arts community is a much more liberal, free-thinking community than the religious community." While some of this tension is in his view healthy, he also says the climate has deteriorated in recent years. "Some of our fellowship recipients are the very artists who have come under attack" by religious groups. "When I hear religious leaders mobilizing the community from the pulpit about 'demon artists undermining the fabric of our society,' that concerns me."

A similar concern is expressed in Dallas by Jerome Weeks. As book columnist and longtime theater critic for the *Dallas Morning News,* he has written numerous articles about the contemporary state of the arts.

He believes the present situation is unduly fraught with misunderstanding. "If so much of your knowledge of the other community is based on these flash points or crises," he reflects, "then you get the idea that artists are basically childish characters or into defaming whatever you hold sacred, or you feel that religious people are just repressive, censorious types who are insecure and feel that everyone has to believe what they do."

While arts leaders are sometimes guilty of stereotyping the views of the entire religious community instead of understanding the diversity of these views, many of their comments focus on the views of evangelicals and fundamentalists. For instance, the late Robert Bergman, who served for many years as director of the Cleveland Museum of Art, remarked, "The [tension] is between religions that have firm sets of beliefs and artists who are testing the envelope everywhere. Well, that edge of the envelope doesn't necessarily sit well with firm beliefs. As fundamentalism in all areas grows, the overall resistance in religious contexts to people pushing the envelope is increasing."

Arts leaders seldom register sympathy for the views they ascribe to fundamentalists. They *do* acknowledge their own concerns about artists who push the envelope just to make money or to evoke scandal. But they regard fundamentalists as rigid dogmatists who fail to understand the direction of modern intellectual traditions or the thinking that underlies current expressions of tolerance for homosexuality, racial and ethnic diversity, and artistic experimentation. In their comments, arts leaders sometimes sound as if fundamentalism is simply a shorthand reference for all views with which they disagree.

But it is also clear that arts leaders operate from different premises than conservative religious leaders do, especially on questions of morality. Some of them agree that artists should exercise restraint, even to the point of respecting the moral standards of religious conservatives. Most, however, think it is important for artists to portray what they see in the culture, even if it is offensive. For instance, Larry Allums of the Dallas Institute of Humanities and Culture argues that artists should follow the lead of William Faulkner, who wrote about the South because that is what he knew best: "The artist has got to write from within his own myth, the story of his people, and not sanitize it." Robert Bergman echoed this sentiment: "There are things hanging on our museum walls that offend people all the time. Am I going to take them down? Are you kidding?"

Arts leaders, then, recognize that tensions are present between the values that govern artistic work and the values that are cherished by many people of faith. They believe there is room for greater cooperation

between arts organizations and churches, and they regret the fact that occasional, highly publicized rifts over particular exhibits or performances color the public's perceptions of the relationships between religion and the arts in general. Most of these leaders insist, just as artists themselves do, that artistic work requires moral integrity, that it often builds character, and that good art challenges people to reflect on serious moral and ethical issues. They nevertheless argue that artists sometimes need to violate conventional moral wisdom in order to portray how things are, and these leaders zealously defend the right of arts organizations to make their own judgments about what is appropriate to exhibit or perform, even though they understand that people of faith will sometimes disagree.

Church Leaders' Views

Clergy and other religious leaders generally perceive fewer tensions between churches and arts organizations than arts leaders do. For the most part, they think of the activities that take place within their own congregations when they talk about music and art, but they also recognize that the art world exists largely outside of the churches and that a full appreciation of the arts requires interacting with major galleries, theaters, and concert halls. Clergy in large, downtown congregations located near the art district in their cities are particularly likely to understand that their own interests and values overlap substantially with their counterparts in arts organizations.

At Fifth Avenue Presbyterian Church in New York, Reverend Margaret Shafer describes the complementary nature of religious and artistic programs. She says they both contribute to "a stronger sense of the goodness of creation, the worth of people, self-esteem, that God loves us and cares about us, that one can sin and be forgiven, that there is hope, that there is something much greater than all the limits and obstacles of our world. Both religion and art speak to those things very, very profoundly and deeply."

In San Francisco, Reverend Schell emphasizes the benefit of churches working in harmony with artists and arts organizations: "The benefit is living community, rather than a dying culture. [Religion and art] are two profoundly human ways—and completely complementary ways— of engaging our experience of the mystery at the heart of the universe. So if I want to let go of that and keep things polarized, the cost is enormous on both sides. If I bring it together, there's actually hope for us

living together in peace with love and respect and doing the work of God. I'm for that."

Because they do recognize common interests with arts organizations, clergy at churches in art districts sometimes lament what they perceive as a continuing set of misunderstandings between some segments of the religious community and arts organizations. Reverend James Dowd at Church of the Covenant (a Presbyterian congregation) in Cleveland is one pastor who feels this way. Although his church is in the same neighborhood as the William Busta Gallery and he tries to encourage stronger relationships with arts organizations, he thinks contact in the wider community is limited. Churches' cooperative relationships, he explains, usually focus on helping the needy, and "arts organizations probably aren't on our radar screens in that sense."

But clergy are divided in how they think about the moral questions that are often at the heart of disputes between churches and arts organizations. Mainline Protestant and Catholic clergy are generally willing to argue that artists sometimes need to violate common standards of decency and respectability. These pastors are not persuaded by arguments that such violations contribute to the moral decadence of the culture. Instead, they think it is important to recognize that decadence exists, and argue that artists sometimes provide a valuable service by bringing it to the public's attention. At the same time, these pastors readily concede that some works of art truly are in bad taste.

Reverend Dowd expresses a view that is typical of many mainline Protestant clergy. "I come out on a pretty open stance relative to the arts. I think they ought to have the freedom to be expressive. The cross in urine, I realize, is pretty distasteful, but I think censorship usually is more distasteful than the occasional project. The use of something sensational as an excuse to censor a whole category of art just strikes me as offensive." In his view, the best way to respond to offensive art is by not going to see it.

His counterpart Reverend John Weigand, a priest at Saint James Catholic Parish in Cleveland, opposes censorship, too. It disturbs him when arts violate standards of decency that he believes are right; indeed, he thinks it is strange for artists to ask for government funding when they purposefully attack the very standards that the public holds dear. But he trusts artists to police themselves most of the time. "I get very angry when ministers use the pulpit to express their own prejudices," he says. "People have come to hear the word of God. They've not come to hear how I feel about this play or that play."

In contrast to these views, evangelical clergy are much more likely to

register concern about the moral standards (or lack thereof) that they perceive among artists. Reverend Bill Counts, pastor of the nondenominational Fellowship Bible Church in suburban Dallas, offers this observation: "I think the popular arts are getting increasingly degraded in a lot of areas, particularly the music that youth listen to. The popular arts are getting very degraded. When you get to the classical things, stuff from the seventeenth and eighteenth centuries, there's no necessary tension there. People tend to appreciate the beauty. But when you get to the popular arts of the day, a lot of it is very degrading, and there is going to be a great tension there. The Christian church is going to be very much against it when you have music coming out that encourages violence, immorality, and rape and all that. The more that hits people, the more that's a problem for the church."

In suburban Cleveland, Pastor Ken Spink of the Berea Baptist Church (a 280-member affiliate of the conservative General Association of Regular Baptists) asserts that "a lot of the art today is perverted. I guess I've gotten turned off a lot from the paintings and so on. In my thinking it expresses the way that our culture is headed downhill. It shows a lot of confusion, a lot of distortion." Pointing to artists who want "to express their evil deeds and their evil heart," he says, "We who are trying to promote truth and wholesomeness and morality would certainly run into conflict with a group that's trying to do that."

But evangelical pastors' comments also reflect some of the cross-pressures of contemporary society. Compared to mainline and Catholic clergy, they are more willing to assert that the government should withhold funding from artists whose moral messages are questionable. They worry that objectionable works of art are leading the culture astray, rather than simply reflecting evil that is already there. In this respect, they credit artists with more influence than mainline and Catholic clergy do. But evangelical pastors often try to sort out what is good about art from what is bad ("We can't condemn the whole art world because of some screwball," says one). They often point out that condemning art does little to stop the problem, either. It interests them more to provide uplifting music and art at their churches than to spend time criticizing what happens at art galleries and theaters.

Evangelicals Talk about the Arts

When evangelical clergy discuss the morality or immorality of contemporary artists, their remarks typically reflect the dual roles that these

clergy play in their communities. On the one hand, they are themselves moral leaders, at least to their congregations, if not to the wider community. They feel compelled to stand up for truth, to defend the Bible, and to uphold moral standards either by positively affirming them or by condemning instances where these standards appear to be violated. On the other hand, evangelical clergy generally understand that their churches exist in a pluralistic religious and cultural environment and, for this reason, these clergy voice opinions that often differ little from those of other community leaders. For instance, they agree that others have a right to different opinions, that it is often good to cooperate with other community leaders with whom one may disagree, and that expedience means choosing one's battles carefully. Thus, an evangelical pastor may condemn an artistic exhibit or performance as a way of making a moral point during a sermon, but refrain from writing a letter to the editor or organizing a protest march.

The *members* of evangelical churches have a somewhat different stake in the arts than their pastors do. Of course, these members vary considerably in their views of the arts and in the degree to which they participate in and enjoy the arts. Nevertheless, it is sometimes easier for them to adopt consistently negative views of the arts than it is even for their pastor to do so. The reason is that members' views are not public in the way a pastor's views are, and for this reason may not be constrained by what they may be taken to represent. Whereas the pastor, as an official spokesperson for his or her church, may condemn the immorality of an artist but defend the right of artists to work as they please, a member is freer to express his or her views as a matter of *personal* conviction and private taste. With even modest reinforcement of negative views from the pulpit, therefore, an evangelical member may come to the opinion that contemporary art is thoroughly evil and morally distasteful.

An illustration of the ways in which some evangelicals (as the survey suggests) espouse particularly negative views of the arts comes from a conservative Baptist church in Pennsylvania, where a dozen members agreed to respond to some specific examples of contemporary art and to discuss their views of the arts more generally. All have been to college, and most work in professional or managerial positions. They are a group who genuinely appreciate certain kinds of music and art. One remembers a hymn that had special meaning when he was a child. Another describes a painting that hung on her parents' living room wall. They all speak glowingly of a Christian man they know who goes from church to church giving evangelistic concerts. Looking at a reproduc-

tion of a landscape painting, several of them imagine that it would look nice on the cover of their church bulletin.

But their tolerance for contemporary music and art is limited. One of the paintings they consider is a garish depiction, titled *The Consumer,* of a robotlike creature busily eating flowers, trees, and everything else in sight. "It's like a lunatic on the West Coast!" is the first comment. As the group's laughter ceases, a second person observes that "this is a picture of the world, consuming everything for one's self and responding to nobody in a lunatic way." This comment causes several of the others to ponder the painting again. "I just thought that it was bizarre," says one, "but I see what you mean." Another woman, however, quickly jumps in: "You certainly wouldn't get me to fork over six dollars to go to a museum that had that painting in it. There's no value to it at all. To me, it's a waste of the painter's time."

Next the group responds to a selection of folk music. It is a vocal duet with guitar accompaniment. The lyrics, written by one of the vocalists as a tribute to her mother, talk about a woman who has journeyed through life, suffering hardship, making friends, and experiencing momentary joy. For the lyricist, the song is also a metaphor of a spiritual journey. "I've heard music like this before," volunteers a man in the group. "It's used in conjunction with witchcraft and the Gaia movement, which is the goddess movement. That's directly what it's used for because it's centered on the female and it's centered on seasons and people's lives and in that type of harmony. So it's preaching about God; it just happens to not be the one that Christians believe in." This comment prompts another member to assert, "I agree. These songs are meant to kind of woo you. It had a catchy tune and kind of sweet melody. It was spiritual, but it wasn't the kind of spirituality that we honor or that honors God." Another member chimes in: "I feel that the sense of spirituality that it's trying to relate is pretty consistent with the people that don't really know God or Christ, and they end up with a hopelessness, believing in something that's not reality."

Finally, the group considers a short selection from Maya Angelou's book *Wouldn't Take Nothing for My Journey Now:* "Many things continue to amaze me, even well into the sixth decade of my life. I'm startled or taken aback when people walk up to me and tell me they are Christians. My first response is the question 'Already?' It seems to me a lifelong endeavor to try to live the life of a Christian."[7] One man responds, "This basically is someone saying what maybe in their own eyes is right, but it is not biblically true." A woman adds that the author fails

to understand what it means to "accept Jesus as our savior." Another man jumps in: "I didn't even need to hear the words here. I'm a little bit familiar with Maya Angelou. She's a former poet laureate. She even spoke at Clinton's '92 inaugural. I think she's an out-and-out bigot. I think she's into all kinds of sodomite perversions and the glorification thereof. She's about as perverse and convoluted a thinker as there is, so I just kind of dismiss anything she has to say. It's all about Satan, if you ask me." A fourth person concludes, "She's definitely not a Christian. What she says is a lot of hooey and baloney."

Interestingly enough, the group did not specifically raise the question of morality with respect to any of the music, art, or literature they discussed. But from the start, they adopted an us-and-them mentality. For the artists with whom they were unfamiliar, they assumed that none were Christians and thus were purveying untruths. If the work was relatively neutral in content, they considered its merits in relation to whether it would fit easily into their own context. The landscape, for instance, was judged acceptable because it could appear on the church bulletin, but this judgment was weighed against the possibility that the artist might be a "polytheist" or a "Muslim." One Christian musician was favored because he sang at their church, but another was condemned because she had become too popular.

The group was particularly suspicious of any claims an artist or author might make about spirituality. Associating art with a spiritual message was considerably more problematic, in their eyes, than simply producing something meant for entertainment. But for every work they considered, the Bible was the standard against which it was measured (and found wanting). One woman expressed the prevailing sentiment well when she told the group that her favorite song, both as a child and now, was "the B-I-B-L-E, yes, that's the book for me." When asked to explain, she remarked, "If you take the Bible and put it behind you, you have nothing to believe in. Otherwise you use your own thoughts and create what's around you. The basis for everything is to believe in the Bible and what it says."

Of course, evangelical churches vary. At another one, members engaged in heated discussion one Sunday about whether artists were leading the culture astray. Most agreed that the culture was in a state of moral decay, and several pointed to examples of artists contributing to the destruction of morality. After talking about some of the Christian artists they liked, they acknowledged that some artists were good and others were bad. One person even proclaimed that seeing a jar of urine

with a crucifix in it didn't bother him because he knew that God was still ultimately in charge of things.

From these and other examples, the negative views of artists that are held strongly by some evangelicals appear to be partly rooted in concerns about specific violations of moral standards, such as depicting homosexuality on stage or including profanity in a song. These concerns are reinforced by teachings about the inherent evil of the world and humanity's need for salvation through Jesus. But the deeper reason for negative views of the arts may be a theological orientation that sharply divides a particular brand of Christianity from virtually everyone else's. To protect this sense that one's own group is in absolute command of the truth, it helps to demonize other sources of influence on the culture. Artists are certainly one of these sources.

Working Together?

Apart from the minority of evangelicals who harbor serious misgivings about the role of art and music in the wider culture, there appears to be considerable support among clergy and leaders of arts organizations for the idea that greater cooperation would be mutually beneficial. Some leaders point generally to the fact that artists are capable of raising questions about the human condition to which churches can respond. Some leaders also observe that most of the artists they know are in one way or another seriously interested in spirituality and thus are exploring issues with which the churches are also grappling. Others focus more on programs that could be run more effectively if churches and arts organizations worked together—such as neighborhood centers at which children from low-income families could come for after-school care.

The barriers inhibiting greater cooperation between churches and arts organizations are, according to leaders of these organizations, significant but not insurmountable. Many leaders are already too busy running their own organizations to think seriously about devoting time to cooperative programs. A few think there might be financial concerns, such as church members withholding donations if they thought funds were being channeled into art programs. Some think the rift that has emerged between religion and the arts over controversial exhibits and performances may be a problem.

The most serious barrier to greater cooperation is undoubtedly the difference in how church leaders and arts leaders approach moral ques-

tions. Clergy of all denominations and traditions are reluctant to say that any and all expressions of morality are equally acceptable. While some clergy may be more tolerant than others, they agree that churches should uphold the standards of morality and public decency found in the Bible. In popular interpretations, this sometimes means condemning particular examples of immorality, but more often it consists of positive affirmations—sermons, stories, Sunday-school lessons, music, and art that present morally uplifting messages. In contrast, artists are less convinced that positive messages about morality, truth, or even beauty constitute the basis for important work. Shocking images that make people think about moral standards by violating them are equally appropriate, in their view, as are works of art that convey the ever-present turmoil of the human spirit. These differences are most evident when evangelicals talk about the arts and are reinforced in some evangelical settings by the view that only they fully understand God's truth.

Still, differences about how to (or whether to) address moral questions seem not to stand in the way of wider efforts to promote more active interaction between churches and arts organizations. The extensive involvement of churches in sponsoring music and art persuades many leaders that greater interaction is also possible between clergy and the directors of arts organizations. In their view, such interaction would cultivate mutual respect, if nothing else. Artists would perhaps come to a better understanding of the positive regard in which they are held in many churches. Clergy and church members would perhaps discover artists interested in advancing greater appreciation of spirituality and the religious imagination.

The Artist in Everyone

Faithful Living in a Spiritual Democracy

If one were to step back from the present situation (say, by retreating to a remote mountain cabin or by reflecting on it from the vantage point of a transcontinental flight), what sense might one make of the current interest in the arts? Does this interest have any particular implications for the ways in which Americans practice and express their faith? Does it suggest a new approach to spirituality that may hold new challenges for the ways in which churches attempt to guide the religious practices of their members? Or is it neutral—a vehicle for personal devotion and public worship that has no particular implications for the ways in which religious institutions go about their business?

The Arts as a Resource

From one perspective, the present interest in the arts can be viewed as a resource simply waiting for the churches to take advantage of it—indeed, as one that is already playing a role in the revitalization of American religion. Music and art have long held a place in the lives of American Christians. Although particular confessional traditions sometimes discouraged their members from attending concerts or listening to popular music, the historical record suggests that most Americans sang folk songs, included music and dance in local festivals, and decorated their homes as they pleased. The music and art that churches sought to regulate were largely the hymns and anthems, the stained-glass windows and altar carvings, and the architecture associated with churches and

church services themselves. Except for occasional diatribes against the immorality of theater and dance, religious leaders largely accepted the fact that most Americans spent part of their time pursuing artistic interests, and some theologians have encouraged people of faith to take the arts more seriously.[1] If there has been an increase in public exposure to the arts in recent decades, this exposure is scarcely a challenge to the ways in which religious institutions have always functioned.

Indeed, the evidence seems to suggest that churches are readily taking advantage of the present interest in the arts as a way to maintain the loyalty of members and attract new ones. Contemporary worship services that incorporate pop/rock and blues and utilize drama and visual aids are but one example. Other churches are experimenting with liturgical dance, evangelistic concerts, art festivals, and poetry clubs. Growing numbers of young Americans have received musical and artistic training in elementary and secondary schools or in colleges and universities, which creates a pool of trained talent on which the churches can draw. Motion pictures, television programs, popular music, and literature provide a common culture to which pastors can refer for sermon illustrations. The close relationship that has developed between certain avocational artistic interests, such as reading poetry, journaling, weaving, making pottery, and listening to inspirational music, and such devotional practices as prayer and meditation also appears to promote spiritual growth in ways that benefit churches.

In this view, religious leaders can engage in selective absorption of the arts with little to worry about and much to gain. The churches can reach out to the arts, just as some religious leaders have courted certain kinds of political leaders. The arts can be courted because there is ample precedent in religious tradition itself for doing so. Not only have music and art been part of church history, but innovation has always been part of this history—from innovations in musical instruments, such as the pianoforte and the electric organ, to innovations in lyrics, popular melodies, and new architectural forms. The arts are sufficiently diverse (and decentralized) that the churches can draw in performers here, composers and writers there, and develop their own niche in the larger market for performances and other works of art. The diversity of tastes in the wider public leaves plenty of room for Christian music and art. Moreover, there is reason to believe that many artists and leaders of arts organizations find the churches' interest in the arts a welcome opportunity. While employment for artists is always limited, churches provide chances to perform, places to practice or hold exhibits, and oppor-

tunities to work in such capacities as musical directors, worship leaders, or artists-in-residence.

A Spiritual Democracy?

But, from a different perspective, the present interest in the arts raises larger questions about the shape of American spirituality. To see the arts only as a resource that church leaders can cultivate for the benefit of religious organizations is to miss the cultural context in which this interest in the arts has arisen and to which it has contributed. We need especially to understand the widespread interest in spirituality, much of which has only tenuous connections with religious organizations, and the great extent to which contemporary spirituality is focused on sacred *experience*. The quest for sacred experience is evident not only in the fact that virtually all Americans say they value feeling close to God, but also in the fact that nearly everyone experiences such feelings from time to time. Music and art contribute to these experiences. A simple praise chorus, a Bach cantata, a favorite poem recited during a time of prayer, and a beautiful painting all serve as ways in which Americans come to feel closer to the sacred. Indeed, there appears to be a strong relationship between artistic interests in general and an orientation toward spiritual growth.

This emphasis on sacred experience is an example of what might be termed a democratizing force in American spirituality. In the popular mind, sacred experiences *happen* to people, largely at unexpected times and places and as a result of circumstances rather than special preparation. To be sure, there are those who understand sacred experiences as the product of long years of diligent searching, including following the ancient practices of saints and mystics. But this is not the common view in American culture. Experience, rather, is there for the taking, at least in small doses. It requires little in the way of doctrinal understanding, serving instead as a personal affirmation of the divine. Just as in the political meaning of *democracy*, spiritual democracy is thus one in which all persons have a voice.

The present interest in connecting spirituality with the arts is congruent with this democratizing perspective. As popularly understood, the arts help each person to gain a richer experiential relationship with life, including the sacred. The richness lies in a heightened emotional state, such as feeling moved by divine beauty or feeling awed by the fact

that divine mysteries are beyond comprehension. The arts block out ordinary thoughts and worries so that a person's inner self can communicate more directly with God, or the arts release one's creative energies to reflect more deeply on God. Each person's experience is unique, fundamentally personal, and beyond questioning by anyone else. The music or art that may facilitate sacred experience, moreover, is understood as a matter of taste. What one person may find repugnant, another may find appealing.

Viewed in this way, the public's attraction to the arts is by no means spiritually neutral. Although churches can borrow some kinds of music and art and reject others, the increasing interest in music and art in the public at large has a qualitative impact on the nature of American spirituality. This is not to suggest that the arts are to blame for this impact. Rather, it appears that interest in the arts reflects a larger cultural orientation that emphasizes the unquestioned right of each person to experience God in his or her own way. In a spiritual democracy of this kind, authority is ultimately located in the common citizen, to borrow Stanley Hauerwas's phrase; it resides in individual experience and in individual opinion.[2] The authority of received religious wisdom erodes, as does the authority of certain standards of artistic excellence. It becomes as appropriate to find God's beauty in a stick-figure drawing as in a Michelangelo. This kind of democracy fits well with American individualism and with the belief that individual freedom—freedom to choose one's values and experiences—is the most worthy of all values. But it is different from the view of authority that has been present in religious communities in the past.

People of faith have nearly always maintained that religious traditions are not democracies. Believers do not elect God, but come to know God as an absolute source of truth and value. They are supposed to love their neighbors whether it is popular or not. Truth is absolute and divinely revealed, not contingent on the majority's opinion. To the extent that truth is subject to interpretation, its interpreters are the clergy, scholars, and other leaders who hold legitimate positions of authority. All this prevents individuals from simply being able to experience the sacred in their own ways. And yet, every expression of faith is profoundly influenced by the habits of its practitioners.

Americans are justifiably proud of their democratic traditions. Even more than being proud, we are so used to behaving democratically that we seldom realize just how much we are indebted to the habits and assumptions of democracy. We expect to have choices in our personal

lives, the same way we do in our political life. We may not be happy with the choices available, but we would be less happy if we had no choices at all. We like to speak up when we disagree, and we anticipate heated disagreements among our leaders. We nevertheless are content much of the time to let the will of the majority prevail. Thus it should hardly be surprising to find that our religious and spiritual habits are decidedly democratic as well.

An analogy may be helpful. Who has not had the following experience? You are a child, and you enter a room where a number of people are gathered. Let us say they are adults, and they are obviously looking at something. By all indications, they like what they see, or at least find it curious. But you don't know what it is. They are bigger than you. And you are standing in the back. Your natural inclination is to say, "Let me see! Let me see!" This statement, "Let me see," is rich with interpretive possibilities. Indeed, the desire to *see* is one that comes up repeatedly when people try to figure out what is distinctive about our time. It is easy, too, to focus on the "me" in this statement. But taking apart the words is always a good way to lose sight of the whole statement. "Let me see" is fundamentally a demand to have the same access as everyone else. It is an act of hubris.

The present connections between spirituality and the arts are fundamentally about seeing. Seeing is not simply being able to visualize better by virtue of looking at a painting or sculpture, although those may be helpful. Seeing involves participating in the presence of God and in God's activity in the world. Or, as many of our interviewees insist, it involves taking seriously the idea that humans are created in the image of God and thus are able to be creative, just as God is creative. Seeing rests on the assumption that people create through the act of perceiving and imagining, thereby becoming cocreators with God. This view is quite different from one in which God's creative power is understood to be so far removed from flawed human abilities that any desire to be a cocreator is idolatrous. It gives each person equal access to the divine.

Spiritual Formation

But the arts invite yet another perspective on the idea of a spiritual democracy. The child who cries "Let me see" may not see very much, even if permitted to look, because of an inability to understand. If the object under observation is a work of art, some training in art, art history, or

art appreciation will likely enhance the observer's ability to see. In short, the person's perceptive capacities must be shaped, or formed, in order for his or her experience to be enriched. So with democracy. Although democratic government respects the right of everyone to vote and to express his or her opinion, democracy works better for all concerned if there is an informed electorate. Civic education shapes people into responsible citizens. In a spiritual democracy, everyone may feel that he or she has access to the sacred, and yet the community of faithful people, individually and collectively, will benefit if some effort is made to cultivate their capacity to see. To the extent that all people have a creative capacity because they are made in the image and likeness of God—to the extent that there is an artist in everyone—this creative capacity will be enhanced by drawing a lesson from the effort that is exemplified in the lives of artists.

What we learn from artists and from devout people who have been influenced by the arts is mostly that a deeper realization of the fullness and the mystery of life is possible. It has been said that Carl Sandburg actually experienced sunsets differently from most of his contemporaries.[3] He did so in part because he had trained himself to do so. The training involved acquiring a lexicon of words that permitted him to see hues of color that would have been missed by someone with a more restricted vocabulary: the sky was not gray but gunmetal, for example. The training also involved teaching himself to be fully attentive to the moment of the sun's setting. Where others may have been deflected from appreciating its beauty because they focused on what they needed to do next, he could pause to absorb fully what was taking place in the here and now.

But, whereas the Sandburg example can be interpreted simply as an instance of art enriching a purely sensory experience (what, for John Dewey, became the "consummatory" role of art), the current interest in spirituality suggests a more profound interpretation.[4] Art, in this view, not only heightens human perception of the natural world, but also encourages reflection on that which transcends nature. Mystery implies that which transcends human experience as well as that which is beyond human comprehension. The discipline required to experience a sunset in all its momentary splendor is matched by that involved in humbly considering the divinity beyond that experience.

Because it is easier to be consumers of art than to create it, it is all the more important to emphasize that art is a strong form of personal discipline. Most Americans have been able to piece their interest in the arts

into an otherwise busy life, taking an hour once in a while to visit a gallery or occasionally purchasing a compact disc or video. For the typical consumer of the arts, there is no indication that he or she has had to work fewer hours a week, pursue a less demanding career, have fewer children or friends, spend less time volunteering, or attend religious services less often than those who have no interest in the arts. Art has been packaged into easily purchased commodities, thereby making it more available to the mass market. A busy public benefits, just as the entertainment industry does. But the more serious pursuit of art takes longer. It involves costs. Seeing the sunset the way Sandburg did may mean missing an evening appointment.

The discipline it takes to perform a musical composition or to create a painting involves old-fashioned hard work. And therein lies the rub. Americans are not averse to working hard; indeed, they spend more hours a year at their jobs than counterparts in most other societies. But for most people, the arts have been defined as a leisure activity—something to be pursued by kicking back and letting others do the work. So with spirituality. For most Americans, spirituality is pursued by getting comfortable in the pew on Sundays, sitting back, enjoying the choir, and hoping for a sermon that is entertaining enough to keep one's interest. The few who take their spirituality more seriously than this know that it, too, is a matter of hard work.

Hard work is generally more effective if it follows certain rules that have been found to help people accomplish their goals. This is why painters learn rudimentary techniques of sketching and pianists learn finger drills. One author puts it this way, "A ballet dancer becomes free to make beautiful moves only by conforming herself to laws and principles in disciplined practice." [5] In the religious life, techniques are often viewed more skeptically. God's grace is said to be free, and feeling close to God is assumed by many to depend more on the mysterious working of the Holy Spirit than on anything they may do to promote this feeling. Still, the role of techniques is well established in all religious traditions. In some, it has consisted almost exclusively of such Bible-mastery techniques as memorizing verses or studying outlines of biblical themes. For a growing number, techniques are also coming to be regarded as a broader set of spiritual exercises, ranging from learning to breathe in a cleansing way to rediscovering the meditative teachings of the early church. The idea behind many of these techniques is that one gains a closer relationship to God by mastering the rules that have been set forth in religious traditions.

But the arts bring in that troubling element of creativity—the dissenting spark that upsets the rules. Artists are mavericks who thrive on paradox and fluidity.[6] This is why many church leaders have been ambivalent about the arts in particular and the religious imagination in general. They want people with artistic gifts to express these gifts *properly*, in a way that conforms to the pastor's sense of propriety, but not to think too creatively. As a result, much of what people imagine when they view a work of art or when they think about divine mystery remains unspoken, private, relegated to personal life, rather than having a place in the corporate life of religious communities.

The arts have thus been—and they remain—a place where individual diversity is treasured. Artists express the quirky ideas about spirituality that people themselves may imagine but feel uncomfortable about expressing to their pastor and fellow church members. In this respect, the arts and religious organizations play complementary roles. The one is a haven for diversity, a place where the unspeakable can be spoken; the other, a refuge for decency and order.

Respecting differences is not just about people having their own quirks, though. It involves acknowledging the vastly different gifts people use in expressing their faith; indeed, the many venues and activities through which people serve and live out their faith. Church leaders are only human, but too often their humanness encourages them to praise the church worker who serves on church committees while ignoring the police worker who keeps the streets safe or the social worker who devotes her gifts to another segment of the community. The notion that everyone is, in a small way, an artist provides a gentle reminder of the value of differences within religious communities and in the wider world.

The personal struggles that artists reveal when they talk about their spiritual journeys reveal the raw underside of what many other Americans experience as they try to relate to religious institutions. These struggles often emphasize alienation from cold, unbending religious structures. Even more so, they show that spiritual life is truly about life as individuals experience it in their daily lives. It is not so much about attending church meetings or studying religious history as it is about dealing with the circumstances of being human. Spirituality is about waking in the night (as Sandra Lommasson did) with someone standing over you holding a knife.[7]

Because it is so intensely personal, the spirituality that artistically oriented people describe is sometimes hard for them to share with others.

They dance because they cannot formulate verbal prayers like the ones they hear preachers uttering from the pulpit. They write poetry that they do not publish because they don't know their own thoughts until they scrawl them on a piece of paper. They sit in worship services feeling uncomfortable with nearly everything around them until at some unexpected moment God's light breaks through.

Yet the difficulties people have in sharing their deepest spiritual concerns do not prevent them from trying. One of the strongest conclusions drawn from looking at arts programs in churches and in other religious settings is that these activities bring people together. Listening to music or playing an instrument may be a private experience, but musicians come together because they need to share these experiences. Even with all the technology that permits us to sit alone, listening to our CDs or watching our televisions, we have an instinctive desire for community.

People talk about their desire for community in so many different ways that it should not be regarded as anything simple or obvious. But one of the recurring themes is that people recognize their own limitations. They know life is richer when they are in the company of others. They also know they are better persons as a result. Others remind them that they have been petty or selfish. Others challenge them to keep going despite feeling discouraged. Art, then, is a means of bringing people together, helping them to form the bonds on which a stronger spiritual democracy depends.

The Role of Leadership

Most of the messages that filter through when people talk about the arts and their spiritual lives are different from the ways in which religion and the arts have usually been discussed. Textbooks and classes on the subject are really about the history of religious art. They focus on the changing composition of religious paintings or religious music and tell something of the assumptions that prompted great painters and composers to do what they did. All of this is helpful for gaining a greater appreciation of the splendor of the arts. But the broader movement in the arts in recent decades has been toward greater grassroots participation and toward a blurring of the line between high art and popular art.[8] This blurring has made it possible for rich interaction between artistic activities and spiritual interests to take place in ways that textbooks about religious art have failed to grasp.

Religious leaders need to be commended for what they are doing to encourage closer connections between religion and the arts. With little fanfare, and often with little recognition from the artistic world, religious leaders have provided space for artists to perform, brought out the crowds to attend concerts, and provided opportunities for millions of children to learn to sing or draw or paint. And yet there are many more opportunities that religious leaders could exploit if they wanted to take the initiative.

The biggest stumbling block in the way of realizing these opportunities is clergy not taking the arts seriously enough. Most clergy have been trained to take theology seriously enough to debate it with their colleagues. They do not have to be convinced that church finances are important. They may put in long hours preparing their sermons, and they earnestly want volunteers to help visit the sick and care for the needy. But too often their response to the music program is, well, that can take care of itself. Or, you know those musicians, you can't tell them anything anyway. Other aspects of the arts, especially the visual arts, are even less likely to receive attention in some churches. Art is mostly a matter of taste, and there is, after all, no accounting for taste.

The best antidote to this view of the arts is to ask people where they turn for inspiration, guidance, or comfort. It is the stained-glass window and the favorite hymn that people remember from childhood, not anything the minister ever said in a sermon. It is the lyric of an inspirational song that keeps people going when they are in their darkest hour. They look to poets and novelists for guidance and to the great masters of the arts for inspiration. Clergy need to understand this.

The point is not to redirect scarce congregational resources from the Christian education program or the homeless shelter to the arts. It is rather to utilize the arts more effectively in the Christian education program or the homeless shelter. Like many other professionals who have spent years in school, clergy too often fall into a pattern of thinking that reality is from the neck up. They would be well advised to take into account the whole bodies of the people to whom they are trying to minister.

But apart from tinkering with an arts festival here or a multimedia presentation there, religious leaders need to understand the profound cultural shift that the current interest in the arts represents. It is a move away from cognition and thus from knowledge and belief, a move toward experience and toward a more complete integration of the senses into the spiritual life. It is uncharted territory. Few clergy have learned anything in seminary that will help them to address it.

One of the most serious mistakes religious leaders can make in try-ing to understand the current shift is to regard it as a reawakening of the medieval consciousness. Some Catholic scholars have been fond of this view, arguing that the Protestant Reformation, with its emphasis on texts and creeds, is finally seeing the error of its ways. Protestants have been even more likely to look back at the Middle Ages as a kind of mag-ical era in which unspoken truths were laid down that can now some-how be rediscovered.

The problem with likening the present time to the Middle Ages is that the church's role in contemporary life is so dramatically different now than it was then. One might say that Americans, living as they do in a television culture, are like medieval peasants who needed icons and paintings in their churches because they could not read. But who would seriously entertain that analogy for more than a moment? Americans can read, and indeed they continue to read a great deal despite half a century of exposure to television. Young people spend more years in school, poring over textbooks, than ever before, and among adults, book sales are booming. The churches can hardly respond to reading or the lack of reading the way they did in the Middle Ages. People have too many other options for getting information and for being entertained. They don't have to go to the cathedral to see a religious painting. They can go to a museum, attend a movie, or surf the Internet.

The present era is different from the past mostly in the large variety of sources from which information can be received. This variety does not mean that we completely ignore the cognitive or the rational. But it does mean that we have more opportunities for thinking about reli-gion and for experiencing spirituality in other ways. Some of us con-tinue to find rational proofs for the existence of God attractive. But many of us look to poetry and paintings and music.

The fact that multiple kinds of input have gained legitimacy in the religious realm means that people increasingly pick and choose what they personally find most valuable. They choose not only from different denominations or theological perspectives, but also from different ways of knowing (if *knowing* is still the right word). God seems nearer to many people when they can relieve some of the stress of daily life by dancing or meditating. For others, God's message is more clearly re-vealed in the brokenness of their lives or in the healing of their rela-tionships. Because of the profound emotional force of these experi-ences, the only way of capturing them may be in artistic expression.

Democracy is often thought to be mainly about freedom. If so, then

the freedom of expression that is embodied in the arts is one of the reasons that Americans who are interested in spirituality are also increasingly drawn to the arts. But democracy also implies resistance. People with strong convictions work hard in a democracy to prevent others from totally having their way. Minority voices clamor to be heard. Democracy even requires resisting the lure of its own temptations, such as simply relying on good procedures to measure its success. The arts should be like this, too, whether they serve in political forums or in spiritual life. They are at their best when they encourage people to look at a problem in a new way. They help us most by showing us our limitations. The arts, much like the most poetic depictions of holiness in sacred texts, show us perfection, and in so doing remind us of our need for redemption.

Methodology

The research on which this book is based was conducted over a four-year period between 1998 and 2002. One part of the project focused on the relationships between spirituality and the arts among professional artists. That part involved in-depth interviews with one hundred artists and was reported in my book *Creative Spirituality: The Way of the Artist*, which was published by the University of California Press in 2001. The other part of the project, which serves as the basis for the present volume, focused on how music and art enrich the spiritual lives of people who are not professional artists and on the spiritual activities of religious congregations. Although it was possible to build on previous studies of arts participation and some literature on worship and church music, the task of finding out how ordinary people make use of the arts was largely one of exploring uncharted territory. For that reason, several kinds of research were conducted, including a national survey, in-depth interviews with a variety of informants, and focus groups.

The Arts and Religion Survey

On the basis of in-depth interviews conducted in 1998 and a review of several previous surveys asking about other kinds of arts participation, I designed the Arts and Religion Survey and commissioned the Gallup Organization in Princeton to conduct the field research for the survey. The survey was conducted during the spring of 1999 among a randomly selected sample chosen to be representative of the U.S. population of

adults age eighteen and over, living in the forty-eight contiguous states, and not living in institutions such as college dormitories, prisons, or rehabilitation hospitals. Technically, the sample is a probability sample down to the block level, after which households and persons within households are selected through an enumeration process. A total of 1,530 interviews were conducted, for which the sampling error is approximately plus or minus 3 percentage points. The interviews were conducted in person by professional Gallup interviewers who did the interviews in the respondents' homes. The Arts and Religion Survey was one of the last surveys that the Gallup Organization did using this methodology and is thus particularly valuable for that reason. In-home interviews have largely been replaced by telephone interviews for reasons of cost efficiency, but in-home interviews are preferable because a considerably larger number of questions can be asked and interviewing aids, such as hand cards for respondents to consider while answering questions, can be included. Each interview in the Arts and Religion Survey lasted approximately fifty minutes and included more than three hundred questions. Nearly all of the questions are described in the foregoing chapters, but a full copy of the questions can be obtained by contacting the author. Table 41 provides basic demographic data from the survey.

For ease of presentation and interpretation, I have used simple percentage tables and cross-tabulations throughout the chapters for showing the results of the survey. In addition, for nearly all the tables, I have examined relationships among the variables using logistic regression analysis and controlling for other variables that might confound or account for the relationships, such as level of education, age, gender, or race. The relevant odds-ratios estimated from these logistic regression equations and levels of statistical probability are included in the notes for each chapter. Table 42 illustrates the logistic regression analysis. In the top half of the table, estimated odds-ratios are presented for the likelihood of saying that spiritual growth is highly (extremely or very) important for age, education, and gender in Model 1; for the Artistic Interest Scale in Model 2; and for all the variables in Model 3. Model 1 shows that older people, those with higher levels of education, and women are more likely to attach high importance to spiritual growth than are younger people, those with lower levels of education, and men. Model 2 shows that persons who score higher on the Artistic Interest Scale are more likely to attach high importance to spiritual growth than persons who score lower on the scale. And Model 3 shows that the relationship between the Artistic Interest Scale and valuing spiritual

TABLE 41. Demographic and Religious Profile of Respondents
in the Arts and Religion Survey
(Percentages of the sample and numbers of people with each of the characteristics listed)

	Percentage	N
Total sample	100%	1,530
Age:		
18–29	20	294
30–49	41	620
50 and over	39	593
Highest degree earned:		
Grade school	14	217
High school	39	586
Some college	23	356
College graduate	24	359
Gender:		
Male	49	754
Female	51	776
Race:		
Black	14	209
White	86	1,321
Region:		
East	21	320
Midwest	23	354
South	35	536
West	21	320
Member of church/synagogue:		
Member	61	927
Nonmember	39	603
Religious preference:		
Evangelical or fundamentalist	17	259
Mainline Protestant	20	310
Roman Catholic	26	394
Attend religious services:		
Every week	34	517
Almost every week	9	144
Once or twice a month	13	199
A few times a year	26	399
Never attend	17	263
Growth in spiritual life is:		
Extremely important	28	428
Very important	28	424
Fairly important	24	359
Not very important	12	191
Not at all important	7	104
Don't know	2	24

TABLE 42. Estimated Odds-Ratios from Logistic Regression Analysis of Attaching High Importance to Spiritual Growth and Saying That One's Interest in Spirituality Is Increasing on Selected Independent Variables; Arts and Religion Survey ($N = 1530$)

	Model 1	Model 2	Model 3
Dependent variable: Spiritual growth			
Independent variables:			
Age (three categories)	1.358***		1.478***
Education (four categories)	1.274***		1.125*
Female	1.938***		1.689***
Artistic Interest Scale (six categories)		1.351***	1.341***
−2 Log likelihood	1991	2027	1934
Degrees of freedom	3	1	4
Pseudo R^2	.063	.063	.111
Dependent variable: Interest in spirituality			
Independent variables:			
Age (three categories)	1.140†		1.218**
Education (four categories)	1.208***		1.080
Female	1.780***		1.567***
Artistic Interest Scale (six categories)		1.319***	1.297***
−2 Log likelihood	2014	2033	1969
Degrees of freedom	3	1	4
Pseudo R^2	.038	.053	.077

†p < .10
*p < .05
**p < .01
***p < .001
(Two-tailed tests; Wald statistic)

growth is virtually undiminished when the controls for age, education, and gender are included. It can also be seen in Model 3 that the relationship between education and valuing spiritual growth is only about half as strong as in Model 1. One interpretation of this result is that artistic interest explains or accounts for some of the relationship between education and valuing spiritual growth. In the bottom of table 42, a comparable analysis is shown for saying that one's interest in spirituality has been increasing (rather than decreasing or staying the same). In Model 1, the coefficients for age, education, and gender are statistically

significant; Model 2 shows that the coefficient for the Artistic Interest Scale is significant; and Model 3 shows that the coefficient for the Artistic Interest Scale remains significant and virtually unchanged when the control variables are included.

Spiritual-Journey Interviews

During the initial phase of the research, in-depth qualitative interviews were conducted with approximately two hundred people. These interviews had several purposes, including finding out how people talked about their spiritual lives and what role, if any, they might see the arts as having played in their spiritual journeys. A majority of these interviews were conducted in Pennsylvania, New Jersey, and New York, but to provide regional diversity some interviews were also conducted in California, Oregon, Illinois, and Texas. Respondents were identified through a network or "snowball" technique, usually starting with a member of the clergy or a lay person who had participated in a previous research project and who then recommended other people who might be willing to talk about their spiritual journeys. Respondents were then contacted and a quota system was used to ensure variation among those with whom interviews were conducted. The quota system required that approximately equal numbers of men and women be selected; that approximately equal numbers of persons in their twenties or thirties, forties or fifties, or sixties and older be included; and that a range of educational and occupational levels, racial and ethnic backgrounds, and religious backgrounds be represented. Each potential respondent was contacted by telephone, after which a letter was sent explaining the purpose of the interview, and then the interview was conducted by a member of the research team at the respondent's place of residence or at another mutually convenient location. Although the discussion of these respondents is limited to Christians because the survey did not include a large enough number of non-Christians for statistical analysis, spiritual-journey interviews were conducted with Jews, Muslims, Hindus, Buddhists, and persons with no religious preference or multiple religious preferences, as well as with Christians.

The spiritual-journey interviews were conducted using one of several versions of a semistructured interview guide designed to encourage people to talk at length and tell stories about their personal experiences. The interviews typically began with a short series of background ques-

tions (which asked for such details as age, level of education, occupation, marital status, and religion), and then proceeded by asking the respondent to take as much time as necessary to describe his or her spiritual journey, starting with childhood and working up to the present. The interviewer was instructed to ask questions to fill in gaps, but otherwise to let the respondent talk without interruption. Subsequent questions then asked the respondent to indicate which religious organizations he or she had been associated with, unless this information had already been provided, why he or she had affiliated with (or disaffiliated from) particular religious organizations, and how he or she would summarize his or her beliefs and spiritual practices at present. The interviews also included a series of specific questions asking respondents about their prayer and meditation practices, other devotional activities, religious experiences, and service activities. For those respondents who happened to be members of religious congregations, questions were also included about the size and composition of the congregation and the activities in which the respondent was involved. The interviews usually lasted between an hour and a half and two hours. All interviews were tape recorded and transcribed. Respondents were given the option to identify themselves by pseudonyms or by their real names and, if they were willing, to review the transcripts and provide corrections or revisions.

The spiritual-journey interviews were used to generate preliminary ideas about the range of artistic activities and experiences that might be meaningful to respondents and to provide a better understanding of the life stories in which these experiences were embedded. These interviews gave an initial sense of how childhood hymns, worship settings, church architecture, poetry, stories, home decorations, paintings, sculptures and home altars, music lessons, choir practice, and a variety of other experiences with the arts might contribute to respondents' spiritual journeys. The interviews also provided a better understanding of how people make use of music, poetry, or religious objects when they pray or meditate, how music or crafts provide comfort during personal crises, and what people appreciate or fail to appreciate about the music they participate in at church or their experiences with artistic activities at spiritual retreats or in small groups. The interviews helped both in formulating structured questions for the survey and in providing interpretations of survey results. The respondents featured in chapters 2 and 3 are examples of persons who participated in the spiritual-journey interviews.

tions (which asked for such details as age, level of education, occupation, marital status, and religion), and then proceeded by asking the respondent to take as much time as necessary to describe his or her spiritual journey, starting with childhood and working up to the present. The interviewer was instructed to ask questions to fill in gaps, but otherwise to let the respondent talk without interruption. Subsequent questions then asked the respondent to indicate which religious organizations he or she had been associated with, unless this information had already been provided, why he or she had affiliated with (or disaffiliated from) particular religious organizations, and how he or she would summarize his or her beliefs and spiritual practices at present. The interviews also included a series of specific questions asking respondents about their prayer and meditation practices, other devotional activities, religious experiences, and service activities. For those respondents who happened to be members of religious congregations, questions were also included about the size and composition of the congregation and the activities in which the respondent was involved. The interviews usually lasted between an hour and a half and two hours. All interviews were tape recorded and transcribed. Respondents were given the option to identify themselves by pseudonyms or by their real names and, if they were willing, to review the transcripts and provide corrections or revisions.

The spiritual-journey interviews were used to generate preliminary ideas about the range of artistic activities and experiences that might be meaningful to respondents and to provide a better understanding of the life stories in which these experiences were embedded. These interviews gave an initial sense of how childhood hymns, worship settings, church architecture, poetry, stories, home decorations, paintings, sculptures and home altars, music lessons, choir practice, and a variety of other experiences with the arts might contribute to respondents' spiritual journeys. The interviews also provided a better understanding of how people make use of music, poetry, or religious objects when they pray or meditate, how music or crafts provide comfort during personal crises, and what people appreciate or fail to appreciate about the music they participate in at their experiences with artistic activities at spiritual retreats or in groups. The interviews helped both in formulating structured questions for the survey and in providing interpretations of survey results. The respondents featured in chapters 2 and 3 are examples of persons who participated in the spiritual-journey interviews.

Leadership Interviews

While the survey was being carried out and the data analyzed, approximately 150 in-depth qualitative interviews were conducted with lay leaders in congregations and with other people whose ministries made explicit use of music and the arts. These interviews were conducted in New Jersey, Pennsylvania, New York, Massachusetts, Delaware, Virginia, Georgia, Texas, Ohio, Illinois, California, and Oregon. The goal of these interviews was to identify a wide variety of people who could illustrate ways in which music and arts are being used in congregations or in various parachurch settings; to learn from them how and why they were making use of the arts and how these programs were structured; and then to talk with other participants in these congregations or settings to see how they were responding to these programs. The procedures used to identify respondents included identifying programs through web sites, newsletters, periodicals, and other publications; talking with clergy in various locations and asking them to nominate people in their communities or circles of ministry who might be interesting to interview; and asking interviewees to suggest other people to contact. We also employed a loose quota system that was designed to ensure gender diversity, a range of age cohorts, racial and ethnic diversity, regional diversity, small and large congregations, a range of religious traditions, and a variety of artistic styles. The respondents included choir directors, worship leaders, clergy who made particular use of music or drama in their ministries, specialists in liturgical dance, artists-in-residence, spiritual directors and counselors who used pottery and painting in their work, graphic designers who worked for religious publishing houses, and editors of journals concerned with spirituality and the arts, as well as amateur artists and musicians and other participants who helped design church art or music programs or who could provide information about such programs. The people featured in chapters 4, 5, and 6 are among these informants.

The leadership interviews followed a semistructured format, as did the spiritual-journey interviews, and each interview was tailored to ask questions about the informant's particular area of ministry or expertise. The interviews asked informants to describe in detail the programs with which they were involved and to tell how they originated and what the responses to them had been. Informants were asked about their own spiritual journeys and about how they had come to be interested in a particular kind of ministry making use of music and the arts. Specific questions were also included about the religious imagination, creativ-

ity, barriers or limitations on the religious uses of the arts, and wish lists for further development of relationships between spirituality and the arts. All interviews were tape recorded and transcribed.

Elite Interviews

Through a related project supported by the Luce Foundation on the relationships between organized religion and the arts, an opportunity became available to collect information from prominent and influential figures in religious circles and in major arts organizations. These interviews were conducted in New York, Philadelphia, Cleveland, Dallas, and San Francisco. The purpose was to learn how leaders of arts organizations and religious organizations view each other in these major metropolitan areas and to understand the dynamics of interaction or barriers to interaction between the religious communities and arts communities in each city. A total of one hundred interviews were conducted, including ten prominent religious leaders and ten heads of prominent arts organizations in each city. All of the leaders opted to speak on the record and agreed to be identified by name. Their names and the organizations with which they are affiliated appear in my chapter "Arts Leaders and Religious Leaders: Mutual Perceptions" in *Crossroads: Art and Religion in American Life,* edited by Alberta Arthurs and Glenn Wallach (New York: New Press, 2001), pp. 31–70. For present purposes, these interviews provide a more expansive view of how religion and the arts are related than that provided by many of the clergy and church members, who spoke more about their particular programs. The elite clergy interviews show how some of the largest and most influential churches in the nation are making use of the arts in their ministries, while the interviews with heads of arts organizations reveal what these organizations are doing to promote greater appreciation of religion and spirituality. These interviews also provide insights into the barriers separating religion and the arts (which are discussed in chapter 7).

Focus Groups

I wanted to supplement the survey and qualitative interviews with information elicited in contexts that provide people with opportunities to

interact with one another and share their views by playing off one an-
other's comments. I also wanted to see how people actually respond to
the arts and music, rather than only having them describe their reac-
tions after the fact. Focus groups provided a way to do both. With the
help of clergy, lay leaders, and some personal acquaintances who had
helped with other parts of the research, we arranged ten focus-group
meetings. Each group consisted of between eight and twelve volunteers
who agreed to meet for approximately two hours to help us with our re-
search on religion and the arts. We tried to make the groups as different
from one another as possible; thus, one group was at a fundamentalist
church, another was at an evangelical church, another was composed of
the members of a young singles group at a different evangelical church,
another was at an African American church, another was at a mainline
Protestant church, another was at a Catholic church, another was com-
posed mostly of Jews, another was composed of people who knew one
another through a program in spiritual direction at a retreat center, an-
other was composed of people who did not attend any church or syna-
gogue, and another was composed of people from several churches,
most of whom had some connection with music and the arts. Internally,
the groups ranged from ones in which people were intimately ac-
quainted because they actually were a group that met regularly for Bible
study or discussion, to ones in which people knew one another well by
virtue of attending the same congregation, to groups in which a mem-
ber of the clergy was present, to groups composed of strangers.

At each of the focus-group meetings, the leader began by explaining
that we were doing a project on religion and the arts and were inter-
ested in getting participants' responses to particular pieces of music and
art. Each of the participants was asked to fill out a short form giving his
or her name, address, religious affiliation, and occupation. The leader
then showed a selection of slides of visual art, played several musical se-
lections, and handed out several selections of poetry or prose that were
read aloud. The selections were organized according to a grid design
that ensured that at least two of the groups received the same selection,
but that a wider range of selections could be used than would have been
possible with any single group. Some of the selections were by well-
known musicians or writers, such as John Tavener and Maya Angelou;
others were by some of the artists featured in *Creative Spirituality*
(these were included because we knew from our interviews with these
artists what some of the artists' meanings and intentions were); and
others were anonymous selections. Following each selection, the group

members were asked to share their views about whether they liked or did not like the selection, why they did or did not like it, and whether they saw any connections with spirituality in the selection. The final part of each session was devoted to open discussion about spirituality and the arts, and about the group's views of what religious organizations might or might not want to do to encourage closer interaction between spirituality and the arts.

Lehigh Valley Clergy Interviews

Finally, data were collected from a random sample of clergy in the Lehigh Valley in northeastern Pennsylvania (the Allentown, Bethlehem, and Easton region). Because the other qualitative interviews we conducted among clergy were not done on a random sample, I wanted to gather some information from clergy without having to worry about possible biases stemming from clergy being elite or being referred to us because of having some particular interest in art or music. I also wanted an opportunity, somewhat like that provided by the focus groups, to present clergy with some actual selections of art and to gauge their reactions. This meant doing the interviews with clergy in person rather than by telephone and thus doing them in a single geographic region. The Lehigh Valley includes approximately six hundred thousand people, making it similar in size to about two hundred other small- to medium-size cities across the country. It is religiously diverse, including a substantial number of Catholics and Protestants, but is more heavily populated with several groups (such as Lutherans and Moravians) than is the case in other locations. At the time of the study, there were 611 churches within a twenty-five-mile radius of downtown Allentown. From this population of churches, I selected a one-in-ten sample using random numbers and then supplemented the sample with additional randomly selected churches to compensate for noncooperation. Interviews were conducted with pastors at sixty churches.

Each interview lasted approximately an hour and included questions about the composition of the congregation, how the pastor would describe it theologically and politically, its budget, and its attendance patterns. The interviewer also asked the pastor what he or she preached about, whether he or she ever used examples from literature or the arts, and what kind of music program the church offered. Near the end of the interview, the pastor was shown pictures of several pieces of visual art

chosen to represent variation from more traditional to more contemporary or free-form themes, and was asked to indicate his or her response to each and whether he or she would think it suitable for display at his or her church or in his or her home. Finally, each pastor filled out a short questionnaire that included statements about various attitudes toward the arts. Some information from these interviews is included in chapter 7.

Notes

Chapter 1. A Puzzle

1. Harvey Cox, *The Secular City: Secularization and Urbanization in Theological Perspective* (New York: Macmillan, 1965), p. 3.

2. Will Herberg, *Protestant-Catholic-Jew* (Garden City, N.Y.: Anchor, 1955).

3. Questions about the accuracy of poll figures on church attendance have been discussed in C. Kirk Hadaway, Penny Long Marler, and Mark Chaves, "What the Polls Don't Show: A Closer Look at U.S. Church Attendance," *American Sociological Review* 58 (December 1993): 741–52; C. Kirk Hadaway, Penny Long Marler, and Mark Chaves, "Overreporting Church Attendance in America: Evidence That Demands the Same Verdict," *American Sociological Review* 63 (February 1998): 122–30; and Tom W. Smith, "A Review of Church Attendance Measures," *American Sociological Review* 63 (February 1998): 131–36.

4. George H. Gallup, Jr., and D. Michael Lindsay, *Surveying the Religious Landscape: Trends in U.S. Beliefs* (Philadelphia: Morehouse, 1999), ch. 1.; the figure for 2000 is from Frank Newport, "Religion in the Aftermath of September 11," *Gallup Poll News Service* (December 21, 2001), http://www.gallup.com/poll/releases. According to this source, a poll taken ten days after the September 11, 2001, attack on New York and Washington showed that 47 percent had attended religious services within the past seven days, but that figure decreased to 42 percent in November and 41 percent in mid-December.

5. General Social Surveys, 1972–2000 (Chicago: National Opinion Research Center, 2000, machine-readable data file), my analysis; based as it is on approximately forty thousand cases, this is a statistically significant, but weak, relationship.

6. Michael Hout and Andrew Greeley, "What Church Officials' Reports Don't Show: Another Look at Church Attendance Data," *American Sociological Review* 63 (February 1998): 113–18 (see esp. p. 118).

7. Robert D. Putnam, *Bowling Alone: The Collapse and Revival of American Community* (New York: Simon and Schuster, 2000), p. 71.

8. Gallup and Lindsay, *Surveying the Religious Landscape,* ch. 1.

9. Peter L. Berger, "The Desecularization of the World: A Global Overview," in *The Desecularization of the World: Resurgent Religion and World Politics,* ed. Peter L. Berger (Grand Rapids, Mich.: Eerdmans, 1999), p. 2.

10. The sociologist of religion Mark Chaves, at the University of Arizona (personal communication, April 2001), says that time-use diary studies suggest that religious participation has in fact declined, which, if true, raises questions about the validity of survey evidence. My argument is not that church attendance has remained absolutely constant, but that religious participation has fared better than expected, given social developments working against it, thus suggesting that some other developments more favorable to religious participation need to be considered.

11. U.S. Census Bureau, *Statistical Abstract of the United States, 2000* (Washington, D.C.: Government Printing Office, 2000), sec. 13.

12. Juliet Schor, *The Overworked American: The Unexpected Decline of Leisure* (New York: Basic Books, 1991), p. 29.

13. General Social Surveys, 1972–98 (Chicago: National Opinion Research Center, 1998, machine-readable data file), my analysis.

14. Arts and Religion Survey (Princeton University, Department of Sociology, 1999, machine-readable data file), my analysis; see methodological appendix for further details on the survey.

15. U.S. Census Bureau, *The American Almanac, 1995–96: Statistical Abstract of the United States* (Austin, Tex.: Reference Press, 1996), table 87; Andrew J. Cherlin, *Marriage, Divorce, Remarriage,* rev. ed. (Cambridge, Mass.: Harvard University Press, 1992); Reynolds Farley, *The New American Reality: Who We Are, How We Got Here, Where We Are Going* (New York: Russell Sage Foundation, 1996), ch. 4.

16. Arts and Religion Survey.

17. Claude S. Fischer, "Ambivalent Communities: How Americans Understand Their Localities," in *America at Century's End,* ed. Alan Wolfe (Berkeley and Los Angeles: University of California Press, 1991), ch. 4.

18. General Social Surveys, 1972–98.

19. Arts and Religion Survey.

20. George H. Gallup, Jr., "Literal Belief in the Bible Declining in U.S.," *Emerging Trends* (January 1992): 1; Gallup and Lindsay, *Surveying the Religious Landscape,* ch. 2.

21. George M. Marsden, *Reforming Fundamentalism: Fuller Seminary and the New Evangelicalism* (Grand Rapids, Mich.: Eerdmans, 1987), p. 302.

22. Arts and Religion Survey.

23. Putnam, *Bowling Alone.*

24. R. Stephen Warner, "Work in Progress toward a New Paradigm for the Sociological Study of Religion in the United States," *American Journal of Sociology* 98 (March 1993): 1044–93.

25. R. Stephen Warner and Judith G. Wittner, eds. *Gatherings in the Diaspora: Religious Communities and the New Immigrants* (Philadelphia: Temple University Press, 1998).

26. Arts and Religion Survey.

27. See esp. Sidney Verba, Kay Lehman Schlozman, and Henry E. Brady, *Voice and Equality: Civic Voluntarism in American Politics* (Cambridge, Mass.: Harvard University Press, 1995).

28. Dean M. Kelley, *Why Conservative Churches Are Growing: A Study in Sociology of Religion* (1972; reprint, Macon, Ga.: Mercer University Press, 1986).

29. Rodney Stark and William Sims Bainbridge, *The Future of Religion* (Berkeley and Los Angeles: University of California Press, 1986); see also Stark and Bainbridge, *Theory of Religion* (New Brunswick, N.J.: Rutgers University Press, 1996).

30. Roger Finke and Rodney Stark, *The Churching of America, 1776–1990: Winners and Losers in Our Religious Economy* (New Brunswick, N.J.: Rutgers University Press, 1992).

31. Helpful discussions of leadership styles and independent churches include George Barna, *The Second Coming of the Church* (Nashville: Word, 1998); and Donald E. Miller, *Reinventing American Protestantism: Christianity in the New Millennium* (Berkeley and Los Angeles: University of California Press, 1997).

32. Christian Smith, *American Evangelicalism: Embattled and Thriving* (Chicago: University of Chicago Press, 1998).

33. R. Laurence Moore, *Religious Outsiders and the Making of Americans* (New York: Oxford University Press, 1986).

34. C. Kirk Hadaway, "Church Growth (and Decline) in a Southern City," *Review of Religious Research* 23 (1982): 372–86; Hadaway, "Conservatism and Social Strength in a Liberal Denomination," *Review of Religious Research* 21 (1980): 302–14; Michael Hout, Andrew Greeley, and Melissa J. Wilde, "The Demographic Imperative in Religious Change in the United States," *American Journal of Sociology* 107 (September 2001): 468–500.

35. From the Gallup Liberal-Conservative Survey, conducted in 1984; my American Values Survey, conducted in 1989; and the Arts and Religion Survey (machine-readable data files, available from author).

36. Mark Chaves, National Congregations Survey (University of Arizona, Department of Sociology), personal communication, April 2001; Arts and Religion Survey.

37. In the 1998 General Social Survey (conducted by the National Opinion Research Center at the University of Chicago [machine-readable data file]), 14 percent of Protestants identified themselves as evangelicals; in the Arts and Religion Survey, 13 percent did so.

38. Another explanation for the relative stability of religious involvement—which has sometimes been entertained among social scientists—is that the declines likely to have been associated with such social changes as rising divorce rates and geographic mobility were being offset by the "aging" of the popula-

tion. On the surface, this argument appears plausible because (a) most studies show that older people are more actively involved (up to the point of declining health) in organized religion than younger people are; and (b) the baby boom generation, which was a relatively large cohort, was aging. But there are two weaknesses in this argument. First, the adult population of the United States has *not* become significantly older during the past three decades; for instance, in the General Social Survey, which has often been used to draw inferences about religious attendance, the average age of adult respondents was forty-five in 1973 and forty-six in 2000. And second, whatever increase in religious-service attendance may be taking place among baby boomers as they age has to be considered in relation to the lower than average attendance rates among new immigrants (as mentioned previously) and among the relatively large cohort of Americans currently in their twenties and thirties.

39. Bryan Wilson, *Religion in Secular Society* (London: Pelican, 1966), p. 14; Robert N. Bellah, *Beyond Belief: Essays on Religion in a Post-Traditional World* (New York: Harper and Row, 1970), ch. 2.

40. Thomas Luckmann, *The Invisible Religion: The Transformation of Symbols in Industrial Society* (London: Macmillan, 1967), p. 86

41. Wade Clark Roof, *A Generation of Seekers: The Spiritual Journeys of the Baby Boom Generation* (San Francisco: HarperSanFrancisco, 1993).

42. Among other sources, the tensions between the arts and the churches are discussed in Leland Ryken, *The Liberated Imagination: Thinking Christianly about the Arts* (Chicago: Harold Shaw, 1989).

43. Max Weber wrote of growing tension between religion and the arts as a result of the process of rationalization in modern societies that, in his view, produced a shift from moral to aesthetic evaluations of conduct. Max Weber, "Religious Rejections of the World and Their Directions," in *From Max Weber*, trans. and ed. Hans H. Gerth and C. Wright Mills (London: Routledge and Kegan Paul, 1948), pp. 323–59; see also Weber, *The Sociology of Religion* (Boston: Beacon Press, 1963), pp. 242–44. And, for overviews of discussions indebted to the Weberian legacy, see Roger O'Toole, "Salvation, Redemption, and Community: Reflections on the Aesthetic Cosmos," *Sociology of Religion* 57 (1996): 127–49; and Judith R. Blau, "The Toggle Switch of Institutions: Religion and Art in the U.S. in the Nineteenth and Early Twentieth Centuries," *Social Forces* 74 (1996): 1159–78.

44. Jerome W. Clinton, "Rumi in America," *Edebiyat: A Journal of Middle Eastern and Comparative Literature* 10 (Fall 1999): 149–54.

45. April Austin, "Art's Longing for 'Connectedness,'" *Christian Science Monitor* (October 4, 1996), p. 10.

46. Henry Miller, *The Wisdom of the Heart* (New York: New Directions, 1941), p. 89.

Chapter 2. Contemporary Spirituality

1. Arts and Religion Survey (see methodological appendix); while responses such as these must be interpreted with caution, the increasing interest in spirituality they suggest is consistent with findings reported in Gallup surveys: "The percentage of Americans who say they feel the need in their lives to experience spiritual growth has surged twenty-four points in just four years—from 58% in 1994 to 82% in 1998" (Gallup and Lindsay, *Surveying the Religious Landscape,* 1).

2. Among the randomly selected clergy I studied in northeastern Pennsylvania (see methodological appendix), more than 90 percent said they had preached about spiritual growth in the past year.

3. Wade Clark Roof, "American Spirituality," *Religion and American Culture* 9 (Summer 1999): 157; see also Roof, *Spiritual Marketplace: Baby Boomers and the Remaking of American Religion* (Princeton, N.J.: Princeton University Press, 1999).

4. Clergy quoted in this chapter are from a randomly selected sample of sixty pastors in a metropolitan area in northeastern Pennsylvania; see methodological appendix.

5. Unless otherwise indicated, these and subsequent percentages are from my Arts and Religion Survey. This was a nationally representative survey of the U.S. adult population conducted person-to-person in 1999 among 1,530 respondents; see methodological appendix for further details.

6. Alasdair MacIntyre, *After Virtue: A Study in Moral Theory,* 2nd ed. (Notre Dame, Ind.: University of Notre Dame Press, 1984), p. 194.

7. For the tables in this chapter, the percentages for the column labeled "highest" are based on the 428 people who said spiritual growth was extremely important; for the column labeled "high," on the 424 people who said spiritual growth was very important; for the column labeled "low," on the 359 people who said spiritual growth was fairly important; and for the column labeled "lowest," on the 295 people who said spiritual growth was not very important or not at all important (respondents who did not answer the question about spiritual growth are excluded from these tables).

8. Colleen McDannell, *Material Christianity: Religion and Popular Culture in America* (New Haven, Conn.: Yale University Press, 1996).

9. The material culture of childhood religion is extensively described in my book *Growing Up Religious: Christians and Jews and Their Journeys of Faith* (Boston: Beacon Press, 1999). On the role of religious art in Catholic homes, see also David Halle, *Inside Culture: Art and Class in the American Home* (Chicago: University of Chicago Press, 1993), esp. ch. 6.

10. Controlling for sex, education, age, and two measures of theological orientation (evangelical or fundamentalist Protestant, and self-identified as religiously conservative), the odds-ratios from logistic regression analysis of the relationships between spiritual interest and the items shown in table 1 are as follows: childhood church attendance, 1.18; hymns, 1.63; pictures, 1.64; objects, 1.35; shrine or altar, 1.44; mysterious encounter, 1.34; and reading religious history, 1.61 (all significant at or beyond the .001 level of probability, except for

church attendance [.01 level]). Substantively, this means, for instance, that the odds of having had a favorite hymn as a child are approximately 63 percent greater among those who currently show the "highest" level of interest in spiritual growth, compared with those with "high" spiritual interest; similar differences are present between the other categories of spiritual interest.

11. Robert N. Bellah, Richard Madsen, William M. Sullivan, Ann Swidler, and Steven M. Tipton, *Habits of the Heart: Individualism and Commitment in American Life,* 2nd ed. (Berkeley and Los Angeles: University of California Press, 1996), pp. 221, 235.

12. Using the same statistical procedures as in the previous table, the odds-ratios from logistic regression analysis of the effects of spiritual interest on the items in table 2 are as follows: 2.25 for increasing interest in religion, 2.00 for church membership, 2.36 for attendance, 2.83 for attendance being important to spiritual growth, 1.78 for admiring clergy, and 1.45 for church shopping (all significant at or beyond the .001 probability level). These figures indicate that all relationships in the table are strong and positive.

13. Richard P. Cimino and Don Lattin, *Shopping for Faith: American Religion in the New Millennium* (San Francisco: Jossey-Bass, 1999), is one example.

14. In the survey, 85 percent indicated having been raised in the Christian tradition (as Protestants, Catholics, Eastern Orthodox, or Mormons), whereas only 2 percent had been raised Jewish and less than 1 percent had been raised Muslim; for this reason, the questions about beliefs that may signify commitment to a tradition focused mainly on Christianity.

15. The odds-ratios for table 4, using logistic regression analysis with the same variables controlled as previously, are as follows: 1.45 for God revealed in Jesus, 1.41 for Christianity, 1.54 for Jesus versus mystery (0.61 for mystery versus Jesus), 1.63 for literalism, nonsignificant for knowing person of other religion, 1.25 for attending service of other religion, 1.67 for interest in learning about other religions, 0.85 for God revealed many ways, and nonsignificant for all religions containing truth (all significant at .001 level unless otherwise indicated).

16. Peter L. Berger, "Protestantism and the Quest for Certainty," *Christian Century* 115 (August 26, 1998): 782–81.

17. MacIntyre, *After Virtue;* and Jeffrey Stout, *Ethics after Babel: The Languages of Morals and Their Discontents* (Boston: Beacon Press, 1988).

18. The idea of spiritual practice is developed further in my book *After Heaven: Spirituality in America Since the 1950s* (Berkeley and Los Angeles: University of California Press, 1998).

19. Exact wording of the question was: "How much effort have you devoted to your spiritual life during the past year—would you say a great deal, a fair amount, only a little, hardly any, or none?"

20. To assess the statistical significance and strength of the relationships in table 4, logistic regression analysis was used; controlling for the same variables as before, the odds-ratios for the effects of spiritual interest on the respective dependent variables are as follows: spiritual effort, 4.44; prayer, 2.46; meditation,

1.97; and increasing interest in spirituality, 2.73 (all significant at or beyond the .001 level of probability). A substantive interpretation of these figures is that the odds of saying one has devoted a great deal of effort to one's spiritual growth in the past year, for example, are approximately four times greater among those whose self-reported interest in spiritual growth is highest than among those whose interest in spiritual growth is next highest, whose odds in turn are four times greater than those at the next level of interest in spiritual growth, and so on.

21. For table 5, the odds-ratios from logistic regression analysis (with the same control variables) of the relationships between spiritual interest and the items shown are as follows: 1.52 for service, 1.61 for volunteering, 1.99 for experience through sermons, 1.51 for experiences through nature, 1.51 for experiences through friends, and 2.29 for experiences through inspirational books (all significant at or beyond the .001 level of probability).

22. The categorization of respondents into fundamentalist, evangelical, mainline, liberal, or other Protestant is based on a question that asked Protestants to indicate which of these labels best described their religious identity. This question was developed by Professor Christian Smith at the University of North Carolina for use in the 1998 General Social Survey administered by the National Opinion Research Center at the University of Chicago and is based on research presented in Smith, *American Evangelicalism.*

23. This relativistic sense of religious truth is reflected in responses to a 1991 Barna Poll (conducted by telephone among 1,005 randomly selected adults), in which a more general statement ("There is no such thing as absolute truth, different people can define truth in conflicting ways and still be correct") elicited agreement from 67 percent of those polled (*Public Opinion Online,* February 11, 1992; available online through Lexis-Nexis).

Chapter 3. A Blending of Cultures

1. Unless otherwise indicated, figures are from the Arts and Religion Survey; for childhood activities, respondents were given a hand card with the items indicated and asked, "When you were growing up, did you do any of the following?"

2. *Education Statistics, 1998* (Washington, D.C.: National Center for Education Statistics, 1998), table 39 (online). The proportion of Americans age five to seventeen who were enrolled in school increased from 72 percent in 1899 to 90 percent in 1989; average days per year in attending school grew from 78 in 1869 to 161 in 1969.

3. Ibid., table 71. While the proportion of teachers specializing in music remained constant between 1966 and 1996, art teachers as a proportion of all teachers increased from 2 percent to 3.3 percent; in table 136, Carnegie Units in the arts among high school graduates increased from 1.43 in 1982 to 1.66 in 1994.

4. Steven J. Tepper, "Making Sense of the Numbers: Estimating Arts Participation in America" (working paper 4, Center for Arts and Cultural Policy Studies, Princeton University, 1998).

5. U.S. Census Bureau, *Statistical Abstract of the United States, 1993, 1998* (Washington, D.C.: Government Printing Office, 1993, 1998), p. 243, table 399, and p. 272, table 448, respectively.

6. Research Division, National Endowment for the Arts, "1997 Survey of Public Participation in the Arts: Half of U.S. Adults Attended Arts Performances or Exhibitions" (September 1998), note 70.

7. With items shown on a hand card, the question read: "Here is a list of activities. Please tell me if you have done each one within the past 12 months."

8. *Statistical Abstract, 1993, 1998,* p. 243, table 399, and p. 272, table 448, respectively.

9. *Statistical Abstract, 1998,* p. 579, table 931. More generally, according to the Bureau of Economic Analysis, consumer spending on the performing arts, as a percentage of after-tax income, rose from 0.07 percent in 1970 to 0.12 percent in 1990; Research Division, National Endowment of the Arts, draft for public comment, "Arts, Humanities, and Culture" (September 7, 1994).

10. Figures cited are from the U.S. Census Bureau, *Statistical Abstract of the United States, 1999* (Washington, D.C.: Government Printing Office, 1999), p. 424, table 675.

11. Research Division, National Endowment for the Arts, research report 37, "Artists in the Workplace" (1995).

12. The question read: "People express their creativity in different ways. Which of the activities on this card especially spark your creativity?"

13. Specifically, 50 percent of respondents born in the 1950s, 1960s, and 1970s (and 53 percent of those born in the 1940s) identify at least one of these activities as sparking their creativity, compared to 36 percent, 41 percent, and 28 percent of those born respectively in the 1930s, 1920s, and 1910s.

14. Respondents were given a hand card containing twelve short statements and asked, "Which of the statements on this card do you mostly agree with?" The two discussed here are "I think of myself as a creative person" and "I think of myself as an artistic person."

15. The question read: "If we think of the arts as including painting, sculpture, music of all kinds, dance, theater, and creative literature, how important would you say the arts are to you in your own life?"

16. A national telephone survey conducted among 1,059 respondents by the National Cultural Alliance in 1992 yielded roughly similar results. When asked, "The arts and humanities are considered to include the visual arts, such as painting and sculpture, literature, the performing arts of theater, dance, and music, and philosophy, history, and languages; would you say the arts and humanities play a major role in your life, a minor role, or no role at all?" Thirty-one percent responded "major," 57 percent "minor," and 11 percent "no role at all" (*Public Opinion Online,* April 14, 1994); available from the Roper Center or through Lexis-Nexis.

17. Bethany Bryson, "'Anything but Heavy Metal': Symbolic Exclusion and Musical Dislikes," *American Sociological Review* 61 (October 1996): 884–99; Richard A. Peterson and Roger M. Kern, "Changing Highbrow Taste: From Snob to Omnivore," *American Sociological Review* 61 (October 1996): 900–907.

18. The scale taps the variety of ways in which people are artistic, either by experience, activities, self-definition, or values; 86 percent had experienced at least one activity growing up, 44 percent currently engaged in one of the activities included, 47 percent expressed their creativity in one of the ways included, 58 percent think of themselves as creative or artistic, and 44 percent say the arts are very important personally; the five items are positively associated with one another (average Pearson correlation coefficient of .260). The Cronbach's Alpha reliability coefficient is .639.

19. Published arguments about the potential relationship between the arts and spirituality include William L. Hendricks and Robert Don Hughes, "Christian Spirituality and the Arts," in *Becoming Christian: Dimensions of Spiritual Formation*, ed. Bill J. Leonard (Louisville, Ky.: Westminster/John Knox, 1990), pp. 90–101; Joanmarie Smith, "Art as Religious Education," *Momentum* (November 1989): 61–62; Linda J. Clark, "Teaching Faith through Music," *APCE Advocate* (Winter 1996): 7; and Doug Adams and Diane Apostolos-Cappadona, eds., *Art as Religious Studies* (New York: Crossroad, 1987). Also of interest are such statements about spirituality in the arts as Wassily Kandinsky, "Concerning the Spiritual in Art," in *Art, Creativity, and the Sacred: An Anthology in Religion and Art*, ed. Diane Apostolos-Cappadona (New York: Crossroad, 1985), pp. 3–7; and Roger Lipsey, *An Art of Our Own: The Spiritual in Twentieth-Century Art* (Boston: Shambhala Publications, 1997).

20. An independent piece of evidence suggesting the relationship between the arts and spirituality comes from a national telephone survey of 756 respondents conducted for *Newsweek* in 1994 by Princeton Survey Research Associates in which 32 percent responded "Yes" to the question "Apart from experiences at your place of worship, what other places or other experiences have given you a strong sense of being in the presence of something sacred? How about a musical concert?" (*Public Opinion Online*, December 21, 1994).

21. Controlling for age, education, and sex, the odds ratio from the logistic regression analysis of the relationship between the Artistic Interest Scale and the spiritual growth question is 1.341 (significant at or beyond the .001 level of probability), indicating that for each increment on the Artistic Interest Scale the odds of saying spiritual growth is very important are approximately 34 percent higher than at the next lower level of artistic interest; for increasing interest in spirituality, the coefficient is 1.297 (significant at or beyond the .001 level of probability). See table 42 in the methodological appendix for further details. Separate analysis shows that each of the five components of the scale is positively associated with spiritual growth, using the same controls. Because the artistic interest and spirituality questions refer mostly to the same time period, the direction of causality cannot be established. However, there is a significant rela-

tionship between the number of *childhood* artistic activities (not including singing at church) and adult interest in spiritual growth (1.16; significant at or beyond the .001 level), suggesting that early artistic exposure may have an effect on later interest in spirituality. Further analysis of the adult participation items in table 9 (see p. 62) shows that all are positively associated with interest in spiritual growth (controlling for sex, age, and education), except for dancing and movies (negatively related) and listening to the radio and reading novels (unrelated).

22. With sex, age, education, and theological orientation (self-identified as evangelical or fundamentalist Protestant, self-identified as religious conservative) controlled, the logistic regression coefficients for effort, prayer, and meditation, respectively, are 1.36, 1.23, and 1.39; adding a control for interest in spiritual growth, they are 1.22, 1.10, and 1.30, respectively (all significant at or beyond the .001 level).

23. There is not a statistically significant relationship between artistic interest and simply having attended church regularly as a child; the logistic regression coefficients (using the same controls) are 2.10 for hymns, 1.49 for pictures, and 1.31 for objects (all significant at or beyond the .001 level); having sung in a choir or ensemble at church is also significant (2.28). The data also show that these childhood religious items are positively associated with childhood artistic activities outside of religion, such as taking art classes or singing in an ensemble at school.

24. With the same controls as before, the coefficient for church shopping is 1.26; for knowing others, 1.27; for attending others, 1.33; and for learning about others, 1.35; controlling only for sex, age, and education (not theological orientation), the relationships between artistic interest and agreeing that God has been fully revealed to humans in Jesus Christ and that Christianity is the best way to understand God are not statistically significant.

25. Controlling for sex, age, education, and theological orientation, artistic interest is weakly but positively associated with preferring personal experience to doctrine as a way of knowing God (1.12) and with agreeing that religious doctrines get in the way of truly knowing God (1.10); the relationship of artistic interest with having felt close to God in nature is 1.49; among friends, 1.37; and while reading an inspirational book, 1.40.

26. These were discussed in chapter 1.

27. Among currently divorced, divorced but remarried, and married but never divorced respondents, respectively, the percentages who report having had to deal with conflict with a spouse or partner are 66, 53, and 33; having moved past something painful in their upbringing, 47, 44, and 33; conflict at work, 44, 37, and 32; overcoming an addiction, 24, 19, and 13; learning to forgive others, 74, 69, and 58; and learning to forgive oneself, 62, 56, and 47. As with divorce, there appears to be an increase in these kinds of conflicts, judging from comparisons among birth cohorts: ever having serious conflict with a spouse or partner rises from 8 percent among the 1910s cohort to 43 percent among the 1960s cohort; conflict at work, from 6 percent to 39 percent; addiction, from 11 percent to 16 percent; moving past something painful, from 12 per-

cent to 39 percent; forgiving others, from 47 percent to 63 percent; and forgiving oneself, from 30 percent to 52 percent.

28. Among those having had conflict with a spouse, 45 percent score high on the Artistic Interest Scale, compared with 32 percent who have not had conflict; for conflict at work, the percentages are also 45 and 32, respectively; for an addiction, 48 and 34; forgiving others, 43 and 27; and forgiving oneself, 45 and 29. These differences are significant controlling for sex, age, and education.

29. The relationships between the arts and times of trial are considered in greater detail in chapter 4.

30. The proportion scoring high on the Artistic Interest Scale is 32 percent among those who know all or most of their neighbors; 40 percent, among those who know half; 38 percent, among those who know a quarter; 38 percent, among those who know only a few; and 26 percent, among those who know none; among those who prefer to be alone instead of around other people, 39 percent; among those who say other people energize them, 42 percent; and among those who say people drain them, 46 percent.

31. Of those who feel the breakdown of community is extremely serious, 39 percent score high on artistic interest, compared with 27 percent of those who think the breakdown of community is not a problem; the comparable percentages among those with different views of materialism are 42 and 30; for selfishness, 41 and 23.

32. Putnam, *Bowling Alone*.

33. In the Arts and Religion Survey, 78 percent said the breakdown of community is a serious or extremely serious problem in our society; 78 percent said this about selfishness; and 69 percent about materialism.

34. Among high school graduates, 38 percent opted for doctrine, 57 percent for personal experience, and 5 percent for both; among college graduates, the percentages were 28, 63, and 9, respectively.

35. The percentage saying their interest in religion has increased rises from 22 percent among those at the low end of the Artistic Interest Scale to 42 percent among those at the high end; church attendance (almost weekly), from 24 percent to 38 percent; and saying that attending services is very important to their spiritual growth, from 34 percent to 45 percent. These relationships are statistically significant controlling for sex, age, education, and theological orientation; introducing level of interest in spiritual growth as a control weakens the relationships to statistical insignificance, suggesting that interest in spirituality is the link between artistic involvement and religious involvement.

Chapter 4. Personal Spirituality

1. Additional information on the ambiance of childhood devotional activity is presented in my book *Growing Up Religious*, esp. ch. 1.

2. Margaret M. Poloma and George H. Gallup, Jr., *Varieties of Prayer: A Survey Report* (Philadelphia: Trinity Press International, 1991), p. 26.

3. Logistic regression coefficients for a model predicting daily prayer (versus less frequent prayer) and including all the following independent variables are as follows: age, 1.92; education, 1.04; African American, 1.58; Hispanic, 0.98; and female, 2.20. The coefficients for age, African American, and female are statistically significant. In a model that adds a dummy variable for evangelical, the coefficient for evangelical is 3.59 and the other coefficients change only slightly. Further analysis shows that women are more likely than men to pray daily in all age groups and categories of marital status.

4. Controlling for age, education, race, gender, and evangelicalism, the logistic regression coefficient for the arts scale is 1.29 (significant at or beyond the .001 level of probability). This means that for each increment in the arts scale, the odds of praying daily improve by 1.29 times.

5. The relationship between prayer, visualization, and art is discussed in Michael L. Northrop, "Painting Spiritual Subjects," *American Artist* 59 (1995): 48–55.

6. The relationships in tables 17 and 18 are all statistically significant at or beyond the .001 level of probability (based on logistic regression), controlling for age, education, gender, frequency of prayer, and frequency of meditation.

7. Howard Gardner, *Art, Mind, and Brain: A Cognitive Approach to Creativity* (New York: Basic Books, 1982), p. 91.

8. Controlling for gender, education, age, and childhood exposure to the arts, the relationships shown in table 22 are all significant at or beyond the .001 level of probability; logistic regression coefficients range from 1.47 to 3.49.

9. See my book *Sharing the Journey: Support Groups and America's New Quest for Community* (New York: Free Press, 1994).

10. In scholarly circles, this mistaken view has been popularized by Robert D. Putnam, "Bowling Alone: America's Declining Social Capital," *Journal of Democracy* 6 (January 1995): 65–78; and Theda Skocpol, "Associations without Members," *American Prospect* (July–August 1999): 66–74.

11. This study was conducted under a grant from the John Templeton Foundation. Fieldwork, subcontracted to the Gallup Organization, began in November 1998 and was completed in February 1999. The data are on machine-readable files that can be obtained from the author at Princeton University.

12. The analysis of small-group members is based on a total of 972 cases, 297 of whom were members of small groups in which art or music was discussed and 675 of whom were in groups that did not include such discussions (respondents in groups that were not part of the regular activities of a church were not included in the analysis). Using logistic regression analysis, the results were examined to make sure they were statistically significant when other factors were controlled. The controls were age (under age thirty or not), race (white or nonwhite), education (having any college training or not), sex, frequency of church attendance, respondents' religious views (conservative, moderate, or liberal), and the number of years the respondent had been involved in his or her group. The standardized logistic regression coefficients (or odds-ratios) and levels of significance for the effect of being in a group that discussed art or music, com-

pared to being in a group that did not do this, on each of the following dependent variables were as follows: healing of relationships, 2.08 (.001); felt God's presence many times, 1.55 (.01); understanding of different religious views, 1.95 (.001); faith grew a lot, 1.33 (.09); helped through an emotional crisis, 1.70 (.001); helped to forgive someone, 1.40 (.05); and group was extremely important, 1.34 (.05).

13. An exception is Margaret Woodward, "The Arts and Christian Formation," *The Way* (Fall 1989): 106–15, which discusses how small groups can make use of the arts.

14. Azara discusses her work in Roxanne M. Green, "Working with the Light: Women of Vision," *Women and Therapy* 17 (1995): 33–42.

15. Jon Davis, "Why Countermeasures?" *Countermeasures: A Magazine of Poetry and Ideas* 4 (1995): 34.

16. Virginia A. Hodgkinson and Murray S. Weitzman, *Giving and Volunteering in the United States: Findings from a National Survey,* rev. ed. (Washington, D.C.: Independent Sector, 1994).

17. For each increment of the arts scale, the odds of engaging in service activity increase by 1.35, controlling for gender, age, education, and church attendance.

Chapter 5. The Joy of Worship

1. Some scholarship has argued normatively that the arts *should be* central to congregational life; for example, Frank Burch Brown, "Characteristics of Art and the Character of Theological Education," *Theological Education* 31 (Autumn 1994): 5–11; and Barbara Wheeler, "Arguments and Allies: The Yale Consultations and Recent Writings about Theological Education," *Theological Education* 31 (Autumn 1994): 29–35. But little empirical attention has been directed to the kinds of music and art to which participants are exposed in congregations or church members' attitudes and beliefs about the role of music and art in congregations. One exception is the National Congregations Survey, conducted by Mark Chaves, Department of Sociology, University of Arizona, which provides some information on the numbers of congregations that include various kinds of musical activities; see Mark Chaves and Peter Marsden, "Congregations and Cultural Capital: Variations in Arts Activity" (paper presented at the Annual Meetings of the American Sociological Association, Washington, D.C., August 2000).

2. Because the present chapter focuses on congregations rather than individual spirituality, the distinction between evangelical and mainline Protestants is drawn on the basis of a question about respondents' denomination. The following were coded as evangelicals: Southern Baptist Convention, National Baptist Convention of America, National Baptist Convention U.S.A., Other Baptist (specified), Baptist (don't know which), Missouri Synod Lutheran, Presbyterian Church in America, Church of the Nazarene, Assemblies of God,

Pentecostal, Fundamentalist, and Nondenominational independent church; and as mainline Protestant: American Baptist Convention, Episcopalian, Evangelical Lutheran Church in America, Other Lutheran (specified), Lutheran (don't know which), United Methodist Church, A.M.E. Zion Church, A.M.E. Church, Other Methodist (specified), Methodist (don't know which), Presbyterian, Presbyterian Church (U.S.A.), Other Presbyterian (specified), Presbyterian (don't know which), United Church of Christ, and Christian Church.

3. On the recent history of liturgical dance, see Doug Adams, *Changing Biblical Imagery and Artistic Identity in 20th Century Liturgical Dance* (San Francisco: Sharing, 1984); and Carla DeSola, *Spirit Moves: A Handbook of Dance and Prayer* (San Francisco: Sharing, 1986); see also Linda Kent and Joanne Tucker, "Liturgical Dance: The Centuries-Old Partnership of Dance and Religion," *Dance Magazine* 70 (December 1996): 72–75; and Jamie Buckingham, "Praise Him Dancing," *Ministries Today* (May–June 1991): 46–51.

4. Controlling for the effect of religious tradition (evangelical, mainline, or Catholic), the logistic regression coefficient for the effect of congregational size on the likelihood of the church having sponsored each of the following in the past year is as follows: adult choir, 1.55; children's choir, 1.66; other musical performances, 1.65; drama or skit, 1.50; art festival, 1.49; group discussion on art or literature, 1.40; liturgical dance, 1.97; music lessons, 1.76 (all significant at or beyond the .01 level of probability).

5. Unless otherwise indicated, figures are from the Arts and Religion Survey.

6. Controlling for size of congregation, its confessional tradition (evangelical, mainline, or Catholic), and how often the respondent attends church, the logistic regression coefficient for the effect of number of congregational arts activities on each of the dependent variables shown in table 28 is as follows: felt uplifted in the past year, 1.99; felt close to God in worship, 1.76; felt close to God while listening to other music, 1.53; music has been very important to one's spiritual development, 1.26; spiritual growth is extremely important, 1.33; devoted a great deal of effort to spiritual growth, 1.46; interest in spirituality is increasing, 1.28; interest in religion is increasing, 1.31 (all significant at or beyond the .01 level of probability, except for music important to spiritual growth, and interest in spirituality, significant at or beyond the .05 level).

7. Although some people may favor some of these activities more than others, support for one is strongly related to support for others, as is indicated by a relatively high Cronbach's Alpha among the five items of .756.

8. Chuck Fromm, "Defining Contemporary Worship" (unpublished paper, November 19, 1999).

9. Kimon Howland Sargeant, *Seeker Churches: Promoting Religion in a Nontraditional Way* (New Brunswick, N.J.: Rutgers University Press, 2000), pp. 65–69. The role of art and drama at Willow Creek is also discussed in Gregory A. Pritchard, *Willow Creek Seeker Services: Evaluating a New Way of Doing Church* (Grand Rapids, Mich.: Baker Books, 1995), ch. 6.

10. From the Calvary Chapel–Costa Mesa homepage, www.calvarychapel.com.

11. Donald E. Miller, *Reinventing American Protestantism*, p. 87.

12. Content analysis of 102 praise choruses from the Calvary Chapel–Costa Mesa homepage.

13. On the Second Vatican Council and liturgical renewal, see Luis Maldonado, "Art in the Liturgy," in *Symbol and Art in Worship*, ed. Luis Maldonado and David Power (New York: Seabury Press, 1980), pp. 3–8; Patrick W. Collins, "Ritual Art Is the Issue," *Pastoral Music* (June–July 1996): 24–26; and Jan Michael Joncas, "'In the Beauty of Holiness': Key Questions about Liturgical Music Aesthetics," *Pastoral Aesthetics* (June–July 1996): 30–40.

14. R. G. Fabian, "Plan for the Mission of St. Gregory of Nyssa" (December 1977), from the Saint Gregory of Nyssa Episcopal Church homepage, www.saintgregorys.org.

15. Ibid.

16. Anthony Ugolnik, "Image and Word," *Reformed Journal* (November 1988): 16–22; Jeannette L. Angell and Susan E. Squires, "Not Just Art: Spiritual Significance of Iconography," *Spiritual Life* 39 (Summer 1993): 67–72; the definitive treatment of icons remains that of Leonide Ouspensky, *Theology of the Icon*, 2 vols. (Crestwood, N.Y.: St. Vladimir's Seminary Press, 1978, 1992).

17. Frank Schaeffer, *Dancing Alone: The Quest for Orthodox Faith in the Age of False Religion* (Brookline, Mass.: Holy Cross Orthodox Press, 1994); Peter E. Gillchrest, *Becoming Orthodox: A Journey to the Ancient Christian Faith*, rev. ed. (Ben Lomond, Calif.: Conciliar Press, 1992).

18. In logistic regression models, controlling for age, education, and gender, the odds-ratios for the relationship between music satisfaction and each of the dependent variables are significant at the .001 level of probability; adjusted odds-ratios, respectively, are 1.67, 1.62, 1.99, 1.59, and 1.47.

Chapter 6. Redeeming the Imagination

1. The focus of this chapter is on grassroots reinterpretations of the religious imagination by clergy and lay leaders; these reinterpretations are also reflected in such scholarly works as John Dillenberger, *A Theology of Artistic Sensibilities: The Visual Arts and the Church* (San Francisco: Harper and Row, 1986); David Freedberg, *The Power of Images: Studies in the History and Theory of Responses* (Chicago: University of Chicago Press, 1989); Garrett Green, *Imagining God: Theology and the Religious Imagination* (San Francisco: Harper and Row, 1989); James P. Mackey, ed., *Religious Imagination* (Edinburgh: Edinburgh University Press, 1986); and Margaret R. Miles, *Image as Insight: Visual Understanding in Western Christianity and Secular Culture* (Boston: Beacon Press, 1985).

2. Discussed in chapter 3, p. 65.

3. Quoted in "Report on the 3rd International Conference on Religion, Literature, and the Arts," *Religion, Literature, and the Arts Newsletter* 1 (March 7, 1996): 1.

4. That responses to the seven items shown in table 32 are highly interrelated is demonstrated by the fact that the Cronbach's Alpha statistic summarizing their relationships is a relatively high .794. This figure warrants combining the

items to form a single measure. In table 33, the measure used gives respondents one point for each of the seven items on which they say they have spent a lot of time; people scoring 4 or higher on the scale (i.e., who have spent a lot of time thinking about a majority of the seven items) are classified as "high" for purposes of comparison in table 33.

5. The creativity index shown in table 33 gives respondents one point for each of the following: agreeing with the statement "I think of myself as a creative person"; agreeing with the statement "I like to do things my way, even if I sometimes have to break the rules" or agreeing with the statement "I like to explore new ways of doing things"; and saying that at least one of the following especially sparks their creativity: "writing," "engaging in arts and crafts," "singing or playing a musical instrument," or "spending time in nature." Among all respondents, 13 percent scored 0, 23 percent scored 1, 27 percent scored 2, and 37 percent scored 3. Scores of 0 and 1 were classified as "low," a score of 2 was classified as "medium," and a score of 3 was classified as "high."

6. Robert P. Mills, "Voicing Creation's Praise: Intersecting Theology and the Arts," *Presbyterian Layman* (September–October 1998): 15–16.

7. Quoted in Max Lieberman and Michael McFadden, "Divine Inspiration and Art," Sol Design web site, www.sol.com.au/kor/9_01.html.

8. Walter Brueggemann, "High Risk Invitation," *Pastoral Music* 11 (April–May 1987): 31.

Chapter 7. The Morality Problem

1. On these controversies, see Robert Wuthnow, "Clash of Values: The State, Religion, and the Arts," in *Nonprofits and Government: Collaboration and Conflict,* ed. Elizabeth T. Boris and C. Eugene Steurle (Washington, D.C.: Urban Institute Press, 1999), pp. 267–90. The relationship between contemporary Catholicism and controversial artists is examined in Eleanor Heartney, "Postmodern Heretics," *Art in America* 85 (February 1997): 32–38.

2. See also Wayne C. Booth, "Religion versus Art: Can the Ancient Conflict Be Resolved?" in *Arts and Inspiration,* ed. Steven P. Sondrup (Provo, Utah: Brigham Young University Press, 1980), pp. 26–34.

3. The Cronbach's Alpha for the Negative Imagery Index is .475.

4. Controlling for age, education, sex, and race, the logistic regression coefficient for the effect of evangelical membership on the Negative Imagery Index is 2.71 (significant at or beyond the .001 level). With church attendance also controlled, the coefficient remains virtually unchanged (2.61), while the effect of church attendance is not significant at or beyond the .05 level. Biblical literalism is significantly associated with Negative Imagery (1.52) as well.

5. Peter V. Marsden, "Religion, Cultural Participation, and Cultural Attitudes: Survey Data on the United States, 1998: A Report to the Henry Luce Foundation" (working paper, Department of Sociology, Harvard University, October 1999), finds that white "conservative Protestants" score significantly

lower than white mainline Protestants and white Catholics on many of the arts participation and arts attitudes included in the 1998 General Social Survey data.

6. With age, education, sex, and race controlled, the logistic regression coefficient for the effect of having heard a sermon about the dangers of art and music on the Negative Imagery Index is 3.46 (significant at or beyond the .001 level of probability); the coefficient for evangelical membership remains significant (2.37). An interaction term for hearing a sermon and evangelical membership is also marginally significant (2.33; significant at the .08 level).

7. Maya Angelou, *Wouldn't Take Nothing for My Journey Now* (New York: Random House, 1993), p. 73.

Chapter 8. The Artist in Everyone

1. George Pattison, *Art, Modernity and Faith: Towards a Theology of Art* (New York: St. Martin's Press, 1991); Frank Birch Brown, *Religious Aesthetics: A Theological Study of Making and Meaning* (Princeton, N.J.: Princeton University Press, 1989); see also Nicholas Wolterstorff, *Art in Action* (Grand Rapids, Mich.: Eerdmans, 1980).

2. Stanley Hauerwas, "Discipleship as a Craft, Church as a Disciplined Community," *Christian Century* (October 1, 1991): 881–84.

3. Brenda Ueland, *If You Want to Write: A Book about Art, Independence, and Spirit* (St. Paul, Minn.: Graywolf Press, 1994).

4. John Dewey, *Art as Experience, Later Works* (Carbondale, Ill.: Southern Illinois University Press, 1987), p. 33.

5. Peter Kreeft, *Making Choices* (Ann Arbor, Mich.: Servant, 1990), p. 63.

6. Peter L. Giovacchini, "The Creative Person as Maverick," *Journal of the American Academy of Psychoanalysis* 19 (Summer 1991): 174–88.

7. Discussed in chapter 4, pp. 79–81.

8. Joan Shelley Rubin, *The Making of Middlebrow Culture* (Chapel Hill: University of North Carolina Press, 1992); and Diana Crane, "High Culture versus Popular Culture Revisited," in *Cultivating Differences,* ed. Michèle Lamont and Marcel Fournier (Chicago: University of Chicago Press, 1992), pp. 58–74.

Index

Text:	10/13 Galliard
Display:	Galliard
Compositor:	G & S Typesetters, Inc.
Printer and Binder:	Sheridan Books, Inc.